The Draftsman's Eye

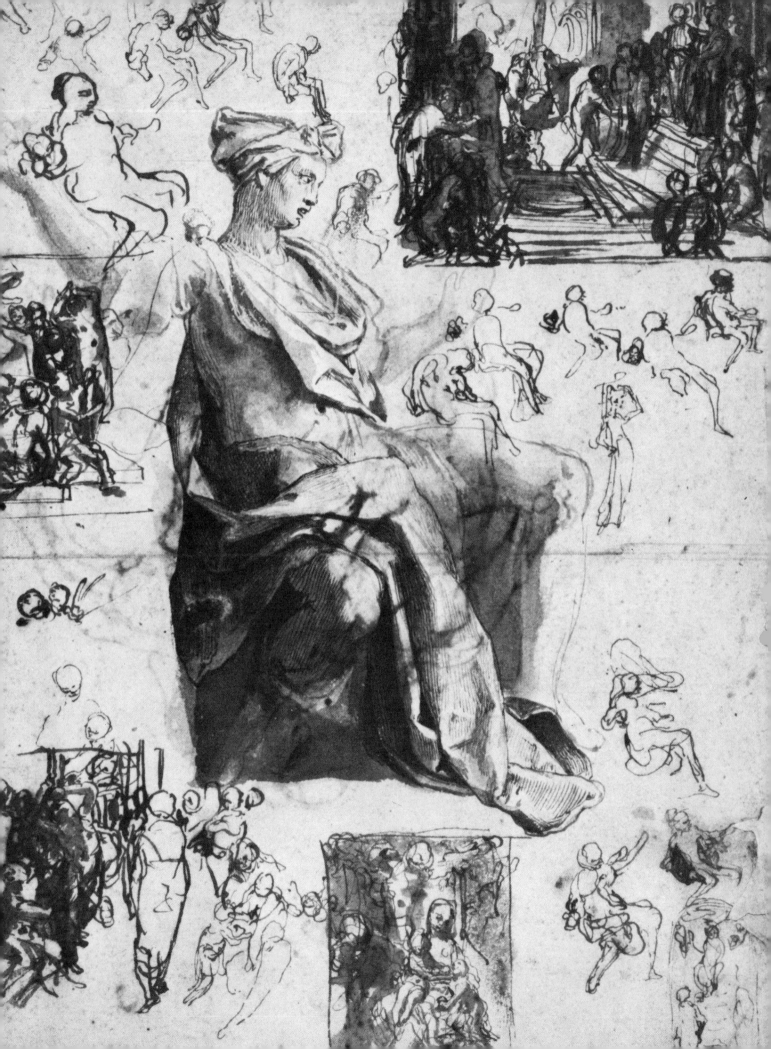

The Draftsman's Eye

LATE ITALIAN RENAISSANCE SCHOOLS AND STYLES

Edward J. Olszewski

with the Assistance of Jane Glaubinger

Published by The Cleveland Museum of Art
in cooperation with the Indiana University Press

Lenders to the Exhibition

The Art Institute of Chicago
Bowdoin College Museum of Art, Brunswick, Maine
E. B. Crocker Art Gallery, Sacramento, California
The Detroit Institute of Arts
Fogg Art Museum
Mr. and Mrs. Stephen C. Kollmar
Library of Congress, Washington
Los Angeles County Museum of Art
Metropolitan Museum of Art, New York
Museum of Fine Arts, Boston
National Gallery of Art, Washington
The Pennsylvania Academy of Fine Arts, Philadelphia
The Pierpont Morgan Library, New York
Museum of Art, Rhode Island School of Design, Providence
John and Mable Ringling Museum of Art, Sarasota, Florida
The Philip H. and A. S. W. Rosenbach Foundation,
 Philadelphia
Janos Scholz, New York
Smith College Museum of Art, Northampton, Massachusetts
Stanford University Museum of Art
Alice and John Steiner
Thomas P. Toth, Milan, Ohio
Janet S. and Wesley C. Williams, Cleveland
Worcester Art Museum
Yale University Art Gallery

The Exhibition THE DRAFTSMAN'S EYE: Late Italian
Renaissance Schools and Styles was held at The Cleveland
Museum of Art from 6 March to 22 April 1979 with the
assistance of a grant from the Ohio Program in the
Humanities.

Frontispiece: Detail of *Studies for the Blinding of Elymas
and for a Holy Family with the Infant St. John* (Recto) [82].
The Art Institute of Chicago, Gift of Robert B. Harshe,
1928.196

Copyright © 1981 by The Cleveland Museum of Art
11150 East Boulevard, Cleveland, Ohio 44106

Design by Merald E. Wrolstad
Title page calligraphy by William E. Ward
Printed in the United States of America
Typesetting by Abetter Typesetter, Cleveland, Ohio 44118
Printing by McNaughton and Gunn Lithographers, Ann Arbor, Michigan 48106

Distributed by Indiana University Press, Bloomington, Indiana 47405

Library of Congress Cataloging in Publication Data
Olszewski, Edward J 1937–
 The draftsman's eye.

 Bibliography: p.
 Includes index.
 1. Drawing, Italian. 2. Drawing, Renaissance—
Italy. I. Glaubinger, Jane, joint author. II. Title.
NC255.043 741'.0945 79-27199
ISBN 0-910386-47-1

Contents

Map of Italy. After Ronald Steel, Ed. *Italy*, The Reference Shelf, XXXV, no. 6
(New York: The H. W. Wilson Company, 1963).

Preface

When Charles de Tolnay, the noted Michelangelo expert and authority on drawings, published his landmark study of old master drawings in 1943, he considered The Cleveland Museum of Art one of the outstanding design cabinets among American collections. Its holdings included sheets by Filippino Lippi, Parmigianino, Palma il Giovane, Lodovico Cardi, Luca Cambiaso, Domenico Campagnola, Federico Zuccaro, Veronese, and Michelangelo—in other words, by some of the most outstanding draftsmen of the sixteenth century. These works formed the nucleus of a collection which has since been expanded significantly. This study, therefore, provides an opportunity to introduce to the general public as well as to scholars a group of fine drawings never before shown together. The forty-seven Cleveland drawings are presented in the larger context of seventy-eight drawings borrowed from other American collections. The Cleveland sheets are thus displayed so that their merits may be appreciated when seen with other master drawings. Loan items, when available, were chosen first by comparison with the Cleveland Museum's drawings for quality, attribution, date, and subject. While some sheets were borrowed as examples from areas in Italy not covered by the Cleveland collection, others illustrate the stylizations and inventive practices of the various Italian schools.

This catalog also offers the opportunity for a more thorough study of a collection of drawings wherein some are well known and thoroughly researched, others less familiar and little studied. Consequently, several sheets associated with Leonardo Cungi, Parrasio Micheli, and the Cambiaso school are published for the first time [41, 101, 127–129]. Revised datings are argued for others (3, 55, 61] as a result of identification with specific projects or reconsideration of previously available information. Based upon evidence in his letters, Michelangelo's study for the Sistine ceiling is reassigned to 1509. Subjects have been identified for some sheets [1, 5, 12, 73, 79, 120], such as Beccafumi's *Study for Moses and the Israelites Drinking,* in several cases by association of the drawings with finished paintings or more completed designs. Among these are drawings by Cardi, Romanino, and Vanni. Also, new attributions are established or suggested for a number of sheets [1, 2, 41, 43, 44, 67, 79, 85, 101, 127–129]. The most significant of these include reassignments from Allessandro Allori to Lodovico Cardi, Correggio to Domenichino, Parmigianino to Bedoli, and Domenichino to Grimaldi.

A project of the scope of this study is the product of the contributions of many people. The responsibility of acknowledging all who helped, therefore, is overwhelming. It is even more difficult to give proper recognition to those whose encouragement was absolutely necessary. Sherman E. Lee, Director of The Cleveland Museum of Art, was supportive of the idea for the exhibition and instrumental in assuring financial support for publication of the catalog. He allowed complete freedom in organizing the exhibition, and his assistance at crucial stages was vital in securing specific loan items. Merald Wrolstad, Editor of Publications, was most helpful in encouraging me to develop themes beyond the narrow focus of the specific drawings in the exhibition. He also designed the catalog and guided its production. I am particularly indebted to Louise S. Richards, Curator of Prints and Drawings, The Cleveland Museum of Art, for her enthusiastic interest, for her advice during the preparation of this catalog, and for her effort in hanging the exhibition. With the aid of A. Beverly Barksdale, General Manager, she was instrumental in obtaining financial support for the cost of loan items through The Ohio Program in the Humanities. I would also like to thank Charles C. Cole, Jr., Executive Director of The Ohio Program in the Humanities for his foundation's support of this project.

Jane Glaubinger, Research Assistant, gave generously of her time in checking references, assembling data, and preparing the exhibition labels, as well as revising the catalog entries and indexes. She unselfishly set aside work on her Ph.D. dissertation for several months to ensure the completion of this project. I appreciated her observations, judgment, and tact. Associate Editor of Publications, Jo Zuppan, spent many long hours on the manuscript and was efficient and agreeable in fulfilling the many responsibilities of an editor.

I was able to enjoy the advantage of an efficient professional staff at every step; Jack Perry Brown, Head Librarian of The Cleveland Museum of Art, and his staff were always helpful. Several members of the Department of Prints and Drawings offered capable assistance including Josephine Poda, Kim Clift, and Marcia Aquino. I was able to rely on the services of the Registrar's office for handling and processing loan items, the utility crew in hanging the exhibition, as well as the Photography Studio, the Printing and Public Relations Departments, and the Museum Designer. The encouragement of Trustees individually and as a group was reassuring.

My desire to compare Cleveland drawings with close examples was frustrated in a number of instances by a failure to secure the appropriate loan items. Several lenders, however, were especially generous. Janos Scholz put his outstanding collection at my disposal. John and Alice Steiner were hospitable and gracious in allowing me access to their superb collection of drawings. Konrad Oberhuber magnanimously postponed a planned exhibition at the Fogg Art Museum to make loan items available to me.

Preliminary research for certain aspects of this exhibition was undertaken by students, both graduate and undergraduate, in seminars and independent study courses on sixteenth-century Italian drawings. Their specific contributions are noted in the catalog entries. I would like to acknowledge Christine Bishop for her extensive help in cataloging information, Karen Smith for researching problems in inconography and formal motifs, and David J. Whipple for general research assistance.

For stimulating discussions on particular issues and the broader category of Italian drawings I owe thanks to Francis Richardson, The Ohio State University; William Hood, Oberlin College; Joseph Rushton, Notre Dame University; and Sarah Wilk, Rutgers University. I am grateful to Florence Kossoff, Kent State University, for her comments on drawings by Lelio Orsi and Girolamo Romanino, and to Steven Ward also of Kent State University, for his advice and comments on questions of anatomy.

I am indebted to the following for various kindnesses and assistance: Licia Ragghianti Collobi, Florence, and Anna Forlani Tempesti, Director, Drawings Cabinet, Uffizi, Florence; Jane Low Roberts, Curator of Prints and Drawings, Royal Library, Windsor Castle; Roseline Bacou, Chief Conservator, Drawings Cabinet, Musée du Louvre; John Gere, Keeper, Department of Prints and Drawings, British Museum; James Byam Shaw, Curator of Drawings, and J. J. L. Whiteley, Assistant Curator, Christ Church, Oxford; Dr. J. H. van Borssum Buisman, Teylers Stichting, Haarlem; Jacob Bean, Curator of Drawings, and Mary Meyers, Assistant Curator, Print Department, The Metropolitan Museum of Art; Felice Stampfle, Curator, Drawings and Prints, The Pierpont Morgan Library; Franklin W. Robinson, Director, Graduate Program in the History of Art, Williams College; Diane D. Bohlin, Curator of Italian Drawings, National Gallery of Art, Washington; Harold Joachim, Curator, and Suzanne Folds McCullagh, Assistant Curator, Department of Prints and Drawings, The Art Institute of Chicago; Ebria Feinblatt, Curator, and Joseph E. Young, Assistant Curator, Department of Prints and Drawings, Los Angeles County Museum of Art; Diana L. Johnson, Curator, and Patricia M. Hurley, Curatorial Assistant, Museum of Art, Rhode Island School of Design; Colles Baxter, Curator, Department of Prints and Drawings, Smith College Museum of Art; Richard G. Baumann, Curator, Renaissance and Modern Art, Museum of Art and Archaeology, University of Missouri-Columbia; Katherine Watson, Director, Museum of Art, Bowdoin College; Judith Hoos Fox, Assistant to the Director, Wellesley College Museum; Terri Hackford, Department of Prints and Drawings, Wadsworth Atheneum; James Burke, Curator of Drawings, Yale University Art Gallery; Ellen Sharp, Curator, and Marily Symmes, Curatorial Assistant, Graphic Arts Department, The Detroit Institute of Arts; John W. Ittmann, Curator of Prints and Drawings, The Minneapolis Institute of Arts; Xenia Cage, Assistant Curator, Drawings and Prints, Cooper Hewitt Museum, New York; Barbara T. Ross, Custodian of Prints and Drawings, The Art Museum, Princeton University; Clive Driver, Director, The Philip H. and A. S. W. Rosenbach Foundation; Kneeland McNulty, Curator of Prints and Drawings and Ann Percy, Associate Curator for Drawings, The Philadelphia Museum of Art; Anthony Rosati, Assistant to the Curator, Alverthrope Gallery, Jenkintown, Pennsylvania; William H. Wilson, Curator, John and Mable Ringling Museum of Art, Sarasota, Florida; Eleanor Sayre, Curator of Prints and Drawings, The Museum of Fine Arts, Boston; Dr. and Mrs. George M. Baer, Atlanta, Georgia; David Woodward, Director, The Herman Dunlap Smith Center for the History of Cartography, The Newberry Library, Chicago.

Finally, I am indebted to the American Philosophical Society, Penrose Fund, for a grant-in-aid in support of my research in Europe, and for a provost's Junior Faculty Grant and two Humanities Division Faculty Grants from Case Western Reserve University in support of my travel to American collections and for the purchase of photographs. To Mrs. Ida Brisky my gratitude for help so readily given in typing the manuscript.

This book is dedicated to N.W.C.

E.J.O.

Numbers in brackets (such as [16]) refer to catalog entries and/or their illustrations.

Introduction

The sixteenth century in Italy was the great age of drawings. Draftsmanship, considered basic for the arts at the end of the Renaissance, had been accepted as such in practice long before it was enunciated in theory. The artist's handbook of Cennino Cennini, circulated in manuscript form from the first years of the Quattrocento, was an early attempt to formalize the study of drawing. Decades later Leonardo da Vinci demonstrated in his notebooks the value of draftmanship for scientific enquiry. Finally, in the sixteenth century art theorists extolled drawing for its intellectual discipline and inspired vision.

The greater availability of paper in the late fifteenth century accounted in large part for the flowering of drawing in the Cinquecento. Its use revolutionized the artist's procedures. It freed him from working directly on a panel or wall. He no longer had to depend on stock poses and stylized figures from medieval pattern books, since he now had the liberty of sketching numerous ideas for poses and compositions. Paper also allowed him to explore media other than the conventional charcoal or pen used on parchment, media permitting more convincing effects of naturalism. Using paper instead of more costly vellum, the artist could work on a larger scale in the trial stages of his project. Paper facilitated transfer of completed ideas for a subject — often arrived at after great effort — directly to the wall or panel surface.

Although drawings expressed an artist's personal style, every drawing also reflected the workshop or region of its origin.[1] With the importance given to naturalistic representation in sixteenth-century Italian painting, every artist had to transpose a real world of substance and volume to a two-dimensional surface. The means for doing this were developed in the artist's studio where the master devised shorthand techniques to expedite the process, and his system of abstractions and stylizations was passed on to his pupils. Thus, the apprentices were taught how to look and how to represent what they saw. Their vision, therefore, was conditioned by pedagogical concerns.[2] Hence, the drawings discussed and reproduced in this volume are grouped by geographical areas of Italy, although exhibited in topical groupings.

These drawings also are considered in the context of sixteenth-century art theory. Information provided by contemporary art treatises, prints, and drawings and by studio practice as revealed in biographies, letters, contracts, and academy proceedings adds to our understanding of individual works of art. New interests of the period

*Everything done by the hand
is based on the order and rules of drawing.*
ANTONIO AVERLINO, IL FILARETE

*For drawing itself is not true
but a demonstration of the thing you [are] drawing
or what you wish to show.*
ANTONIO AVERLINO, IL FILARETE

A good draftsman can never produce bad works.
BENVENUTO CELLINI

and old subjects considered in novel ways are also reflected in drawings, and curiosity about the real world is revealed in anatomy studies, portraiture, and landscape drawings.

Disegno, the Sign of God

At the end of the sixteenth century, Federico Zuccaro discussed the etymology of the Italian word for drawing, *disegno*, and revealed both the importance of draftsmanship for the arts and the unique status of the artist. In Zuccaro's view, *disegno* originated from the phrase *segno di dio in noi*, or "the sign of God in us," indicating that those skilled in design were divinely inspired.[3] At the beginning of the century Michelangelo had already been referred to as divine, slightly later Raphael was called "Il divino," and at mid-century Giorgio Vasari in his collection of artists' biographies maintained that Perino del Vaga's genius was a gift from heaven.[4]

Art did not always enjoy such status. In the fifteenth century the artist's concern with elevating painting and sculpture from craft to art first led to an association of painting with mathematics, one of the traditional liberal arts. The link with mathematics was made through the artist's dependence upon perspective.[5] Next, as is evident from the writings of Leonardo da Vinci, painting was equated with poetry, an idea based upon the *Ars poetica* of Horace.[6] It was through such associations that the painter came to share the status of the poet. In addition, contemporary literary theory reinforced Vasari's elitist view of the artist as gifted from birth.[7] It was a corollary to this belief that one born without the gift of art could never hope to succeed as a painter.[8] These attitudes seem

to deny a need for studio training, but Vasari quickly pointed out that Perino del Vaga fortified his natural talent with much study. Indeed, at the end of the Cinquecento, Giovanni Battista Armenini in his treatise on painting stressed the commonsense view that without proper training the artist might lose or waste his natural gifts.[9]

Once the painter's function had been equated with that of the poet, he was bound to imitation. To Aristotle *imitatio* meant conformity with nature and truth to life, but to Armenini, art was to be imitated, since painting consisted of the judicious study of other masters until one became like them. This idea derived from Dionysius of Halicarnassus, a writer of the first century BC popular in the Renaissance, whose *mimesis* expressed the concept of creation as a synthesis of other's works.[10]

The early Renaissance artist's dependence upon nature soon diminished. This is evident from the Venetian art theorist Lodovico Dolce's remark that nature was "to be improved."[11] The view of nature as flawed—common to Neoplatonic as well as Aristotelean thinkers—was widely accepted in the sixteenth century. Indeed, Armenini held that nature was "declining continually" and no longer a source of beauty "unless corrected by a competent artist."[12] The products of nature, therefore, were base and stunted a beautiful style. Indeed, *disegno* provided the means for correcting nature. Armenini considered beauty a correspondence of parts dependent for coherence on the artist's personal style. Through a singular style the artist could counter nature and transform it into something of quality. Imitation, then, as practiced during the Cinquecento, led to idealizing the object imitated, and reality was perfected rather than counterfeited as the accurate gave way to the beautiful.

Armenini defined *disegno* as "a prearranged plan originating in the intellect and materializing on paper by way of lines, and light and shadow after a series of studies and one or more acts of judgment."[13] For Raffaello Borghini *disegno* was a linear demonstration of something conceived in the mind and imagined in the idea.[14] These definitions clarify the conceptualistic bias of late Renaissance art theory and the separation of art and nature. They repeated Vasari's view of *disegno* as "a visible expression and declaration of our inner conception and of that which others have imagined and given form in their idea."[15]

Two paths of imitation—both of which involved processes once removed from nature—were open to the aspiring artist: He could copy the art of one great master or that of several.[16] In either case he should copy the best. Cenino Cennini argued for the late medieval tradition of following a single master.[17] But Armenini warned of the difficulty of fully understanding one master's style and so felt the second choice more prudent. The novice drew regularly and copied many masters to acquire skill in draftsmanship. Ultimately, by practicing from nature, the work of others, and antiquity, the sixteenth-century artist acquired facility in his art so he could create from memory.[18]

Once painting became an accepted liberal art its basis in philosophy was assumed, and principles (or theory) and practice became equally important.[19] Theory explained the essence of reality whereas *mimesis* or copying imparted knowledge of externals. Practice as manual copying, however, could be transcended by *imitazione* as Aristotle understood it, that is, as rational observation involving analysis and speculation.

The naturalness of a sixteenth-century design depended more on the information it provided than on how well it reproduced the external appearance of reality. In anatomy, the study of the skeleton, muscles, and ligaments and of the names and positions of the parts expressed the need to understand causes in nature and to comprehend function and principles of motion, as much as to understand structure for the sake of appearance.[20] *Disegno*, therefore, manifested nature more nobly.

This academic tendency at the end of the century resulted from the belief that painting appealed to reason rather than to the eye. *Disegno*, as a speculation born in the mind, could be taught, and *l'occhio dell'intelletto*—that is, "the eye of the intellect"—could be enlightened by the proper rules.[21] Federico Zuccaro emphasized the intellect's importance by his distinction between *disegno interno*—that is, artistic form observed in the mind—and *disegno externo*—the idea expressed in an art object.[22]

The Draftsman's Training

The greater independence of the Renaissance artist resulted from the gradual breakdown of the guild system in the late Middle Ages, coupled with the Renaissance master's desire to rise above the status of craftsman. This newly found freedom did not mean, however, that the Renaissance studio verged on anarchy. In the medieval workshop, guild law dictated that youths spent two to six years acquiring the fundamentals of painting, including draftsmanship. They could then practice as journeymen until they felt ready for the tests for master's status.[23] A roughly equivalent period was necessary in the Renaissance studio, although the length of the training period was determined by the student's ability. The apprentice or his family paid for his instruction, but the master might salary a precocious talent instead. The student, upon completing his term of training, became the master's assistant and had greater independence.[24]

The aspiring artist's training began with mastering the rudiments of drawing.[25] The apprentice also performed menial tasks such as cleaning brushes or grinding pigments and, when more advanced, could help prepare panels and frescoes. Leonardo advised the novice to begin by studying perspective and proportions (reflecting Quattrocentro interests and no doubt his own training).[26] Next, the pupil was to copy the drawings of an accomplished artist, then to draw from reliefs, natural models, and finally the works of various masters. Copying provided practice for the eye and exercise for the hand.

Armenini further outlined the normal procedures followed in the studio by 1550.[27] The practice of *disegno* began with tracing line drawings from a respected master. Next, students worked from engraved designs, which continued their training in the definition of outline and also accustomed them to working in larger compositions. Then they imitated painted works and, even better, antique sculpture.

Drawing was more strongly emphasized in the training of Renaissance artists after mid-century when certain artists and writers expressed fears of a decline in the arts, especially painting. The deaths of Leonardo da Vinci and Raphael in quick succession (1519 and 1520, respectively) were significant losses, and no new talents were seen emerging to replace them. Renewed attention was given to the formal training of the artist, and it was almost as if Giorgio Vasari anticipated Michelangelo's death by establishing the Accademia del Disegno in Florence in 1563. A basic tenet of the academy was that all the arts had a common origin in *disegno*, an idea not novel to Vasari. Earlier in the century in Castiglione's *Courtier*, Count Lodovico da Canossa observed that, "although painting differs from sculpture, both spring from the same source, namely, good design."[28]

Greater emphasis was placed on the practice of draftsmanship when the Carracci founded the *Accademia degli Incamminati* in Bologna in 1582. The academy remained loosely structured in spite of the drawing competitions and prizes initiated by Agostino Carracci.[29] The casual mode of working can be illustrated by an etching published in 1608 by Odoardo Fialetti, a former pupil of the Carracci studio (Fig. I). Here the pupils sketch independently, working from plaster casts of busts and torsos. At the left, two students exchange criticisms while, in the background, masters work at their own projects.

Enea Vico's engraving of 1550 also shows artists working in groups [74], a procedure Leonardo recommended as a reliable way for a pupil to improve his skill in drawing since he could advance through the advice and opinions of his peers.[30] Leonardo believed such interchange would keep the student from falling too far behind the progress of his companions out of shame, praise would inspire him to do better, and the works of others would be available for emulation. Exchange of criticism was a normal part of the studio environment; indeed, the youthful Michelangelo had his nose broken by the young apprentice sculptor, Torrigiani, for being too lavish with his criticism of the latter's drawings.[31]

Instruction focused on copying plaster casts of parts of the human body. Lodovico Carracci apparently preferred to practice from casts of hands, while Agostino was said to carry a plaster ear with him.[32] Similar paraphernalia abound in Cesare Pollini's drawing of the workshop [60]. The greater interest in movement after mid-century is reflected in this preoccupation with parts of the human figure. Animated poses would lead to more complicated figures, often foreshortened, and assembled in additive

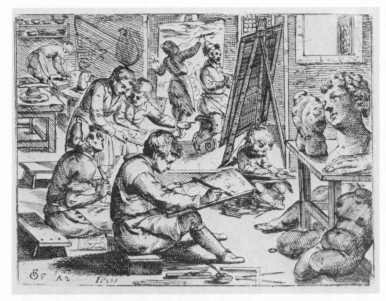

Fig. I. *The Artist's Studio*, etching. Odoardo Fialetti, Italian, 1573–1638. Rare Book Division, The New York Public Library, Astor, Lenox and Tilden Foundations.

fashion little aided by canons of proportions. Foreshortening was an important topic in academies and late Renaissance treatises not only as a result of the predilection for representing figures in motion but also because many decorative programs for palaces and churches involved paintings with figures viewed *di sotto in su*, that is, as if seen from below in perspective recession (see [33, 43, 77, 104]).[33] The use of violently foreshortened figures was stimulated by Michelangelo's Sistine ceiling—especially the daring portrayal of Jonah[34]—by Correggio's ceiling frescoes in Parma, and by Guilio Romano's ceiling paintings in the Palazzo del Te, Mantua. In the late decades of the century, one of the most active figures in decorating palaces was Pellegrino Tibaldi, whose projects reflect similar interests in animation and unusual vantage points (Fig. II).

Michelangelo's biographer, Ascanio Condivi, indicated in 1553 that exact measurements were always lost during representation of an object,[35] but one of the earliest and most consistent examinations of the problems of foreshortening appeared in Leonardo's notes and drawings. His studies as represented in the *Codex Huygens* exemplify the shortcomings of proportional canons and also attempt the representation of foreshortened figures in a systematic way by the method of parallel projections (Fig. III).[36] This system of representation never became popular in Italy, but interest in presenting figures *di sotto in su* remained vital to the end of the century.

Examining figures shown in perspective in Albrecht Dürer's woodcuts reveal that even that exacting German painter and graphic artist realized the inadequacies of proportional canons. Dürer's woodcut (Fig. IV) shows the artist at work with various aids for depicting foreshortened subjects. In every instance the subject is static. Indeed, one scene represents an attempt at portraiture.

3

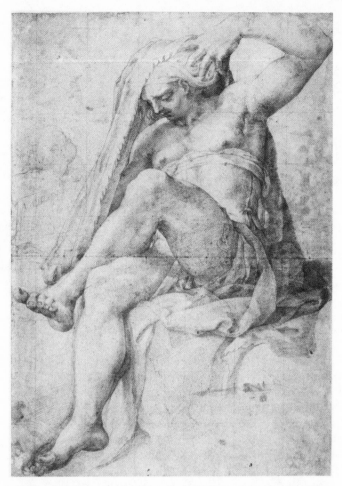

Fig. II. *Seated Figure*, red chalk, 476 × 340 mm. Pellegrino Tibaldi, Italian, 1527–1596. The Pierpont Morgan Library, New York.

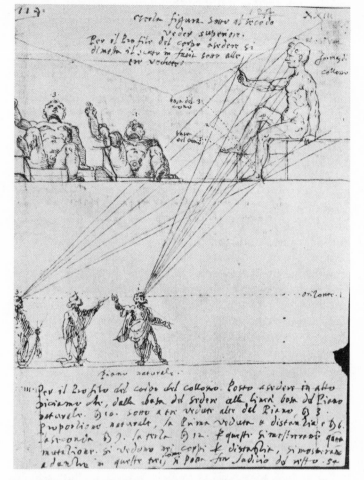

Fig. III. *System of Parallel Projections*, pen, 137 × 186 mm. Girolamo Figino, Italian, ca. 1520–after 1612. The Pierpont Morgan Library, Gift of Felix M. Warburg, 1918.

Fig. IV. *The Draftsman of the Sitting Man*, woodcut, 130 × 148 mm. Albrecht Dürer, German, 1471 × 1528. The Metropolitan Museum of Art, New York, Gift of Henry Walters, 1917.

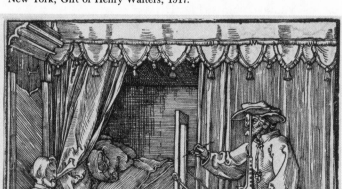

The subject is always viewed from a fixed point which is analogous to the point of origin in Leonardo's cone of vision illustrated in the *Codex Huygens*.

Dürer depicted several methods for translating the three-dimensional world to a two-dimensional surface, the illusionistic preoccupation of the Cinquecento artist. These constructions are methodical but avoid the need for a complicated system of numerical ratios. After describing how to construct a perspective system, even the humanist Leon Battista Alberti, in his early Quattrocento treatise on painting, advised using a reticulated net if the creation of an exact system of perspective became too tedious.[37] Leonardo, and later Armenini, described a method strikingly similar to that illustrated by Dürer (Fig. V).[38] Some of these techniques were recommended into the seventeenth century, as in the Italian *Sketchbook on Military Art* [29] where other possibilities are suggested (Fig. VI).

In view of the late Cinquecento interest in receding figures and the inadequacy of proportional systems, the Carracci's approach made sense. When figures painted above eye level are foreshortened drastically, a foot may be juxtaposed with a knee or a knee with a head and shoulder, so that a sound knowledge of the body's parts

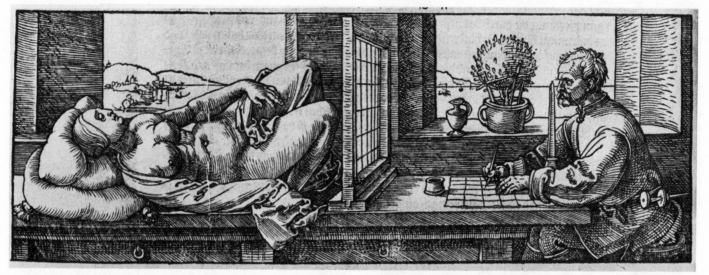

Fig. V. *The Draftsman of the Reclining Woman*, woodcut, 76 × 212 mm. Albrecht & Dürer, German, 1471–1528. The Metropolitan Museum of Art, New York, Gift of Felix M. Warburg, 1918.

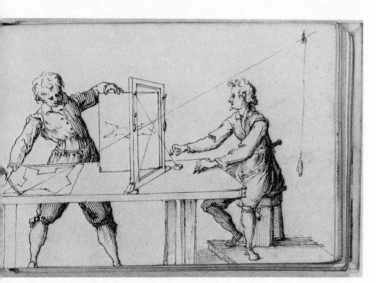

Fig. VI. *Sketchbook of Military Art*, pen. Italian, after 1630. Library of Congress, Rosenwald Collection.

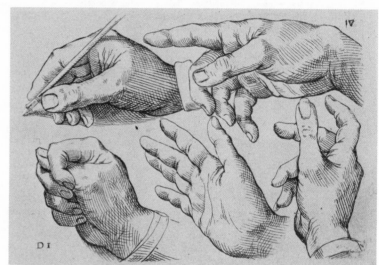

Fig. VII. *Studies of Hands*, etching. Odoardo Fialetti. Rare Book Division, The New York Public Library, Astor, Lenox and Tilden Foundations.

allows the artist to assemble the figure as needed. Carletto Caliari's sheet of studies [99], filled with different views of hands, is just such an exercise in mastering part of the body. This approach was codified in a more deliberate fashion in Fialetti's etchings (Fig. VII), some of which were based upon Agostino Carracci's drawings. A single page demonstrates the extent of his didacticism (Fig. VIII). The procedure for drawing an eye begins with a simple curved line, continues with a second line, then an oval for the pupil, and finally adds several more lines, to define the eye fully. Similar approaches are given for ears, nose, feet, and for different views of them. That manuals such as Fialetti's were taken seriously is demonstrated in the lower left of Pierfrancesco Alberti's engraving of the artist's studio [31], where a master criticizes a pupil's drawing. The object of discussion is a sheet representing the human eye in various stages of completion, perhaps based on a page from Fialetti's primer.

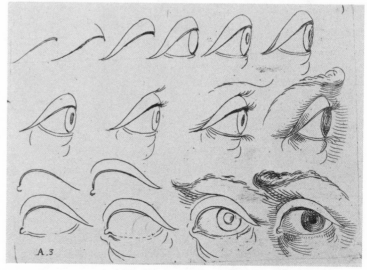

Fig. VIII. *Studies of Eyes*, etching. Odoardo Fialetti. Rare Book Division, The New York Public Library, Astor, Lenox and Tilden Foundations.

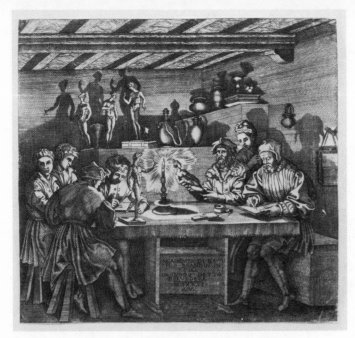

Fig. IX. *The Academy of Baccio Bandinelli*, engraving, 1531. Agostino Veneziano, Italian, 1490–1540. The Metropolitan Museum of Art, The Elisha Whittelsey Fund, 1949.

Fig. X. *Taddeo Zuccaro Drawing in the Villa Farnesina*, pen and wash, 419 × 190 mm. Federico Zuccaro, Italian, 1540–1609. Uffizi, Florence.

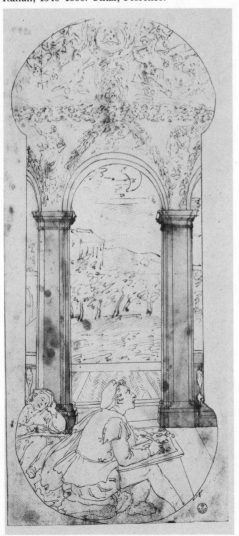

Copying, one of the formative stages in learning to draw, provided practice for the eye and exercise for the hand. Most of the drawings exhibited, however, reflect more advanced levels of draftsmanship and are practical in that the artist was testing poses and compositions. They represent the methods of trained artists.

The Academy of Baccio Bandinelli (Fig. IX) by Agostino Veneziano, an engraving of 1531, provides another view of the artist's training.[39] Bandinelli's pupils work in his Vatican Belvedere studio studying clay or wax models illuminated by artificial light. Alberti believed that copying even a mediocre sculpture was more helpful than drawing from an excellent painting because one would not only acquire a feeling for form but would also learn how light and surfaces interact to define planes and volumes.[40]

The illustrations of academies by Enea Vico and Pierfrancesco Alberti [74, 31] include heads among the studio accoutrements either as plaster casts or marbles. Parmigianino's *Head of Julius Caesar* [89] is an accurate copy of a Roman marble, one of several views of the subject made to study the play of light on the complicated surfaces of a carved face. In Bandinelli's studio each artist works independently and concentrates on the human figure, stressing poses and definition of musculature. According to Armenini, use of models in artificial light most readily taught the articulation of musculature.[41] Light could be made to fall on the model from different directions by moving it or by turning the figure, thus defining the muscles in relief. In Enea Vico's engraving [74], made twenty years after Veneziano's, the studio members also draw by artificial light but seem more concerned with working from fragments and skeletal parts and less interested in the total figure. The pupils in Pierfrancesco Alberti's print [31], on the other hand, work in the bright light of day, indicating the seventeenth-century interest in a return to the normative. In contrast, and possibly inspired by Vico's and Veneziano's engravings, is Federico Zuccaro's romantic scene of his elder brother Taddeo copying by moonlight the frescoes of what would seem to be the *Loggia di Psiche* of the Villa Farnesina (Fig. X).

Working in artificial light may have had other ramifications for the Cinquecento workshop, especially for the origins of some late sixteenth-century stylistic idiosyncrasies. In contrast to the highly ordered, classicizing art of the high Renaissance, a willful approach to space, the human figure, light, color, and emotion frequently characterized Cinquecento painting after 1520. Drawings of the Tuscan school [8, 10, 22-25, 27] show this most clearly. The questioning of traditional values in politics (Machiavelli), religion (Martin Luther), and science (Copernicus) was paralleled in the arts by mannerist painting, sculpture, and architecture. A late manifestation of mannerism called *maniera* was a striving for purely visual effect at the expense of subject matter and expression. The term *maniera*, translated into English as "style," is interpreted more correctly as "the stylish style" and con-

notes an art of affectation and ornamentality.[42] Perhaps the rational, structured art of the high Renaissance, perfect and short lived, should be considered an anomaly in the history of Italian art, representing a brief interruption between the mannerisms of Botticelli and the mannerism of Pontormo [23] and Rosso [25].

Maniera artists—that is, those Mannerists given to decorative pursuits—were preoccupied with distorting the extremities of figures. In part, this was due to the preference of the Tuscan and Roman schools for line and contour over color, a bias reinforced by knowledge of the ancient myth of painting's origin from tracing a man's shadow on a wall. Leonardo knew the myth, and Vasari even identified the first draftsman as Gyges of Lydia.[43] In Vico's print of Bandinelli's Academy [74] students work in artificial light, while in Veneziano's engraving (Fig. IX) models on the ledge beneath the ceiling cast distended shadows onto the walls.[44] Alberti observed that objects illuminated by stars cast shadows equal to their size, but objects illuminated by fire-light had larger shadows.[45] A drawing in the *Codex Huygens* associated with the school of Leonardo (Fig. XI) illustrates this idea. Leonardo understood the folly of careless experimentation with shadows. He explained that a shadow can never be of the same size as the body that cast it because bodies will produce longer or shorter shadows in proportion to their distance from the source of light. He also stated that an object will never produce a shadow of identical form and that the shadow will result in a true image only in the rare circumstance of a light source placed equidistant from all edges of the object.[46] In effect, extraplanetary light sources can be said to be equidistant from the extremities of all objects they illuminate. The circumstances under which a figure and its shadow will be equal are so rare that one must conclude from Leonardo's scientific observations that every shadow is a distortion. Thus what artists in the studio observed working with artificial light may have reinforced their interest in a free interpretation of human proportions and contributed to the formal extravagance found in their drawings.

Elongated proportions and twisted poses were also the natural result of other attitudes prevalent among sixteenth-century artists, explained by their approach to *invenzione* and their interest in grace, difficulty, and novelty. Vasari stressed the importance of *varietas*, but Armenini noted the impossibility in his time of creating anything new.[47] He felt, therefore, that borrowing from the inventions of others was permissible, but only if the motifs were modified and made to conform to the copier's style. A drawing was the logical vehicle for such transferences, and Armenini indicated what devices the artist could use.[48] For example, Polidoro da Caravaggio traced figures from antique friezes, some perhaps even previously used in other combinations, onto a sheet in pen or charcoal.[49] But mere copying to form a composite of elements would not ensure success because style also depended upon the artist's inventiveness.

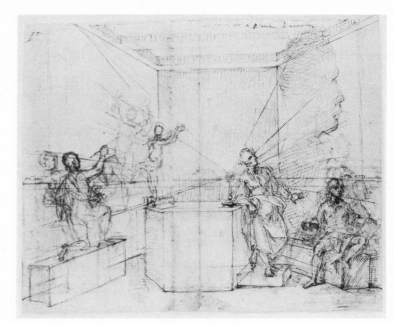

Fig. XI. *Figures Drawing Cast Shadows*, pen, 232 × 183 mm. Girolamo Figino. The Pierpont Morgan Library.

Fig. XII. *Religion*, black chalk, 304 × 177 mm. Francesco Primaticcio, Italian, 1504–1570. The Pierpont Morgan Library.

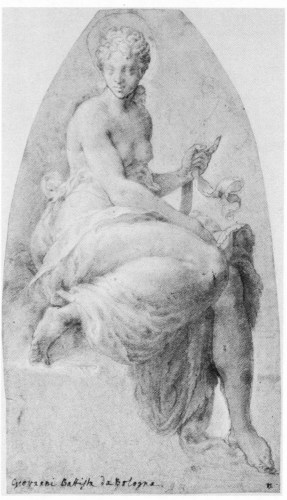

7

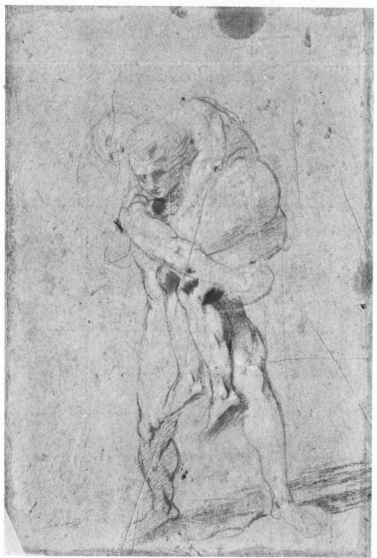

Fig. XIII. *Nude Male Bearing a Figure on His Shoulders*,
black chalk, 377 × 237 mm. Federico Barocci,
Italian, 1535–1612. Uffizi, Florence.

numerous, including Lorenzo di Credi's *Madonna and
Child* [15], Raphael's *Studies of a Seated Model* [61], and
Taddeo Zuccaro's *Studies for the Blinding of Elymas* [82].
While the procedure is more appropriate for the early
stages of a project, it can also be found in a finished study
like Bronzino's *Copy after Bandinelli's "Cleopatra"* [9].

Leonardo originally used and recommended this
method which he romanticized to put painting on a par
with poetry among the liberal arts.[52] He explained that
the practice was analogous to the poet's creative process of
deleting words and adding lines as he saw fit. Leonardo's
approach became a matter of routine through the six-
teenth century, receiving the enthusiastic endorsement of
Armenini for whom it was natural and logical since, in
his opinion, the artist's first idea was never perfect.[53] The
final arrangement resulted from a necessary sequence of
tentative sketches and repeated acts of judgment by the
artist.

Since the intellect was naturally flawed, the composi-
tion had to be developed in a series of drawings. Even the
gifted Raphael reworked sketches and revised poses [61],
experimenting endlessly. Working drawings [46, 73, 99,
109] allowed the artist to correct errors as he proceeded
from rough sketches to finished drawing and finally the
cartoon. Often, to exercise his imagination, the painter
made several finished studies of the same subject, some
significantly different. Such was the case with Luca
Cambiaso's *The Annunciation* [123–124] where a dozen
drawings, some quite polished, were made. The best
elements of these were synthesized in the final composi-
tion. Both Dolce and Armenini credited Raphael for this
eclectic method of invention.[54]

Federico Barocci followed an alternative method which
may be called the academic approach because it followed
the piecemeal studies pursued in the academies. It is
exemplified by Barocci's *Aeneas's Flight from Troy* [34]
which is close to the completed painting yet diverges from
it in some ways. Along the right margin there are sketches
for alternative poses for Aeneas and Anchises, and for
Creusa. These explorations continue on recto and verso of
a drawing in the Uffizi (Fig. XIII) and on numerous other
sheets where Barocci reworked the entire composition,
single figures, elements of the background, and various
details. These explorations led to more refined figurative
action and embellishment of particulars, with the final
painting emerging from the original compositional state-
ment and its subsequent challenge and extension in detail
studies.

Enough drawings by Luca Cambiaso and Federico
Barocci survive to allow some insight into each artist's
mode of invention. Cambiaso's synthetic or eclectic ap-
proach with multiple composition studies leading to the
final work contrasts with Barocci's analytical or academic
method which was also followed by Annibale Carracci.[55]
Such techniques, taught in the workshop to aid the artist's
inventiveness in narrative and composition, depended first
on a thorough grounding in human anatomy.

Francesco Primaticcio's personification of *Religion* (Fig.
XII) with a redrawn face pasted over an earlier version
and a study [24] with figures cut from different sheets
pasted together in a new arrangement demonstrate other
means for achieving variety in poses and compositions.
Often an artist masked his model by removing details,
adding clothing or weaponry, or altering the pose some-
what.[50] Raphael was said to test his inventiveness by mak-
ing many drawings suitable for his subject, setting them
out before him, and borrowing elements from one, then
from another until he completed his composition.[51]

The sixteenth-century draftsman also explored various
ideas by repetitive delineation of details. Hands and feet
were sketched over earlier markings without erasures until
the artist was satisfied. Examples of this practice are

Anatomy Studies

Modern science had its origin in the Renaissance studio where the artist's training emphasized precise records of visual data. Interest in the human figure soon eclipsed the Quattrocento preoccupation with perspective and landscape. The human figure became the primary vehicle of expression for the Italian Renaissance artist. Publication of Vesalius's treatise on anatomy in 1543 reinforced study of cadavers and skeletons. It was in the sixteenth century, when art and science functioned as correlatives, that the study of anatomy became an exact science.

Once Leon Battista Alberti established the *istoria* or narrative as the painter's most appropriate subject, the importance of the human figure in art grew.[56] Since narratives required figures to enact them, the human body was studied for structure, harmony of proportions, movement, and expression. Alberti's dictates ruled in Parmigianino's idealized view of the artist's studio (Fig. XIV), for the figures are conceived as nude with faintly indicated traces of drapery.[57] Indeed, the artist at his easel assumes the *ad locutio* pose of ancient orators and emperors that became the standard format for *écorché* or flayed figures from the sixteenth century on. The value of the pose for anatomy study is that it presents half the musculature tensed with the other half of the torso relaxed. In Enea Vico's engraving [74] the figure standing right of the fireplace outlines on his sketchpad a standing nude figure with left arm raised.

Artists first began dissecting in the late Quattrocento.[58] At the beginning of the Cinquecento artists were more familiar with the actual structure of the human body than were physicians who depended on medieval texts rather than their own perception. Despite being members of the same guild — the *Medici e Speciali* — and sharing the same patron — the physician-painter St. Luke — painters and physicians appear to have had little mutual exchange throughout the fourteenth and fifteenth centuries.

Leonardo's anatomy studies date from 1485 and survive in thousands of pages of scattered notes and drawings. His insatiable curiosity about the structure and mechanism of the human body resulted in his study of numerous cadavers.[59] As medical illustrations Leonardo's anatomical drawings were revolutionary, but their impact beyond his immediate circle is uncertain.[60] Michelangelo shared Leonardo's belief in the artist's need for a scientific knowledge of anatomy because "these indications *of action* are of the first importance and necessity in any painter or sculptor who professes to be a master" (italics supplied).[61] Indeed, Condivi confirmed that Michelangelo examined corpses at the hospital of Santo Spirito during his early years in Florence.[62] Michelangelo's study of legs (Fig. XV) contains details typical of his drawings. Symbols mark joints and muscles, and a light sketch of the knee joint is included as a reminder of the underlying structure. James Byam Shaw noted that the study was "almost an écorché," but the skin has not been flayed and the muscle tension is that of a live model.[63]

Before dressing a man we first draw him nude, then we enfold him in draperies. So in painting the nude we place first his bones and muscles which we then cover with flesh so that it is not difficult to understand where each muscle is beneath.

LEON BATTISTA ALBERTI

He who knows how to draw well and merely does a foot or a hand or a neck, can paint everything created in the world.

FRANCISCO DE HOLLANDA

We may thus judge that those who think they do better in studying the torso, an arm, leg, or other member, making good muscles and understanding them all, are in error, for this is a part and not the whole

GIORGIO VASARI

Fig. XIV. *The Artist's Studio.* Parmigianino, Italian, 1503–1540. The Pierpont Morgan Library.

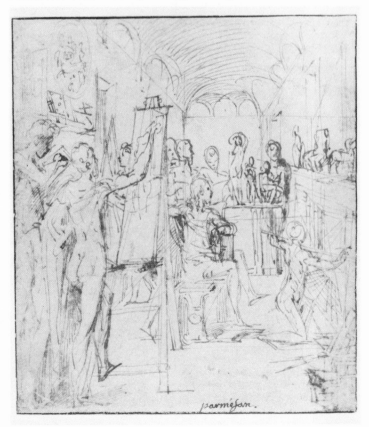

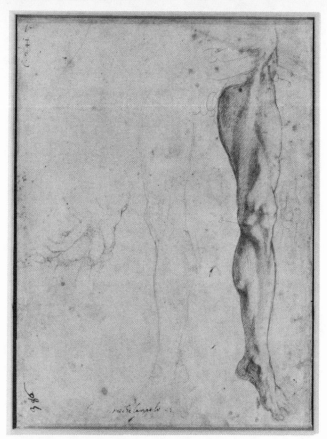

Fig. XV. *Studies of a Man's Left Leg* (verso),
red chalk, 283 × 212 mm. Michelangelo Buonarroti,
Italian, 1574–1564. Christ Church, Oxford.

Fig. XVI. *Studies for the Libyan Sibyl*, red chalk, 289 × 213 mm.
Michelangelo Buonarroti. The Metropolitan Museum of Art,
Purchase, 1924, Joseph Pulitzer Bequest.

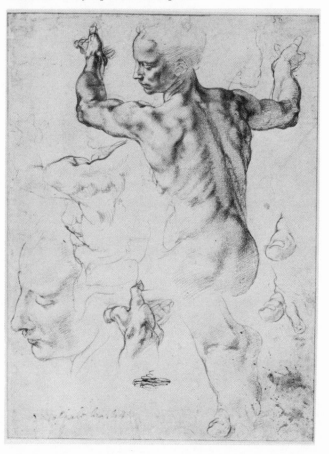

Michelangelo's studies for the Sistine ceiling contain numerous figures balanced on their toes in poised and extended attitudes (Fig. XVI). This muscular tension is noticeable in the *Study for the Nude Youth over the Prophet Daniel* [55]. Michelangelo's subtle understanding of human anatomy allowed him to exploit the pushing power of the big toe so essential for balance and locomotion. Pressure on the big toe and extension of it also flex the calf muscles, something only observed in cadaver studies by flaying. Such a tensed figure is immobile until certain muscles are relaxed, but it suggests Pomponius Gauricus's notion of the pregnant or ambiguous moment when heightened posture implies past and future movement.[64] It is important to appreciate this principle of motion in Michelangelo's figures, the understanding of which eluded so many of his contemporaries who arranged their figures similarly but for other purposes.

Leonardo favored pen and ink for its linear precision which was particularly apt for the scientific depiction of musculature. He warned, however, that the tissue and skin connecting muscles should be taut, especially where they overlap hollows.[65] Michelangelo, therefore, chose chalk for his figure studies to indicate better the coalescence of parts. Although Lomazzo criticized Michelangelo for emphasizing musculature, he anticipated Dolce's advice that "dressing the bones in pulpy and tender flesh is a good deal more important than laying them bare."[66]

A thorough grounding in anatomy is evident even when an artist strove for visual effect. Bronzino exemplifies this in a figure study [10] as does Pontormo, whose youths [22, 23] are anatomically correct despite liberties taken with their proportions. Salviati's *Kneeling Figure* [27] and Giuseppe Cesari's *Half-Length Figure of a Man Holding a Banner* [39] also show the changing taste toward affectation and convoluted posture but with no loss of respect for anatomical correctness.[67]

Since all muscles are relaxed in a corpse, the full understanding of musculature required studying the flayed cadaver. Regular lectures on anatomy were scheduled in the academy in winter, presumably to extend the cadavers' "working life" and minimize their offensiveness (see Alberti's engraving [31]).[68] Observing the anatomical features in Bartolommeo Torre's drawing [66] would be difficult even in an exceptionally muscular individual. *Anatomy Study* [59] illustrates how cadaver studies taught students about a classically muscular figure. The two views of legs with half of each figure flayed on the recto of Torre's sheet provide a convenient comparison of surface contours with underlying musculature, but also reflect the typical practice of removing only part of the skin to minimize drying out or rotting. The legs on the left half of the page are generally anatomically accurate, but those on the right are rendered more carelessly. The right-hand figure also appears disemboweled, as if for an anatomy study of the first major cavity as shown in the frontispiece of Vesalius's first edition of *De humani corporis fabrica* (Fig. XVII) and of Realdo Columbo's *De re*

anatomica of 1559. For reasons of sanitation this would be a natural procedure in the pedagogical sequence of dissecting corpses.[69]

By mid-century, studio practice appears to have over-emphasized sculptural rather than live models. Jacopo Chimenti da Empoli's *Two Figure Studies of a Woman* [13] depicts different views of an antique Venus,[70] and Enea Vico's *The Nile* [75] renders the overly muscled, mesomorphic type of Hellenistic sculpture. Even Michelangelo based his *Ignudo* [55] on the Vatican *Belvedere Torso*, although he apparently checked anatomical details against a live model. Bronzino drew from a small bronze of Cleopatra [9], and Naldini's study of *Samson Slaying the Philistines* [19], like that associated with Tintoretto [106], is after a sculpture by Michelangelo. The strong outline of Naldini's figure creates unresolved problems along the back and shoulders of Samson, and difficulties occur in the left thigh and hip of the figure associated with the Tintoretto studio. These problems indicate how far artists had strayed from the original subject, the human body.[71]

Federico Zuccaro's drawing describing his brother's early artistic education (Fig. X) was one of a series (Figs. XVIII–XX) recording Taddeo's activities in Rome in the 1550s,[72] much as Armenini's treatise recalled his own adventures there as a hopeful young artist at mid-century. The city itself was a studio. Taddeo copied façade frescoes by Polidoro da Caravaggio (Fig. XVIII) and other paintings by established masters as well as drawing from antique statues (see also Enea Vico's *The Nile* [75]), reliefs, and columns (Fig. XIX).[73] He also drew the nudes from Michelangelo's *Last Judgment* fresco (Figs. XX, 41a), a common activity as studies by Leonardo Cungi [41], G. A. Figino [46], and Daniele da Volterra [76] testify. Armenini warned students to temper their study of Michelangelo with anatomy studies to avoid exaggerated musculature [46], attitudes or contours [76].[74] The compulsion for Cinquecento artists to imitate Michelangelo's style caused Condivi, Armenini, and the master himself to express misgivings about the extensive copying of his works.[75] As an alternative to drawing in the Sistine Chapel, and to balance the extremely personal style of Michelangelo, Armenini proposed making models and drawing from life (Fig. XIV), a final step in the artist's training.

Portrait painting was also an important activity in the Renaissance studio, especially for artists under the patronage of a great prince. Of all sixteenth-century Italian draftsmen, however, only Leonardo da Vinci addressed the problem of portraiture at some length.[76] He was especially concerned that lighting be soft and uniform, and so arranged as to cast a shadow equal in size to the head of the sitter. Giovanni Agostino da Lodi's *Head of a Bearded Old Man* and *Head of a Young Man* [114], executed in red chalk, approach the subtle tonalities of Leonardo's portrait paintings. They illustrate the *sfumato*, soft modeling, and qualities of mood and late

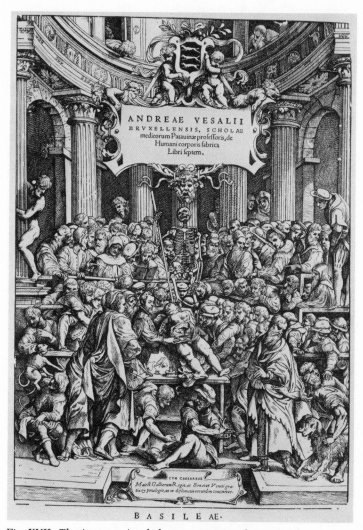

Fig. XVII. *The Anatomy Amphitheater*, engraving, frontispiece of Vesalius's *De humani corporis fabrica* (Basil, 1543).

afternoon light that Leonardo recommended.[77] Lifelikeness and recognizability underscore the sitter's presence in Beccafumi's *The Head of a Woman* [4] and Ottavio Leoni's portrait drawings [51, 52].

The character of portrait studies is a function of technique and media. Two heads associated with the studios of Parmigianino and Passarotti illustrate how much pen and ink contribute to stylization [91, 58]. The profile views emerge from a web of lines constructed by cross-hatching and parallel strokes. The first, *Male Head*, is probably based on a drawing or antique relief rather than a posed model. Although *Profile Portrait* more obviously conveys an individual likeness, neither sheet approaches the naturalism of Lodi's chalk drawings [114]. Other head studies from the northern provinces are in black chalk. The broader medium of chalk seems appropriate for the larger format. Girolamo Savoldo's *Man's Head and Hand* [122] and Lorenzo Lotto's *Head of a Bearded Man with Eyes Closed* [115] are painterly and atmospheric. Jacopo

11

Figs. XVIII-XX. *Taddeo Zuccaro Copying Ancient Statues and Façade Frescoes by Polidoro da Caravaggio*, pen and wash (copy), 406 × 181 mm.; *Taddeo Zuccaro Copying Antiquities*, pen and wash, 183 × 426 mm.; and *Taddeo Zuccaro Copying the Last Judgment of Michelangelo*, pen and wash (copy), 424 × 182 mm. Federico Zuccaro. Uffizi, Florence.

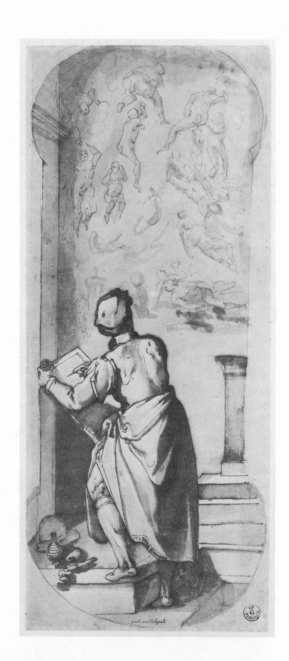

Bassano attained greater immediacy and naturalistic presence with colored chalks [96]. Ottavio Leoni used colored chalk in his many Roman portraits, confirming Armenini's observation that "even an artist of mediocre talent can master this art [portraiture] sufficiently as long as he is experienced in colors."[78]

The painter could not refer to classical models because no painted portraits were known to have survived from antiquity, and tomb portraits and carved portrait busts could only provide general formats. In addition, many artists found portraiture confining. The genre demands close nature study as the artist attempts to record facial topography, the specific relation of parts, and the uniqueness of individual physiognomies. Already early in the Cinquecento portraiture was a problem for artists committed to the notion that nature was imperfect in individual things. A frequent solution to the problem of portraiture was that Michelangelo adopted while carving the tomb figures of Lorenzo and Giuliano de' Medici. Michelangelo's response to the criticism that his sculptures did not resemble the

characters they represented was that in a thousand years no one would know the difference.[79] Late Renaissance artists, therefore, used portraiture to aggrandize the prince, and the stylized court portrait became the antidote to the earthly and particular.

The late Renaissance emphasis on decorum permitted this departure from the actual in portraiture. An object was beautiful by being appropriate. This consonance of style and subject matter was a basic element of Horace's *Ars poetica*, and Alberti and Leonardo discussed it.[80] In Rosso's *Head of a Woman with an Elaborate Coiffure* [25] the general refinements of style with the adornments of Rosso's personal touch create a perfected image of what is imperfect in nature. The literary critic Girolamo Fracastoro noted in his *Naugerius, sive de poetica dialogus* published in 1555, that the poet was "like the painter who does not wish to represent this or that particular man as he is with many defects, but who, having contemplated the universal and supremely beautiful idea of his creator, makes things as they ought to be"[81]

Leonardo sketched various physical types including the aged and deformed, and the drawings occasionally verge on caricature. Idealization, caricature, and fantasy are different facets of conceptualization and polar opposites to the precise record of human physiognomy. Rosso's *Head of a Woman with an Elaborate Coiffure* is an idealized type that might have been inspired by the courtly discussions of female beauty recorded by Baldassare Castiglione in his *Courtier* or the canons of female beauty codified in treatises such as Agnolo Firenzuola's *Dialogo delle bellezze delle donne* of 1548.[82] Rosso's is the most extreme of all the head studies as an ideal of feminine beauty. Associated with it as an expression of the Renaissance notion of *fantasia* are the *Head of a Satyr* [57] by Passarotti and Giuseppe Cesari's *Satyr Head* [40]. Inventive and imaginative, these fanciful heads delight and astonish, and reflect the wit and improvisational power of the mannerist mentality.

Landscape Drawings

Niccolò Machiavelli in his dedication to *The Prince* characterized his discussion of Italian politics by using the metaphor of the landscape painter who studied peaks from the valleys below and described plains from the heights above. Landscape as subject matter, therefore, was already understood in the first years of the Cinquecento. The earliest surviving landscape is Leonardo da Vinci's view of the Arno, dated 1473 in Leonardo's hand.[83] Another early example, Piero di Cosimo's impressive *St. Jerome in a Landscape* in the Uffizi, combined with such sheets as Fra Bartolommeo's *Farm on the Slope of a Hill* [3] reveal the considerable interest in landscape in Florence at the end of the fifteenth and the beginning of the sixteenth centuries.[84] Indeed, a few of Fra Bartolommeo's sheets from the Gabburri album have been found to describe actual sites.[85]

He [Perugino] also introduced a landscape which was then considered most beautiful, the true method of doing them not having been found at that time.

GIORGIO VASARI

We can say that the earth has a vegetative soul and that its flesh is the land, its bones are the structures of the rocks

LEONARDO DA VINCI

Alberti explained the Florentine interest in landscape by noting that "our minds are cheered beyond measure by the sight of paintings depicting the delightful countryside, harbours, fishing, hunting, swimming, the games of shepards [sic] — flowers and verdure."[86] He made this observation in his chapter on the decoration of private apartments and gardens in his treatise on architecture. The statement is similar to Vitruvius's description of the Roman fresco decorations for private chambers which depicted landscapes in great variety with harbors and seacoasts, rivers and promontories, groves and mountains, often with shepherds tending flocks.[87] While antique prototypes of landscapes were virtually nonexistent save for the rare discovery of an ancient "grotto" (the Pompeiian wall paintings were yet undiscovered), Pliny's writings offered the Italian artist precedents. His account of the Roman painter Spurius Tadius as the first to decorate "walls with pictures of country houses and porticoes and landscape gardens, groves, woods, hills, fishponds, canals, rivers, coasts, together with various sketches of people going for a stroll or sailing in a boat"[88] could almost be taken as a description of Annibale Carracci's *Landscape with a Boat* [37].

Perhaps the new Italian interest in landscape simply reflects the beauty of Italy. Anyone familiar with its rich and varied terrain from the Roman campagna to the hills of Tuscany can appreciate Paolo Pino's observation in *Dialogo di pittura* of 1549 that the Italian countryside is the "garden of the world" and so pleasant that no painting could do it justice.[89]

The general Renaissance interest in the careful record of sensory data, pursued with progressively more dedication into the sixteenth century, explains Leonardo's series of deluge drawings.[90] The study of natural phenomena and especially atmospheric effects and weather became a special interest of Italian artists. The climate in fifteenth- and sixteenth-century Italy was harsher than today, being more like that of twentieth-century America. Hurricanes, tornadoes, and torrential rainstorms were recorded by Niccolò Macchiavelli and Luca Landucci as well as by Leonardo himself, suggesting that Pino's garden may have required as much tending as Pangloss's.[91] Pliny's boast that Apelles could paint lightning and thunderstorms offered an additional challenge to Leonardo.[92] It also

stimulated Pintoricchio's rainbow in the Sienese fresco *Departure of Aeneas Silvius Piccolomini* and Giorgione's lightning bolt in the *Tempest*, as both artists strove to demonstrate their virtuosity at depicting the most ephemeral of natural phenomena.

For the Venetians, mountains and thick forests, castles on promontories, farms among rolling hills, caverns, and escarpments were novelties. The seafaring Venetians' interest in lush foliage and panoramic vistas was reflected in Francesco Colonna's romantic writings with their woodcut illustrations of ancient ruins, in Sannazaro's Arcadian poetry and more practically in the Venetian government's land reclamation projects instigated by Alvise Cornaro.[93]

The Venetian affection for landscape first manifested itself visually in Giovanni Bellini's painting in the Frick Collection, *St. Francis in Ecstasy*.[94] It continued in the paintings of Giorgione and Titian and in the drawings and prints of Domenico Campagnola and Titian.[95] Campagnola's *Landscape with St. Jerome* [100] probably resembles in many respects his pen and ink landscapes which Marcantonio Michiel reported in the collection of the Paduan lawyer, Marco Benivedes.[96] Titian's lush pen drawing of trees [108] reveals both the richness of his ap-

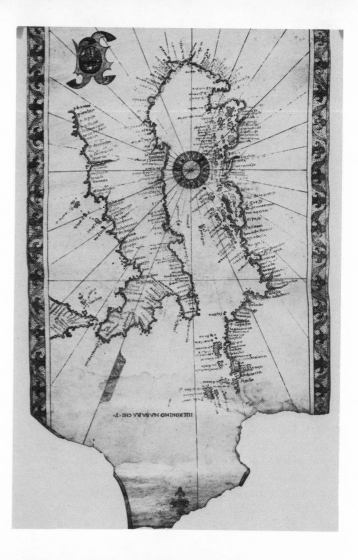

Fig. XXI. *Chart of the Adriatic Sea, ca. 1560*, pen. Hieronimo Masarachi, Italian, Courtesy of the Newberry Library, Chicago.

Fig. XXII. *Bird's Eye View of Venice: Lower Central Portion*, woodcut. Jacopo de' Barbari, Italian, ca. 1440/50–ca. 1516. The Cleveland Museum of Art, Purchase from the J. H. Wade Fund.

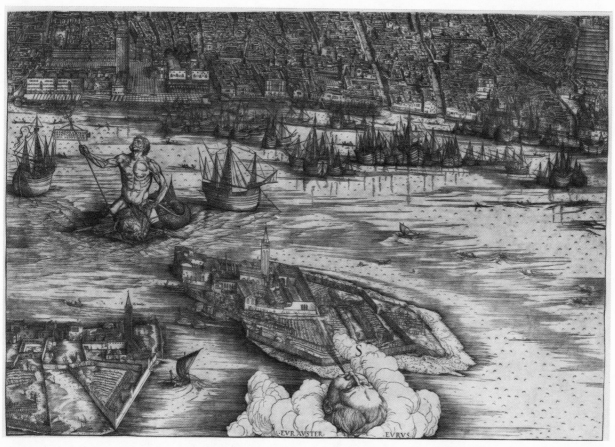

proach to even a landscape detail and the special strength of his pen technique in controlling light effects.

The presence of Flemish painters and paintings in many Quattrocento courts, like that of Federigo da Montefeltro at Urbino, also encouraged Italian fascination with landscapes. In addition, it reflects a broadened world view and Italian participation in the age of exploration. Especially in Venice, interest in maps for navigation (Fig. XXI) was paralleled by the fascination of princes and humanists with world maps and topographical views, such as Jacopo de' Barbari's *Bird's Eye View of Venice* (Fig. XXII).[97]

Although the earliest landscapes appeared in Tuscany, Florentine interest in the genre quickly gave way to pre-occupation with the human figure. It remained for the Venetians to cultivate the subject until mid-century when interest revived somewhat in the south. Eventually landscape emerged as an independent genre in the late Cinquecento. Through the 1520s and 1530s, Polidoro da Caravaggio developed landscape in his Roman church frescoes in a way that had much in common with the Third Pompeiian style of ancient Roman murals. Although Vasari praised Parmigianino for his ability in landscapes, confirmation of his skill can only be found in his shimmering sketches and etchings.[98] None of Parmigianino's landscape drawings has been identified with a finished work, nor have Fra Bartolommeo's sheets from the Gabburi album, with one exception. Even Annibale Carracci seems to have produced most of his landscape studies out of his own delight in the subject and with no larger work in mind.[99]

The renewal of interest in landscape occurred in Rome after 1550 with the arrival from Urbino of Federico Barocci, whose painted backgrounds feature high bluffs, a prominent tree or clump of trees, or an escarpment overgrown with a cluster of weedy underbrush. *Plants above an Eroded Bank* [32] with its silvery haze may have been a study for such a composition. Barocci portrayed St. Francis receiving the stigmata in paintings, drawings, and an etching in which trees play a prominent role.[100] Such details may have had an iconographical significance for Barocci.

Among those active in Rome after mid-century was the Brescian, Girolamo Muziano, whom Giovanni Baglione described as "il giovane dei paesi," which can be translated colloquially as "the landscape kid."[101] His series of penitent saints has rugged landscape backgrounds which are dependent upon Campagnola for details and which describe an untamed nature as setting for their ascetic occupants. Thus, the remote wood functioning as a refuge and secret place where visions occur [56] can be added to topographical views, Roman ruins, and panoramic vistas as landscape types. Other examples are Lelio Orsi's *The Flight into Egypt* [88] and Federico Zuccaro's *The Vision of St. Eustace* [81]. In many cases artists manipulated trees in their landscapes for purposes of mood and composition. For Campagnola trees added compositional solidity;

they were threatening for Muziano, and mysterious for Barocci. Annibale Carracci also made important contributions to the genre during his sojourn in Rome. Although landscape painting remained only a peripheral activity for him, his continued production of landscapes revealed his deep love of nature.[102]

Since in the sixteenth-century Italian view perfection could only be found in nature as a totality and not in its individual parts, Annibale Carracci created an ideal landscape by imposing order and structure in the arrangement of separate elements. His *Eroded River Bank with Trees and Roots* [36], noble and monumental, reflects the Carracci school's practice of working from details. *Landscape with a Boat* [37] matches Campagnola's *Landscape with St. Jerome* in its sweep and Fra Bartolommeo's *Farm on the Slope of a Hill* as a scene of contemporary life. The low horizon, scattered figures, and recession from mass to mass create an expansive space, however, and are uniquely Carracci's.

The advance made in Annibale's paintings suggests that landscapes had never existed as an independent genre in sixteenth-century Italy. The purity of landscape in Cinquecento Italy, therefore, was preserved only in the drawings of its masters. Annibale's landscape sketches, anthropomorphic and architectonic, left an indelible mark on future generations. Even a simple view, such as Grimaldi's of St. Peter's basilica [44], reflects his clarity and order.

A reassessment of landscape began in the last two decades of the Cinquecento, heralded by the loosely systematic approach of Cristoforo Sorte in his treatise of 1580.[103] Sorte was less interested in landscape than in establishing guidelines for the use of color, that is, in determining colors appropriate for various types of subjects, such as fertile settings, austere landscapes, varieties of trees, the density of a forest, the color of flowers, effects of dawn, distant perspectives, etc. In 1584 G. P. Lomazzo made an initial attempt to categorize types of landscapes.[104]

The reasons given for the new Italian concern with landscape at the end of the Quattrocentro only explain why there was any interest at all in the genre. Alberti had early established *istoria* or narrative subject matter as the painter's ideal, ranking it in importance with the colossal figure for the sculptor.[105] The counter-reforming interests of the Council of Trent in the area of painting led to a stress on narrative subjects, especially religious works, where generous settings provided narrative clarity. Landscape, then, became synonymous with setting. Furthermore, since Italian Humanists accepted nature as imperfect, it was incumbent upon the artist to correct her flaws, as Lodovico Dolce was moved to observe that "the painter should try not only to imitate nature, but to surpass it."[106]

The Draftsman's Tools

Drawings can be broadly classified by appearance, as linear, plastic or pictorial, with specific media largely determining each category.[107] Linear drawings are characterized by a respect for the two-dimensional surface of the sheet with emphasis on silhouette and the character of line, whether flowing, decorative, or descriptive. Pen and ink, metalpoint, and pencil are the preferred media for drawings where the value and importance of line are preeminent as shown by Perino del Vaga's calligraphic *St. Peter* [68] or the simpler and more deliberate compositional study by Giovanni Battista Paggi [129].

Workshop tradition at the end of the Quattrocento dictated that artists learn draftsmanship by making pen and ink drawings. Even after chalks became popular, apprentices continued to be drilled in pen and ink.[108] The early drawings of Michelangelo, Raphael, Beccafumi, and Fra Bartolommeo, for example, are largely in this medium. Indeed, the late Renaissance theorist, Raffaello Borghini, preferred pen and ink drawings because he considered the technique to be the most beautiful.[109] Vasari and Benvenuto Cellini considered pen and ink drawings that used the white of the paper for highlights as the most trying and masterful.[110]

The advantages of pen and ink include speed of execution, sureness, permanency, and the ability to achieve nuances in texture, light, and the creation of space. It is instructive to note that most of the landscape drawings, where tonal contrasts and variety in texture are important, are pen and ink compositions [3, 36, 37, 56, 100, 108]. Pen and ink is suitable for careful, detailed studies such as Giovanni Battista Franco's *Rib Cages* [49] as well as quickly and freely executed sketches like Francesco Vanni's *Sheet of Figure Studies* [73].

Two types of pens were known to sixteenth-century artists. One, the reed, although used in antiquity, was rarely used in the Renaissance. Nevertheless, Carlo Cesare Malvasia noted that Odoardo Fialetti worked with a reed pen.[111] The quill became popular because it was more adaptable and produced a finer, more fluid stroke.[112] Examples of quill pen drawings include Fra Bartolommeo's *Farm on the Slope of a Hill* [3] and Annibale Carracci's *Landscape with a Boat* [37]. The variety of accents in the Florentine landscape results from changing pressure on the quill nib; contrasts of value and areas of light and shadow are suggested as line swells and tapers.

Akin to the essential linearity of pen and ink is metalpoint, where designs are inscribed by means of a metal stylus on a prepared ground, usually made of white lead, bone dust, powdered egg shell, or seashell.[113] Frequently pigments were added to the ground as in *Madonna and Child* by Lorenzo di Credi [15]. Raphael's *Studies of a Seated Model* [61], executed early in his career, is more representative of the Quattrocento when metalpoint was popular. The metalpoint line tends to be uniform and the drawing precisely controlled and delicate. The technique requires an accomplished draftsman and was only practiced after the artist acquired facility in pen and ink. As artists strove for greater spontaneity, bolder statements, and painterly effects, metalpoint lost popularity to pen and ink, brush and wash, and chalk.[114]

Drawings concerned with plastic effects generally involve figure studies, often of single figures, and usually are in chalk or charcoal. The red chalks that became widely used in the early Cinquecento were naturally occurring mineral substances, oxides of iron of varying composition which caused them to differ in value. They were sawed, cut into sticks, held in a tube or stylus, and sharpened to a point. The warmth and glow of the red chalks help account for their appeal. *Pastelli* or fabricated chalks, popular at the end of the century, were softer and more friable than the natural chalks. Crosshatching allowed the draftsman to round his subjects by defining shadows and contours. He could also rub the chalk with his finger or a piece of cloth to suggest even more subtly the play of light and shadow on the body's surface. Since it allowed a greater breadth of softer effects than pen and ink, chalk was preferred for figure studies like Jacopo da Pontormo's [22] and Michelangelo's [55].[115]

The early Cinquecento preference for chalk over pen and ink, especially in central Italy, paralleled the switch from landscape to a preoccupation with the human form. Significantly the verso of Etienne Dupèrac's sheet, *View of the Tiber* [45], describes the landscape in pen and ink, while the figure of the Bacchante is in chalk.

In pictorial drawings, figures and setting are equally important, and attention is paid to the overall surface of the sheet. The approach tends to be more painterly and optical. Pen and ink are combined with brush and wash in Luca Cambiaso's drawings [123–126], where broad washes define planes and describe volumes. In the highly finished *Holy Family with St. Lucy* [112], the impressionistic *Baptism of Christ* [103], and the splendid *Lucretia* [90], as outlines dissolve, lines fuse into shadows and form is organized in masses to approximate the effects of a finished painting. In *Man in Armor Beside a Chariot* [28], tinted paper, washes, and white highlights result in a surface articulation both subtle and descriptive. Impasto highlights add substance and volume to the *Kneeling Figure* [11] but are used for effects of light and atmosphere in *Plants above an Eroded Bank* [32]. A combination of colored chalks adds a degree of naturalism to *Head of a Bearded Old Man* [96], while the use of colored washes allows the artist to approach more closely the appearance of a painting as in *The Vision of St. Eustace* [81].

Color in Drawing

When Giorgio Vasari defined painting as filling in contours with color, it was clear that color was considered almost an afterthought, and that the cartoon or *studio* was synonymous with the finished work.[116] But Armenini's remark equating the cartoon with the finished work "save for color" implied that absence of color made the cartoon incomplete.[117] At mid-century Paolo Pino and Lodovico Dolce, departing from the Florentine view of Vasari, ranked color with draftsmanship by defining the constituents of painting as invention, design, and color.[118]

Monochromatic studies, like Bernardino Campi's *Holy Family with St. Lucy* [112], could fix value relations, rendering color unnecessary even at the final stage of the drawing, but the simple addition of red chalk to black, as in Bernardino Pocetti's *Woman and Child Standing* [21], provided more intermediate values. Comparing Pocetti's drawing with the final fresco shows that juxtaposing red and black generally indicated light and shadow.

Although the high Renaissance masters popularized red chalk in the first decade of the sixteenth century, its frequent use in combination with black chalk only occurred several decades later. Taddeo Zuccaro began to use red washes during his early projects in Rome, such as *Studies for the Blinding of Elymas* [82] for the Frangipani chapel, decorated between 1557 and 1566. Federico followed his brother's practice and used red wash in *The Healing of a Demoniac Woman* [79]. The single advantage of red over brown wash—since both create the same type of contrast of light and dark—is the warmth and richness of the red pigment.

Beyond offering draftsmen a greater range of values for suggesting relief, color was also truer to nature and brought the design closer to the finished painting. In the latter half of the sixteenth century, as color became equated with naturalism,[119] the Florentines held that it had a vulgar appeal. Attitudes in Tuscany and Rome gradually changed, however, as Venetian painting became ascendant.[120] Even the Venetian Paolo Pino felt use of color in drawing was a waste of time, but Pino so depended upon Alberti's treatise on painting that one might question whether this attitude typified Venice.[121] Out of fairness to Pino, one must admit that, with the exception of the popular use of blue paper, as in Veronese's *Study of a Fur Cape* [110], color in Venetian drawings before 1550 is relatively rare.

Pino was far from a systematic thinker. His observation that colors defied explanation reveals how complicated the topic seemed to the Renaissance art theorist.[122] Even that most loquacious art critic, Giorgio Vasari, had difficulty discussing color.[123] This attitude changed quickly after 1550 when Borghini insisted upon the importance of color and Lomazzo called it the root of painting and its source of perfection.[124] The Venetian concern with color at mid-century is evident in the tonal paintings of local masters such as Titian and Tintoretto, in Fulvio Morati's book on the symbolic meaning of colors (1545), and in Lodovico

I prefer a good drawing with a good composition to be well colored.

LEON BATTISTA ALBERTI

Coloring takes its cue from the hues with which nature paints.

LODOVICO DOLCE

Nor does he who can draw need to labor to hide his want of design beneath the attractions of coloring as many of the Venetian painters

GIORGIO VASARI

In fact, one can say but for the colors the cartoon is the work itself.

G. B. ARMENINI

Dolce's *Dialogo . . . della qualità diversità e proprietà dei colori* (1565).[125]

Although in the Quattrocento color was considered a property of light, an abstraction independent of objects, by the end of the following century it was accepted as an inherent property of an object illuminated or revealed by light.[126] Raffaelo Borghini noted that color was one of the natural extensions of bodies, like odor and dimension. This may have been more a rationalization for the then popular use of color rather than an argument in its favor.[127] He defended color as an integral part of sensible reality by citing Aristotle, who was increasingly appreciated through the Cinquecento. A tenet of Aristotelean natural sciences given explicit recognition by Lomazzo was that color as a fixed property of natural things was essential for the complete cognition of reality.[128]

Beyond the theoretical, interest in color was expressed in drawings and oil *bozzetti* and the invention of *pastelli*. The new Cinquecento preoccupation with color probably led to the invention of *pastelli*, rather than the reverse. Since *pastelli* were made of the same minerals used for paint pigments, the same variety of colors was obtainable. This enabled artists to execute closer copies of works observed during their travels which would be useful for later reference.[129] *Pastelli* were also used to make *bozzetti* or *modelli*, studies of an entire composition on paper that allowed color relationships to be tested before the design was completed in fresco.[130] Barocci's *Putto* [33] and Parmigianino's *Lucretia* [90] may have fulfilled just such a function. The colored drawing also guided assistants and increased efficiency in the large workshops.

It is difficult to believe that Jacopo Bassano's *Head of a Bearded Old Man* [96] is only in chalk, for the flesh tones of the forehead and under the right eye look like washes, as do some of the complicated mixtures of gray and brown in the beard and the touches of yellow in the gray hair atop the old man's head. Such imitation of flesh tones

17

and naturalistic coloring make the figure appear alive, a suitable goal for the artist according to Dolce, and an appropriate use of color.[131]

The Draftsman's Works

Drawings can also be broadly characterized by purpose. The *schizzo*, or quick sketch, is the preliminary idea for a composition or the first tentative design for a figure study. Examples include Girolamo Mazzola Bedoli's *Studies of the Madonna and Child* [85] and Veronese's *Various Sketches of the Madonna and Child* [109]. Vasari valued the *schizzo* for revealing the artist's frenzied attempt to capture his fleeting inspiration.[132] One can imagine Taddeo Zuccaro hastily jotting down experimental arrangements in the *Studies for the Blinding of Elymas* [82] and Giulio Romano swiftly executing *A River God* [62].

Intermediate between the spontaneous summary sketch and the *studio*, or elaborated study, can be found a wide range of working drawings. Luca Cambiaso's *The Martyrdom of St. Lawrence* [125], Bernardino Pocetti's *Woman and Child Standing* [21], and Domenichino's *Study for a Cupid* [43] are all designs subsequently modified.

The *studio* is a finished, polished drawing. It can be a detail [99], one figure for a larger work [12], or a completed composition [98]. Although often the final study to be engraved or painted—like *The Vision of St. Eustace* [81] and *The Annunciation* [124]—the *studio* may also be a presentation piece for a collector. Perhaps Lelio Orsi's magnificent *The Flight into Egypt* [88] and the stylish *Head of a Woman with an Elaborate Coiffure* [25] by Rosso Fiorentino were executed for this purpose.

The completed design was transposed to the final work either directly or by enlargement. If directly, the *studio* was pricked along its outlines or incised with a stylus.[133] If by enlargement, the design was squared and transferred to a cartoon, a second larger sheet squared to scale.[134] Alberti warned the artist that enlarging a design would magnify small errors.[135] In Domenichino's *An Allegory of Temperance* [42] the figures are squared rather than the sheet, possibly with the face of the seated Virtue used as a module. This implies that the space where the design was transferred was first squared, then the drawing marked off by the same number of squares, concentrating on the image.

The size of the squares is also revealing. Domenichino's *An Allegory of Temperance* is twenty-eight squares high (each 20×20 mm.), whereas Federico Barocci's *Putto* [33] has fewer but larger squares (95×95 mm.). This suggests that Barocci's final work was intended to be only two or three times as large as the drawn figure, while Domenichino's painted figure would be significantly larger than that in the drawing. In drawings for altar panels Barocci used a matrix of smaller squares, roughly 20×20 mm., suggesting a more substantial expansion of the design.[136]

*Princes and captains . . .
are guided by the draftsman's hand alone.
For architects, masons, engravers, goldsmiths,
embroiderers, woodworkers and even smiths
all have recourse to draftsmanship
One must acknowledge the navigation map
as the artist's creation*

LODOVICO DOLCE

*Moreover, drawing is of exceedingly great use in war
to show in sketches the position of distant places
and the shape of the mountains and the harbours,
as well as that of the ranges of mountains
and of the bays and seaports,
for the shape of the cities and fortresses*

FRANCISCO DE HOLLANDA

*Vitruvius says that one
who wishes to practice that art [architecture] well
must have something of music and good drawing.*

BENVENUTO CELLINI

Practical Aspects of Drawing

The same source that inspired Renaissance artists to equate painting with poetry, namely Horace's *Ars poetica*,[137] was also responsible for their compulsion to justify the importance of draftsmanship in practical terms.[138] Horace observed that the purpose of painting, like poetry, was to instruct as well as delight. Under the influence of Horace (and of Cicero), Alberti underscored painting as morally uplifting, and Armenini noted that images could confirm the devout in their faith.[139] Although painting's role in mankind's salvation was stressed, the draftsman's service to the prince also was cited. Dolce remarked that the masters of *disegno* limned maps so lords could chart their domains.[140] In addition, merchants relied on maps for navigation (Fig. XXI), and military leaders trusted the draftsman to mark terrain. The *Sketchbook on Military Art* [29] demonstrates the artist's value to the military commander in plotting projectiles and defenses.

By the early fifteenth century Florence had become a center of cartographic study, with Tuscany apparently the origin for the portolan maps used in navigation.[141] The intersecting grids of these charts suggesting angle and direction required the same sense of linear measure later demanded by perspective constructions in paintings. On the other hand, Ptolomaic maps, topological studies, and cosmological maps satisfied the speculative interests of princes and humanists.

When Alberti spoke of the proper way to learn painting, he used the metaphor of learning to write whereby letters are learned first, then words. By analogy, the

young artist should first observe outlines, then surfaces, and finally parts of the whole.[142] Alberti's comparison was lost sight of by the end of the sixteenth century, for Armenini maintained that the student with good penmanship would have an advantage in learning how to draw: "for those who are accustomed to write with a fine hand are considered to have made a certain good beginning in drawing. The better they write, the greater promise they show in drawing and . . . the skill which children, through continual practice, acquire in handling the pen well and in forming good letters will make the imitation of designs easier since one learns to write in part through the imitation of another's letters."[143]

Armenini's equation of drawing with penmanship was reasonable in the sense that students learned both by imitation. The need to rationalize the importance of draftsmanship in the late Renaissance in terms of its function in mapmaking and by its association with penmanship seems unnecessary in light of the artist's usual activities. The daily routine of the workshop involved making objects of modest size, including decorative bronze figurines or useful items such as ink wells, candelabra, and carved or painted chests. At the opposite extreme was the architectural project, perhaps with a complicated fresco program involving decoration of ceiling vaulting, an apse, or the cupola of a dome. Drawings were used in such projects for working out designs, for offering variety in decorative ideas, for future reference in model books, and for recording studio activities.

Even major artists designed utilitarian works, frequently of small scale, and often liturgical in nature. Raphael's and Perino del Vaga's workshops were occupied with designs for candlesticks and church vestments [65, 67, 70, 71 recto] some of which may have been part of pattern books for studio reference, such as the demarcated page by Parentino [116]. Major artists such as Raphael and Giulio Romano often executed designs for silver plate and tableware. *Naval Battle* [80], associated with Federico Zuccaro, is related to a set of ceramic ware. In addition, drawings were made for prints, such as Beccafumi's reclining figures [5] and Muziano's landscape [56].

Artists also produced designs for grand architectural projects. The folio associated with the Sansovino school [64] offers an idea for a palace or chapel wall. Parrasio Micheli's design [101] depicts an ambitious iconographical program to decorate the wall of a library, and Franco's drawing for a chapel [47] also represents a grand scheme, although it is not known whether this project or Micheli's were carried out. A cupola decoration which was executed but unfortunately has been destroyed is preserved in part in Federico Zuccaro's colorful *Angels and Putti in the Clouds* [77].

You must go about and constantly as you go, observe, note, and consider the circumstances and behavior of men in talking, quarrelling or laughing or fighting together: the action of the men themselves and the actions of the bystanders, who separate them or who look on. And take a note of them with slight strokes thus, in a little book which you should always carry with you . . . for the forms, and positions of objects are so infinite that the memory is incapable of retaining them, wherefore keep these [sketches] as your guides and masters.

LEONARDO DA VINCI

Finding something that pleased him [Leonardo] and suitable for what he wished to paint, he would draw it with a stylus in the little book he always carried with him.

GIOVANNI BATTISTA ARMENINI

I beheld nothing either antique or modern in painting, sculpture, or architecture of which I did not make some record of its best part

FRANCISCO DE HOLLANDA

Sketchbooks and Albums

Sketchbooks were important in the Renaissance workshop as well as in training young draftsmen. Renaissance notebooks differed in type and usage: The artist's sketchbook—a bound collection of blank sheets—could serve as a practice book for learning to draw, as a source of motifs and compositional improvisations, as an antiquarian record, or as an accounting of studio commissions. Intact sketchbooks reveal the relationship of an artist's ideas for a given project: how they were combined or discarded, which were conceived at the same time, and which found new possibilities in a later project.

Classical monuments were reproduced in sketchbooks as records of their character and location, or as motifs for later use in paintings. Girolamo da Carpi in his Roman sketchbook [35], for example, depicted the Maleager sarcophagus in the church of Sant'Angelo in Pescheria (Fig. XXIII). Carpi's volume (now remounted for purposes of conservation) is a relatively intact sketchbook from a brief but impressionable period in the mature artist's life (1549–1554). Although a seasoned draftsman at this point in his career, Carpi may have used the drawings as much for practice as for future reference. Technically a *taccuino* or bound, portable sketchbook (with a pocketsize, rectangular format), it appears to have served Carpi in the studio as a copy book more than as a spontaneous record of observations made on walks through Roman streets. Drawn mostly in pen and ink with occasional use of washes, the sheets are filled with

studies of ancient sculptures and sixteenth-century works, based on drawings by other artists.[145]

Girolamo da Carpi's antiquarian sketchbook exemplifies the importance of ancient art for the Renaissance artist.[146] For Renaissance humanists, the culture of ancient Rome was a source of secular literature, new ideas, and ethical values; for the Italian studio, it provided original subject matter, new standards for the visual arts, and formal models for the artist. Freestanding statues, reliefs from Roman sarcophaghi and triumphal arches, fragments of busts and torsos, and small bronzes provided a vocabulary that the Renaissance artist made into his own visual language. River gods became seated apostles or prophets (compare Enea Vico's drawing of *The Nile* [75] and Beccafumi's *Study for Moses and the Israelites Drinking* [5]), orators gesturing rhetorically were transformed into decorative figures in affected poses, and Hellenistic statues were the sources for ecstatic principals in narrative scenes like *Naval Battle* [80] and *The Healing of a Demoniac Woman* [79] which are dependent upon the Lacoön. Perhaps the most enthusiastic antiquarian was Pirro Ligorio, who compiled a forty-volume record of Roman antiquities, published in greatly reduced form in 1553.[147] Ligorio's *Seated Sibyl* [53] reflects his style and interest in pagan subjects.

Many studios kept another type of sketchbook as a reference source for future projects. *Various Sketches of the Madonna and Child* [109] by Veronese may once have served this function. Such books often contained architec-tural renderings of doorways, windows, pilasters, and a variety of decorative ornaments. Probably several of the decorative drawings [65, 67, 70, 71 recto, 116] as well as the architectural design associated with the school of San-sovino [64] were part of such pattern books. It also became the practice in Venetian studios to record com-pleted commissions in model books. Since many of these were used in the studio and passed from one generation to the next, few have survived intact. As collecting became more fashionable, connoisseurs often rescued outdated ones, but in later centuries the books were often dis-mantled so that sheets could be sold individually.

Significantly different in character and perhaps best known of all are Leonardo da Vinci's notebooks. It is difficult to determine if Leonardo's scattered comments were simply elaborations on his drawings or if the draw-ings illustrated his observations, since Leonardo had in-tended them as the basis for a treatise on art. Indeed, his now scattered notes may have originally been organized into a coherent text, since there is evidence that such a treatise once existed.[148] The hundreds of sheets of pen and ink drawings with Leonardo's inscriptions written back-wards include every topic except antiquarian records.[149] Subjects treated include human and equine anatomy, ar-chitectural designs, composition studies, landscapes, por-trait heads, and caricatures. Leonardo's drawings affected his Lombard followers [111–122] in subjects, style, and morphology.

Fig. XXIII. *The Death of Maleager*, pen, 342 × 132 mm. Girolamo da Carpi, Italian, 1501–1556. The Philip H. and A. S. W. Rosenbach Foundation, Philadelphia.

The album, as distinguished from the sketchbook, was assembled from individual drawings and often contained sketches by different artists. It is important for revealing the tastes of individual collectors. The *Libro de' disegni* of the Florentine artist and biographer, Giorgio Vasari, was among the earliest and most impressive albums.[150] Vasari began his ambitious collection of drawings in 1528 with the acquisition of a number of sheets from Vittorio Ghiberti, the great-grandson of the Quattrocento sculptor, Lorenzo Ghiberti.[151] Vasari's five volumes of drawings contained examples of works from Cimabue to artists of his own time. He intended the drawings to supplement and illustrate his monumental collection of artist's biographies. Since Vasari began collecting when he was quite young, he probably cherished the drawings initially for their intrinsic value, and only later when urged to write his *Lives of the Artists* did he consider them documents in the history of style and examples of the worth of individual artists.[152]

Fra Bartolommeo's *Farm on the Slope of a Hill* [3] was part of an album of more than forty sheets of his landscape drawings, combined by the Cavaliere Niccolo Gabburri in 1730. Assembling such an album would be nearly impossible for an individual collector today, and the modern connoisseur must often depend upon exhibitions to experience drawings at first hand.

The art of painting does not derive its basic principles from the mathematical sciences and needs no recourse to them in order to learn rules or methods for its practice or even for its theoretical discussion. For this art is assuredly not the daughter of mathematics, but of nature herself and of Design.

FEDERICO ZUCCARO

Conclusion

Documentation, literary descriptions, biographical notes, insights into workshop procedures, as well as the technical information and theorizing of art treatises all add context to individual drawings and enhance our understanding of them. In the end, however, the drawing has its own power to command the attention of the viewer and thus make manifest the eye of the draftsman.

We have seen that the individual styles of Renaissance artists can be considered personal embellishments of the broader stylizations learned in the studio which distinguished each school or region. Shorthand techniques devised by the master for his pupils to facilitate the translation of a three-dimensional reality onto a two-dimensional surface characterized the workshop. In training apprentices to record what they saw, the master used a variety of materials for the *studiosi* to practice from — including drawings, engravings, antique marbles, wax models, plaster casts, cadavers, and skeletons — as demonstrated by the works of art reproduced here.

It is a puzzling contradiction that in the Italian Renaissance — an epoch associated with the most striking return to naturalism in the history of Western art — studio practice became so removed from nature. Why this was so can be explained in part by the pessimistic view of nature and by the academic mentality in sixteenth-century Italy. Academic thinking held that art could be taught, a conviction that led to the search for constants. As demonstrated by Cinquecento drawings, these constants included the antique, anatomy and life drawing, and the art of the high Renaissance — specifically that of Michelangelo and Raphael. The objects and devices used to aid the late Renaissance artist in seeing and recording reality became instead substitutes for it. Commonsense studio practices were made canonical in the academies and turned into principles in late Renaissance treatises. They were justified by association with Leonardo or Michelangelo or sanctioned as having their origin in the practice of Raphael. Methods for stimulating an artist's inventiveness resulted finally in the deliberate compositional eclecticism of Luca Cambiaso and Lelio Orsi or the exhaustive analytical approach revealed in the drawings of Federico Barocci and Annibale Carracci. Clear examples of these modes of invention are indicated in a number of the following drawings.

Full entries for sources cited can be found in the bibliography by author and year for books and articles or by city and year for exhibition catalogs.

1. The hypothesis of formal elements as characteristic of a region was first studied systematically by Bernhard Degenhart (1937) and explored more recently by Konrad Oberhuber (Munich, 1967, and Washington, 1973).

2. Ernst H. Gombrich (1960) discussed this selective vision among several facets of a psychology of vision and has pursued the subject in numerous publications since. Gombrich explained that the artist saw only what he was looking for, and that what he looked for was what he was trained to see. The draftsman's eye, then, is conditioned by his training and refined by the cultural and ethical priorities of his age.

3. Hiekamp, 1961, pp. 300-305.

4. Vasari-Milanesi, 1878-85, V, 587-588.

5. Richter, 1970, I, 18, 27; Pino, 1946, pp. 74, 87-88.

6. Richter, 1970, I, 387; Alberti, 1966, p. 91. In 1536 Lodovico Dolce published an Italian edition of the *Ars poetica* of Horace (Horatius Flaccus, written about 20 BC). It described painting as mute poetry and poetry as painting with words. For a full discussion of this important document for Italian Renaissance art, see Rensselaer Lee, 1967, pp. 3-9.

7. Bembo, 1548; Hall, 1959, pp. 64-69.

8. Armenini, 1977, p. 36.

9. Ibid., pp. 116-118.

10. Bullock, 1928, pp. 293-299. Dionysius's view of *mimesis* diverged so far from that of Aristotle in his *Poetics* that it approached a theory of plagiarism. Creation as a synthesis of other masters was also an idea taken from ancient treatises on oratory, especially those of Cicero and Quintilian. The latter provided the *topos* of the bee sampling from many flowers. The publication of Cicero's and Quintilian's treatises in 1465 and 1470, respectively, ensured the broad acceptance of this notion. Castiglione restated it as a model for the artist (Castiglione, 1959, pp. 42-43). Antonio Minturino spoke of poets as bees inspired by God to gather up all that is beautiful, thus underscoring the poet's divine inspiration (Minturino, 1559, p. 18).

11. Roskill, 1968, p. 131.

12. Armenini, 1977, pp. 112-113.

13. Ibid., p. 109.

14. Borghini, 1584, p. 137; "Il disegno non estimo io che sia altro che una apparente dimostrazione con linee di quello, che prima nell'animo l'huomo si havea concetto, e nell'Idea imaginato, . . ."

15. Vasari-Milanesi, 1878-85, I, 169; "esso disegno altro non sia che una apparente espressione e dichiarazione del concetto che si ha nell'animo, e di quello che altri si è nella mente immaginato e fabbricato nell'Idea."

16. Armenini, 1977, p. 130.

17. Cennini, 1960, pp. 14-15.

18. *Memoria* was an important principle in rhetoric, another example of the significance of this discipline for artistic values in the late Renaissance.

19. Conformity of theory and practice was necessary to liberal arts with theory either correctly becoming the basis for practice or, wrongly, becoming a rationalization of practice.

20. Bialostocki, 1963, II, 19-30. Bialostocki distinguishes between the Renaissance views of *natura naturata* or created nature and *natura naturans* or nature as process.

21. Armenini, 1977, p. 96.

22. Heikamp, 1961, pp. 152-153.

23. Assunta, 1961, IV, 561-564. On organization of artists' shops see Larner, 1971, pp. 285-348; Wackernagel, 1938.

24. *Encyclopedia of World Art*, 1963, VIII, 149-151; Pevsner, 1973, p. 44. For apprentice contracts see Ottokar, 1937, pp. 55-57; and Ciasca, 1922.

25. Cennini, 1960, p. 4. Cennini's instructions were emphatic and direct: "You begin with drawing."

26. Richter, 1970, I, 243.

27. Armenini, 1977, pp. 127-128.

28. Castiglione, 1959, p. 78.

29. Passeri, 1772, p. 60.

30. Richter, 1970, I, 249. This too was a remnant of the medieval workshop where master and pupil were in frequent consultation.

31. Condivi mentions this encounter briefly, and Benvenuto Cellini recalled it in Torrigiani's own graphic words: "I felt bones and cartilage go down like biscuit beneath my knuckles." Condivi, 1553, pp. 49-49v; Condivi, 1976, p. 108; Cellini, pp. 23-24.

32. Lewine, 1967, p. 20.

33. Armenini, 1977, pp. 161-164.

34. Condivi, 1553, p. 23; Condivi, 1976, p. 48.

35. Condivi, 1553, pp. 44-44v (corrected pagination); Condivi, 1976, pp. 97-99.

36. Panofsky, 1940; Pedretti, 1977, I, 70-75.

37. Alberti, 1966, p. 69.

38. Richter, 1970, I, 260-261; Armenini, 1977, 162-164. In these woodcuts Dürer seems to have conceded that other methods were more practical than his canons of proportions for depicting foreshortened figures.

39. Colasanti, 1905, pp. 406-443.

40. Alberti, 1966, p. 94.

41. Armenini, 1977, p. 47.

42. Shearman, 1967. For an alternative interpretation see Levey, 1975.

43. Vasari-Milanesi, 1878-85, I, 218. A fresco decoration in Vasari's house in Florence depicts Apelles drawing his shadow. Pliny recorded the anecdote and a similar fable about the sculptor Butades's daughter who traced her departing lover's silhouette. Pliny, *Natural History*, XXXV, 15, 151-152; Alberti, 1966, p. 64; Armenini, 1977, p. 114; Ridolfi, 1914, I, 22. Alberti and Armenini repeated slightly different versions in the fifteenth and sixteenth centuries, as did Carlo Ridolfi in the seventeenth.

44. Janetta R. Benton previously noted the exaggerated shadows in Agostino Veneziano's engraving (Fig. IX); Providence, 1973, no. 117.

45. Alberti, 1966, p. 50.

46. Richter, 1970, I, 93-95, 107.

47. Armenini, like Condivi before him, acknowledged the great difficulty in imitating Michelangelo's art. Armenini, 1977, p. 138; Condivi, 1553, pp. 40v-41; Condivi, 1976, pp. 93-94.

48. Armenini, 1977, p. 149.

49. Ibid., pp. 145-148. Similar techniques date back to the Trecento as Cennini had given instructions on the oiling of parchment to make it transparent for tracing. Cennini, 1960, pp. 13-14.

50. Armenini, 1977, p. 136; Gombrich, 1963, pp. 31-41.

51. Armenini, 1977, p. 136.

52. Gombrich, 1966, pp. 58-63.

53. Armenini, 1977, pp. 144.

54. Roskill, 1968, p. 129; also in Barocchi, 1960, I, 170-171; Armenini, 1977, p. 146.

55. Lewine, 1967, p. 24.

56. Alberti, 1966, p. 72.

57. Ibid., p. 73.

58. Vasari credited Pollaiuolo with examining cadavers, although his engraving of the *Ten Battling Nudes* suggests greater reliance upon nude models and only superficial observation of exposed muscles. Vasari-Milanesi, 1878-85, III, 295; A. Levenson, et al., 1973, pp. 75-76.

59. Richter, 1970, II, 107-108; Vasari-Milanesi, 1878-85, IV, 33-37.

60. Leonardo showed the skeleton as a framework for muscles which in turn supported the flesh. He depicted parts of the body with topographical dissections. His drawings of bones and muscles were meticulous, with the tendons of the hand especially accurate. Joints were properly situated and provided with ligaments and capsules; muscles were correct in the degree of their relief and precise in their mode of insertion. Leonardo's cross-sections gave clarity to the interrelation of muscle masses. His delineations of facial muscles were accurate in their form, connections, and description of function. McMurrich, 1930; London, 1977, pp. 15-21; Pedretti, 1964, p. 108.

61. Richter, 1970, I, 190.

62. Condivi, 1553, p. 8; Condivi, 1976, p. 17. Perhaps these first studies were among the drawings Michelangelo later ordered destroyed. This would explain why few exist while so many examples of live model drawings remain.

63. Byam Shaw, 1976, I, no. 62.

64. Gauricus, 1969, pp. 198-201.

65. Richter, 1970, I, 294; 190: "O Anatomical Painter! beware lest the too strong indication of the bones, sinews and muscles, be the cause of your becoming wooden in your painting. . . ."

66. Lomazzo, 1584, p. 291; Roskill, 1968, p. 175.

67. Indeed, Alessandro Allori, a leading mannerist, made cadaver studies routine in his studio, but the meticulousness of Battista Franco's osteology [48, 49], lacking in *Skeletal Study* [2], is compensated for by a sense of whimsy; see entry [11].

68. Pevsner, 1973, p. 48.

69. The upper torso on the verso of Torre's sheet [66], with its accentuated shadows along the linea alba, suggests that only the skin and connective tissue were removed and bone detail overlooked. The sternal portion is casually drawn, the muscles never meeting a mid-line pectoral major. Also, the pectoralis complex in humans never fuses up and down the sternum as in non-human primates where it is important for tree climbing and the chest wall becomes exceedingly complex. The muscle complex of the stomach, or rectus abdominus, is rendered accurately only in its relationships, but not in description. Also, the muscles are generally square rather than pear shaped. Torre shows the multiplicity of the serratus but not how the muscle mass interdigitates with the serratus. The deltoid is usually drawn as a single mass, but Torre compartmentalized it to show its architectural complexity. The delto-pectoral triangle is also highly pronounced.

70. Female models in anatomy drawings are rare less out of religious scruples than a belief that only male figures had fixed proportions. For this reason, Michelangelo used a male model for his *Studies for the Libyan Sibyl* (Fig. XVI).

71. Anatomical studies were not limited to the human figure. Leonardo, a splendid horseman and twice involved in projects for major equestrian monuments, intended a treatise on equine anatomy. In *Studies for Horses* [69], Perino del Vaga explored the interaction of leg bone and muscle in kicking and bending.

72. This series of drawings, formerly in the Rosenbach collection in Philadelphia, is reproduced in part from copies of the sheets in the Uffizi collection. In them, Federico eulogized his prematurely dead brother, Taddeo, by recording his struggles as an aspiring artist. Heikamp, 1957, pp. 200-215.

73. Armenini, 1977, pp. 127-128.

74. Ibid., p. 136-138.

75. Condivi, 1553, pp. 40v-41; Condivi, 1976, pp. 93-94; Armenini, 1977, p. 138.

76. Richter, 1970, I, 257, 259-260, 288-290.

77. Ibid., pp. 259-260.

78. Armenini, 1977, p. 258. For an alternative view on portraiture, see Vasari's comments: Vasari-Milanesi, 1878-85, IV, 463.

79. Howard Hibbard, *Michelangelo* (New York: Harper and Row, 1974), p. 188.

80. Alberti, 1966, pp. 74-78. Alberti was one of the first critics to deal with the need for decorum in art. See also, Lee, 1967, pp. 34-41.

81. Fracastoro, 1924, p. 376. I am grateful to David C. Ditner for calling this passage to my attention.

82. Castiglione, 1959, pp. 202-282. The third of Castiglione's four books is devoted to a discussion of the beauty and character of women. Firenzuola's dialogue, first published in Florence in 1548, is one of many dialogues and treatises on feminine beauty published in the Cinquecento. See Zonta, 1913; Cropper, 1976, pp. 374-394.

83. Popham, 1945, p. 149, no. 253, pl. 253; Pedretti, 1973, p. 9; Ernst H. Gombrich (1976, pp. 33-34) recently argued that the drawing does not represent an actual view but reproduces a painted detail, perhaps from Jan van Eyck's *The Stigmatization of St. Francis.*

84. Rome, 1972, no. 2, fig. 2.

85. Glaser, 1959, p. 17: Rome, 1972, no. 4.

86. Alberti, 1965, p. 192. Translation from Gombrich, 1966, p. 111.

87. Vitruvius, 1960, p. 211.

88. Pliny, *Natural History*, XXXV, 116-117.

89. Pino, 1946, p. 145.

90. Pedretti, 1973, pp. 20-23.

91. Ibid., p. 21.

92. Pliny, *Natural History*, XXXV, 96.

93. Colonna, 1499; Sannazaro, 1888; Ackerman, 1966, pp. 22, 53.

94. Meiss, 1964, p. 23.

95. Washington, 1976.

96. Williamson, 1903, p. 33.

97. See Schulz, 1978, pp. 425-474; Edgerton, 1975, pp. 91-105, 113-115.

98. Vasari-Milanesi, 1878–85, 217-218; Popham, 1957a, 275-287.

99. Posner, 1971, I, 113.

100. New Haven, 1978, nos. 30-31.

101. Baglione, 1649, p. 49.

102. Posner, 1971, I, 113.

103. C. Sorte, *Osservazioni nella pittura* (Venice: 1580). Reprinted in Barocchi, 1960, I, 275-276, 280-282.

104. Lomazzo, 1584, pp. 473-475.

105. Alberti, 1966, p. 72; Roskill, 1968, p. 173.

106. Roskill, 1968, p. 131.

107. Tolnay, 1943, p. 71.

108. Generally, charcoal was used for practice since mistakes could be brushed away, but Cennini indicated that the novice was to begin drawing with a stylus and after a year turn to pen. Cennini, 1960, pp. 5-8; Ames, 1978, I, 81.

109. Borghini, 1584, pp. 138-143. Armenini observed that "questo e tenuto ottima per gl'ignudi. . . ." Armenini, 1977, p. 126.

110. Vasari-Milanesi, I, 175; Barocchi, 1971–77, II, 1929. The Greeks regarded paintings as colored drawings: Lodge, 1953, p. 256, n. 28.

111. Malvasia, 1841, I, 312.

112. Watrous, 1957, p. 50.

113. Ibid., p. 13.

114. Its unyielding nature made metalpoint unpopular in sixteenth-century Italy. Borghini discussed metalpoint and the use of silver and lead styluses, but Armenini did not include it among the four types of drawings he described. Borghini, 1584, pp. 138-139.

115. Tolnay, 1943, p. 71.

116. Brown, 1960, p. 208; Vasari-Milanesi, I, 168-169.

117. Armenini, 1977, p. 177.

118. Pino, 1946, p. 100; Barocchi, 1960–62, I, 164; Roskill, 1968, p. 117.

119. Mahon, 1953, p. 312.

120. Vasari-Milanesi, 1878–85, I, 179; Armenini, 1977, pp. 176, 294.

121. Pino, 1946, pp. 109, 116-119.

122. Ibid., p. 109.

123. Vasari-Milanesi, 1878–85, I, 179; IV, 113.

124. Borghini, 1584, p. 188; Lomazzo, 1590, p. 72.

125. Barasch, 1978, p. 91.

126. Armenini, 1977, p. 183.

127. Borghini, 1584, p. 227.

128. Lomazzo, 1584, pp. 190-191.

129. Armenini, 1977, p. 120.

130. Ibid., p. 183.

131. Roskill, 1968, p. 153.

132. Vasari-Milanesi, 1878–85, V, 528.

133. When drawings are pricked for transfer, pin holes are made along the outlines and then the perforated design is pounced, or dusted, with a bag of charcoal. Called the *spolvero* technique, it was most popular in the late Quattrocento and was used on Filippino Lippi's *St. Jerome in His Study* [17]. Since Lippi's drawing is not darkened by charcoal, it may have been pounced on the verso or perforated against a second sheet which was then used to transfer the image [16] thereby preserving the original drawing as well as avoiding a reversal of the image. Brown, 1960, p. 289.

134. The image was then transferred to the support whether wall, canvas, or panel by pouncing the perforated cartoon or incising it. It could also be enlarged directly from the *studio* to the final surface without making a cartoon. Vasari-Milanesi, 1878–85, I, 175; Borghini, 1584, p. 140.

135. Grayson, 1972, p. 101, para. 57.

136. New Haven, 1978, nos. 12, 45.

137. Horace, *Ars poetica*, 361.

138. Ibid., 333-335; Lee, 1967, pp. 32-34.

139. Alberti, 1966, p. 63; Armenini, 1977, pp. 106-108.

140. Roskill, 1968, pp. 112-113.

141. Edgerton, 1975, pp. 91-99.

142. Alberti, 1966, p. 92.

143. Armenini, 1977, p. 122.

144. Canedy, 1976, p. 65.

145. Armenini, 1977, pp. 49-50, 61, n. 168; Canedy, 1976, pp. 6, 28. This common studio practice in training apprentices became a literary *topos*, so that even baroque masters like Ribera and Luca Giordano were praised for skillfully mimicking other artists' styles. Obviously the practice presents problems for modern connoisseurship.

146. A few notebooks by non-Italian artists survive as documents of trips to Rome. The volume of drawings in Madrid by Francisco de Hollanda is one example. Compiled during Hollanda's stay in Rome (ca. 1539–1540) this volume includes views of sculpture courts including the Vatican Belvedere, carefully finished drawings of single statues from the collections of Cardinal della Valle and Cardinal Cesi, restored monuments, and views of the city (Brummer, 1970). Other examples include the sketchbooks of the French painter Pierre Jacques, who was in the Holy City from 1572 to 1577, and Etienne Dupérac, who arrived there around 1559 and whose Roman drawings date from 1574 to 1577 (Reinach, 1902). The folio in the National Gallery of Art attributed to Dupérac is significant for its view of the Tiber with the Castel Sant'Angelo on the recto and a Roman statue of a Bacchante on the verso [45], both animated by Dupérac's characteristic wavy line. Other sketchbooks were compiled by the Netherlandish painter Martin van Heemskerck, who went to Rome in 1532 for four years (Hülsen and Egger, 1913 and 1916). One in Berlin, filled with views of the city, describes the construction of St. Peter's basilica.

147. Mandowsky and Mitchell, 1963; Ligorio, 1553. The surviving fraction of this work includes volumes in Paris, Naples, Oxford, and Turin.

148. Steinitz, 1958, pp. 8, 21.

149. The surviving 5,342 pages date from 1489 to 1518 and are found primarily in the Ambrosian Library, Windsor Castle, the Library of the Institut de France, the Victoria and Albert Museum, the British Museum, and the Biblioteca Reale in Turin. A transcript, perhaps assembled by Leonardo's heir, Francesco Melzi, exists in eight volumes in the Vatican collection.

150. Recent research has uncovered 526 drawings by 226 artists once part of Vasari's album (Collobi, 1974). These sheets included works representing the major regional schools of Italy, and the fourteenth, fifteenth, and sixteenth centuries, as well as a variety of techniques with sketches of all types from architectural designs, anatomical studies, single figures, studies of heads and grotesques, plus narrative subjects treating religious compositions, histories, and scenes from mythology. The album was inherited by Vasari's nephew Giorgio and shortly thereafter was acquired by the noted collector Niccolo Gaddi. When Gaddi died in 1591, the drawings were sold to his heirs, but there is evidence that Vasari's nephew had already begun to separate some sheets even before dispersal of the volumes by Gaddi's relatives. Most of the drawings originally in the *Libro de' disegni* are today in the Louvre and the Uffizi, while others are in the Albertina, the British Museum, Stockholm, Chatsworth, and Oxford. Two sheets once part of Vasari's *Libro* are in The Cleveland Museum of Art: Parri Spinelli's late Trecento *Navicella* (CMA 61.38) and Filippo Lippi's *Funeral of St. Stephen* (CMA 47.70).

151. Collobi, 1974, I, II; Tolnay, 1943, p. 5.

152. Vasari-Milanesi, 1878–85, VII, 681-684.

Tuscany

The region of Tuscany included the cities of Pisa, Siena, and Arezzo, with Florence dominant in politics, culture, and the arts. The major artists active in Florence into the first decade of the Cinquecento were Filippino Lippi, Piero di Cosimo, Fra Bartolommeo, Leonardo da Vinci, and Lorenzo di Credi. Filippino Lippi, a pupil of Botticelli, often drew in a sketchy, reworked style, but his *St. Jerome in His Study* [17] is a manicured pen study. The rigid frontal pose of St. Jerome, the closed composition, and dry line are conservative and of the fifteenth century, but Lippi's dependence upon line for contour and surface articulation is a major development of Quattrocento Tuscany with sufficient aesthetic momentum to carry it through the following century. Similar simplicity and tentativeness characterize the paintings of Lorenzo di Credi, who trained with Leonardo in the workshop of Verrocchio. Slightly younger than Leonardo, Credi is seen in his silverpoint *Madonna and Child* [15] as a transitional figure. This sheet is associated with Leonardo's art in terms of composition and repetitive drawing. Credi's insistent reworking of the stylus persists in the calligraphic freedom of Tuscan draftsmanship for the next hundred years.

The vitality of late Quattrocento studies in Florence is noted in the appearance of new compositions, new iconography, and new subjects. Not only did Verrocchio have talented pupils in Leonardo and Botticelli, but he stimulated their imaginations and gave them the freedom to experiment with techniques and subjects. Leonardo's pioneering landscape studies lived on in the notebooks of Fra Bartolommeo [3]. His view of a farm is a balanced composition; its elevated setting and undefined foreground appear unfinished possibly because of its intended use as background for his painting in Lucca. It is, however, the only drawing from the Gabburri album of Fra Bartolommeo landscapes to be associated with a finished work. Parallel lines which span the breadth of trees comprise his description of foliage in an unequivocally linear approach. Fra Bartolommeo's atmosphere is the clear air of late Quattrocento Florentine paintings. The lack of reference to clouds would be unthinkable to Campagnola and his Venetian contemporaries. His landscape, therefore, represents the expression of a Florentine intellectualism in its crystalization of form as opposed to the more organic approach of the Venetians.

Line and an interest in the human figure dominate Florentine drawings. Individual lines are mutually dependent and serve descriptive or decorative functions. Parallel lines in concert define planes. Lines in the form of crosshatching suggest shadows so objects emerge in relief. Pen and chalk—the preferred media for Tuscan draftsmen—are both basically linear in nature. In Sienese drawings line seems less disciplined and yields to pattern and rhythmic contrasts in shading. In a sense, Beccafumi's art is the anomaly proving the soundness of the rule. A net of lines builds up the surface relief of face, neck, and head in *The Head of a Woman* [4], whereas in his *A Kitchen Maid* lines work alone or in concert to suggest angle and direction. His sheet in crayon and white highlights [5] is an exercise in contrasts which is finally understood in the chiaroscuro woodcut [7]. Whereas the drawing has the haste and looseness of the most frenzied *schizzo*, the outlines of the figures have been traced with a stylus revealing the drawing's function for the related engraving [6] and woodcut.

Another Sienese, Marco Pino, left Beccafumi's studio to join the Florentine Perino del Vaga in Rome. The power of suggestion in Beccafumi's line appears in Pino's treatment of hair in *The Battle of Anghiari* [20], and his use of washes can be associated with Beccafumi's interest in shadows. The continuous silhouette of the foreground horse, however, mimics Perino's extended line. Pino's use of human extremeties for visual effect, occasional daring foreshortenings, posturing, and convoluted poses all reflect his surrender to the dictates of mannerism. Francesco Vanni was also a native of Siena and, like Pino, influenced by Roman painting and late Cinquecento mannerism, although ultimately Federico Barocci's paintings had the greatest effect on Vanni's style.

Although Michelangelo's *Doni Tondo* was an important milestone in the history of Florentine painting, his major paintings were Roman. The Sistine Chapel projects, represented here by his chalk study of a male nude [55], kept Michelangelo in the Holy City for extended periods. His stay in Florence between these commissions—a term of more than twenty years—was occupied almost exclusively with sculptural projects. Painting in Florence from 1510 to 1530, then, was dominated by Fra Bartolommeo and Andrea del Sarto, whose works are generally symmetrical in composition with a strong sense of order and clarity. By contrast, the paintings of Pontormo and Rosso are less predictable and represent the earliest manifestations of mannerism in Florence. Pontormo's chalk studies of figures [22, 23] were for commissions from the 1520s. Although the drawings have a basis in human anatomy,

the distended torsos and heightened expression reflect liberties with the model that remain in the paintings. Touches of naturalism occur in the bony servant and the cast shadow of Rosso's Judith [26]. On the other hand, Rosso errs in the direction of stylized elegance in his highly formal *Head of a Woman with an Elaborate Coiffure* [25] which offers another example of over intellection in Florentine art.

Like Pontormo and Rosso, Francesco Salviati was influenced by Andrea del Sarto. He was also in the studio of the Florentine sculptor Baccio Bandinelli and like Bandinelli worked both in Florence and Rome. His *Kneeling Figure* [27], a study of 1553 for a Roman fresco, is given a distinct silhouette shaded along the edges. In the face, arm, and right half of the back Salviati's hatching takes on a slightly gritty quality suggesting the graininess of the human epidermis.

Bronzino, in his *Copy after Bandinelli's "Cleopatra"* [9], combines with the formal model of Bandinelli the assurance of his master, Pontormo, in his use of black chalk, especially in his clear, determined outline. Although conventional for figure studies, black chalk may have been chosen by Bronzino in an attempt to soften the metallic hardness of his model, which he may have seen in the study of the Grand Duke of Tuscany, Cosimo I.[1] His late *Study of a Male Nude* [10] was for a frescoed figure of 1565 in San Lorenzo. In pose it represents an extravagant *maniera* statement typical of Duke Cosimo's court painter. The sheet can be ranked with Rosso's *Head of a Woman with an Elaborate Coiffure* in its formal arrogance.

Naldini was also a Pontormo pupil who worked for a period in Rome before joining Vasari's studio in Florence. His *Samson Slaying the Philistines* [19], like Bronzino's *Copy after Bandinelli's "Cleopatra,"* is a copy of a work of sculpture probably based upon a bronze like that in the Bargello taken from Michelangelo's composition, Naldini's blurred red chalk technique seems more Venetian than the similar copy associated with Tintoretto [106]. This rendition appears highly impressionistic by virtue of the merging of background hatching with contours. Naldini imposes a different canon of proportions on his version of Michelangelo's model than is found in the Venetian drawing, but both figures betray problems with anatomy.

Bernardino Poccetti matured as an artist during a generation dedicated to the standards of *maniera*. His *Woman and Child Standing* [21] for a fresco in the SS. Annunziata is more normative in expression and proportions, reflecting not only the transitional character of Poccetti's position in the history of Florentine painting but also the new seriousness that had emerged in Italian art at the end of the century.

Boscoli's highly sculptural *Annunciation* [8] has figures in high relief and planes emphatically stated. The persistence of line in Tuscan art is evident in this drawing where shadows are achieved by means of uniformly thin parallel lines tightly hatched in concert. Line is an integral part of the aesthetic of Boscoli's sheet which is as cleanly limned as Salviati's *Kneeling Figure*.

Alessandro Allori came out of the workshop of Bronzino and trained the artist Lodovico Cardi. Indeed, there is a consistent tradition in Florentine art from Andrea del Sarto, who trained Pontormo and Salviati, to Pontormo, who was the master of Naldini and of Bronzino, who in turn trained Allori. The red chalk *Figure Study* [1] and *Full-Length Skeleton* [2]—both associated for some time with Allori and reflecting elements of his style and subjects—are here attributed to Lodovico Cardi as examples from the early years of his career. By the 1590s, however, he had developed an impressive wash style that allowed him to describe his figures as grand volumes with a noble sense of presence, such as *Standing Male Figure* [12], a study for his lost canvas of the *Assumption* (Fig. 12a). The impasto highlights add a dramatic note and impressive plasticity to the figure, but outline remains as important for Cardi's saint as it was for Bronzino's *Study of a Male Nude* [10]. The Fogg's *Kneeling Figure* [11] is later and slightly looser, but in the same style and technique. Associates of Cardi in Florence were Jacopo Chimenti and G. B. Paggi, who spent the last two decades of the Cinquecento in Tuscany, having fled his native Genoa. The breadth and corporeality of Paggi's *Standing Archer* [130] bear testimony to the impact of Florentine taste on his style. The black chalk contours are thick and roughly handled and rubbed along the back of the thigh and hips. Paggi is for other reasons, however, associated with the Genoese draftsmen.

1. Northampton, 1941, no. 23.

Allessandro Allori

1535–1607

Allessandro Allori entered the studio of Bronzino at the age of five after the death of his father. He became a son as much as an apprentice to Bronzino, who had himself been cared for by Pontormo. Allori spent time in Rome studying the work of Michelangelo in the late 1550s, but Bronzino's *maniera* idiom remains evident in Allori's *Pearl Fishers* in the Palazzo Vecchio, Florence, painted in the early 1570s for Vasari's project of decorating the Studiolo of Francesco I. His figures have the hard finish of polychromed wood and their gestures a precious quality that reveals the triumph of artifice over nature. In his later years Allori's paintings involved a studied reworking of Michelangelo whereby exaggerations of pose are made to appear more extreme through the normalization of proportions.

Attributed to Allessandro Allori

1 *Figure Study*
2 *Full-Length Skeleton* (recto); *Three-Quarter-Length Skeleton* (verso)

Although exhibited as attributed to Allessandro Allori, these drawings are here attributed to Lodovico Cardi and listed under his name on pages 36–38.

Fra Bartolommeo, Baccio della Porta

1472–1517

Baccio della Porta became associated with the Ghirlandaio workshop after learning the fundamentals of art in the studio of Cosimo Rosselli. His earliest surviving paintings of the late 1490s show some of Leonardo's influence. In 1500 in response to the fiery preaching of Savanarola he entered a Dominican monastery. Taking the name Fra Bartolommeo, he seems to have abandoned art for the next few years. When he resumed painting, Fra Bartolommeo revealed an awareness of Leonardo's return to Florence in 1504, as soft modeling and greater naturalism are already evident in his *Vision of St. Bernard* (Accademia, Florence). Frederick Hartt mentions the steps in the middle ground: "there only to lead us to the distant landscape" and to the Virgin who enters a symmetrically balanced composition open at the center.[1] During an eight-month stay in Venice in 1508, the Frate was impressed by the art of Giovanni Bellini in terms of color, mood, light and shadow, and formal motifs. Fra Bartolommeo became the dominant artist in Florence after the departures of Leonardo and Raphael. In 1514 he visited Rome.

1. Hartt, 1971, p. 427.

Fra Bartolommeo

3 *Farm on the Slope of a Hill*

Pen and brown ink, traces of black chalk, 222 × 294 mm., ca. 1506–1508. Watermark: Chariot (similar to Briquet 3541). Dark stains upper right and left, lightly foxed.

The Cleveland Museum of Art, Gift of Hanna Fund, Purchase, Dudley P. Allen Fund, Delia E. Holden Fund, and L. E. Holden Fund, 57.498.

Provenance: Fra Paolino da Pistoia, Florence; Sister Plautilla Nelli, Florence; Convent of St. Catherine, Piazza San Marco, Florence; Cavaliere Francesco Maria Nicolò Gabburri, Florence; William Kent, England; Private Collection, Ireland. *Sale:* London, Sotheby (Drawings of Landscapes and Trees by Fra Bartolommeo), 20 November 1957, no. 3. *Exhibited:* New York, 1959, no. 13; Cleveland, 1971, no. 57; St. Louis, 1972, no. 2. *Published:* Jeudwine, 1957, pp. 132-133, 135, fig. 1; CMA *Bulletin*, 1958, p. 68 repr.; Fleming, 1958, p. 227; Kennedy, 1959, p. 11, no. 30; Richards, 1962, pp. 172-173, fig. 5; *Selected Works*, 1967, no. 139; Baer, 1973, pp. 15, 50, no. 8, pl. 51.

Of the several drawings in the Cleveland collection with impressive histories, Fra Bartolommeo's *Farm on the Slope of a Hill* can be traced back to the artist's death in 1517. At that time Fra Paolino da Pistoia inherited the contents of Fra Bartolommeo's studio and subsequently gave many of the drawings to a Dominican nun, Sister Plautilla Nelli.[1] Upon her death in 1588 the works were left to the convent of St. Catherine in the Piazza San Marco, Florence, where they remained until sold to Francesco Maria Nicolò Gabburri in 1725.

3

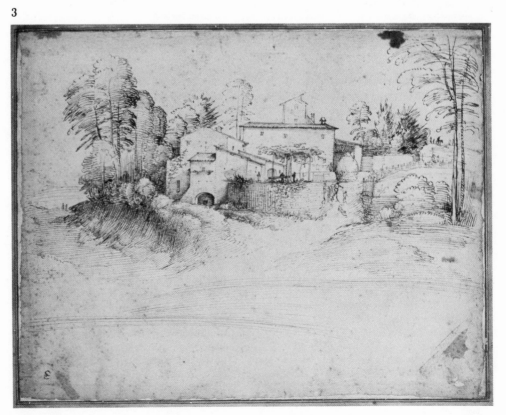

Gabburri was a dedicated collector, an acquaintance of P. J. Mariette and Antonio Zanetti, and president for a time of the Academy of Painters in Florence. A catalog of his collection in 1722 listed 1,336 items. Among them was a group of forty-one landscape drawings that Gabburri had bound into a sheepskin volume in 1730 and incorrectly attributed to Andrea del Sarto.[2] The volume was sold after Gabburri's death in 1742 to the Englishman William Kent, who, it is believed, was a lesser known Florentine art dealer.[3] Nothing more is known concerning the album until it was purchased in 1925 in southern Ireland by a private collector who sold the sheets separately at Sotheby's in 1957.

Pen and ink and metalpoint were favorite media in late Quattrocento Tuscany. Fra Bartolommeo chose pen for the execution of *Farm on the Slope of a Hill* for its qualities as a drawing tool — freedom, descriptive power, and clarity. The sheet reflects the high Renaissance ideals of quiet dignity and compositional solidity. The linear severity of the farm buildings — a few simple, spare, geometric shapes — is softened by the freely drawn foliage. Straight, sharply drawn lines are used to define the architecture which provides a stable central focus. In contrast curving, looping strokes, full of movement and energy, suggest trees and bushes. Areas of dense activity and excitement alternate with restful blank spaces which seem to sparkle in sunlight.

Fra Bartolommeo utilized a scene similar

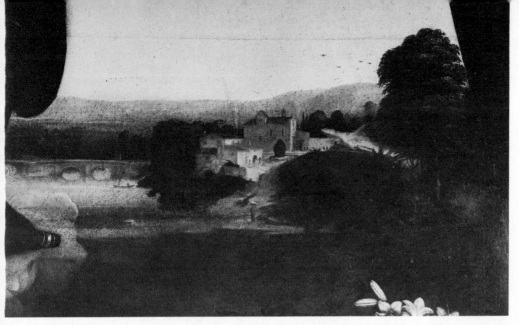

Fig. 3a. Detail of *God the Father with Saints Mary Magdalene and Catherine*, oil on panel. Fra Bartolommeo. Pinacoteca Nazionale, Lucca.

to *Farm on the Slope of a Hill* in the background of a painting in Lucca, *God the Father with SS. Mary Magdalene and Catherine of Siena*, executed in 1509 (Fig. 3a). Although it has been somewhat simplified in the painting and the buildings are there seen from a point of view which is slightly higher and farther to the right, the architectural configuration, the arrangement of the trees, and the slope of the land are quite similar. As this is the only drawing in the Gabburri album to be connected with a more finished work, most of these sheets were probably not done with paintings in mind. They do, nonetheless, reflect an intense interest in nature—in such things as the structure of a single tree—and an acute observation of the life of the countryside. Notice the small, sprightly figures that enliven *Farm on the Slope of a Hill*. An adult and child playing with a dog at the gate, two figures at the wine press under the grape arbor, and the laundry hanging on a line nearby are all details he probably noticed when sketching this scene.

The landscape subject created a special problem for the artist with reference to the pervasiveness of light. In his fresco paintings Fra Bartolommeo had only to coordinate the direction of fictive light with that entering a window. Here he was forced to deal with the ubiquity of light in an outdoor scene. It became necessary for him, therefore, to temper his crisp accents and sharply drawn line with softer shadows against the white of the page. The resultant tonal nuances are sufficiently subtle and varied to define the breadth of space revealed and articulated by light and to suggest the changing nature of light affected by atmosphere.

The firm date of the Lucca painting may serve as a *terminus post quem* for dating *Farm on the Slope of a Hill*. Ruth Kennedy thought the drawings in the Gabburri

album were done when Fra Bartolommeo traveled from Florence to Venice in March and April of 1508.[4] The recto of Sheet No. 22 shows two monks in the rocky and hilly terrain which could be the Apennines north of Florence, and the two subjects which have so far been identified—the *View of Fiesole Across the Mugnone* (Sheet No. 14) and *A View of the Monastery of St. Mary Magdalene at Caldine* (Sheet No. 8)—are near Florence.[5] Although Fra Bartolommeo visited this monastery several times during his career, Kennedy claimed that "the tall, slight Lombard tower which appears in the distance on Sheet No. 18 is surely on the banks of the Po."[6]

From the identification of the monastery at Caldine where Fra Bartolommeo spent his retreat of five years (abandoning painting but obviously continuing to draw), it is clear that some of the drawings in the Gabburri album antedate the Venetian journey and may be as early as 1500. While it is reasonable to assume that Fra Bartolommeo made numerous sketches during his brief stay in Venice, it is unacceptable that he could have done so many drawings so different in style and technique. His calligraphy ranges in character from hesitant and empirical to highly accomplished, the media from pen and ink to wash to chalk. There are some reasons to date the Gabburri album ca. 1505–1508. The rapid sketch of a small figure in the lower left verso of Sheet No. 5 resembles the infant St. John in a drawing from 1505–1506, *The Holy Family*, in the Uffizi.[7] In both the child rushes forward with outstretched arms and open mouth, while a length of drapery floats behind him like a curled tail. Furthermore, after evaluating Fra Bartolommeo's other work, this dating seems appropriate.

The gnarled mulberry tree behind Christ in a sheet in the Uffizi of 1505–1506[8] is repeated in *St. John the Baptist in a Land-*

scape.[9] In both thin branches reach up and out from a short, thick trunk. The light comes from the left, and the shadow on the right side of the trunk is drawn with parallel curved strokes over a series of vertical ones. Leaves are summarily delineated by groups of oval forms, and the rocks are outlined by a curved or slightly scalloped line. Evenly spaced parallel lines or crosshatching shade the rocky terrain. Similar mulberry trees appear in several sheets from the Gabburri album as do the delicately drawn and curved saplings to the right of St. John in the Louvre sheet. In fact, the same arrangement of mulberry tree at the left and sapling at the right, both on hillocks framing the scene, is repeated on the recto of Sheet No. 19.[10]

Late Quattrocento influences for Fra Bartolommeo's landscape activities include Leonardo's nature studies, a contemporary fashion for views as in the cityscapes of Ghirlandaio's *Codex Escurialensis*,[11] the impressive landscapes of Piero di Cosimo (such as *St. Jerome in a Landscape* in the Uffizi),[12] and the backdrops of Perugino's paintings which Fra Bartolommeo would have been familiar with in the workshop of Cosimo Rosselli. Perugino's feathery trees appear as details in Fra Bartolommeo's *Annunciation* of 1497 in the cathedral in Volterra and *Noli Me Tangere* of 1506 in the Louvre.

The Gabburri album represents approximately one third of Fra Bartolommeo's known landscape studies. His total output can only be guessed at, but the number of extant sheets is impressive. By 1506 Fra Bartolommeo was a mature and confident draftsman, and *Farm on the Slope of a Hill* is one of the first pure landscape drawings of the sixteenth century.

I would like to acknowledge the research assistance of Roslynne Wilson during the preparation of this study.

1. Gronau, 1957, p. iii.
2. Ibid., p. iv.
3. Fleming, 1958, p. 227.
4. Kennedy, 1959, p. 8.
5. Sheet numbers are those cited in Gronau's catalog (1957). The landscape locations were identified by Kennedy, 1959, p. 10.
6. Ibid.
7. *Sketches of a Farmhouse, a Watermill and a Child*, pen and ink, 287 × 216 mm., Museum of Fine Arts, Boston; repr. London, Sotheby, 28 June 1962 (Catalogue of Drawings of Landscapes and Trees by Fra Bartolommeo), lot 5 (verso); *Holy Family with Angels in Landscape*, pen and ink on pink prepared paper, 154 × 229 mm., Uffizi, no. 457 (verso), von der Gabelentz, 1922, II, no. 120, pl. 29.
8. *Studies for Christ and the Samaritan Woman*, pen and ink and wash, Uffizi, no. 1139 (verso), von der Gabelentz, 1922, II, no. 162.
9. *St. John the Baptist in a Landscape*, pen and brown ink, 140 × 135 mm., Louvre, no. RF 5558 (verso), repr. Bacou, 1968, II, no. 22; von der Gabelentz, 1922, II, no. 424.
10. *Village on the Crest of a Hill*, pen and ink, 285 × 216 mm., repr. Sotheby, 28 June 1962, lot 19 (recto).
11. That Fra Bartolommeo was acquainted with the *Codex Escurialensis* is evident from his sheet in Windsor Castle which reproduces a female figure in the *Codex*; Fahy, 1966, p. 460.
12. Rome, 1972, p. 6, fig. 2.

Domenico Beccafumi, il Mecherino

ca. 1486–1551

The native Sienese elements of Domenico Beccafumi's work were tempered by early trips to Rome and Florence. Fra Bartolommeo's art had a more profound influence on him than Raphael's and Michelangelo's high Renaissance paintings. Beccafumi's *Trinity and Saints* of 1513 (Pinocoteca, Siena) is a denial of contemporary classicism more by virtue of naïve misunderstanding than by deliberate contradiction. Less modern in his borrowings than his Sienese companions, his work into the 1520s also represents a less abrupt break with late Quattrocento mannerisms than is to be found in the art of his contemporaries in Rome where he appeared for a second time in 1519. After becoming thoroughly familiar with the projects of the Raphael school, he returned to Siena the same year and immediately began designs for narrative pavement tiles in the Siena cathedral. His paintings of the 1520s reflect the Roman interest in chiaroscuro effects and a dependence upon antique prototypes for formal motifs. The *Christ in Limbo* of 1535 (Pinocoteca, Siena) demonstrates how delicate and sophisticated his art had become. Beccafumi was in Genoa the following year, then Pisa in 1538, and Rome in 1541. His late paintings are marked by dramatic light effects, abrupt jumps in figural scale, and enigmatic foreshortenings.

Domenico Beccafumi

4 *Page from a Sketchbook:
The Head of a Woman* (recto);
A Kitchen Maid (verso)

Black chalk, with traces of red chalk (recto); black chalk (verso), 216 × 146 mm., ca. 1513. Watermark: Anchor (similar to Briquet 466, Mosin 477). Creased, soiled.

The Cleveland Museum of Art, L. E. Holden Fund, 66.120.

Provenance: George Hibbert (Lugt 2849); Coghlan Briscoe (Lugt 347c); Dr. W. M. Crofton. *Sale:* London, Agnew, 1-27 November 1965 (Domenico Beccafumi 1486-1551. Drawings from a Sketchbook), no. 33. *Exhibited:*

Cleveland, 1966, no. 74, repr. p. 203 (recto). *Published:* de Liphart Rathshoff, 1935, pp. 41-42, 59, figs. 3 (recto), 17 (verso); Sanminiatelli, 1957, p. 405, n. 9; Sanminiatelli, 1967, pp. 186, 189-190.

This sheet, a page from a sketchbook, was attributed to Beccafumi by R. de Liphart Rathshoff.[1] Sanminiatelli suggested that the sketchbook was instead by Beccafumi's pupil, Marco Pino, while Claire F. Tyler found the variety of styles indicated that several hands were responsible for the drawings.[2]

Possibly associated with a fresco of 1514 in Santa Maria della Scala, Siena, the female head on the recto of this sheet is an example of Beccafumi's early career.[3] Already the draftsman is self-assured; the parted lips, pointed nose, and small ear set at the back of the head are characteristics found in later works such as the chalk study of *Gaius Mucius Scaevola* in the Morgan Library and a sheet of female heads in Cologne where the handling of the hair is similar.[4]

4 Recto

4 Verso

Beccafumi's approach to this profile view is initially planar, the head forming an almost perfect square. His sensitive draftsmanship is evident in the red chalk outline, the black chalk crosshatching which models the head, and the dark accents at chin, lips, nostrils, and eyebrows.

The servant woman on the verso is a surprising genre touch since such subjects are rare in the high Renaissance. Although Beccafumi is sketchier here than on the recto, a rigid formalism is evident in the structure of the figure. The servant's back is a large oval, and her figure evolves into a three-dimensional volume as added details contradict this basic shape and define planes. As the shawl tapers to the small of her back, it restrains the swelling of her skirt from the hips, and the cincture of the servant's belt further restrains the expansion of form. A line at the back of her neck disappears into the oval lip at the roll of the maid's collar, and serves as evidence of Beccafumi's careful observation of nature.

I would like to acknowledge the research assistance of Marian Jill Sendor with this drawing.

1. de Liphart Rathschoff, 1935, pp. 37, 41-43, 52, 59.
2. Sanminiatelli, 1967, pp. 186, 198-199; Providence, 1973, no. 18.
3. Agnew & Sons, 1965, no. 33
4. *Gaius Mucius Scaevola Holding His Hand in the Fire*, red chalk, 296 × 224 mm., The Pierpont Morgan Library, New York, 1964.7; and *Studies of Heads*, black and red chalk, 208 × 136 mm., Wallraf-Richartz Museum, Cologne, no. Z 1986.

Domenico Beccafumi

5 Study for Moses and the Israelites Drinking

Black crayon, heightened with white, touches of pen and black ink, on tan paper, incised, 234 × 419 mm., ca. 1530. Notations: on mat, in brown ink, *Becco Fumi, il Mecarino da Sienna. 1404–1549 Domenico Beccafumi; from vol 1st p. 12*. Large patch lower right corner, small patch upper left corner, soiled.
The Cleveland Museum of Art, Delia E. Holden Fund, 58.313.

Provenance: Earl of Pembroke (Lugt 2636b); Archibald George Blomefield Russell (Lugt 2770a); A. Scharf, London. *Sales:* London, Sotheby, 9 June 1955 (Russell collection), no. 1. repr. (sold to A. Scharf, London). London, Sotheby, 5-10 July 1917 (Pembroke collection), no. 511 (sold to Moore). *Exhibited:* Detroit, 1958, no. 98; Providence, 1968, no. 14, p. 1, pl. xiv, fig. 1. *Published:* Sanminiatelli, 1956, p. 59, pl. 32; Richards, 1959, pp. 24-29, repr. 26; Oberhuber, 1966, under no. 206; Sanminiatelli, 1967, p. 133 under no. 4, p. 138 no. 4; Fern and Jones, 1969, p. 15, repr. p. 14; Providence, 1973, under no. 75.

Reclining figures, so ubiquitous in Beccafumi's art that they may almost be taken as signature equivalents, often serve as repoussoir elements enclosing a composition or directing the vision diagonally into it. They are as frequently, however, spatially equivocal. It was early recognized that

works by Michelangelo were models for the reclining figures seen here. Louise Richards suggested the Sistine ceiling *Adam* as a possibility, and Stephen Ostrow added the figure of *Noah*.[1] The "momentary and restless appearance" Richards perceived in Beccafumi's figures and the similarity of pose suggest Michelangelo's personification of *Giorno* in the Medici chapel as the prototype for the nude in the foreground.[2] The third and most distant figure, observed more legibly in the related engraving [6], is close to Michelangelo's marble *Crouching Youth* in the Hermitage.[3]

Although utilized by Michelangelo, reclining figures originated with Roman river gods. Beccafumi could have known some ancient examples from his earliest trip to Rome in 1510–1512 such as those on the Capitoline Hill or the Hellenistic figures of the *Tiber* and the *Nile* [75]. The reclining figures of this composition could be identified as philosophers and Olympian deities as well.[4]

The subject would more properly seem to be Moses and the Israelites Drinking in the Desert, from an episode of the flight out of Egypt described in Exodus 17:3-6, which Beccafumi illustrated in the pavement tiles in the Siena Cathedral (Fig. 5a). The scene of Moses striking the rock, where water miraculously spouts forth — alleviating the desert thirst of the wandering tribe of Israelites — includes one reclining figure drinking from a cup. That the cup touches the lips of the figure in the drawing suggests that it was made from the tile pavements and was intended to be reproduced by graphic means since the drawing is a reversal of the pavement figure. The engraving and chiaroscuro print, however, more clearly indicate the figures' activities. The largest drinks from a cup, the next, turbaned, holds a set of tablets and can be identified with Moses to whom both figures

turn their attention. In this context, then, the use of reclining river gods as prototypes takes on added meaning, for what could be more appropriate for this miracle of water than aquatic deities? The figures flanking Moses are the elders of Israel who witnessed his striking the rock to produce water. The episode served as proof of the Lord among the Israelites. The print may have fulfilled a similar function for sixteenth-century Italians who, after the Sack of Rome and the Protestant Reformation, needed evidence of God's favor and presence among them.

The tonal polarities of the chiaroscuro print are prefaced in the accented washes of the drawing, which is primarily an exercise in values of light and dark. While details in the drawing are not precisely described, nonetheless, all three figures are incised, presumably for transfer of the design to the engraver's plate.[5] The coalescence of engraved and woodcut designs in the chiaroscuro print is analogous in effect to the meld of wiry line and light-dark contrast found in Beccafumi's pavement tiles in the Siena Cathedral.

Additional evidence for dating this sheet in the 1530s can be found in a tempera sketch for the head of a bearded figure lying in the lower foreground of Beccafumi's *Christ in Limbo* of ca. 1535.[6] It is strikingly similar to the center figure in Beccafumi's drawing.

A drawing in Siena is almost identical to the engraving. Cesare Brandi felt it was a preparatory study and used it to assign a date of pre-1528 to the print.[7] Donato Sanminiatelli recognized this drawing as an inferior copy after the engraving[8] and suggested, instead, a sketch in the Uffizi.[9] Other drawings of reclining men that might be studies for the print are a sheet in the Louvre[10] and a figure in the left section of a long horizontal drawing for a border of one

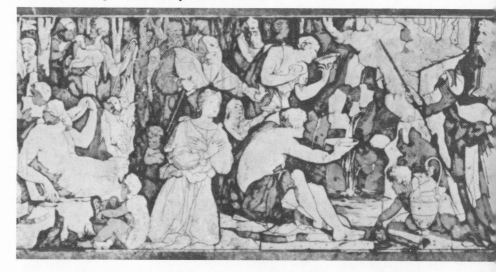

Fig. 5a. Detail of *Moses Striking the Rock*, pavement tile. Domenico Beccafumi. Siena Cathedral, Opera della Metropolitana di Siena.

5

6

31

7

of the Siena pavements depicting Israelites drinking as Moses strikes the rock, in the British Museum.[11] Drawings of reclining nude men, one of Beccafumi's favorite types, abound.

I would like to acknowledge the research assistance of Marian Jill Sendor with this drawing.

1. Richards, 1959, p. 25; Ostrow, 1968, p. 32.
2. Repr. in Tolnay, 1970, III, fig. 18.
3. Tolnay, 1970, III, figs. 57-60.
4. Richards, 1959, p. 25.
5. A drawing in the Albertina of a reclining nude is similarly incised along its major outlines. See Koschatzky et al., 1972, no. 33; *Reclining Nude*, pen and wash, black chalk and white highlights, 222 × 431 mm., Albertina, no. 276.R.205.
6. Sanminiatelli, 1955, p. 39, fig. 7.
7. Brandi, 1934, p. 361.
8. Sanminiatelli, 1967, p. 146, no. 39.
9. Repr. in Forlani, 1964, p. 195, no. 53. *Reclining Male Nude*, pen, 76 × 111 mm., Uffizi, no. 1510F.
10. Repr. in Collobi, 1974, I, 133; II, 232, fig. 410; *Old Reclining Nude*, pen and wash, 236 × 392 mm., Louvre, no. 257.
11. *Old Testament Scenes*, pen and wash, 250 × 1610 mm., British Museum, no. 1845-5-13-3.

Domenico Beccafumi

6 *Moses and the Israelites Drinking*

Engraving, 208 × 408 mm., ca. 1530. Horizontal fold center, missing upper left corner.

The Cleveland Museum of Art, Delia E. Holden Fund, 58.314.

Provenance: Earl of Pembroke (Lugt 2636b); Archibald George Blomefield Russell (Lugt 2770a); A. Scharf, London. *Sales:* London, Sotheby, 9 June 1955 (Russell collection), no. 1 (sold to A. Scharf, London). *Exhibited:* Detroit, 1958, no. 98; Providence, 1968, no. 14, p. 2, pl. xiv, fig. 2. *Published:* Richards, 1959, pp. 24-29, repr. 27; Sanminiatelli, 1967, p. 133, no. 4; Fern and Jones, 1969, p. 15, repr. p. 14.

Domenico Beccafumi

7 *Moses and the Israelites Drinking*

Chiaroscuro print: engraving printed in black over woodcut printed in gray, 204 × 395 mm., ca. 1530. Notation: on strip attached to verso, in pen and ink, *St. Ma . . . in,* (illegible word). Vertical tear near right edge, tears, creases.

Library of Congress, Washington.

Provenance: Earl of Pembroke (Lugt 2636 b). *Sales:* London, Sotheby, 5-10 July 1917 (Pembroke collection) no. 306; London, Maggs Bros., June, 1918, cat. 364, no. 148. *Exhibited:* Providence, 1968, no. 14, p. 3., pl. xiv, fig. 3; Pro-

vidence, 1973, no. 75, repr. p. 73. *Published:* Brandi, 1934, p. 362; Fern and Jones, 1969, pp. 15, 18, no. 49, repr. p. 15.

This is the final version of Beccafumi's composition. The rough design of the drawing [5] and the skeletal foundation of the engraving [6] are completed by the woodblock which adds the middle tone, while the bare paper forms the highlights.[1] The mixed chiaroscuro—part woodcut, part engraving—was an exceptional print process which Parmigianino also occasionally used.[2] It is noteworthy that the woodcut was printed first with the engraving printed over it.[3] Only one other impression of the complete print is known, in the Pinacoteca Nazionale, Siena.[4]

1. Richards, 1959, p. 28.
2. Ibid., p. 29.
3. Ostrow, 1968, p. 33.
4. Inv. no. 136; Brandi, 1934, p. 362, fig. 13.

Andrea Boscoli

ca. 1555–1606

Andrea Boscoli trained under Santi di Tito in his native Florence. He turned in his late years to the styles of Andrea del Sarto, Rosso, and Pontormo. His paintings are characterized by strong light, linear sharpness, and tangible forms. While in Siena in 1589, Boscoli became aware of Federico Barocci's paintings. In 1593 he painted an *Annunciation* for Santa Maria del Carmine, Florence.

Andrea Boscoli

8 *The Annunciation* (recto);
Ornamental Sketch (verso)

Red crayon (recto); black chalk (verso), 362 × 288 mm., after 1570. Notations: verso, in pencil, *Pomerancie;* in pen and black ink, *Andrea Boscoli.*

Fogg Art Museum, Harvard University, Cambridge, Massachusetts, Bequest of Charles Alexander Loeser, 1932.216.

Provenance: Charles Alexander Loeser (under Lugt 936a). *Published:* Berenson, 1938, II, 317, no. 2458G (as School of Il Rosso); Mongan and Sachs, 1940, I, no. 174 (as School of Il Rosso); Florence, 1959, under no. 13 (as Boscoli); Oberhuber, 1979, no. 25, repr. (recto) (as Boscoli).

Originally attributed to Andrea Boscoli, the *Annunciation* was associated with the school of Rosso by Berenson and by Agnes Mongan and Paul J. Sachs.[1] Anna Forlani returned it to Boscoli's oeuvre, relating it to a red crayon drawing in the Uffizi of the *Resurrection of Lazarus* by this artist.[2] The *Annunciation* can also be connected with another work by Boscoli in the Uffizi, *Seated Madonna with Christ Child,* since the facial features of the Christ Child are similar to those of the angel and both drawings exhibit the same sharp contrast of light and dark which creates a pattern of geometric planes.[3] Forlani implied a date early in Boscoli's career for this sculptural style, probably the 1570s when Boscoli was still under the influence of works like Rosso's *Deposition* in Volterra.[4]

The drawing has not been associated with a finished painting by Boscoli. Analogous faceting of planes occurs in a drawing of an angel in the Uffizi which is a study for the *Annunciation* in Brefotrofio de Fabriano,[5] in his *Nativity* in the Museo Civico at Fabriano (dated to ca. 1600 by Adolfo Venturi), and in his *Wedding of Joseph and Mary.*[6]

1. Berenson, 1938, II, 317, no. 2458 G; Mongan and Sachs, 1940, I, 94, no. 174.
2. Forlani, 1959, p. 20, no. 13; *Resurrection of Lazarus,* red crayon, 370 × 488 mm., Uffizi, no. 457 F.
3. *Seated Madonna with Christ Child,* red crayon, 429 × 318 mm., Uffizi, no. 464 F. See Forlani, 1959, p. 19, no. 12.
4. Forlani, 1959, p. 6.
5. Repr. Venturi, 1934, IX, 7, 731, fig. 405.
6. Repr. ibid., p. 745, fig. 416, p. 746, fig. 417.

8 Recto

Agnolo di Cosimo Tori, called Bronzino

1503–1572

Because Bronzino trained in the Florentine studio of Pontormo from about the age of fifteen, the works of his early period are often confused with those of his teacher. In the early 1530s Bronzino worked for the Duke Guidobaldo in Pesaro. Upon his return to Florence in 1532, he began to develop as a portrait painter. The hard line, pointed forms, and aloof posturing of the sitter in his portrait of *Ugolino Martelli* (Berlin-Dahlem) are typical of his style through the decade. By 1541 Bronzino was engaged in executing fresco decorations for Eleanora of Toledo's chapel in the Palazzo Vecchio, where he alternated flat and recessive spaces populated by glossy forms in hard, pure colors. There are slight intrusions of sentiment in his art after a period in Rome (ca. 1546–1548), but by 1552 Bronzino returned in his forms to a cold clarity and reflective hardness, as in *Christ in Limbo* in Museo di Santa Croce, Florence. Finally his approach to figure and anatomy became canonical as in the frescoed *Martyrdom of St. Lawrence* in San Lorenzo, Florence, which Sydney Freedberg characterized as "a beautifully artificial fusion of gymnasium and ballet. . . ."[1]

1. Freedberg, 1970, p. 315.

Agnolo di Cosimo Tori, called Bronzino

9 *Copy after Bandinelli's "Cleopatra"*

Black chalk, 385 × 214 mm. Notation: upper right, in pen and brown ink, *Angiolo Bronzino*. Watermark: Angel in circle with six-pointed star above head.

Fogg Art Museum, Harvard University, Cambridge, Massachusetts, Bequest of Charles Alexander Loeser, 1932.145.

Provenance: G. W. Reid; Charles Alexander Loeser (under Lugt Suppl. 936) *Exhibited:* Northampton, 1941, no. 23; Hartford, 1946, no. 8, repr.; Cambridge, 1962, no. 5.; Birmingham, 1969, no. 4. *Published:* McComb, 1928, p. 147, pl. 45; Berenson, 1938, I, 321, no. 3., II, 62, no. 593D; Mongan and Sachs, 1940, I, no. 71, II, fig. 61; Tolnay, 1943, no. 94, fig. 94; Smyth, 1955, p. 286, fig. 150 (as School of Bronzino); Moskowitz, 1962, I, no. 204, repr.; Ames, 1963, pl. 76; Oberhuber, 1979, no. 20, repr.

9

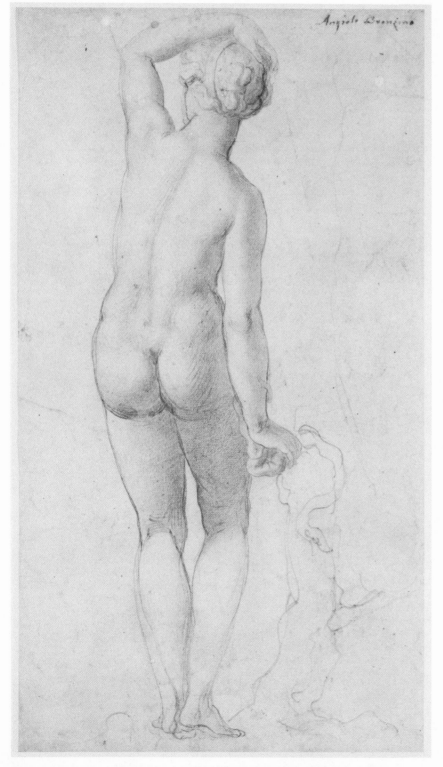

This is a drawing after a bronze figurine of *Cleopatra* by Baccio Bandinelli in the Bargello in Florence.[1] The serpent winds around Cleopatra's right arm, through her hand, and then slithers down the tree stump. In copying the statuette, Bronzino has conveyed the glint of light on a reflective surface. Especially pleasing are the shapes of the negative spaces between the figure's knees, right leg, and tree stump; right arm and torso; and head and raised left arm.

The drawing was accepted as an autograph Bronzino by Berenson and by Mongan and Sachs.[2] The formal purity, clarity, soft steady light, sharp contours, and subtle modeling of surface anatomy are indicative of Bronzino's sophisticated draftsmanship. Linear corrections of the figure's silhouette can also be found in other drawings by Bronzino.[3]

1. See Venturi, 1936, X,2, fig. 183.
2. Berenson, 1938, II, 62, no. 5930; Mongan and Sachs, 1940, I, no. 71.
3. J. C. Rearick, 1964a, pp. 363-382, pls. 3, 9.

Agnolo di Cosimo Tori, called Bronzino

10 *Study of a Male Nude*

Black chalk, 239 × 460 mm., 1565. Notations: lower right corner, in pencil, *Angelo Bronzino*. On verso of nineteenth-century mounting, *No. 9*. Upper corners and tips of lower corners clipped diagonally, patched hole upper left, foxed.

Alice and John Steiner

Exhibited: Cambridge, 1977, no. 3.

This figure by Bronzino is a study for one of his last works, the fresco *Martyrdom of St. Lawrence* in the Medici church of San Lorenzo in Florence. The painting was commissioned by Cosimo de' Medici in 1565 from Pontormo who died before the work could be completed. The best view of Bronzino's fresco, located in the left aisle, is from the Medici family's second-story loge across the nave. From this higher vantage point the extreme verticality of the composition, so disturbing at floor level, appears as a logical extension of perspective. In addition the receding columns at the top of the fresco are aligned with those in the nave.

There is a figure study in the Louvre for a standing male in the lower left corner of the San Lorenzo fresco.[1] The Steiner sheet, of a seated male figure in a convoluted pose, was a study for a similar nude in the lower right corner of the painting. The complicated pose and robust muscularity of the figure allude to the influence of Michelangelo, perhaps the marble *Giorno* of

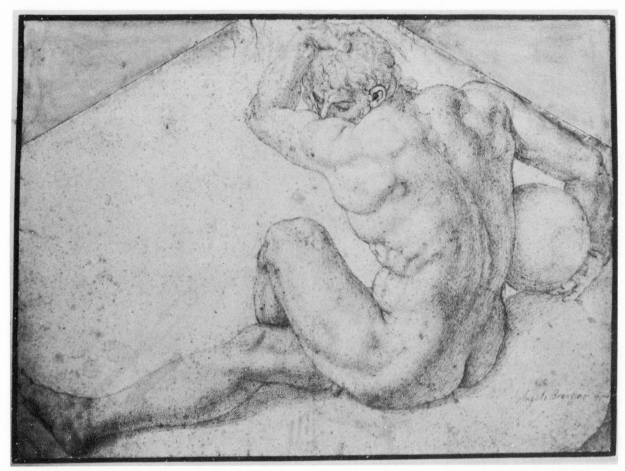

10

Giuliano de' Medici's tomb, but the unequivocal line, descriptive power, and delicate touch are uniquely Bronzino's. The Steiner sheet shares with the Louvre drawing Bronzino's characteristic contour — crisp and unyielding — and his steady, delicate luminosity.

Charles Saumarez-Smith suggested that Bronzino was not satisfied with the drawing as a final solution for the fresco since the figure has not been squared for transfer.[2] In addition, the sphere held by the figure becomes an urn and is positioned differently in the painting. These are, however, minor modifications, and the figure is transferred from drawing to fresco essentially intact.

As an undisputed Bronzino study in an American collection, this is a rare drawing. Indeed, if one accepts the meticulously clinical approach of Craig Smyth, this may be a unique Bronzino sheet. Smyth has reduced the body of Bronzino's drawings to fewer than fifteen sheets by his acceptance only of those that can be associated without equivocation with known works.

1. Smyth, 1971, fig. 40.
2. Cambridge, 1977, p. 29.

Lodovico Cardi, called il Cigoli

1559–1613

Lodovico Cardi first appeared in Florence ca. 1572–1574 upon leaving his native Cigoli near Pisa. He began his artistic training in the Tuscan capital in the studio of Allessandro Allori where, like Bartolomeo Torre [66], he contracted an illness during the anatomical dissections required by Allori of his pupils.[1] In 1578 he entered the studio of Santi di Tito, where he associated with Jacopo Chimenti (da Empoli) and Jacopo Ligozzi. The three artists so freely exchanged figural motifs that their works are often confused.

Cardi concentrated on religious subjects. His work is reflective of the new seriousness that entered art in the 1580s as a response to the emotional reticence of the *maniera*. In this sense he can be linked with Federico Barocci and Santi di Tito as a transitional or proto-baroque figure. His innovative and characteristic drawing style of the 1590s, combining brush and brown ink and white highlights on paper prepared with green wash, may be traced to the chiaroscuro graphics of Jacopo Ligozzi, who arrived in Florence from Verona in 1576. The last decade of the century was for Cardi one of stylistic sobriety as static figures in

voluminous drapery with measured and independent gestures populated his paintings and drawings. It was his directness, clarity, sentiment, and flair for the dramatic that established Cardi as a leading Florentine artist in the 1590s.

Cardi's late works are characterized by a misty chiaroscuro with large-scale, ecstatic figures in naturalistic settings. He was chosen to do one of the six large altar paintings for the crossing piers of St. Peter's Basilica in Rome, *St. Peter Healing the Cripple*, ca. 1599. Cardi moved to Rome in 1604 where he resided until his death.

Cardi was a member of the Accademia del disegno and of the literary academy in Florence. He was also a poet, an accomplished musician, and a friend and frequent correspondent of Galileo. In Rome he was associated with Annibale Carracci, worked with Guido Reni, and knew the art theorist Monsignor G. B. Agucchi. Baldinucci credited Cardi with a leading role in reestablishing the principles of good draftsmanship at the end of the Cinquecento.[2] When he was accepted into the Academy of St. Luke in Rome, he gave a learned and well-received lecture on the artist's need for a strong foundation in drawing.

1. Baldinucci, 1846, III, 235-236.
2. Ibid., pp. 276-277.

Attributed to Lodovico Cardi

1 *Figure Study*

Red chalk over black chalk indications, 394 × 169 mm., ca. 1579. Notations: verso, in black chalk, *Auction Klinkosch, Wien, April 1889, cat. no. 825; 319; 319; A. del Sarto f.*; in pencil, *4, zar, L.* Mended tear at upper right, several creases, brown stain under right eye.

The Cleveland Museum of Art, John L. Severance Fund, 51.492.

Provenance: Joseph Karl Ritter von Klinkosch (Lugt 577); Adalbert Freiherr von Lanna (Lugt 2773); Maurice Delacre, Ghent (Lugt 747a). *Sales:* Vienna, expert Wawra, 15 April 1889 (Klinkosch collection), no. 825 repr. (as Andrea del Sarto); Stuttgart, H. G. Gutekunst, 6-11 May 1910 (von Lanna collection), no. 565, pl. xxxii (as Andrea del Sarto); Bern, Gutekunst and Klipstein, 21-22 June 1949 (Delacre collection), no. 419, pl. xxxi (as Andrea del Sarto). *Exhibited:*

Cleveland, 1971, no. 61, repr. (as Francesco Morandini, called Il Poppi). *Published:* Berenson, 1938, II, no. 2369A (as Pontormo); Rearick, 1964, I, no. A378 (as Allessandro Allori); Olszewski, 1977, fig. 38 (after Pontormo).

Figure Study has proven to be as elusive in terms of authorship, date, and subject as it is visually intriguing. The facial asymmetry, slight double chin, casually parted hair, and rustic features have the character of a portrait. The downcast eyes and emotional reserve give an effect of modest elegance.

Attributed to Andrea del Sarto in the Klinkosch, von Lanna, and Delacre sales, this drawing was given to Pontormo by Bernard Berenson, who erroneously described it as a figure of a man in black chalk.[1] Janet Cox Rearick discounted both

1

attributions and argued in favor of Allessandro Allori.[2] Two drawings in the Uffizi strengthen the connection with Allori. One, *Head of a Woman*,[3] is similar to *Figure Study* in the handling of lips, eyes, and parting of hair, while the other, *Capella Eleonora*, is identical to the Cleveland design in the precise analysis of anatomical detail which is characteristic of Allori.[4] In both these drawings the hands have pronounced veins and the skin is tautly drawn against the bone at the wrist. More recently Edmund Pillsbury suggested that the drawing was by the Florentine, Francesco Morandi (called Il Poppi, 1544-1597),[5] but careful study of the corpus of Morandi drawings in the British Museum and Uffizi collections reveals Morandi's drawing style as more fragile and complex.

It is also necessary to recognize that the figure in the Cleveland drawing is comparable to a woman standing at the far right in Lodovico Cardi's fresco of ca. 1581 in the cloister of Santa Maria Novella, Florence.[6] They have similar waistbands, and both have gathered their garments in the left hand and have headdresses which end in a piece of rolled fabric. The blank space above the woman's arm in the drawing has been fully elaborated in the fresco as a shawl which also explains the curving lines behind both shoulders in the drawing. In the same way the diagonal line from the wrist to the bottom of the sheet becomes the contour of a drapery fold in the painted version.

Because the fresco represents a further development of the figure in the drawing, the sheet must be a study for the painting and not a copy after it, as evidenced by the several differences between them. The gathered drapery over the left shoulder and the material wound about the head are not the same in drawing and painting. The woman's hair is more evident in the fresco where the sash is partially covered.

The fact that *Figure Study* was executed in red chalk also supports an attribution to Cardi. Only a handful of the scores of Allori designs in the Uffizi are in red chalk, and these are of questionable authorship, whereas Cardi frequently used red chalk. Aspects of other Cardi drawings are similar to those in the Cleveland sheet. In Cardi's drawing of a woman looking up, in Rome,[7] the precisely outlined lips, clearly incised eye sockets, and flared nostrils are close to those in *Figure Study*, as is the fall of drapery across the throat and at the left shoulder and arm of the kneeling woman in the lower right of Cardi's design for *Christ Carrying the Cross* in the British Museum.[8] The sweeping parallel strokes in *Draped Male Figure with Staff* and the crisp folds of drapery with deep creases causing velvet shadows in *Monk* are characteristics also seen in *Figure Study*.[9]

Cardi's fresco with the woman in the Chiostro Grande of Santa Maria Novella,

with *Christ in Limbo*, dates from 1581–1584. Together they represent Cardi's first important commission and placed him among the major artists in Florence.[10]

1. Berenson, 1938, II, 307, no. 2369 A; "Uomo con una sciarpa."
2. J. C. Rearick, 1964b, I, 413, no. A 378.
3. *Head of a Woman*, black chalk, 118 × 91 mm., Florence, Uffizi, no. 1473.
4. *Copy of Bronzino, Capella Eleonora*, black chalk, 321 × 246 mm., Florence, Uffizi, no. 10320.
5. Cleveland, 1971, no. 61.
6. *Investiture of St. Vincent Ferrar*, fresco, 370 × 398 cm., ca. 1581, Florence, Santa Maria Novella, Chiostro Grande; M. Bucci et al., 1959, no. 1, pl. i.
7. *Head Looking Up*, red chalk, 104 × 96 mm., Rome, Gabinetto Nazionale delle Stampe, no. F C 125674.
8. *Christ Carrying the Cross*, red chalk, 360 × 233 mm., London, British Museum, no. 1859-6-25-572.
9. *Draped Male Figure with Staff*, red chalk, 404 × 236 mm., Lille, Musée Wicar, no. 354; *Monk*, red chalk, 280 × 248 mm., Lille, Musée Wicar, no. 142.
10. Bucci et al., 1959, p. 30.

Attributed to Lodovico Cardi

2 *Full-Length Skeleton* (recto);
Three-Quarter-Length Skeleton (verso)

Red chalk, 397 × 192 mm., after 1570. Notation: lower right in pencil, *Cigoli*. Watermark: Circle enclosing lamb with pennant (similar to Briquet 48). Soiled.

Janet S. and Wesley C. Williams.

Exhibited: Cleveland, 1971, no. 59, repr. (recto, verso).

Edmund Pillsbury suggested that this skeleton study may have been made for the funeral decorations in San Lorenzo on the death of Michelangelo in 1564, or possibly for the funeral of Cosimo I de' Medici ten years later.[1] If so, the study was a design for one of a series of banners decorating the columns of the nave. Four drawings by Allori in the Uffizi also depicting skeletons[2] help one visualize the somewhat bizarre

effect the banners would have had with their kneeling, bowing, and shuffling figures. Pillsbury observed that as the funeral procession advanced through the nave, the banners would "have created the effect of a medieval 'Dance of Death.'"[3] This drawing demonstrates the same wit found in the Uffizi sheets. Notice the skeleton's gaping jaw, swinging right arm, and the way in which the coccyx at the end of the spinal column has been turned into a hairy tail.

Unlike the Uffizi drawings, however, this sketch is in red chalk instead of black,[4] and the technique is more delicate and less finished. The rib cage is sketchier, the contours fainter, and the drawing generally looser. The author of the sheet takes liberties Allori does not as with the coccyx, the rows of uneven teeth, the feathery ribs, the

2 Recto

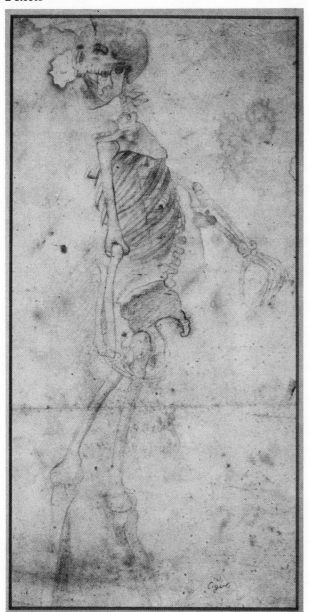

2 Verso

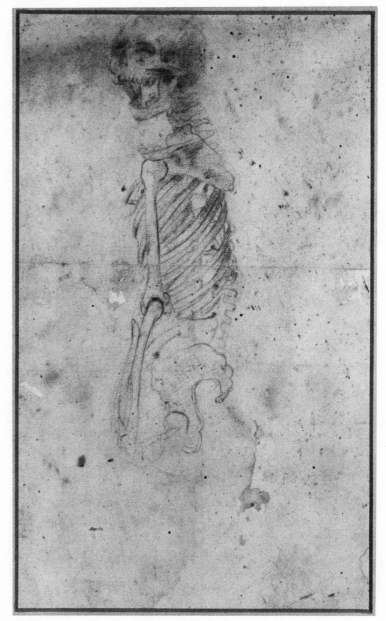

suggestion of a winking eye socket[5] and the poorly executed knee joints.

The inscription "Cigoli" at the lower right of the sheet may offer a clue to the identity of the draftsman. It is possible that Cardi, called il Cigoli, may have copied Allori's work after joining his studio in the 1570s. Further, of the eighty-two sheets by Allori in the exhibition of his drawings in Florence, none was exclusively in red chalk and only a few even had traces of it. Filippo Baldinucci informs us that it was mandatory for Allori's students to draw from cadavers and that Cardi's earliest experiences in this exercise resulted in illness.[6] This drawing may represent Cardi's clever alternative to an unpleasant practice. If so, it is the only known surviving sheet from Cardi's anatomy studies during his early years in Allori's studio.

1. Cleveland, 1971, no. 59.
2. *Mostra di disegni dei fondatori dell'Academia delle Arti del disegno*, 1963, nos. 50-53, figs. 40-41.
3. Cleveland, 1971, no. 59.
4. See also Giovannoni, 1970, no. 16, fig. 11.
5. See R. and M. Wittkower, 1964, pp. 118, 162, nos. 16-17, figs. 16-17.
6. Baldinucci, 1846, III, 235-236.

Lodovico Cardi, called il Cigoli

11 *Kneeling Figure*

Brush and brown ink, heightened with white on paper prepared with green wash, 390 × 285 mm., 1603. Notation: on mount, lower left, in pen and brown ink, *Ludovico Civoli.* Watermark: Ladder on shield over star (Briquet 5927).

Fogg Art Museum, Harvard University, Cambridge, Bequest of Charles Alexander Loeser, 1932.337.

11

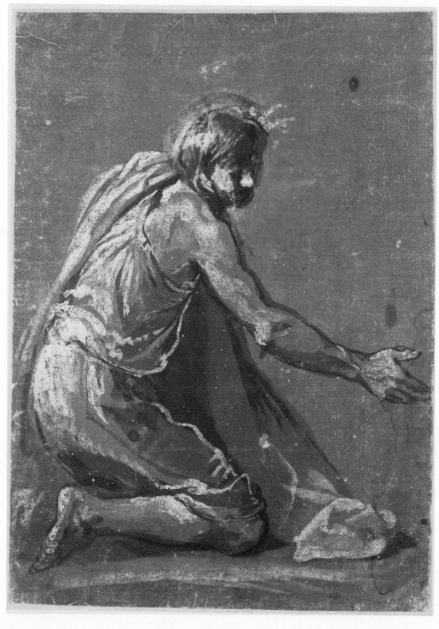

38

Provenance: Peter Lely (Lugt 2092); Charles Alexander Loeser (under Lugt 936a). *Exhibited:* Detroit, 1965, no. 125, repr.116; New York, 1969, no. 13. *Published:* Mongan and Sachs, 1940, I, no. 245, II, fig. 128; Oberhuber, 1979, no. 26, repr.

Dwight C. Miller described the style of this drawing, with its painterly approach to the realization of form, as characteristic of Cardi.[1] The figure was first broadly brushed in with brown wash, then further defined by thick, creamy highlights. The paper, tinted green, acts as the middle tone. The same technique was also used by Cardi for another drawing in the exhibition, *Standing Male Figure* [12].

Mongan and Sachs observed that the drawing may have been a study for a kneeling figure in the lower left of Cigoli's *Entrance of Christ into Jerusalem*, Santa Croce, Florence (ca. 1604), but Miller noted that there was not a one to one correspondence between the figures.[2] In Cardi's oeuvre single figure drawings have been found in many cases to conform exactly to the painted figures for which they are studies. A similar kneeling figure occurs in the lower left of Cardi's *Miracle of St. Anthony and the Mule*, San Francesco, Cortona (1597), but there are still differences.[3] The head of the painted figure is turned upward and to the left instead of down and to the right. If it is not certain that this drawing was executed in preparation for one of these paintings, it can, nonetheless, be dated close to them on the basis of style.

1. Dwight C. Miller in Wittkower, 1965, no. 125.
2. Mongan and Sachs, 1940, I, no. 245; Venturi, 1934, IX,7, 704, fig. 391.
3. Bucci et al., 1959, no. 24, pl. xxiv.

Lodovico Cardi, called il Cigoli

12 *Standing Male Figure*

Brush and brown ink heightened with white on paper prepared with green wash, 402 × 276 mm., 1593-1594. Notations: in upper right corner, in pencil, *112;* in brown ink, *3;* lower left, in pen and brown ink, *Cigoli;* on mount, in brown ink, *Lodovico Cigoli;* in pencil, *Cigoli, 1, 1159-1613, Full Length figure of our Saviour, From the collections of Charles 1st, Barnard, Pond & Price, From Dr. Wellesley's Collection, Lanière, Nat. ivd. ⅝, double-cream, inside 3 mm., 1;* on verso of mount, in pen and brown ink, *Price, E Collect^ne Regis Caroli Primi, the 8th night Lot 52, 4n 3.5;* in Jonathan Richardson, Sr.'s handwriting, *H39, W9, Y19, H59;* in John Barnard's handwriting, *JB N471 15¾ by 11;* in pencil, *1183, Collections, 45.*

The Cleveland Museum of Art, Charles W. Harkness Endowment Fund, 29.555.

Provenance: Nicholas Lanier (Lugt 2885); Jonathan Richardson, Sr. (Lugt 2184); Arthur Pond (Lugt 2038); John Barnard (Lugt 1419); Uvedale Price (Lugt 2048); Dr. Henry Wellesley (Lugt 1384); Richard Johnson (Lugt 2216); Richard Johnson Walker (under Lugt 2216); William Bateson (Lugt 2604a). *Sales:* London, Sotheby, 25 June 1866 (Rev. Dr. Wellesley collec-

tion), no. 336; London, Sotheby, 23-24 April 1929 (William Bateson collection), no. 22. *Exhibited:* Cleveland, 1971, no. 63, repr.

Filippo Baldinucci, Cardi's primary biographer, observed that Cardi and several of his companions including Jacopo da Empoli shared a studio and maintained an informal academy. Working closely together, they developed similar styles and techniques.[1] A figure drawing such as this one which lacks setting and exact identity could be adapted to many uses in the artist's studio. It is no surprise, then, that the Cleveland drawing is close in pose and treatment to the figure of Christ in the *Calling of St. Peter* originally in the Collegiate Church at Impruneta and attributed by Lionello Venturi to Cardi.[2] The painting is, however, by Jacopo da Empoli and dates from 1615–1616. Moreover a more exact quotation of the figure can be found in a black chalk drawing in the Uffizi (Fig. 12a).[3] A finished work utilizing this figure does exist within Cardi's own oeuvre.

Cardi had completed an *Assumption of the Virgin*, now lost, in 1594 for the Collegiate Church at Impruneta (Fig. 12b)[4] The apostle at the far right corresponds with the standing figure in the Cleveland sheet. A drawing in the Uffizi — similar to the one in Cleveland in its voluminous drapery and thick, white highlights — was apparently a study for the kneeling apostle to the right.[5] Recently a fourth drawing, in Naples, was associated with this painting.[6] It is a study of a kneeling, nude male figure, presumably an earlier sketch than the Uffizi's for the figure of St. John.

The Uffizi also possesses a design (Fig. 12c) which appears to be an early study for the Impruneta *Assumption,* modified in its final form by the substitution of apostles for St. Francis and St. Lawrence.[7] The Virgin and surrounding angels in the upper half of the drawing were transposed to the painting essentially intact; the Virgin's head was turned slightly and her robe made to extend in a broad sweep from her elbows. The *Standing Male Figure* is similar to the apostle at the far right of the Uffizi sheet in pose, in the diagonal fall of the drapery, and the placement of the hands. This figure reappears in the same place in the painting.

Miles Chappell noted that the *Standing Male Figure* had been used in a drawing for the cupola of the Capella Paolina (Fig. 12d), a project Cardi worked on from 1610 to his death and which was never completed.[8] Chappell was inclined to place the Impruneta *Assumption,* which is undocumented, later than the 1593 date K. H. Busse cited for the dedication of the altar for which the *Assumption* was intended.[9] It can be noted, however, that the *Standing Male Figure* is close in style, pose, volume, and expression to St. Peter in Cardi's *Madonna with SS. Michael and Peter* at San Michele in Pianezzole which is dated 1593.[10] Also Forlani found the date of 1593

reasonable for the Uffizi drawing of the figure of St. John.[11]

Baldinucci, an avid collector of drawings, reports how he cherished those of Cardi.[12] The present sheet has an impressive provenance and can be traced to within fifty years of its creation in the prestigious collection of Nicholas Lanier. His mark, a six-pointed star, appears in the lower left corner.[13] Lanier's father had been a musician in the court of Queen Elizabeth. Nicholas, also a musician, became director of Charles I's court orchestra. He was a dedicated collector of art works and purchased numerous objects during a three-year stay in Italy. In the following century the drawing entered the collection of Jonathan Richardson, Sr., who was a portrait painter and art theorist.[14] He specialized in collecting drawings of the Italian schools, although he

was never able to get to Italy. Arthur Pond, the drawing's next owner, was a painter and graphic artist who had been to Rome as a youth and had become acquainted in Paris with the noted collector, Mariette. In collaboration with Knapton, Pond engraved sets of drawings by Italian masters. The succeeding owner of the sheet, John Barnard, was a collector of great taste who for more than fifty years acquired sheets of exquisite quality.[15] The Eton-educated author, Uvedale Price, acquired his aptitude for Italian drawings on a trip to Italy in 1768; although he purchased many for his collection,[16] he found this sheet in England. Price died in 1829, and *Standing Male Figure* was purchased by one of the finest private drawing collectors of the nineteenth century, the Rev. Dr. Henry Wellesley.[17]

12

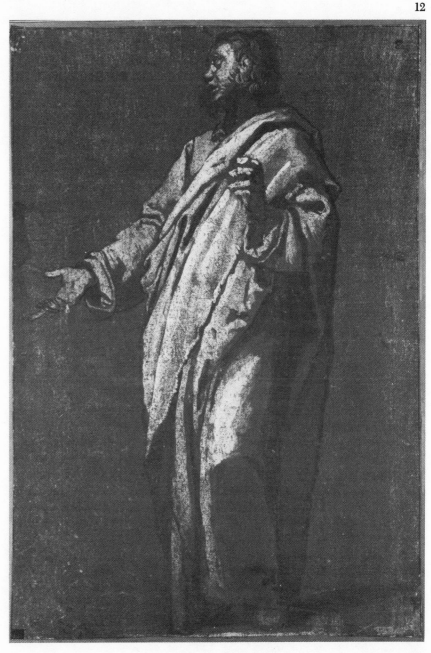

I am deeply indebted to Janet Knowles Seiz for research assistance with this drawing.

1. Baldinucci, 1846, III, 233-236.
2. Venturi, 1934, IX, 7, 706, 709, fig. 395.
3. Forlani and Bianchini, 1962, nos. 50, 51, fig. 30; Ferri, 1913, no. 13.
4. Busse, 1911, p. 24. Dated 1593 by Busse. Guido Batelli believed that this painting, which was lost in the Second World War, is the same *Assumption* mentioned by Baldinucci as painted for the monastic library of San Domenico in Fiesole and later moved to Impruneta. Cardi, 1628, p. 21, n. 4; Baldinucci, 1846, III, 246.
5. Bucci et al., 1959, no. 47, pl. xlii. *Cloaked Youth Kneeling*, brown ink heightened with white on paper tinted dark green, 384 × 270 mm., Uffizi, no. 8995F.

6. Chappell, 1978, pp. 395-396, fig. 2. *Kneeling Nude Male*, pen and ink, Museo di Capodimonte, Naples, no. 886.
7. Study for *The Assumption of the Virgin*, pen and ink and wash, Uffizi, no. 886.
8. Letter from Miles Chappell, 1 January 1979, Curator's file, The Cleveland Museum of Art. Rodinò, 1977, no. 54, fig. 54.
9. Busse, 1911, p. 24; Thieme-Becker, VI, 590.
10. Chelazzi-Dini, 1963, pp. 55, 63, no. 20, fig. 53a.
11. Forlani, 1959, no. 47.
12. Baldinucci, 1846, III, 239.
13. Lugt, 1921, pp. 533-534. In the catalog entry for the sale, London, Sotheby, 25 June 1866, (Rev. Dr. Wellesley collection), p. 23, no. 336, the provenance for this sheet is listed as including Charles I. This

misconception can be traced to the catalog, *John Barnard Collection*, Greenwood, London, p. 7, where the Lanier star is mistakenly identified as "the mark of King Charles the First in drawings." The error is ultimately traced to Vertue who stated that Lanier marked drawings acquired for the king with a large star and his own purchases with a small star. Popham has observed that there is, however, "more than one variety of small star" and that no information is given as to when the practice began. "Vertue Notebooks," *Walpole Society*, XVIII (1929–1930), 45, 47; Popham, 1957, p. 138.
14. Lugt, 1921, pp. 406-408.
15. Ibid., pp. 255-257.
16. Ibid., pp. 377-378.
17. Ibid., pp. 246-248.

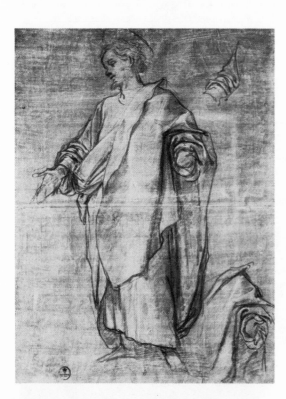

Far left
Fig. 12a
Standing Christ,
black chalk with
traces of white,
565 × 420 mm.
Jacopo da Empoli,
Italian, 1561–1640.
Uffizi, Florence.

Left
Fig. 12b.
Assumption of the Virgin
(lost), oil on canvas.
Lodovico Cardi.
Church of the Virgin,
Impruneta.

Left
Fig. 12c. *Study for the Assumption of the Virgin*,
pen and ink and wash. Lodovico Cardi. Uffizi, Florence

Fig. 12d. *Study for Apostles*, traces of black and red chalk,
pen and brown ink, blue and white water color, 134 × 396 mm.
Lodovico Cardi. Gabinetto Nazionale delle Stampe, Rome.

Jacopo Chimenti da Empoli
1561–1640

Jacopo Chimenti da Empoli trained in the studio of Maso da San Friano but was also influenced by the paintings of Andrea del Sarto and Pontormo. By the 1580s his style demonstrated a firm naturalistic bias dependent upon strong effects of chiaroscuro and phosphorescent hues, especially yellow. The result of this approach was a simplification of composition, since details are lost in shadows and erased by strong highlights.

Jacopo Chimenti da Empoli

13 *Two Figure Studies of a Woman over a Sketch of a Putto*

Black crayon heightened with white on paper prepared with yellow wash, 226 × 160 mm., ca. 1570. Notation: verso, in black chalk, *Russo, Soc G 623, FAA.* Patched hole upper left corner.

The Cleveland Museum of Art, Gift of Mr. and Mrs. Ralph L. Wilson, in memory of Anna Elizabeth Wilson, 62.202.

Exhibited: Cleveland, 1962, no. 136 (as Rosso Fiorentino).

These thickly drawn black chalk figures tend to obscure the putto which had first been sketched on the sheet. They are three-quarter views, from back and front, of an antique statue of Venus. Although once given to Rosso, the sheet was identified by W. R. Rearick as a work of the Florentine, Jacopo da Empoli.[1] As such, it is an example of his early style and can be compared with a *Standing Nude Woman* of similar technique in the Uffizi.[2] The figures in both sheets share facial features reduced to a mere touch of the chalk, stringy hair, protruding stomachs, heavy outlines, and a characteristic looseness of line. Forlani judged the Uffizi *Nude Woman* to be one of the earliest of Jacopo's surviving drawings.[3] The Cleveland sheet may be slightly later since the modeling is more certain and the draftsman's touch more secure.

1. Verbal communications, 25 January 1967.
2. Jacopo da Empoli, *Standing Nude Woman*, charcoal, 411 × 242 mm., Uffizi, inv. no. 3430 F; Forlani and Bianchini, 1962, p. 17, n. 5, fig. 2.
3. Ibid.

Jacopo Chimenti da Empoli

14 *Madonna and Child*

Pen and brown ink, black and red chalk on tan paper 327 × 223 mm., ca. 1600. Notations: verso of mount, in ink, *Coreggio*, in black chalk, *Empoli, Correggio* crossed out, *Mk. 1000-*, in pencil, *3, I 700* in circle, *Antonio Aleg Deto Coregio.* Watermark: P. Creased across center horizontally and vertically, stained; holes where ink has reacted with paper.

The Cleveland Museum of Art, Charles W. Harkness Endowment Fund, 29.10.

Exhibited: Cleveland, 1971, no. 62, repr.

It was almost an obsession with Jacopo da Empoli to rework hands in his single figure studies. In this instance the grasp of the Virgin's left hand on the Christ Child is studied in detail in the upper right corner. Also typical of Empoli are thick lips, puffy noses, and the use of delicate short, parallel, diagonal chalk strokes for shading.

Paul J. Sachs and W. R. Rearick both identified Empoli as the author of this Madonna.[1] The work is from the artist's mature years and may be dated to ca. 1600. A similar attitude of the Virgin's right arm

13

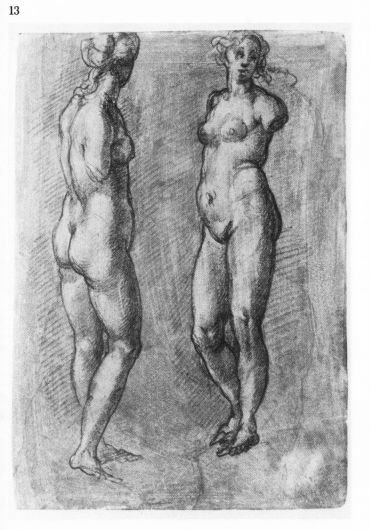

14

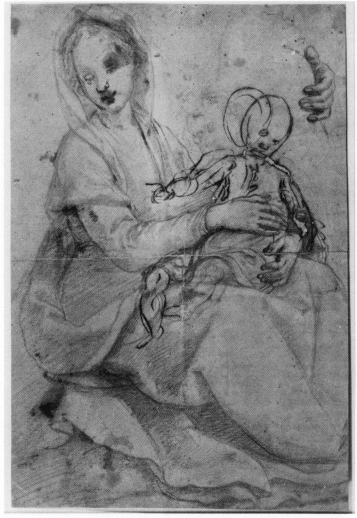

can be found in a black chalk *Madonna* in the Uffizi.[2] The downcast eyes, high forehead, and lips thickened at the corners also relate these sheets, although the Cleveland drawing is later.

1. Notations on the mount: W. R. Rearick, 25 January 1967, "Definitely by Jacopo da Empoli"; Paul J. Sachs, "by Empoli."
2. Forlani and Bianchini, 1962, no. 7, fig. 5; *Madonna and Child with St. John the Baptist*, black chalk, 212 × 167 mm., Uffizi, no. 9394F.

Lorenzo di Credi

1459–1537

Lorenzo di Credi was a trusted assistant in the studio of Andrea del Verrocchio, the master of Leonardo da Vinci, Sandro Botticelli, and Pietro Perugino. According to Vasari, it was the extreme meticulousness of Credi's work that Verrocchio greatly appreciated. The master's confidence in Credi was so great that he became the executor of Verrocchio's estate.

The biographical information for Credi is sparse, but he left an impressive legacy of religious paintings and portraits. Especially sensitive are the many silverpoint studies of Madonnas, youths, and old men.

Lorenzo di Credi

15 *Madonna and Child*

Silverpoint on salmon prepared paper, damage on right arm of Virgin, 145 × 94 mm., ca. 1510. Notation: on verso of mount, in pencil, *Lorenzo di Cre.*

The Cleveland Museum of Art, John L. Severance Fund, 63.472.

Provenance: E. Desperet (Lugt 721); Emile Galichon (Lugt 1058); Louis Galichon (Lugt 1060); John Postle Heseltine (Lugt 1507); Henry Oppenheimer (Lugt 1351); Sir Thomas Barlow; Dr. Francis Springell (Lugt 1049a). *Sales:* Paris, expert Clément, 7-13 June 1865 (Desperet collection), no. 57; Paris, expert Danlos, 4-9 March 1895 (L. Galichon collection), no. 35; London, Christie, Manson and Woods, 10, 13-14 July 1936 (Oppenheimer collection), cat. by K. T. Parker, no. 78; London, Sotheby, 28 June 1962 (Springell collection), no. 9, repr. *Exhibited:* London, 1953, I, no. 32; London, 1959, no. 20; Cleveland, 1963, no. 117; Cleveland, 1971, no. 55, repr.; Los Angeles, 1976, no. 16, repr. p. 21. *Published:* Heseltine, 1913, no. 18, repr.; Degenhart, 1932, p. 107, fig. 9 (as Jacopo di Castrocaro); Berenson, 1938, II, 350, no. 2738 (as Giovanni Antonio Sogliani); Richards, 1964, pp. 190-192, fig. 1; Regoli, 1966, no. 257 (as Maestro della Conversazione di S. Spirito, G. Cianfanini?).

15

In this drawing, Credi takes liberties with the silverpoint technique by using the metal stylus freely much in the manner of a pencil, correcting or ignoring misplaced lines. This is a departure from the more finished traditional approach wherein a precisely controlled build-up of fine lines was used to distinguish values.

A clear attribution for this *Madonna and Child* is lacking in the early literature. G. D. Rigoli assigned the sheet to Giovanni Cianfanini, Berenson to Credi's pupil Giovanni Antonio Sogliani, and Bernard Degenhart to Gianjacopo di Castrocaro.[1] Degenhart correctly equated the style of the drawing with others by Credi in the Louvre and Darmstadt. The playfulness of the infant and its twisted pose add a touch of naturalism suggesting the influence of Leonardo. The sheet may have served as a study for a painting of the same subject perhaps similar to Credi's oil on panel in the Cleveland Museum. While conservative in medium, the free use of line and full forms suggest a date after 1500.

1. Regoli, 1966, p. 193, no. 257; Berenson, 1938, II, 350, no. 2738; Degenhart, 1932, p. 107. The Louvre and Darmstadt sheets mentioned by Degenhart are almost identical in size to the Cleveland drawing.

Giovanni Antonio da Brescia

active ca. 1490–after 1525

16 *St. Jerome in His Study*

Engraving, 270 × 194 mm., ca. 1510. Notations: verso, in pencil, *Pass. V. 108.36, Hind p. 208 No. 6, c 10194, Giovan ant. da Brescia;* in pen and brown ink, *Ernest Devaulx, 1863.* Watermark: Eagle (similar to Hind, 1938-48, I, 323, no. 6).

The Cleveland Museum of Art, Gift of Leonard C. Hanna, Jr., 24.531.

Provenance: Unidentified collector's mark; Ernest-Théophile Devaulx (Lugt 670). *Exhibited:* Cleveland, 1971, no. 70, repr. (as anonymous, late 15th century). *Published:* Hind, 1938-48, I, D.IV.6 (as Florentine, Miscellaneous, ca. 1490-1520); Passavant, 1860-64, V, 108, no. 36 (as Antonio da Brescia); Hind, 1910, I, D.III.6 (as miscellaneous Florentine engravings ca. 1500); Levenson et al., 1973, p. 236, no. 93, repr. p. 249 (as Antonio da Brescia).

This print corresponds closely with portions of the drawing by Filippino Lippi [17]. The contours of the saint, the desk top, and the lion were pricked to transfer the design. The engraving—due to the nature of the medium, where the lines are harder and more even—appears polished compared to the softer and freer manner of the drawing. St. Jerome's features are harsher in the print, making him sterner and more detached than in the preparatory study.

The lion identified with St. Jerome appears in the lower left corner. He might be expected to be licking the paw from which the saint removed a thorn, according to the legend recorded by the thirteenth-century monk, Jacobus de Voragine.[1] The object

looks more like a rock than the underside of the lion's paw, and the animal may instead be licking dried blood from the rock St. Jerome used to beat his breast in penitance, as in Castagno's fresco of the *Vision of St. Jerome* in SS. Annunziata.

Jerome is frequently associated with books as an allusion to his love of classical writings, especially the works of Cicero. More importantly, the books are a reference to the saint's translation of the Bible into Latin, an activity which occupied the last decades of his life when he was head of a monastery in Bethlehem. Although a book in praise of St. Jerome was written in Bologna before 1350, he did not become popular in visual imagery until the fifteenth century.[2] The origins and popularity of his iconography have been treated by Millard Meiss.[3] The Venetian preference was for St. Jerome in a landscape setting [100].

1. Voragine, 1969, p. 589.
2. Meiss, 1976, p. 189.
3. Meiss, 1963, pp. 157-159.

Filippino Lippi

1457–1504

Filippino Lippi's father was the noted Florentine painter, Fra Filippo Lippi, who, while chaplain of a convent in Prato, ran off with the nun, Lucrezia Buti. At the urging of Fra Filippo's patron, Cosimo de' Medici, Pope Pius II released both parties from their vows and allowed them to marry. Filippino's artistic education began in his father's shop, but after his father's death in 1469, he spent almost ten years in the studio of Botticelli.

Filippino is linked with the early Quattrocento through his completion of Masaccio's frescoes in the Brancacci chapel in 1484. His work of the early 1480s reflects the soft contours and landscape interests of Leonardo da Vinci's style at this time. Later, Filippino's paintings, such as the enormous tondo of *The Holy Family with the Infant St. John and St. Margaret* in The Cleveland Museum of Art, are distinguished by the strong pure colors favored in Florence in the 1480s and 1490s. The *Vision of St. Bernard* in the Church of the Badia, Florence, Filippino's masterwork, summarizes the characteristics of late Quattrocento Florentine painting.

After completing a commission for Santa Maria sopra Minerva in Rome, Filippino returned to Florence where from 1487 to 1502 he worked on frescoes depicting events from the life of St. Philip in the Strozzi chapel, Santa Maria Novella. The fussy and fantastic designs in the decorative borders of the frescoes contain masks, urns, lamps and interlocking tendrils which were based on motifs found in the Golden House of Nero, which had been recently excavated in Rome.

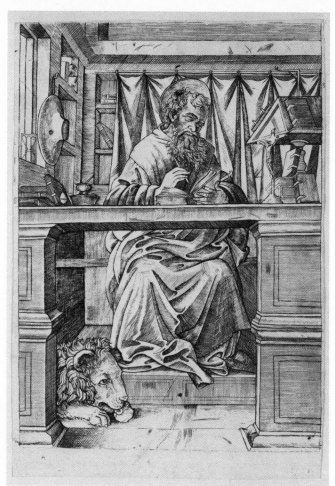

16

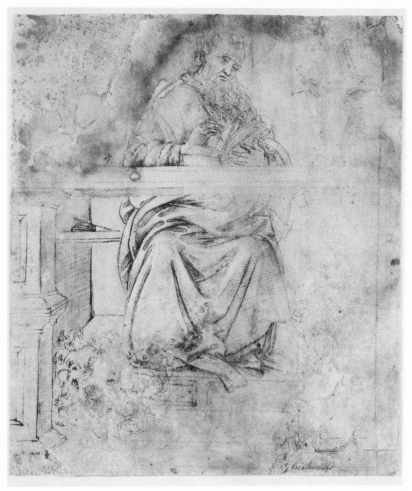

17

Filippino Lippi

17 *St. Jerome in His Study*

Pen and brown ink, brown wash, heightened with white (oxidized), pricked, 241 × 209 mm., ca. 1490. Notations: lower right, in pen and brown ink, *Ghirlandaio*; verso of mount, in brown ink, *Domenico Ghirlandio Fiorentino*; in pencil, *R. Johnson–1877, A 273*. All corners missing, numerous holes and tears, soiled.

The Cleveland Museum of Art, Gift of Leonard C. Hanna, Jr., 24.532.

Provenance: Richard Johnson (Lugt 2216); Richard Johnson Walker (under Lugt 2216). *Exhibited:* Cleveland, 1924, p. 141; Cleveland, 1971, no. 54, repr. *Published:* Berenson, 1938, II, 142, no. 1277 F; III, fig. 221; Hind, 1938–48, I, under D.IV.6. (as probably by Filippino Lippi); Suida, 1951, under no. 15; Degenhart, 1955, pp. 218, 251, n. 307, fig. 269 (as Giuliano da Sangallo); Shapley, 1961, under no. 13; Shapley, 1966–73, I, 137; Levenson, et al., 1973, under no. 93, fig. 10-2 (as ascribed to Filippino Lippi); Shoemaker, 1975, pp. 449-450 (as Giuliano da Sangallo); Armenini, 1977, fig. 60.

Images of saints in their studies were popular in Florence at the end of the Quattrocento. At the Ognissanti Ghirlandaio painted a fresco of St. Jerome in this setting and Botticelli did one of St. Augustine. Jay Levenson suggested that Botticelli's painting of St. Augustine in the Uffizi was the model for Filippino's design.[1]

Berenson dated this drawing as contemporary with Filippino's paintings in the Carafa chapel of Santa Maria sopra Minerva.[2] The face of St. Jerome is similar to that of a heretic in the St. Thomas fresco and also close in physiognomy to Abraham in the Strozzi chapel of Santa Maria Novella.

Pin holes along the central portion of the design indicate that this drawing was a study for a finished work in another medium. There are two related works, an engraving by Giovanni Antonio da Brescia [16] and a panel painting in the Kress Collection, El Paso Museum of Art, attributed to Filippino.[3] The painting, which is much larger than the drawing, is a simplified version of the scene focusing on the figure of the saint. Background details are minimal (even the lion has been omitted), and St. Jerome is placed in the foreground. A large figure taking up most of the picture space, he dominates the painting.

The engraving, however, is much closer to the drawing. Since St. Jerome is the same size in both, the design seems to have been transferred directly from one technique to the other. Because the drawing is mounted on heavy paper, it cannot be examined for charcoal stains on the verso. These would be the result of pouncing the perforated design with a charcoal bag, a procedure used to translate the dotted outline to a second surface, whether paper, panel, canvas, or metal. It is also possible that the perforations were made against a second sheet of paper which was then used to effect the transfer, thereby preserving the original drawing.[4] In either case the design was placed recto down against the engraver's plate so that it would print in the same direction as the drawing rather than in reverse.

1. Levenson et al., 1973, no. 93.
2. Berenson, 1938, II, 142, no. 1277F.
3. Shapley, 1966, I, 137, no. K 1727, fig. 375. This panel is dated to the 1490s
4. The procedure was described by Armenini in his treatise on painting of 1586; Armenini, 1977, p. 174.

Tommaso Manzuoli, called Maso da San Friano

1536–1571

Maso da San Friano's brief career was conditioned by the equivocal nature of his artistic personality and his early tendency to borrow from the art of the high Renaissance and later (ca. 1565) to use elements of the *maniera* spirit then in vogue. An early interest in Andrea del Sarto was eclipsed by a later preoccupation with Pontormo and Rosso. Maso had sufficient standing in the Florentine artistic community to participate in Vasari's project for the Studiolo in the Palazzo Vecchio, painting the *Fall of Icarus* and *The Diamond Mine* as part of a program dedicated to the four elements.

Tommaso Manzuoli, called Maso da San Friano

18 *Three Standing Soldiers*

Black chalk, 209 × 241 mm., ca. 1560s. Notation: lower right corner, in pen and ink, *Federico Zuccaro*. Soiled along edges.

Los Angeles County Museum of Art, Gift of the Graphic Arts Council, M. 75.34.

Provenance: H. Schickman, New York. *Exhibited:* Los Angeles, 1976, no. 30, repr. p. 29.

This drawing was characterized by Ebria Feinblatt as an example of Maso's draftsmanship under the influence of Jacopo da Pontormo.[1] She observed that the gesturing soldier at the right is similar to the figure in Pontormo's *Seated Nude* in the Uffizi.[2] The figure with helmet, shield, and spear at the left can be compared favorably with the warrior at the lower left in Maso's drawing, *Ecce Homo*, also in the Uffizi.[3] Maso's line is looser and more decorative than Pontormo's, although his artistic personality as a draftsman has not been clearly defined.

The exact subject of this drawing is not certain. In date it should be close to the period, ca. 1561, when Maso was taken with the art of Pontormo and was also becoming involved with projects in the Palazzo Vecchio, where subjects of ancient Rome and modern Florentine battles were commonplace.

1. Los Angeles, 1976, no. 30.
2. J. C. Rearick, 1964, II, fig. 291.
3. Los Angeles, 1976, no. 30; *Ecce Homo*, Florence, Uffizi, inv. no. 999S.

18

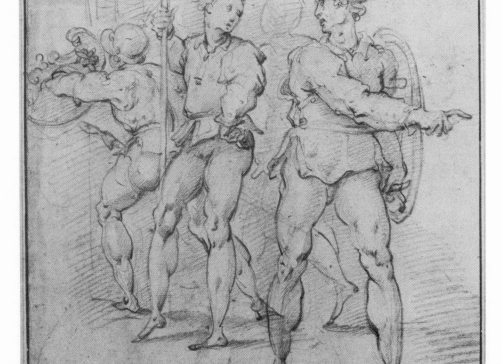
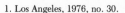

Giovanni Battista Naldini

ca. 1537–1591

In 1557 after an eight-year apprenticeship with Pontormo, Giovanni Battista Naldini studied in Rome before returning to his native Florence around 1561. There he joined Vasari's projects in the Grand Council Hall of the Palazzo Vecchio for four years. In 1570 Naldini painted two allegories for the Studiolo. Raffaelo Borghini praised his *Pietà* of 1572, an altar painting in Santa Maria Novella, as his masterwork.[1] In 1578 Naldini painted the fresco for Michelangelo's tomb in Santa Croce. A second visit to Rome was made in the late 1570s, after which his works became less painterly, although varied postures and gesturing for effect remained in his paintings through the 1580s as in the *Calling of St. Matthew* in San Marco (1584-1588).

1. Borghini, 1584, p. 614.

Giovanni Battista Naldini

19 *Samson Slaying the Philistines* (recto); *Anger* (verso)

Red chalk (recto, verso), 334 × 232 mm. Notations: lower right, in pen and ink, *G. di Bologna*; verso, lower right, in pen and ink, *Gio Bologna*. Soiled.

Lent by the Metropolitan Museum of Art, Gift of Cornelius Vanderbilt, 1880, 80.3.301.

Naldini, like Tintoretto [106], was attracted to Michelangelo's group of *Samson and the Two Philistines* and made sketches after it. Although Michelangelo's original sculpture is lost, a clay model and several bronze copies have survived.[1] Tolnay dated the original after 1529–1530 and connected it with the project for a sculpture in the Piazza della Signoria, Florence, which has a long and involved history beginning in 1508,[2] and ultimately resulted in Baccio Bandinelli's marble *Hercules and Cacus*.

An attribution to Naldini was made in 1958 by Philip Pouncey.[3] Similarities in style can be found with Yale's *Seated Youth*. Both are well modeled, strongly outlined, powerful figures full of movement; in each

drawing the hands, feet, and heads are given a much more summary treatment than the rest.[4] The rubbed red-chalk technique of this sketch adds a note of blurred energy to the struggling figures. The verso of *Samson Slaying the Philistines* is a personification of Anger which is a copy of a lost drawing by Rosso engraved by Caraglio.[5]

1. Tolnay, 1945, III, 186, figs. 277-278.
2. Ibid., pp. 183-187.
3. Notes in the Curator's file, the Metropolitan Museum of Art, New York.
4. New Haven, 1974, no. 32, *Seated Youth*, red chalk, pink wash, corrected with white, 226 × 203 mm., Yale University Art Gallery, no. 1972.38.
5. Kusenberg, 1931, pl. xx.

19 Verso

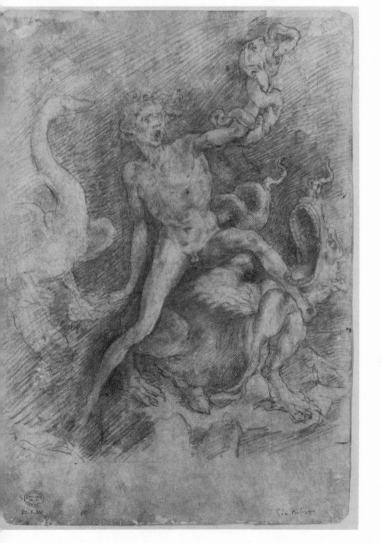

19 Recto

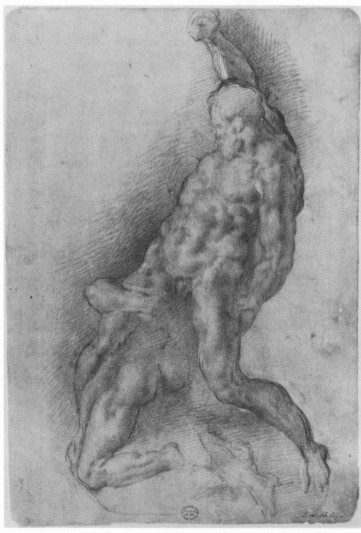

Marco Pino

ca. 1525–1579/88

Pino trained with Beccafumi before joining Perino del Vaga's studio in 1546 at the Castel Sant'Angelo in Rome. In 1550 he assisted Daniele da Volterra in SS. Trinità dei Monti. Seven years later Pino settled in Naples where his prodigious output of altarpieces made him a dominant figure in the arts.

Marco Pino

20 *The Battle of Anghiari*

Pen and brown ink, brown wash heightened with white, partially incised, 279 × 387 mm., 1550s. Vertical fold down center, several holes and cracks.

Los Angeles County Museum of Art — Anonymous Gift, M.63.38.

Provenance: Giuseppe Vallardi (Lugt 1223); B. Anthon. *Exhibited:* Los Angeles, 1976, no. 28, repr. p. 29.

This sheet is not associated with any known painting by Pino for whom Venturi lists only religious works.[1] It does, however, fit the context of Quattrocento cassone panels and such works as Paolo Uccello's *Rout of San Romano* and Giulio Romano's *Battle of Constantine* in the Vatican, and Leonardo's representation of the Florentine victory over Milan at Anghiari in 1440 for the Palazzo Vecchio — unfinished and now lost, but known from Rubens's copy. Pino certainly captured the savagery and sweep of battle from these other scenes. More particularly, the fallen warrior in the foreground is similar to a dying soldier in Romano's work, although Pino's figure may have been based on its Roman prototype on Trajan's Column.

Although this study was originally assigned to Taddeo Zuccaro, Philip Pouncey and John Gere identified its style as Marco Pino's. Many stylizations peculiar to his work can be noted: dark outlines, triangular eyes, clumps of blowing hair, rosettelike knee caps, and curlicue navels. The advancing figure at the right, whose pose is close to Michelangelo's figure of Haman in the Sistine ceiling, is similar to the executioner in Pino's drawing of the *Beheading of John the Baptist*.[2] The Roman references and mannerisms of Pino's battle drawing suggest a date in the 1550s, following Pino's associations with Perino del Vaga and Daniele da Volterra.

1. Venturi, 1932, IX, 5, 520-522.
2. Marco Pino, *Study for a Headsman*, pen and ink, 165 × 110 mm., Florence, Uffizi, no. 702.

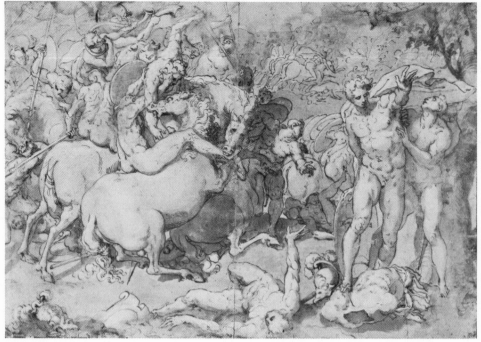

20

Bernardino Poccetti

1548–1612

Bernardino Poccetti was born into the generation of Florentine artists who specialized in the *maniera* phase of mannerism with its decorative extravagance and striving for visual effect. His early years were occupied with façade paintings and other fresco decorations. If Poccetti's commission for the cloister of S. Maria Novella in 1580 caused a crisis in his style, it did not manifest itself until later. Intended as a didactic project in the idiom of inspirational Counter-Reformation works, it was to join other paintings from 1568 by the *maniera* artists of Vasari's generation. While working on secular decorative paintings, Poccetti also became increasingly involved in projects dealing with religious narrative. His frescoes of the early 1590s at the Certosa di Val d'Ema are evidence of an emphatic naturalism, but by 1602, when he began the cloister frescoes at San Marco, the appearance of decorative flourishes revealed some regression in his style.

Bernardino Poccetti

21 *Woman and Child Standing* (recto); *Study of a Man's Leg* (verso)

Black and red crayon (recto); black crayon (verso), 224 × 162 mm., ca. 1602. Notations: verso, lower left, in pen and ink, *F. Zuc.ro.*; upper left, in pen and ink, *F. Zuccaro/3.2*. Soiled at edges.

Bowdoin College Museum of Art, Brunswick, Maine, 1811.10.

Provenance: Peter Lely (Lugt 2092); James Bowdoin, III. *Exhibited:* Regina, 1970, no. 27, repr. p. 131. *Published:* Johnson, 1885, no. 14; Mather, 1913, p. 248, fig. 14.

This drawing served Poccetti as a study for a fresco in the Florentine cloister of the SS. Annunziata. The woman and child appear in the far right foreground of one of the fourteen lunettes in the Chiostro dei Morti dealing with the founding of the Servite order.[1] The graceful attitudes of the figures so charmed Venturi that he commented on the "deliziosa bambina aggrappata alle vesti materne."[2] The other woman and child, only faintly indicated in the drawing, do not appear in the fresco. The seated male is retained in the painting but as looking over his left shoulder at the standing woman behind him.

The fresco project for the choir dates from 1601 and was still in progress in 1604.[3] Whether Poccetti completed his designs for the project at the outset or singly as work on the individual lunettes progressed is open to speculation.

In style the drawing matches a sheet in the Ashmolean collection. It is also like *Child Seated* in the Uffizi in the use of single, wavy black chalk lines for hair, in the low placement of cheekbones in the children which cause the nose and chin to be pinched, and in the accenting of edges in order to stabilize the composition.[4] By stressing contours the figural grouping is balanced, enclosed, and made compact.

1. Repr. Venturi, 1934, IX,7, 607,fig. 329.
2. Venturi, 1934, IX,7, 604. He also refers to them as "grand figures" and "noble personnages": "Le figure grandi in primo piano, . . . visibile ad esempio nel nobile personaggio con beretto di velluto e nella deliziosa bambina aggrappata alle vesti materne. . . ."
3. Venturi, 1934, IX,7, 598, 630 n.1.
4. *Man Standing*, black chalk, 388 × 205 mm., Oxford, Ashmolean Museum, no. 472; *Child Seated*, black chalk and wash, 285 × 230 mm., Florence, Uffizi, no. 8560 F.

Jacopo da Pontormo

1494–1557

Pontormo trained for brief periods in the studios of Piero di Cosimo and Andrea del Sarto (ca. 1512). His early paintings were also influenced by the art of Fra Bartolommeo. Pontormo's *Visitation* of 1515 in the SS. Annunziata in Florence incorporated the order, arrangement, and figural treatment of the high Renaissance — elements soon contradicted by the Visdomini altarpiece and *Joseph in Egypt* (National Gallery, London), both of 1518. In these paintings there is a lack of compositional focus and human proportions depart from the normative.

A greater degree of naturalism is evident in the frescoes at Poggio-a-Caiano of 1520–1521. The use of descriptive local color and figures in casual poses was appropriate for this rural setting. When the plague broke out in Florence in 1523, Pontormo fled to the Certose di Val d'Ema, where he painted a series of five frescoes on Christ's Passion. Evident here are intense expression, distended forms, and the influence of Dürer's handling of drapery. Perhaps an

emotional response to the plague, these frescoes represent a clear departure from the classicism of the high Renaissance. From 1525 to 1528 Pontormo painted much of the Capponi chapel of Santa Felicità and executed a Deposition for the altarpiece. Here he combined highly personal expression with stylistic refinements such as linear clarity, full forms, and smooth surfaces. Pontormo pursued his own form of *paragone* in the altar panel by introducing the concept of time. Since the painting includes elements of the Deposition, Pietà, and Entombment, it condenses into one scene events that actually occurred sequentially.

After 1530 Pontormo remained influenced by the corporeality of Michelangelo's art. His figures are highly individual and elegantly decorative. The last twenty years of Pontormo's life were spent under Medici patronage, where he designed tapestries and fresco projects for churches and villas. His late frescoes in San Lorenzo compelled Vasari to write that, "The whole is full of nudes, arranged, designed, and colored after his fashion, with so much melancholy as to afford little pleasure to the observer, for even I, though a painter, do not under-

stand it, and it seems to me that in this labour of eleven years Jacopo has sought to bewilder both himself and those who see the work."[1]

1. Vasari-Milanesi, 1875–85, VI, 286-287.

Jacopo da Pontormo

22 *Half-Length Figure of a Youth*

Red chalk, 157 × 127 mm., ca. 1525. Notation: upper right corner, in pen and brown ink, *4*. Soiled.

Janos Scholz, New York.

Provenance: Giovanni Piancastelli (Lugt 2078a); Edward and Mary Brandegee (Lugt 1860c). *Exhibited:* Indianapolis, 1954, no. 10 repr.; Bloomington, 1958, no. 38, fig. 38; Oakland, 1961, no. 70, pl. 70; Hamburg, 1963, no. 124; fig. 25; New Haven, 1964, no. 44; Milwaukee, 1964, no. 31; London, 1968, no. 74; Middletown, 1969, no. 12; Notre Dame, 1970, no. D17, repr. 109; New York, 1971, no. 68; Norton, 1971; Providence, 1973, no. 56, repr. 52; Washington, 1973, no. 26, repr. 34. *Published:* Berenson, 1961, II, no. 2256J; J. C. Rearick, 1964b, I, no. A234 (as 16th-century copy); J. Scholz, 1976, no. 44, pl. 44.

Janet Cox Rearick doubted the authenticity of this drawing because of its closeness to a

21 Recto

21 Verso

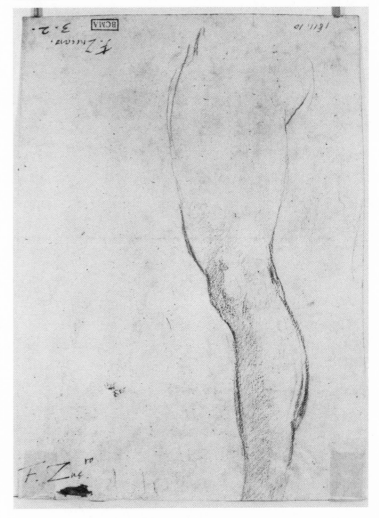

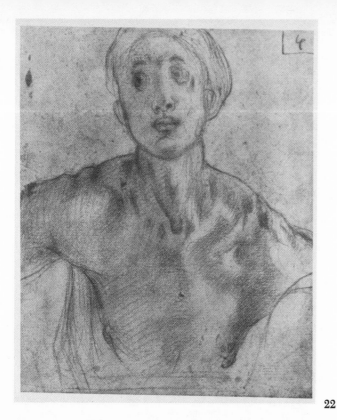

22

second, more finished figure study in the Uffizi, since no other examples of pairs of similar drawings by Pontormo exist.[1] The dilemma posed by these two sheets was also discussed by Konrad Oberhuber and Dean Walker.[2] If one of the drawings is by another hand, it would most likely be the one in the Uffizi which has harsher contrasts and lacks some of the linear details in the face and turban seen in the version in the Scholz collection. This sheet, furthermore, has the freedom, respect for anatomy, delicate line, and soft rubbing of the chalk to yield supple surface effects, that characterize Pontormo's drawings. Also present is the curious, highly individual expression of emotional intensity — emphasized by the shaded ovals used for eyes.

Identified as a study for the Virgin in Pontormo's *Deposition* of 1526–1528 in Santa Felicità, Florence,[3] the sketch could also have been used as a study for the youth at the left holding the shoulders of the dead Christ.

23 Recto

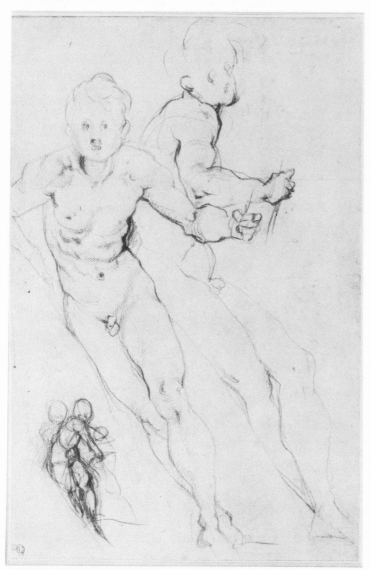

23 Verso

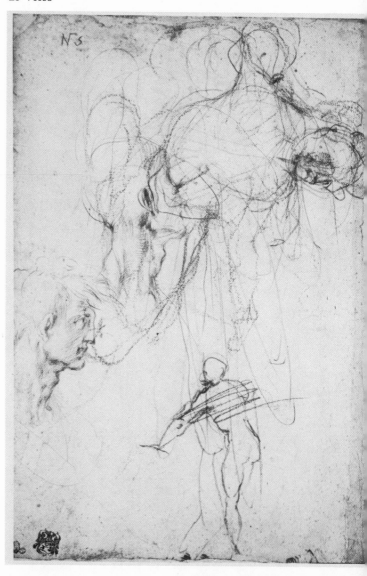

1. J. C. Rearick, 1964b, I, nos. 269, A234, II, fig. 256. *Bust of a Nude Staring Forward*, red chalk, 165 × 146 mm., Uffizi, no. 6666 F, recto.
2. Washington, 1973, no. 26. Christine I. Swartz listed the scholars who accepted this sketch as an autograph Pontormo: Providence, 1973, no. 56.
3. J. C. Rearick, 1964b, I, 259.

Jacopo da Pontormo

23 *Three Sketches of a Nude Youth, a Sketch of Two Standing Figures* (recto); *Two Profile Studies, Two Studies of Male Figures* (verso)

Black and red chalk, 435 × 285 mm., ca. 1520. Watermark: Scales in a circle surmounted by a crown (similar to Briquet 2518).

Fogg Art Museum, Harvard University, Cambridge, Massachusetts, Bequest of Charles Alexander Loeser, 1932.342.

Provenance: Giuseppe Vallardi (Lugt 1223); Pacini (Lugt 2011); Carlo Prayer (Lugt 2044); Charles Alexander Loeser (under Lugt 936a). *Exhibited:* Hartford, 1946, no. 46; Indianapolis, 1954, no. 9, repr. (recto); Baltimore, 1961, no. 62, repr. p. 54 (recto); Cambridge, 1962, no. 26, repr. on cover; Fort Worth, 1965, p. 65 repr.; Providence, 1973, no. 55, repr. p. 50 (recto, verso). *Published:* Clapp, 1914, pp. 84-85; Berenson, II, 273, no. 1955A; Mongan and Sachs, 1940, I, no. 145, II, fig. 83 (recto); Tolnay, 1943, no. 95, fig. 95 (recto); J. C. Rearick, 1964b, I, nos. 139, 151, II, figs. 131 (verso), 143 (recto); J. C. Rearick, 1970, under no. 142a; Oberhuber, 1978, repr. p. 466 (recto); Oberhuber, 1979, no. 15, repr. (recto).

This figure sketch is a study for a nude youth in Pontormo's fresco in the Villa Medici at Poggio a Caiano near Florence commissioned by Pope Leo X in 1520. It was first identified by Mongan and Sachs as the figure to the right above the window in the lunette fresco, *Vertumnus and Pomona*, in the Sala Grande.[1] A compositional study of Pontormo's initial idea reveals a fantasy of six distended figures.[2] In the final solution the figures have been reduced to a more human size and have been placed in an arcadian setting.

An almost perverse strain marks many of Pontormo's subjects, with figures quite often appearing on the verge of hysteria. In spite of the curious emotional state and distended forms, the poses and anatomical details offer evidence that he relied upon posed studio models. His use of chalk, especially red, is an apt medium for dealing with the subtle hollows and varied projections of bone and muscle and is a legacy from his experience in the studio of Andrea del Sarto.

1. Mongan and Sachs, 1940, I, no. 145; J. C. Rearick, 1964b, II, pl. 122.
2. J. C. Rearick, 1964b, I, no. 131, II, pl. 123. *Study for Vertumnus and Pomona*, pen and ink, wash, over black chalk, 198 × 380 mm., Florence, Uffizi, no. 454 F.

Matteo Rosselli

1578–1650

A pupil of Passignano, Matteo Rosselli was better known as a teaching master than as an artist. He preserved the Florentine tradition of elegant line and local color so popular in the Medici court through the seventeenth century. He educated such prominent Florentine masters as Francesco Furini, Lorenzo Lippi, Volterrano, and Carlo Dolci, among others.

Matteo Rosselli

24 *Three Figures*

Pen and brown ink, black chalk, 149 × 129 mm., after 1600. Notation: lower right, in pen and brown ink, *Eugenio*. Four pieces of paper joined, creased and soiled.

Anonymous Loan.

Provenance: Herbert Bier, London; Dr. and Mrs. Sherman E. Lee, Cleveland.

The attribution of this drawing remains open to speculation. Edmund Pillsbury suggested it was a work of Matteo Rosselli, who painted numerous battle scenes for the Medici.[1] The gesturing protagonists and disjunctive figure scale are found in many of Rosselli's battle paintings, but can also be found in works of Antonio Tempesta and are in general characteristic of late mannerist manifestations in Rome and Florence.

Three Figures can be compared stylistically with a pen and ink archer in St. Louis, unfortunately anonymous but, due to its rapid sketchy graphic style, considered Venetian[2] and associated with Jacopo Tintoretto and the school of Palma il Giovane. The figures in both sheets, delineated with thick pen strokes, have thin ankles and bulging calves.

Three Figures is a composite of two drawings and the page is comprised of four sheets pasted together. As such, it is like Domenichino's *Temperance* [42] except in that case four fragments were joined to make a larger sheet upon which the composition was drawn. In *Three Figures* two separate drawings were joined in a new composition. Perhaps a more appropriate comparison can be made with Raphael's *Venus* where the top half and bottom half of two different figures were joined to create a third.[3] Raphael's composite figure may have inspired his *Galatea*, but the top half was taken from a Madonna and Child study or a Pietà as indicated by the second head faintly drawn in between the figure's arms.

24

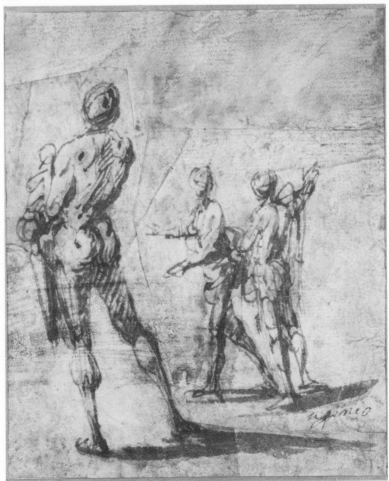

1. Note of 18 March 1971 in Registrar's file, The Cleveland Museum of Art.
2. *An Archer*, anonymous, Venetian, ca. 1600, pen and brown ink, squared in black chalk, 190 × 135 mm., St. Louis Art Museum, no. 1128:40; Neilson, 1972, no. 18 repr.
3. Raphael, *Venus*, metal point on pink surface, 1508, 238 × 100 mm., London, British Museum, no. 1895-9-15-629; Pouncey and Gere, 1962, I, no. 27; II, pl. 32.

Rosso Fiorentino, Giovanni Battista di Jacopo

1495–1540

Rosso Fiorentino's first major commission in Florence, an Assumption for SS. Annunziata (1516), contained references to Fra Bartolommeo and Andrea del Sarto. Although primarily classical in orientation, his individual taste in color and expression foretold the emphatic anticlassicism evident in the *Deposition* at Volterra (1521). The vertical format, harsh contrasts, lack of focus, faceted modeling, arbitrary treatment of drapery, and psychological intensity became characteristic of Rosso's work. Elegance and preciosity are first seen in *Moses and the Daughters of Jethro* of ca. 1524 (Uffizi, Florence) which may involve the triple appearance of Moses in continuous narrative.[1]

Rosso journeyed to Rome in 1524 and remained until the sack of 1527, when he escaped to Arezzo. The influence of Michelangelo's plastic figures is obvious from paintings such as the Boston Museum of Fine Art's *Dead Christ* (ca. 1526). In 1530 Rosso was invited to France where he remained until his death in 1540.

1. This suggestion was first made by Norman W. Canedy. Moses may be seen here as slaying his Egyptian overlord, as separating the pair of fighting Israelites, and again as rescuing the daughters of Jethro.

Rosso Fiorentino

25 *Head of a Woman with an Elaborate Coiffure*

Black chalk, pen and black ink, brown wash, 235 × 176 mm., ca. 1527–1528. Notations: at top center, in pen and brown ink, *Rosso Fiorentino*; at right margin, in pen and brown ink, *Giulia Gonzaga Duchezz . . . /di Mantoa*; lower right corner, in pen and brown ink, *93*; on verso, *Le Rosso or Master Roux of Florence 1496/1541, 1524*; on Talman mount, in pen and brown ink, *di Rosso Fiorentino, Julia Gonzaga/Barbarossa the famous Turkish Pirate attempted to suprize this famous Beauty in order to make a Present of Her/ to Solyman y^e Emperour; & for that purpose landed by night 2000 souldiers near Fundi where she then was; but at ye/first alarm she mounting a Horse without any clothes but her smock made her Escape; at wch y^e Barbarian was / so inraged that he burnt the Town; this lady was the widow of Vespasian Colonna. Thuanus speaks much in her Praise. /Dictionaire de Moreri*; verso of mount, *e collectione J. Talman*.

Lent by the Metropolitan Museum of Art, Rogers Fund, 1952, 52.124.2.

Provenance: John Talman (Lugt 2462); Joshua Reynolds (Lugt 2364); John Fitchett Marsh (Lugt 1455); H. M. Calmann, London. *Exhibited:* New York, 1965, I, no. 77, pl. 77. *Published:* Vitzthum, 1966, pp. 109-110, fig. 60; Carroll, 1976, II, no. D.25, fig. 81; Barolsky, 1978, pp. 106-107, figs. 5-3.

While typically modish and in conformity with patrician Florentine tastes in the 1520s, it is doubtful that this drawing is a portrait. An inscription on the verso, which Hugh Macandrew considered to be in the hand of John Talman, suggests that the drawing is a portrait of the Countess of Fondi, Giulia Gonzaga (1513–1566),[1] but Jacob Bean recognized the highly idealized character of the sheet with its focus on decorative and formal qualities.[2]

The elaborate hairdo—comprised of entwined braids, bundled satin, strings of pearls, and a ram's horn—reflects the mannerist love for complication and a Florentine tradition found earlier in the headgear and costumes of Uccello's *Rout of San Romano* (1445) and the elaborate coiffure of Fra Filippo Lippi's Uffizi *Madonna* or Botticelli's graces in the *Primavera*. Eugene Carroll noted that the pose and stylishness of the high necked gown, puffed bouffant sleeves, and drapery fastened at the back with a brooch, link the sheet with a figure in Rosso's Borgo Sansepolcro *Deposition*.[3] Carroll, therefore, dated this sheet ca. 1527–1528. In terms of draftsmanship he also related it to the Uffizi's drawing, *Woman Seated in a Niche*, and the Louvre's *Madonna della Misericordia*.[4]

Soon after this drawing entered the Metropolitan Museum's collection, the influence of Michelangelo's studies of ideal heads, such as the one in the British Museum, was noted.[5] Carroll observed that Rosso's mimicry of Michelangelo's draftsmanship included the finely textured shading of the face and shoulders.[6] The brown wash and the Talman mat are later additions.[7] The fanciful story along the lower border is evidence of the romanticism inspired by this graceful, coy, and highly stylized head.

1. Curator's file, Drawings Department, Metropolitan Museum of Art, New York.
2. Bean, 1965, no. 77.
3. Carroll, 1976, I, 172.
4. Ibid., II, 272-283.
5. Curator's file, Drawings Department, Metropolitan Museum of Art, New York. Michelangelo, *Ideal Head of a Woman*, black chalk, 287 × 235 mm., 1525–1528, British Museum, no. 1895-9-15-493; Wilde, 1953, pp. 78-79, no. 42, pl. lxxvii (recto).
6. Carroll, 1976, I, 173.
7. Curator's file, Drawings Department, Metropolitan Museum of Art, New York.

Rosso Fiorentino

26 *Judith with the Head of Holofernes*

Red chalk, 232 × 197 mm., 1538–1540. Notation: lower left corner, in pencil, *Rosa*.

Los Angeles County Museum of Art, Dalzell Hatfield Memorial Fund, m.77.13.

Provenance: Eugène Rodrigues (Lugt 897). *Published:* Carroll, 1978, pp. 25-49, repr. on cover.

This sheet and *Head of a Woman* [25]—each so different in character—reflect the versatility and highly individual artistic personality of Rosso. The technique and figure types of *Judith with the Head of Holofernes* occur early in his art. The female at the lower left in *Virtue Conquering Vice*, for example, is similar to Judith in facial type and treatment of the torso.[1] Another early red chalk sheet, *Memento Mori*, establishes a precedent for the emaciated hag.[2] The drawing of Judith, however, is a more integral and harmonious figure study. On this basis Carroll argued for a late date, after Rosso's studies for the Gallery of Francis I, 1538–1540.[3]

The Book of Judith relates how, when the city of Bethulia was under seige and had its water supply cut, the beautiful widow Judith volunteered to enter the camp of Holofernes, general of the Assyrian army, ostensibly to reveal how the city might be captured.[4] She was taken into Holofernes's confidence, and one evening at the end of a banquet, when Holofernes collapsed in a drunken stupor, she cut off his head. Since Judith was allowed to leave the camp every evening to pray, she was able to escape before the deed was discovered.

Rosso had dealt with the subject in a painting of ca. 1530–1531—now lost, but engraved by Boyvin[5]—in which the servant is omitted. She is essential to the narrative and her inclusion was traditional in Italian Renaissance art. The nudity of both women in Rosso's drawing, however, confounds both scripture and previous representations. Studies of figures which would have been clothed in the final work, however, were often executed as nudes to gain a better understanding of anatomy.[6] Rosso does retain a few elements of costume which further emphasize the nudity of the figures. Judith's braids tied around her neck and her hat are mentioned in the Bible but the necklace is his own invention.[7] The servant usually appears with her head covered.

The hag, sinewy and shapeless, serves as a foil for the beauty of Judith. The contrast illustrates the ephemeral nature of beauty as opposed to virtue, which endures. Judith—whose divinely inspired beauty[8] caused the downfall of Holofernes (the result of his pride and sensuality)[9]—lived to be well over 100 years old.[10] Rosso's drawing is a form of *paragone* wherein the fourth dimension, time, is inferred. The passage from youth to age is a form of dialectic and a constant in the human condition.

The servant concentrates her gaze on the face of Judith. Is she attempting to recall her own lost beauty or is she fascinated by Judith's ultimate triumph in both retaining her virtue and restoring the freedom of her city? When the ancients of the city "saw Judith they were astonished, and admired her beauty exceedingly,"[11] but upon returning to Bethulia, Judith spoke, "the Lord hath not suffered me his handmaid to be defiled, but hath brought me back to you without pollution of sin, rejoicing for his victory, for my escape, and for your deliverence."[12]

This drawing exemplifies the power and suitability of chalk for figure studies, and Rosso's mastery of the medium. His perception of nature is evident in simple details such as the delicately raised heel of Judith's right foot and the shadow underneath it, the foreshortening of the feet, and the subtle and skillful modeling of the thighs, abdomen, and breasts. Carroll doubted that this drawing was made as a study for a painting, suggesting instead its use for an engraving or that it was intended to remain only a drawing, a private work of art known only to a few.[13]

1. *Virtue Conquering Vice*, ca. 1521–1522, red chalk over traces of black chalk, 140 × 207 mm., Darmstadt, Hessisches Landesmuseum, no. AE 1476; Carroll, 1978, fig. 3.
2. *Memento mori*, 1517, red chalk, 320 × 502 mm., Florence, Uffizi, no. 6499 F; Carroll, 1978, fig. 25. See also *St. Roch Distributing His Inheritance*, black chalk, 240 × 210 mm., Brussels, Andre de Hevesy Collection; Carroll, 1976, II, fig. 68.
3. Carroll, 1978, pp. 25, 28, 36.
4. Judith, 1-16.
5. Carroll, 1978, p. 28, fig. 12.
6. Alberti, 1966, p. 73.
7. Judith 10:3, 16:10.
8. Judith 10:4, 11:19: "There is not such another woman upon earth in look, in beauty, and in sense of words." "And the Lord also gave her more beauty: because all this dressing up did not proceed from sensuality, but from virtue; and therefore the Lord increased this her beauty, so that she appeared to all men's eyes incomparably lovely."
9. Judith 9:12, 12:16, 13:28
10. Judith 16:28.
11. Judith 10:7. Carroll observed that the hag in Renaissance art was frequently a personification of Envy. Carroll, 1978, p. 42.
12. Judith 13:20.
13. Carroll, 1978, p. 45.

25

26

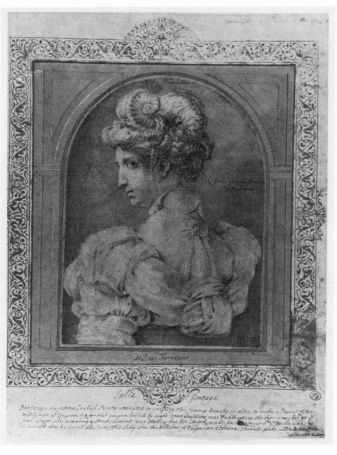

Francesco de' Rossi, called Salviati

1510–1563

It was in the Florentine studio of Baccio Bandinelli that Salviati met his lifelong friend, Georgio Vasari. His Florentine experience also included a period in the workshop of Andrea del Sarto. In 1530 Salviati journeyed to Rome where he was joined by Vasari. One of his first major commissions was the *Visitation* fresco for the Oratory of San Giovanni Decollato. Surprises in figural scale and alternations of normal with convoluted poses and of placid with rippling draperies transform a religious scene into an entertainment.

In 1538 Salviati left Rome for a two-year stay in Venice. Perhaps the most important aspect of his journey was seeing Parmigianino's paintings in Bologna. From 1543 to 1548 he was in the service of Duke Cosimo I de' Medici. His scenes in the Audience Hall of the Palazzo Vecchio memorialize the triumphs of Camillus. Before returning to Rome in 1548 Salviati, with Bronzino and Pontormo, created tapestry designs for Duke Cosimo and painted a *Deposition* in Santa Croce.

Salviati's early works in Rome include decorations in the Palazzo della Cancelleria and the *Birth of St. John* in San Giovanni Decollato (1551). The frescoes in the Palazzo Ricci-Sacchetti (ca. 1553), which illustrate the story of David, combined Salviati's *maniera* interests in a decorative calligraphy with the plastic forms of Michelangelo. The linear emphasis in the design make this one of Salviati's most visually successful projects. His final years — interrupted only by a brief trip to Dampierre, France, in 1555 — were spent executing a grand decorative scheme in the Palazzo Farnese's Sala dei Fasti where he made use of illusionistic devices borrowed from the Raphael school's Hall of Constantine.

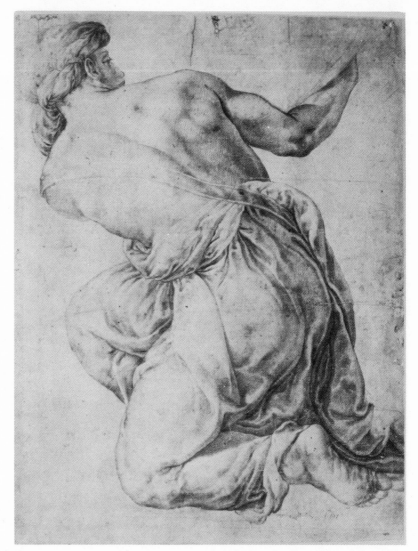

27

Francesco de' Rossi, called Salviati

27 *Kneeling Figure*

Black chalk, 371 × 272 mm., ca. 1553. Notation: lower right, in pen and brown ink, *P 143*. Holes, tears, creases, soiled, foxed.
Lent by The Pennsylvania Academy of the Fine Arts, 79.
Provenance: Padre Resta; Barry Delany (Lugt 350); John S. Phillips Collection, Philadelphia.
Published: Bernheimer, 1942–43, pp. 23-27, repr. 24.

This is a study for the figure left of center in the *Beheading of John the Baptist* in the Oratorio of San Giovanni Decollato, Rome, of 1553 (Fig. 27a).[1] The turban and right forearm, as well as the powerful treatment of figure, are absent in the painting. Largely the work of Salviati's studio, perhaps Pedro Roviale Spagnuolo, the fresco tends to be dry and weak.[2] Michael Hirst accepted the study as an autograph Salviati, and John Gere identified a number on the sheet with the prestigeous collection of Padre Resta.[3]

Fig. 27a. *Beheading of St. John the Baptist*, fresco. Salviati, San Giovanni Decollato, Rome.

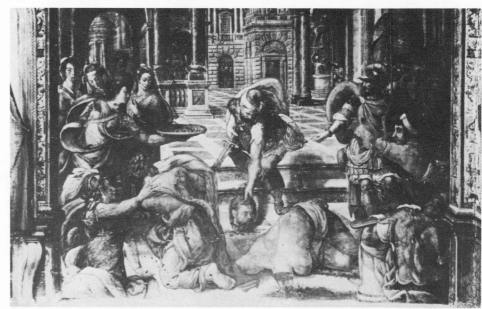

1. Steinberg, 1971–72, p. 46.
2. Keller, 1976, pp. 114-122.
3. Ann Percy to Edward J. Olszewski, 21 January 1977.
Hirst studied the drawing in 1975.

School of Francesco de' Rossi, called Salviati

28 *Man in Armor Beside a Chariot*

Pen and brown ink, brown wash, heightened with white, over black chalk on blue paper, 357 × 270 mm., ca. 1550. Notations: on verso of mount, in pencil, *WCA 3202, Maturino, Elève de Raphael, Ecole de Rome*; on mat, in pencil, *Salviati*; on verso of mat, in pencil, *Salviati, WCA 2303*. Two holes top center, holes, tears, stained.

The Cleveland Museum of Art, Dudley P. Allen Fund, 64.99.

Provenance: Giuseppe Vallardi (Lugt 1223); Maurice Marignane (Lugt 1872). *Exhibited:* Cleveland, 1964, no. 139, repr. p. 242 (as attributed to Salviati). *Published:* Armenini, 1977, fig. 37 (as attributed to Salviati).

There is a clear link between *Man in Armor Beside a Chariot* and Francesco Salviati's series of frescoes in the Audience Hall of the Palazzo Vecchio, Florence, which illustrates the story of Camillus recounted in Plutarch's *Lives*.[1] The pose of the soldier in the drawing is almost identical to that of the figure in front of the horses on the right side of the scene of *The Triumph of Camillus*.[2] Other similarities with figures in the frescoes include the costume, the treatment of hair as a mass of thick curls, the long lean torso, and the bulging calves.

While this figure has the puffy eyes, long straight nose, and pursed mouth of numerous figures in the frescoes, it lacks the sculptural volume and massiveness of Salviati (compare with *Kneeling Figure* [27]). Iris Cheney also felt the style of this drawing to be a bit delicate, lacking Salviati's customary boldness, and that the artist, therefore, must have been a close associate who knew Salviati's style well.[3] *Man in Armor* might be a copy of a lost drawing by the master. A figure ready to ignite a pile of war trophies would be appropriate for one of the frescoes, the scene of *Camillus Routing the Gauls*, where the Roman hero sets fire to the ramparts of the Latins. Since alternative compositional studies exist for two of the frescoes, perhaps this figure appeared in another depiction of the episode. Other possibilities exist. The theme of burning arms appears in the fresco cycle above the doorway, where an allegorical representation of peace holds a palm in one hand while the other lowers a lit torch onto a pile of armor. Since Lomazzo recommended subjects involving fire as appropriate for decorating chimneys and fireplaces,[4] this study could have been devised by the Salviati workshop for just such a purpose. When viewed from a lower vantage point, the exaggerated perspective of the cart's axle and curious foreshortening of the wheel, are more convincing and the soldier's movement seems more spontaneous.

I am indebted to David Whipple for research assistance with this drawing.

1. "Life of Camillus," *Plutarch's Lives*, tr. John Dryden (New York: Modern Library, n.d.), p. 176
2. That Salviati repeated stock poses is evident from the figure at the right for which a study exists in the Uffizi, and who reappears as the figure of King Saul in the Palazzo Sacchetti fresco of *David and Saul; Draped Male Figure from Back*, pen and wash, 410 × 260 mm., Florence, Uffizi no. 1077.
3. Iris Cheney to Edward J. Olszewski, 21 December 1976.
4. Lomazzo, 1584, pp. 342-343; see also Armenini, 1977, p. 269 n. 7.

28

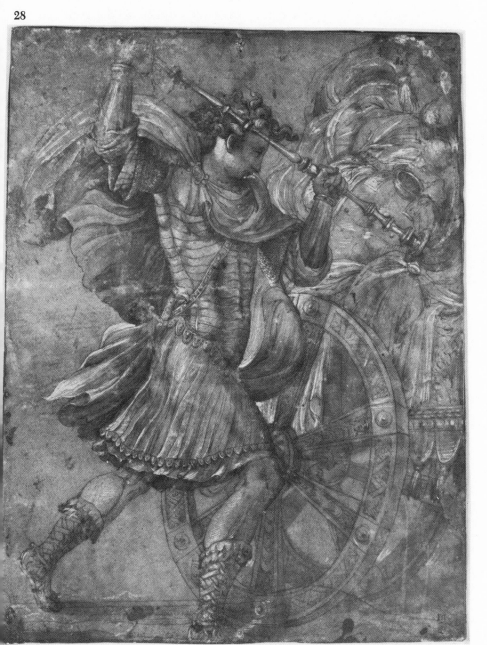

Rome

*What immortal buildings and what noble statues
does this city still possess
which I have not already stolen from it and
carried away without carts or ships on thin paper?*

FRANCISCO DE HOLLANDA

Among the Italian schools, Rome was the least simple in its origins, developing continuously under the influence of numerous outside forces. It was dominated for many decades by the artistic personality of the Florentine, Michelangelo. The Umbrian, Raphael, shaped its taste with his ordered compositions and harmonious forms, and the extended visits of the Venetian, Sebastiano del Piombo, and of Taddeo Zuccaro and Federico Barocci from Urbino underscored the importance of color for the Romans. After mid-Cinquecento, Roman draftsmanship was intimately tied to developments and interests in Bologna. Dependence upon the didacticism of the academy, an interest in nature, especially landscape, and the use of line to enhance the plastic values of figures and objects were a few Bolognese elements to receive a sympathetic reception in Rome. Draftsmen like the native Giulio Romano or Giuseppe Cesari relied upon pulsating line to describe contours and articulate undulating and rippling surfaces. In the end, Bolognese naturalism with the new seriousness of the Counter-Reformation, the robustness of Hellenistic sculpture, and the mesomorphic forms of Michelangelo led to a tectonic and strongly plastic art.

Michelangelo was a dominating force. The Sistine ceiling [30], an essay on the human figure, lends conviction to Michelangelo's complaint that he was a sculptor and not a painter when in 1508 Pope Julius II diverted him from the monumental project of carving the papal tomb. Michelangelo's ceiling was so revered through the sixteenth century that Giorgio Vasari referred to it as a beacon for artists noting that "painters no longer care about novelties, inventions, attitudes and draperies, methods of new expression or striking subjects painted in different ways, because this work contains every perfection that can be given."[1] Equally powerful and stimulating was Michelangelo's *Last Judgment* of the 1530s on the Sistine Chapel's west wall (Fig. 41a) which provided artists in Rome with a full vocabulary of figures. Federico Zuccaro depicted it as an object of study for his older brother, Taddeo (Fig. XX). It was a work Vasari confirmed as "so often copied" that Armenini maintained it provided, with anatomy studies, the final exercise for young artists about to begin their independent careers.[2] The practice is verified by such examples as Leonardo Cungi's copy of *Christ and the Virgin* [41], one of a series of drawings by Cungi after the *Last Judgment*. The demonic quality of Minos is captured in Figino's wash

drawing [46], the musculature more pronounced by virtue of Figino's unconventional technique for a figure study. Vasari also found Michelangelo's fresco noteworthy for the wide range of human emotions represented in his maelstrom of figures.[3] On the other hand, pose and form appear to have been Daniele da Volterra's primary interest in his powerful chalk drawing [76]. The figure's curious jig is explained by the faintly drawn hand grasping its wrist which is that of a superior figure pulling the soul to paradise in the fresco. The same figure appears in the section of wall being copied by Taddeo Zuccaro in Federico's drawing. Bartolomeo Torre's flayed figure [66] and the Passarotti school's study of the back of a man [59] represent the ancillary activity of anatomy study advised by Armenini.

Michelangelo's painting and sculpture dominated the Italian Cinquecento even after his death in 1564, but his absence from the artistic scene provided pause for a more objective assessment of the status of Italian painting which some critics considered to be in decline.

The creation of artists' academies in the late decades of the century required an art that was teachable. This led to a renewal of interest in the highly ordered statements of Raphael. His school dominated Roman painting ca. 1510–1530 and even exerted a major influence on painting in Genoa and Mantua. Raphael's metalpoint sheet [61] may antedate his Roman years, but the seated female study drawn there was an early idea for his compact tondo of the *Madonna della Sedia*, a work of about 1514–1516. Giulio Romano, a native of the Holy City and more associate of Raphael than pupil, was heir to Raphael's studio and completed the master's projects in the Vatican stanze's Hall of Constantine after the master's death in 1520. His *River God* [62] is a study for a fresco detail in the Palazzo del Te in Mantua where Romano worked after he left Rome in 1524. The *Sacrifice of a Goat to Jupiter* [63] is also associated with his activity there, both sheets influenced by Roman prototypes and the antiquarian interests Romano acquired in Rome. Perino del Vaga, although a native Florentine, was another important member of Ralphael's school. His pen study for *St. Peter* [68] departs from Raphael's drawing style in its more decorative character, but the pose and commanding presence of the figure depend upon Raphael's personifications in the Vatican stanze. (Perino's *Studies of Horses* [69] is associated with his early years in Genoa after the sack of Rome in 1527.) Related to the studio of Perino del

Vaga—more specifically to Luzio Romano, who worked with Perino at the Palazzo Doria in Genoa and later at the Castel Sant'Angelo in Rome—are the *Design for a Candlestick* [70] and *Studies of Five Arms* [71]. Another important and early member of Raphael's workshop was the ornamental painter and stucco worker Giovanni da Udine. He did much work on decorative borders and panels in the idiom of ancient Roman mural paintings. *Design for Two Vases* [67] contains the balance of line and relief so characteristic of the Roman school of Raphael, and a second design [65] with a liturgical function is in a similar vein.

Raphael was only the first of several artists from Urbino to make important contributions to Roman art in the Cinquecento. Taddeo Zuccaro arrived in the Holy City in 1543 and had a successful career as a fresco painter until his death in 1566. His richly inventive sheet of studies [82], a working drawing for frescoes in the Roman church of San Marcello al Corso, dated 1557, is significant for its introductory use of red washes. Taddeo was influential in stimulating the coloristic interests of his brother, Federico, and his compatriot, Federico Barocci, both of whom had joined him in Rome in the decorative projects for the Casino of Pius IV. Barocci's *Putto* [33]—which is similar in details of pose to two painted cupids in the Casino—may be an early experiment in colored chalks. His *Aeneas's Flight from Troy* [34] of 1585, as an episode from Virgil's epic poem of the founding of Rome, had special meaning for Romans, but Cristoforo Sorte considered the subject an excuse for painting nocturnes.[4] Federico Zuccaro's *Angels and Putti in the Clouds* [77] and *Vision of St. Eustace* [81] are also indicative of the new interest in color. The red chalk *Dead Christ Supported by Angels* [78] and *Healing of a Demoniac Woman* [79] are contemporary with these works of the 1560s, the last in red wash influenced in technique and composition by Taddeo Zuccaro. The *St. Eustace* also reveals Taddeo's hold on Federico, for the pose of the saint is a subtle variation on that of the proconsul in Taddeo's *Studies for the Blinding of Elymas* [82]. Roman history provided artists with formal models as well as popular subjects. Federico's *Demoniac Woman* and his *Naval Battle* [80] depend upon the *Laocoön* for prototypes. This Hellenistic grouping was recommended by G. A. Gilio in his *Due dialoghi* of 1564 as a model for subjects involving the sufferings of Christ, martyrs, and saints.[5]

Other foreigners who made important contributions to Roman art and who were, as was often the case, highly influenced themselves by art and artists in Rome, included the Neapolitan, Pirro Ligorio. An architect and antiquarian, he planned the Casino of Pius IV and was involved with the Villa d'Este in Tivoli and, after Michelangelo's death, with the construction of St. Peter's. Ligorio's *Seated Sibyl* [53] has the clean outline and vigorous interior modeling that so often characterize Roman drawings. Another architect and antiquarian who was also active in Ferrara was the painter Girolamo da

Carpi whose sketchbook [35] offers an antiquarian record of his Roman visit at mid-century. The Parma native, Enea Vico, documented his visit to Rome in the early 1540s, with his *Nile* [75], and an engraving of Baccio Bandinelli's studio [74]. Vico retained his meticulous pen technique in recording the robust Hellenistic river god, a technique no doubt influenced by his prodigious output of engravings. On Vico's death in 1567, Ligorio replaced him as Alfonso d'Este's court antiquarian in Ferra. Girolamo Muziano, who arrived in Rome from Brescia during the papacy of Julius III, executed panoramic frescoes at the Villa d'Este. His *Landscape* [56] offers a forbidding scene of rushing water, dense overgrowth, and steeply ascending outcroppings of rock in a setting totally unsympathetic to the presence of man.

Arguments can as easily be made for grouping Francesco Vanni with the Tuscan and the Lombard schools as with the Roman. He was, however, strongly affected by the paintings of Federico Barocci through the last two decades of the Cinquecento. The sweet smiles of the infants and prettiness of the Virgins in Barocci's paintings are repeated in Vanni's works. Vanni was also fascinated with the art of the great masters of the high Renaissance in Florence during the first decade of the sixteenth century. For *Madonna with the Infant Christ and St. John* [72] he borrowed the pose of Michelangelo's *Tadei Tondo* Christ of 1504. His rapid and repetitive drawing style, common by the 1580s, was related to Leonardo and Raphael, as was his preoccupation with squirming infants. *Sheet of Figure Studies* [73], with its Roman rhetoric and academic discipline, is a work of Vanni's late years.

Grouped in this exhibition with the school of Rome are a number of Bolognese artists including Bartolomeo Passarotti, the Carracci, and Domenichino. The school of Bologna is important in its own right as innovative, as the source of a prodigious and impressive output of paintings, and as having an important impact on Italian baroque painting in terms of style and studio practice. It provided a major impetus in shaping the direction of Roman painting through the seventeenth century and was supported by significant Roman patronage. For these reasons the above-mentioned artists are considered in the context of Roman art.

Passarotti spent almost fifteen years in Rome where he associated with the Zuccaro brothers and became addicted to the art of Michelangelo. He established an important studio in Bologna on his return there in 1565 where Agostino Carracci received his early training. The great impression Michelangelo's assured anatomies made on Passarotti was reinforced in Bologna by the mannerist Pellegrino Tibaldi, who had himself been influenced by the master's nudes during a Roman stay from 1546 to 1553 and who was also an important early influence on Annibale Carracci. Tibaldi's red chalk figure (Fig. II) combines Michelangelo's power with mannerist extravagance. A similar forcefulness in the anatomy study [59] connected with the circle of Passarotti can explain its mistaken

association with Michelangelo by a former collector. *Profile Portrait* [58] after Passarotti is related to the tradition of head studies he established during his career as a portrait painter in Rome and represents a refinement into formula of the technique displayed by Passarotti in his *Head of a Satyr in Profile* [57].

Landscape was one aspect of art that was never fully realized in Rome or developed to its full potential until the arrival of Annibale Carracci. His masterful pen and ink studies, *Eroded River Bank* [36] and *Landscape with a Boat* [37], reflect the assurance of a firmly established graphic technique. The predilection for etchings and engravings in Bologna and the emphasis on drawing in the academy are manifest in Annibale's control of the medium. The *Holy Family at Table with an Angel* [38] by Annibale's cousin, Lodovico, is an exemplary pen and ink study and is indicative of the Roman use of apocrypha for religious narratives.

Technique, clarity, and subject link Giovanni Francesco Gimaldi's *River Landscape with View of St. Peter's* [44] with Annibale Carracci's landscapes. Originally attributed to Domenichino, the sheet is now associated with Grimaldi, a native of Bologna who trained in the Carracci academy and spent many years in Rome. Like the *View of the Castel Sant'Angelo* [45] by the Frenchman, Etienne Dupérac, this drawing depicts a specific view of the Tiber.

Domenichino trained in the Carracci academy in Bologna but matured as an artist in Rome. His *Study for a Cupid* [43] as a study for a ceiling decoration is strongly foreshortened. The red chalk of this early sheet was quickly abandoned for Domenichino's preferred technique of black chalk with white highlights used in the *Allegory of Temperance* [42] of some twenty years later.

Important contributions to Roman art were made by natives like Giulio Romano and Giuseppe Cesari, whose *Half-Length Figure of a Man* [39] and *Satyr Head* [40], with their interior modeling and clear contours, continue the tradition established by Raphael and Michelangelo. Cesari was one of the many prominent Romans who sat for portraits by Ottavio Leoni. The latter's two chalk portraits [51,52] are even less in the spirit of Cinquecento drawings than Giraldi's *View of St. Peter's*. All are, however, emphatically Roman.

1. Vasari-Milanesi, 1878-85, VII, 179. Translation taken from Vasari, 1927, IV, 127.
2. Vasari-Milanesi, 1878-85, VII, 210; Armeni, 1977, p. 48.
3. Vasari-Milanesi, 1878-85, VII, 214.
4. C. Sorte, *Osservazioni nella pittura* (Venice: 1580), cited in Barocchi, 1960-62, I, 292.
5. G. A. Gilio, *Due dialoghi* (Rome: 1564), reprinted in Barocchi, 1960-62, II, 87. See also Ettlinger, 1961, I, 126.

Anonymous

29 *Sketchbook on Military Art*
Pen and brown ink, red water color, 120 × 160 mm., ca. 1630.
Library of Congress, Rosenwald Collection, ms. no. 27.
Provenance: The Rosenbach Company. *Published: Rosenwald Collection*, 1954, no. 879; *Rosenwald Collection*, 1977, no. 1363; Wheelock, 1977, pp. 97, 102 n. 20, fig. 4; Armenini, 1977, p. 47 n. 128.

This sketchbook deals primarily with military concerns such as sightings, the geometry of artillery trajectories, and fortifications. The last section, however, considers artist's problems such as foreshortening and mechanical devices for translating a three-dimensional reality onto a two-dimensional surface. Some of the techniques are based on Albrecht Dürer's woodcuts (Fig. 29a) from the *Treatise on Measurement* (1525).[1] On the basis of style this sketchbook has been dated to the early seventeenth century,[2] certainly after 1624 because quotations from Francesco Tensini's *La fortificatione*, published in that year, appear on leaves 29[b] and 102[b].[3]

1. Armenini, 1977, p. 47 n. 128.
2. Ibid.
3. *Rosenwald Collection*, 1977, no. 1363.

Cherubino Alberti
1553–1615
Cherubino Alberti was born in Borgo San Sepulcro but is known for his paintings and engravings executed in Rome. There he worked on decorations for the Sala Clementina in 1596–1598 and then on the vault of the Aldobrandini Chapel in Santa Maria sopra Minerva.[1] Alberti was made an honorary citizen of Rome in 1612 and became the Principe of the Academy of St. Luke under Pope Clement VIII. After 1613 he was occupied with fresco decorations for the Casino of the Palazzo Rospigliosi-Pallavicini.

Bartsch lists 172 engravings by Alberti, most of which were executed in the 1570s and 1580s.[2] His contemporary graphic artists, Agostino Carracci and the Netherlander Cornelis Cort, have a stronger feeling for form and are more adept at tonal contrasts, but Alberti's graphics are distinguished by a fluent and elegant flow of line.

1. Wittkower, 1969, p. 37.
2. Bartsch, 1818, XVII, 49-112, nos. 1-172; Thieme-Becker, 1907, I, 192.

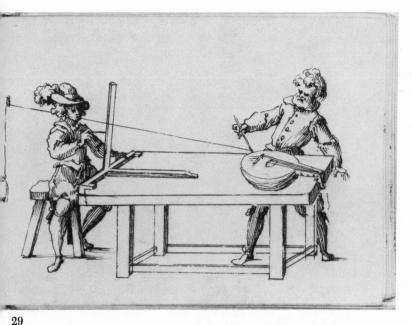

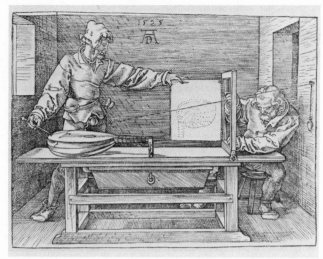

Fig. 29a. *Artist Drawing a Lute*, woodcut, 130 × 182 mm. Albrecht Dürer. The Metropolitan Museum of Art, New York, Harris Brisbane Dick Fund, 1941.

29

Cherubino Alberti

30 *Part of the Ceiling of the Sistine Chapel with the Prophet Daniel*

Engraving, 430 × 545 mm., executed in 1577, published in 1628. Notation: lower center, in pencil, *Part of the Capella Sistina.* Engraved inscriptions in plate: in cartouche at top, *opus quod in capella pallatila ppostol/michaelangelus bonarrota p fecit/aeneis tabellis a. nemine excussum/sereniss⁰. francisco maximo hetruriae/ duci/romae a.d.m. lxxvii;* below cartouche, *Cherubinus Albertus De Burgo S Sepulcri/Dicavit;* in placques, *Nason, Libica, Iessi/David/Salomn, Daniel, Iosap;* at bottom, *Cum privilegio Summi Pontificis 1628.* Vertical crease center, soiled.

Lent by the Metropolitan Museum of Art, Bequest of Joseph Pulitzer, 1917, 17.50.19-153.

Published: Bartsch, 1818, XVII, 76, no. 72.

This print is part of Alberti's series of engravings depicting sections of Michelangelo's Sistine ceiling and is pertinent to three of the nine drawings by Michelangelo in American collections.[1] The figure of a nude youth [55] appears in the upper right corner of the engraving above the colossal figure of the prophet Daniel. In addition there are the famous sketch for the Libyan Sibyl (Fig. XVI) and an early idea for the design of the vault (Fig. 30a). This tentative ceiling composition lacks the enthroned prophets and sibyls, has angels in place of the male nudes, and is divided into smaller and more varied geometric areas.

The uniform system of fictive lighting used by Michelangelo is clearly visible in the engraving. The lighting in drawings of single figures for the ceiling conforms in direction with that in the print suggesting that Michelangelo already knew when he executed them exactly where each figure would go in the finished ceiling. Therefore he must have had a complete design of the ceiling before he began painting or even drawing single figures. This contradicts in

Fig. 30a. *Plan for a Ceiling Decoration*, black chalk, pen and ink, 372 × 254 mm., 1508–1510. Michelangelo. The Detroit Institute of Arts, Purchase, City Appropriation.

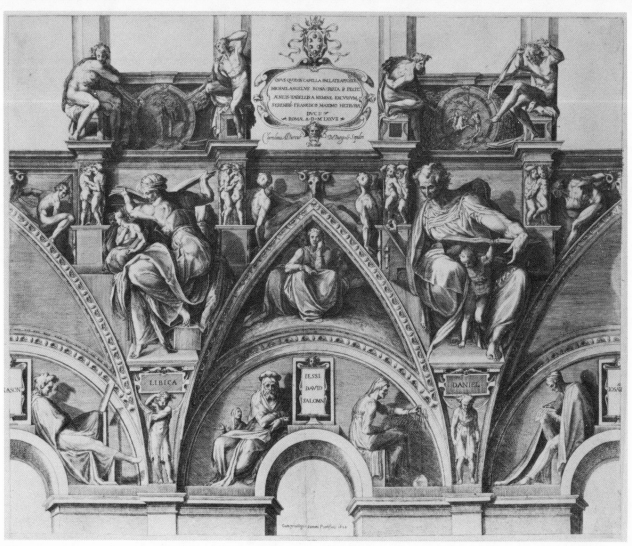

30

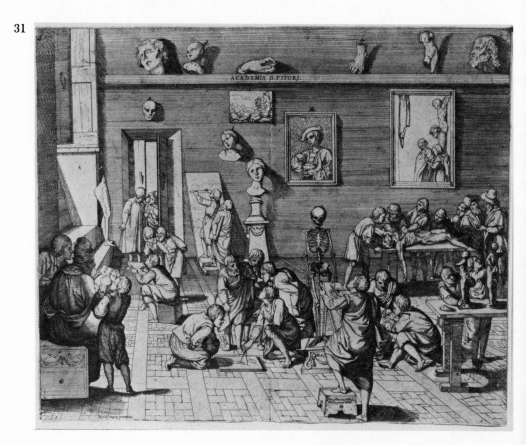

31

one sense Tolnay's contention that as work on the ceiling progressed Michelangelo became more "mannered," i.e., the *ignudi* grew more agitated and open in pose as the painting approached the altar wall.[2] If so, it was not the result of an evolution in style and expression as Michelangelo worked, but something deliberately intended from the outset.

1. Bartsch, XVII, 76, nos. 72-77.
2. Tolnay, 1945, II, 65.

Pierfrancesco Alberti
1584–1638

Born in Borgo San Sepulcro, Pierfrancesco Alberti is recognized primarily for his engravings. Perhaps the best known is his charming description of an artist's workshop. Very little is known of the details of Alberti's life and career as an artist.

Pierfrancesco Alberti

31 *A Painter's Academy in Rome*

Engraving, 220 × 280 mm. Engraved inscriptions in plate: at top center, *academia d' pitori;* at lower left, *P. Romae Super. permissu;* at bottom right, *Petrus Frāciscus Alber/tus Inventor et fecit.* Vertical tear center.
Lent by the Metropolitan Museum of Art, The Elisha Whittlesey Collection, The Elisha Whittelsey Fund, 1949, 49.95.12.
Published: Bartsch, 1818, XVII, 313-314, no.1.

The future well-being of the arts lies at the portal of the artist's academy through which an aspiring artist enters and where the lines of perspective converge. The back wall of the studio attests to the proper function of draftsmanship in architecture, sculpture, and painting. Three pictures illustrate the appropriate subjects for painting: landscape, portrait, and religious themes. Alberti's print gives a more comprehensive view of the artist's academy than the examples by Vico [74] and Pollini [60]. The room is littered with paraphernalia: a death mask, plaster casts of parts of the human body, portrait busts, a skeleton, and a corpse. Surprisingly, a live model is absent. In the left foreground a young apprentice's drawing of eyes, apparently based upon an artist's primer like Fialetti's (Fig. VIII), is criticized by a master. Right of center two *studiosi* draw from a skeleton (see [2, 49]) while advice is offered to one of them by an older artist, and near the door a young man sketches a plaster cast of a leg. Elsewhere students model in clay and a cadaver study is in progress (see [59, 66]). In the center of the room a group discusses geometry, mimicking a similar arrangement of figures in Raphael's *School of Athens* where Euclid and Ptolomy do the same. All activity now takes place in the bright light of day.

Federico Barocci
ca. 1535–1612

Federico Barocci dominated Italian painting in the decade up to 1595. A native of Urbino, he studied for a short time with Battista Franco who was in Urbino from 1545 to about 1553. Barocci visited Rome in 1555. On a second trip to Rome around 1560, he suffered a serious illness and claimed to have been poisoned. After languishing in inactivity for four years in Urbino, Barocci began to paint again in 1567, abandoning the mannerist principles of his early style for an art influenced by the paintings of Correggio. His art matured in the direction of a sweet sentiment. It reflected a new seriousness characterized by normative proportions, purposeful gestures, and a descriptive naturalism. Barocci preferred brittle, glowing colors and form blurred by a delicate *sfumato.*

Federico Barocci

32 *Plants above an Eroded Bank*

Black chalk, brown, red-brown, and gray washes with pink and white opaque water color, 200 × 132 mm., ca. 1580. Notations: lower right, in pen and black ink, *del Barocci;* verso, in pen and brown ink, *originale del Barocci;* in pencil, *D21 7EHLX.*
The Cleveland Museum of Art, J. H. Wade Fund, 73.171.
Provenance: Camuccini, Rome; Yvonne Tan Bunzl, London; Dean of Chichester. *Sales:* Florence, Sotheby, 18 October 1969, no. D71, repr. 46; London, Yvonne Tan Bunzl, 6-25 April 1970, ŋo. 7, repr. *Exhibited:* Cleveland, 1974, no. 49; New Haven, 1978, no. 33, repr. front cover. *Published:* Bertelà, 1975, under no. 16 (inventory number incorrectly cited as 73-108).

As Harald Olsen has observed, "Barocci never painted a landscape proper," yet more than 170 landscape drawings were in

32

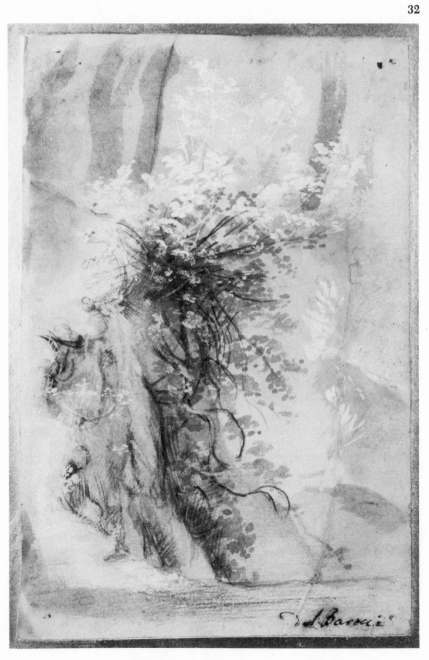

33

is as much an essay on light as it is a land-scape study. The touches of brown wash and gobs of white impasto daubed at the top center function as tiny wild flowers and shimmering leaves reflecting filtered light. Line and form are spatially active, and the power of suggestion is strong throughout. Certain brown lines can be read as rills in an embankment, others as roots and branches, and thin highlights as allusions to grass.

The technique in the Cleveland drawing is similar to that in *St. Francis Receiving the Stigmata.* Other drawings include studies of trees evocative of mood and atmosphere in a way that would be ap-proached again only in the paintings of Corot and Monet.[4] The Louvre's large sheet of a forest scene may be the closest Barocci ever came to a finished landscape; it rivals early Cinquecento Venetian landscapes in its feeling of reverie.[5] In fact Oberhuber noted Barocci's dependence upon Titian's woodcut of *St. Jerome in the Wilderness* for the composition of the *Stigmata.*[6]

1. Olsen, 1965, pp. 27, 32.
2. *Stigmatization of St. Francis*, pen and brown ink, brown wash, white highlights over black chalk on blue paper, 390 × 270 mm., London, British Museum, inv, no. Pp. 3-203; Pillsbury, 1978, no. 30.
3. *Precipice with a Shrub*, black chalk, charcoal, white highlights and water color, 423 × 277 mm., Florence, Uffizi, inv. no. 418P; Emiliani and Bertelà, 1975, no. 78. Pillsbury dates Barocci's landscape drawings ten years later than Bertelà's date of 1565–1570 for the Cleveland sheet. See Emiliani and Bertelà, 1975, no. 16 and New Haven, 1978, no. 32.
4. Rome, 1972, nos. 143, 145.
5. *Study of Forest Bed with a Reclining Figure*, black chalk, pen and ink, brown wash and white highlights, 605 × 463 mm., Paris, Louvre, inv. no. 2916; Rome, 1972, no. 143, pl. xv.
6. Washington, 1973, no. 17; New Haven, 1978, no. 31.

Federico Barocci

33 *Putto*

Black, white, and colored chalks on blue paper, squared for transfer in black chalk, 424 × 273 mm., ca. 1565. Notations: lower left corner, in pen and brown ink, *X - Lagnori / L (R)agunor;* verso of mount, in pencil, *3,4;* scratched into paper, *ADAMIDI BL Hotel Fo Chateau Frontas.* The Cleveland Museum of Art, Dudley P. Allen Fund and Delia E. Holden Fund, 69.70.

Provenance: Giuseppe Vallardi (Lugt 1223); A. Mouriau (Lugt 1853); Two unidentified collector's marks. *Sale:* Paris, expert Vignères, 11-12 March 1858 (Mouriau collection), no. 21. *Exhibited:* Cleveland, 1970, no. 155, repr. p. 12; St. Louis, 1972, no. 8, repr.; New Haven, 1978, no. 11, repr. p. 39.

No painting by Barocci has been discovered in which a figure of a putto corresponds fully to the one in this drawing, although the pose of the legs may be found in several other figures, such as the Christ Child in the *Martyrdom of St. Sebastian* in Urbino of 1557–1558. It has been shown that this figure is a combination of two putti fres-coed in the Casino of Pius IV where Barocci

his studio at his death,[1] of which barely twenty survive. Landscape elements began to appear in his paintings with greater fre-quency and more prominence about 1565. He paid particular attention to single trees and pairs of trees in his studies for *St. Fran-cis Receiving the Stigmata.*[2] The mystical light that strikes the tree gives it icono-graphical significance. A similar suggestion has been made by Andrea Emiliani and Gio-vanna Bertelà concerning *Precipice with a Shrub*, and perhaps this is also true for *Plants above an Eroded Bank.*[3]

The Cleveland sheet is an example of Barocci's preoccupation with a detail which is typical of his use of drawings. It was his practice to resketch individual figures as

well as to rework limbs of single figures — torsos, arms, legs, feet — after having fixed the figure in a composition. A number of such studies can be associated with *Aeneas's Flight from Troy* [34]. This practice par-allels the study of the fragment — of human anatomy in the studio and of broken marbles by the antiquarians.

This drawing has been variously titled, *Flowering Bush above an Eroded Bank, A Study of Trees on a Bank,* and *Study of Plants on a Bank.* Several interpretations are possible because Barocci provides no clues to indicate scale. The question re-mains: Is this a weed on a clump of sod, a bush on an embankment, or a tree on the side of a mountain? Whatever, the drawing

worked between 1561 and 1565.[1] Is this putto, then, a composite of the ones in the papal Casino or were the painted figures derived from the drawing? The drawing seems to have been in preparation for a project since it has been squared in black chalk to facilitate the transfer of the design to a larger surface, but perhaps it was never used or the painting in which it appears has been lost.

The only non-religious subject Barocci is known to have painted, besides portraits, is his late *Aeneas* [34], although Bellori reports him copying Raphael's mythological figures in the Villa Farnesina.[2] The subject here is also from mythology, Cupid aiming an arrow while seated on the knees of his mother, Venus. The drawn bow functions as a compositional focus in this design. It arches below the left arm of the putto connecting with the figure at the hip to dissipate its energies diagonally through the extended left leg. The string and arrow are the only straight lines in this otherwise pulsating composition. The bow also provides a motive for the counterpoise of the figure and adds visual interest as its curvature is played against the diagonal of the arrow and the triangle of the drawn string.

Pillsbury suggested that this drawing may have been an experiment for Barocci in mixing chalks and, one might add, exploring color possibilities.[3] Bellori reported that his interest in colored drawings was sparked by an artist from Parma who, while visiting Urbino, showed Barocci several works in color by Correggio. Gere pointed out that Barocci was influenced by the colored drawings of Taddeo Zuccaro which he saw in Rome and it was after this trip that he produced many large-scale studies in colored chalks.[4]

Although there is the connection between the *Putto* and the Casino decorations of ca. 1565, it is difficult to be certain when the drawing was executed. Pillsbury found no correspondence in terms of style, subject, or technique with Barocci's drawings from the decade 1555–1565. When Barocci left Rome (ca. 1565) to convalesce in Urbino, he would have been unable to work on large projects and perhaps it was then that he began to explore the use of colored chalks and the synthetic *pastelli*. Pillsbury observed that the *Putto* compares well with other early chalk drawings by Barocci now in Berlin, Stockholm, and New York and that more drawings unrelated to known paintings survive from this period than from any other in Barocci's career. Also, compared to later works, Barocci had not yet settled on his use of flesh colors for highlights on chin, nose, and cheeks; instead pink pastel is used more homogeneously and with a light ochre to suggest the warmth and vitality of human flesh. White highlights, used sparingly and uncertainly, appear on knees and left bicep. Because of the extensive use of ochre, the formula modeling, and hesitant

contours, Pillsbury suggested that the sheet may be by a studio assistant, perhaps Ventura Mazzi, who worked in colored chalks and made large drawings after putti in Barocci's works of the 1560s.[5]

1. New Haven, 1978, no. 11; Neilson, 1972, no. 8; Olsen, 1962, pl. 8b.
2. Bellori, 1672, p. 172; see also Pillsbury's translation of Bellori's biography of Barocci in New Haven, 1978, p. 14.
3. New Haven, 1978, no.11.
4. Gere, 1963a, p. 394, n. 12.
5. New Haven, 1978, no. 11.

Federico Barocci

34 *Aeneas's Flight from Troy*
Pen and brown ink, brown wash with pale yellow opaque water color over black chalk, on blue paper, 276 × 426 mm., 1587–1588. Notations: lower left corner, in pen and brown ink, *17*; lower right corner, in pen and brown ink, *Barocci, 55*; verso of mount, in pen and brown ink, *Intagliato da Agostino Caracci Il quadro è in Casa Borghese*; in pencil, *2767*.
The Cleveland Museum of Art, L. E. Holden Fund, 60.26.

Exhibited: Cleveland, 1960, no. 72, repr. p. 245; Detroit, 1965, no. 63, repr. p. 74; Los Angeles, 1976, no. 112, repr. p. 95; New Haven, 1978, no. 54, repr. p. 77; Washington, 1979, p. 328, no. 2.
Published: Richards, 1961, pp. 63-65, repr. 63; Olsen, 1962, pp. 77, 182, pl. 64; *Selected Works*, 1967, no. 148; Bacou, 1974, under no. 14; Bertelà, 1975, under no. 56.

The story of Aeneas's flight from Troy is recounted by Virgil in Book II of the *Aeneid*.[1] As fire rages within the walls of the besieged city, Aeneas lifts his aged father, Anchises, to his shoulders. Anchises clutches the household gods as the pair departs accompanied by Aeneas's wife, Creusa, and their young son, Ascanius. With the fall of Troy, Aeneas begins the long journey that will end in the fulfillment of his destiny as founder of Rome.

It is understandable that the subject was of interest to such patrons as the Holy Roman Emperor, Rudolf II, and the Roman Monsignore, Giuliano della Rovere. Rudolf delighted in paintings with allegorical references to himself as Vertumnus and other Roman emperor-deities.[2] In 1585 he commissioned a painting of Aeneas's flight from Federico Barocci which was delivered to Prague three years later, but which is now lost. A replica painted in 1598 for Monsignore della Rovere is the version now in the Villa Borghese in Rome.[3]

Numerous drawings related to this project exist[4] showing how carefully Barocci studied each aspect of the composition. Many explore and refine poses for the figures. A sketch for the *Head of Anchises* is in Windsor, sketches for Creusa and for her hands, for the arm and leg of Ascanius, the legs of Anchises and of Aeneas and Anchises are in Berlin,[5] and Pillsbury has recently assigned to Barocci a study for the *Head of Ascanius*, formerly thought to be a copy, in Princeton.[6]

A chalk drawing in the Uffizi of a striding female nude with bowed head was used for Creusa, while other Uffizi drawings are for the battling figures in the background, Aeneas and Anchises (Fig. XIII), and the hands and feet of Anchises.[7] One of these, for Anchises's right hand, is a significant detail for the narrative (an attempt to reinstate the *istoria* to the importance given it by Alberti in the early Quattrocento), since the old man clutches the household gods which serve as symbols of domestic virtue and as a counterpart to the respect for family found in the three generations of the central grouping.[8]

It is interesting to note the sources Barocci utilized for this composition. The idea of Creusa glancing backward to see if they are being pursued was probably inspired by the figure of Lot's wife in a fresco depicting Lot and his family fleeing Sodom in the fourth bay of Raphael's Vatican Loggia executed by Raphael's assistants Giulio Romano and Gianfrancesco Penni.[9] A pair of men in Raphael's fresco, the *Fire in the Borgo*, may have served Barocci as a model for the figures of Aeneas and Anchises. He did not, however, quote Raphael exactly, as did Jacopo Caraglio in his engraving.[10] The reversal of the figures suggests that Barocci may have worked from a print such as Caraglio's although he was often in Rome and devoted to Raphael to the extent that he would have known the fresco. Perhaps Barocci was also influenced by Adamo Ghisi's engraving because several changes found in Ghisi's print reappear in his painting.[11] Ghisi added the idol carried by Aeneas (but held by Anchises in Barocci's version). Barocci also retained Ghisi's invention of Ascanius clinging to Aeneas's thigh.

Olsen recognized Bramante's Tempietto included in the background of the painting and also identified Sansovino's library.[12] Barocci's study for the Tempietto is in the Uffizi with a second sketch in Urbania. The artist did not derive the background setting from the Roman monuments themselves, but rather from the illustrations of Serlio's third book on architecture first published in Venice in 1540.[13]

There are also several studies for the entire composition. The Uffizi has a black chalk sketch which establishes many elements of the final scheme; the placement of the figures, the perspectival delineation of the space, the open right side, and the staircase at the left. The Cleveland drawing and a squared cartoon in the Louvre were both probably used for the original version of the painting.[14] They differ from the Borghese canvas in certain details, and it seems unlikely that Barocci would produce a new set of studies for the painted copy. The Cleveland study is a working drawing with trial sketches for Creusa and for Aeneas and Anchises in the right margin. In the painting the fleeing group is placed

Fig. 34a. *Aeneas and Anchises,* brown oil, heightened with white.
Agostino Carracci, Italian, 1557–1602. Royal Library, Windsor Castle.

more prominently in the foreground and the architecture is more pronounced providing a stabilizing matrix for the composition. The plumes of Aeneas's helmet, the medallion over Anchises's shoulder, and the dog, presumably the family pet excited by the noise and confusion of the pillaging, have all been omitted from the painting.

There is also a brown oil sketch heightened with white in the Royal Library, Windsor Castle (Fig. 34a), which may be the work listed by Mariette in his catalog from the Pierre Crozat sale in 1741.[15] Rudolf Wittkower suggested that this served as a study, by Agostino Carracci, for the engraving he executed after Barocci's painting. Bellori mentioned this print, and Carlo Cesare Malvasia related that Agostino sent Barocci two proof impressions but they were not well received.[16] Rosaline Bacou reasoned that Agostino's source was a final preparatory drawing, now lost, for the first version of the work, since the painting had been sent to Prague in 1589, before Agostino's arrival in Rome.[17] and the second version of the painting is dated 1598 while the engraving is signed 1595.

34

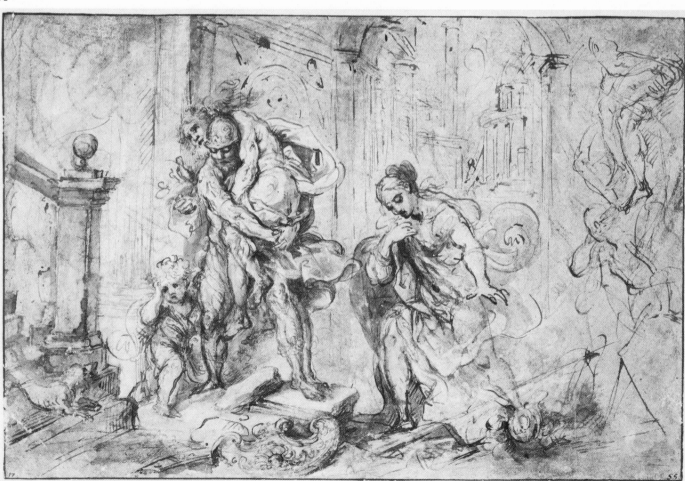

I am grateful to Brenda Dawes for assisting in the research of this drawing.

1. Virgil, *Aeneid*, II, 671-744.

2. The emperor was depicted in the painted fantasies of Arcimboldo as a god of the harvest. See Kaufmann, 1976, pp. 295-296; Evans, 1973, pp. 168-172.

3. The first version of the painting later entered the collection of Queen Christina of Sweden and was last known when it appeared at auction in London in 1800; Olsen, 1962, pp. 180-182, no. 39. The copy is repr. della Pergola, 1969, p. 7.

4. Olsen, 1962, p. 182.

5. *Head of an Old Man Turned Three-Quarters to the Left, Inclined, and Looking Down*, colored chalks on blue paper, Royal Library, Windsor Castle, no. 5233, Popham and Wilde, 1949, pl. 92; in the Kupferstichkabinet, Staatliche Museen, Berlin: *Study for Creusa*, no. 4588, *Study for Creusa's Hands*, no. 20274, *Study for the Arm and Leg of Ascanius*, no. 20293, *Study for the Legs of Anchises*, no. 20262, and *Study for Aeneas and Anchises*, no. 20294.

6. *Young Boy Resting Head on His Right Arm*, black and white chalk on green tinted paper, 359 × 243 mm., The Art Museum, Princeton University, inv. no. 47-119; Pillsbury, 1976, p. 63; New Haven, 1978, no. 55, repr. p. 79.

7. In the Uffizi, Florence, *Figures Battling in the Background*, no. 11353 F, Florence, 1975, fig. 164; *Study for Creusa*, no. 11296 recto, study for *Aeneas and Anchises*, no. 11642 verso, repr. Di Pietro, 1913, fig. 96, *Study for the Hands and Feet of Anchises*, no. 11666 F, repr. Di Pietro, 1913, fig. 97.

8. *Study for the Right Hand of Anchises*, Florence, Uffizi, no. 11650 F, repr. Di Pietro, 1913, fig. 98.

9. Repr. Dacos, 1977, pl. xxia. Penni's drawing for the fresco is in the Ball State University Art Gallery. See Providence, 1973, no. 42.

10. Bartsch, XV, p. 94, no. 60.

11. Bartsch, XV, p. 420, no. 9. Other works after Raphael that Barocci may have known include Ugo da Carpi's chiaroscuro woodcut and Parmigianino's drawing. The latter was executed as a chiaroscuro woodcut by A. M. Zanetti in 1723, repr. Karpinski, nos. 104.12, 175.35.

12. Olsen, 1962, p. 78, n. 153. The column in the background is reminiscent of the Roman Columns of Trajan and Marcus Aurelius. See Malmstrom, 1968-69, p. 44.

13. *Study for the Tempietto*, Florence, Uffizi, no. 135 A, repr. Günther, 1969, p. 243; *Perspective Study for Architecture*, black chalk, squared in black and red chalk, Biblioteca Comunale di Urbania, no. 137, II verso, repr. Bianchi, 1959, pl. 4

14. See New Haven, 1978, p. 78. *Compositional Sketch*, black and white chalk on blue paper, Florence, Uffizi, no. 11296 F, verso, repr. Emiliani and Bertelà, 1975, fig. 163; *The Flight of Aeneas*, black chalk, Louvre, no. 35774, repr. Bacou, 1974, pl. ix.

15. Mariette, 1741, p. 24, no. 248; "Deux grands Desseins du Baroche faits à huile en blanc et noir; l'un de l'Icendie de Troyes qui a été gravé par le Carache."

16. Wittkower, 1952, p. 113, no. 99; Bellori, 1672, p. 115; Malvasia, 1678, pp. 267-268.

17. Bacou, 1974, no. 14; see also Olsen, 1962, pp. 180-182, no. 39.

Girolamo da Carpi

1501–1556

Girolamo da Carpi was a native of Ferrara who from about 1525, resided in Bologna for ten years. During this time the strongest impression on his style was made by Raphael and Giulio Romano. He collaborated with Garofalo and Battista Dossi working primarily in Ferrara on projects for the Este family. Girolamo's preoccupation with Roman antiquities, evident in the sketchbooks now in Philadelphia and Turin, was sparked by a trip to Rome in 1549. He remained in Rome as architect for Pope Julius III on the Vatican Belvedere until his return to Ferrara in 1554.

Girolamo da Carpi

35 *Roman Sketchbook*

Pen and brown ink, brown wash, most sheets ca. 345 × 125 mm., 1549-1553. Watermark: CM (Briquet 495). Soiled.

The Philip H. and A. S. W. Rosenbach Foundation.

Provenance: Thomas Lawrence (Lugt 2445); Samuel Woodburn (Lugt 2584); Thomas Phillipps (under Lugt 924b); Thomas Fitzroy Phillipps Fenwick (Lugt 924b); A. S. W. Rosenbach, Philadelphia. *Published:* Canedy, 1976.

The Roman sketchbook of Girolamo da Carpi, has been studied extensively by Norman Canedy.[1] It was compiled during Girolamo's stay in Rome from 1549 to 1554 and contains drawings of grotesques, ancient sculptures, and contemporary works. The designs were not directly based upon the objects they recorded but were instead after other artist's drawings, especially those of the Raphael circle and Parmigianino. Three of Girolamo's sketchbooks were borrowed by Francesco Brizio when in the possession of Cavaliere Bolognetti.[2] In his treatise on painting Armenini recommended making faithful imitations of other artists' inventions to attain facility in draftsmanship. The artist was encouraged to copy the works of other masters so closely that original and imitation would be indistinguishable.[3]

Canedy identified many subjects of the drawings and a number of artists of the original versions. They include a relief of the Death of Maleager from a sarcophagus in Sant'Angelo in Pescheria (Fig. XXIII), one of the Dioscuri horsemen from the Montecavallo in Rome below which is a figure of Juno [35], a statue located in the garden of the Cesi family in the sixteenth century, and a Psyche now in the Capitoline Museum which was once in the Roman villa of Agostino Chigi (Fig. 35a).[4] Perino del Vaga's drawing in Chantilly for a frieze in the Castel Sant'Angelo is copied on another leaf (Fig. 35b).[5]

Canedy noted that Girolamo's Roman sketchbook is "The most extensive single compilation of figural studies from the hand of a mid-sixteenth-century Italian artist of

35

stature."[6] It also represents the largest repertory of antiquities known from a Cinquecento sketchbook which makes it valuable in providing new information about antique sculpture in Rome.

1. Canedy, 1975.
2. Malvasia, 1678, I, 542.
3. Armenini, 1977, p. 124.
4. Canedy, 1976, p. 65, no. R123; pp. 41-42, no. R31; p. 50, no. R102.
5. Ibid., p. 75, no. R169.
6. Ibid., p. ix.

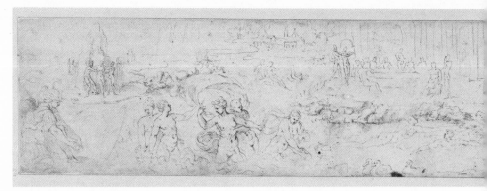

Fig. 35b. *Perseus*, pen and brown ink, 127 × 402 mm. Girolamo da Carpi. The Philip H. and A. S. W. Rosenbach Foundation, Philadelphia.

Fig. 35a. *Psyche*, pen and brown ink, 362 × 122 mm. Girolamo da Carpi. The Philip H. and A. S. W. Rosenbach Foundation, Philadelphia.

Annibale Carracci

1560–1609

The Carracci family—Annibale, his brother Agostino, and cousin Lodovico—ran a large and active studio in Bologna, where the stylizations of late Cinquecento *maniera* were contradicted by a new emphasis on the study of nature. This led to the development of genre scenes, like Annibale's *Butcher Shop* of the 1580s (Christ Church, Oxford).

The Carraccis collaborated on frescoes for the Palazzo Fava (1584) and Palazzo Magnani (1568–1591) and pursued individual projects for altarpieces. Annibale was summoned to Rome in 1595 by Cardinal Odoardo Farnese; Agostino and their pupils Domenichino, Guido Reni, and Lanfranco arrived shortly after. Annibale's fresco project for the Farnese Gallery dominated his stay in the Holy City. It was a commission of epic proportions and prolonged duration which allowed him to absorb the art of Raphael, Michelangelo, and the antique. The large-scale figures and festive nudes of the allegorical paintings—with simulated moldings, sculpture, and bronze medallions—comprise a harmonious and legible decorative program for the room. Annibale's *Flight into Egypt* for the Palazzo Aldobrandini chapel demonstrates his contributions to classical landscape. After Annibale fell ill ca. 1605, he relied upon studio assistants to complete his projects.

Annibale Carracci

36 *Eroded River Bank with Trees and Roots*

Pen and brown ink, on tan paper, 402 × 280 mm., ca. 1590. Notation: lower center, in pen and brown ink, *Anibbale Caracci*. Mounted on closely trimmed Mariette mat.

The Pierpont Morgan Library, New York, 1972.6 (It.16.4).

Provenance: Pierre-Jean Mariette (Lugt 2097); Count Moriz von Fries (Lugt 2903); Thomas Lawrence (Lugt 2445); Lord Francis Egerton, first Earl of Ellesmere (Lugt 2710b). *Sale:* London, Sotheby, 11 July 1972 (Ellesmere collection, drawings from the Lawrence collection, Part I), no. 54,

repr. p. 120. *Exhibited:* London, 1836, no. 60; London, 1938, no. 362; Leicester, 1954, no. 65, pl. xix; London, 1955, no. 31; Bologna, 1956, II, no. 239; Newcastle upon Tyne, 1961, no. 97; Hamburg, 1972; New York, 1973, no. 25; Los Angeles, 1976, no. 91. *Published: Catalogue of the Ellesmere Collection of Drawings at Bridgewater House*, no. 74; Stampfle, 1974, no. 8, repr.; Bodmer, 1934, pl. 63 (as Agostino); Morgan Library, 1976, pp. 145, 157 f.

Annibale's important contributions to the development of landscape painting were made in Rome. According to Donald Posner, "a new, ideal vision of nature and of the relation of man to nature crystallized in his Roman works, which became the foundation of one of the most inspired landscape traditions in the history of Western painting."[1]

Eroded River Bank with Trees and Roots is close in conception to his painting of ca. 1599, *Landscape with the Sacrifice of Isaac*.[2] Here Annibale chose a theme often found in northern European works, "a view of a great height and of the vast expanse of land below it."[3] Richard Turner's observations on the painting are also valid for the drawing: "The large tree is a fine summary of Annibale's dexterous and tasteful accomplishment as a landscapist," and while "Annibale's most brilliant essay in landscape, it was hardly the most typical or influential."[4]

The Morgan *River Bank* is vigorous, majestic, and solemn. Comprised of decayed and flowering trees, a gnarled trunk, and graceful saplings, it is an essay in contrasts. Light open spaces alternate with textured gray areas and dark cavities. Pressure on the pen and the direction of the strokes are varied to yield thin and heavy lines. In the opening to the left a figure in a boat is barely more discernible than the hill rising in the mist-filled background beyond it, with details lost in the scattered light. Although this study may have been atypical for Annibale, it confirms nonetheless, that landscape was for him essentially a problem in light and spatial structure.[5]

1. Posner, 1971, I, 113.
2. *Landscape with Sacrifice of Isaac,* oil on copper, 450 × 340 mm., ca. 1599, Paris, Louvre. Repr. Posner, 1971, II, no. 117, pl. 117.
3. Posner, 1971, I, 119.
4. Turner, 1966, p. 186.
5. Ibid., p. 191.

Annibale Carracci

37 *Landscape with a Boat*

Pen and brown ink, 224 × 405 mm., ca. 1595. Notations: on verso of mount, in pen and black ink, 77 (crossed out),* *91 Agostino Carracci A Landscape with a river and boats: one full of company executed with a pen, size 8¾" × 16" (¾ crossed out) From the Collections of M. Mariette & Sir Thomas Lawrence.*

The Cleveland Museum of Art, Purchase, J. H. Wade Fund, 72.101.

Provenance: Everhard Jabach (Lugt 2959); Pierre Crozat (Lugt 2951); Pierre-Jean Mariette (Lugt 2097); Count Moriz von Fries (Lugt 2903); Thomas Lawrence (Lugt 2445); Lord Francis Egerton, first Earl of Ellesmere (Lugt 2710b). *Sale:* London, Sotheby, 11 July 1972 (Ellesmere collection, drawings from the Lawrence collection), Part I, no. 52, repr. p. 116. *Exhibited:* London, 1836, no. 64; Leicester, 1954, p. 4, no. 43, pl. xvii; London, 1955, no. 19; Bologna, 1956, no. 240; Newcastle upon Tyne, 1961, no. 96; Hamburg, 1972; Cleveland, 1973, no. 146, repr. p. 76. *Published:* Catalogue of the *Ellesmere Collection of Drawings at Bridgewater House,* no. 91; Levey, 1971, under no. 56 (mistakenly as in the Duke of Sutherland's collection); Cooney and Malafarina, 1976, p. 133, fig. xix.

*The crossed out 77 may refer to a similar landscape drawing shown in the Royal Academy exhibition in London in 1938, no. 364, as by Agostino Carracci.

In the overall context of Annibale's activity, landscapes formed only a peripheral interest for the artist. In terms of the genre, however, his works are of major significance. His interest in landscape was stimulated by a trip to Venice in 1587–1588. The landscape paintings executed during Annibale's next few years in Bologna are weak and exploratory, due in part to the lack of a vital and coherent local landscape tradition.[1] The last decade of the sixteenth century, which spanned the late years of his stay in Bologna and his early Roman phase, nevertheless, was Annibale's most fertile period of activity in developing landscape as a self-contained composition, independent of other content. In this rich and imaginative phase of Annibale's career his landscape inventions were as brilliant and varied as his work in the Farnese gallery.

Annibale's Roman landscape paintings are inviting and tranquil and represent mythological or religious subjects.[2] While the Cleveland drawing's subject is more general, it depicts a placid scene and is highly sophisticated in terms of composition. Annibale has created an orderly, perfectly balanced world illuminated by bright sunlight. The foreground bank eases movement into the scene. It initiates the landscape and softens the severity of the regular pen border. With the pollard tree at the left and the intertwined clump of trees at the right, it also concentrates the spectator's vision on the winding river. Annibale's strong sense of interval enhances the structure of his composition, and the interaction of solid and void imparts a feeling of advance and recession in Annibale's probing of space.

Landscape with a Boat can be dated later than the National Gallery of Art's painting of 1589–1590 which is confining in the rigid placement of heavy trees across the foreground, and which is more obviously contrived than the Cleveland design.[3] *Landscape and River Scene* (1593) in Berlin has the same idyllic mood and note of reverie as the Cleveland drawing.[4] The painting, however, is still too composed and the spatial construction is less coherent. This time a large architectural structure obstructs the view of the distance and the observer is forced back into the foreground. The Cleveland drawing is closer in style to Annibale's *Landscape with a Man Sleeping Beneath a Tree* (1595),[5] and the sheet conforms more with the accomplishments of his Roman period.

Elements of this study were incorporated into paintings by other artists such as *Landscape with a River and Boats* (Fig. 37a), which represents a reworking of the drawing's composition with some additions.[6] A similar version is in the Denis Mahon collection.[7] A reversal of the composition appears in the etching by Michelangelo Corneille made when the sheet was in Eberhard Jabach's drawing cabinet (Fig. 37b).[8]

36

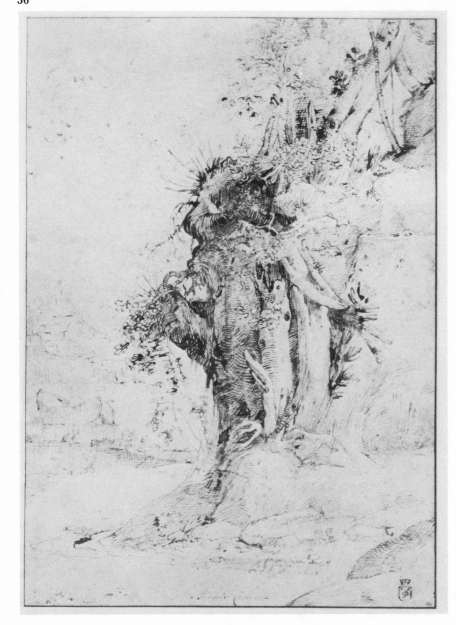

1. Posner, 1971, I, 113.
2. Ibid., p. 118.
3. *Landscape*, Washington, National Gallery of Art (Samuel H. Kress Collection), repr. Posner, 1971, II, pl. 50.
4. *Landscape and River Scene*, Berlin, Staatliche Museen, repr. Posner, 1971, II, pl. 74.

5. *Landscape with a Man Sleeping Beneath a Tree, His Dog to the Right*, pen and brown ink, 304 × 224 mm., London, Sotheby, 11 July 1972, (Ellesmere Collection), Part I, no. 58, repr, p. 128.
6. *National Gallery, General Catalogue*, 1973, no. 56. See also Leicester, 1954, no. 43; Levey, 1971, no. 56.
7. Domenichino, *Landscape with a Boating Party*, oil on canvas, 349 × 546 mm., London, Collection of

Denis Mahon, *L'Ideale*, 1962, no. 13, pl. 13. While the pollard trees in painting and drawing are similar, the painted boat does not contain a sail, and other trees at the right are only approximately like those in the drawing.
8. *Recueil d'Estampes au Cabinet du Roy*, 1754, no. 11.B; Robert-Dumesnile, 1842, VI, 314, no. 72.

Fig. 37a. *Landscape with a River and Boats*, oil on canvas, 952.5 × 1321 mm. Style of Annibale Carracci, Italian. The National Gallery, London.

Fig. 37b. *Landscape with a Boat*, etching. Michelangelo Corneille, French, 1642–1708. Bibliothèque Nationale, Paris.

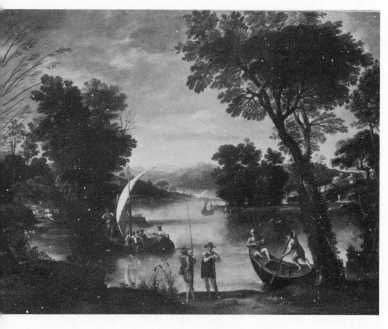

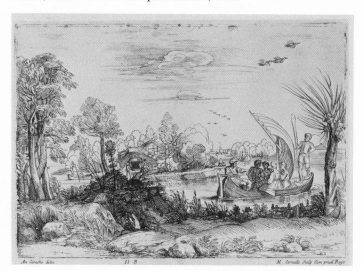

37

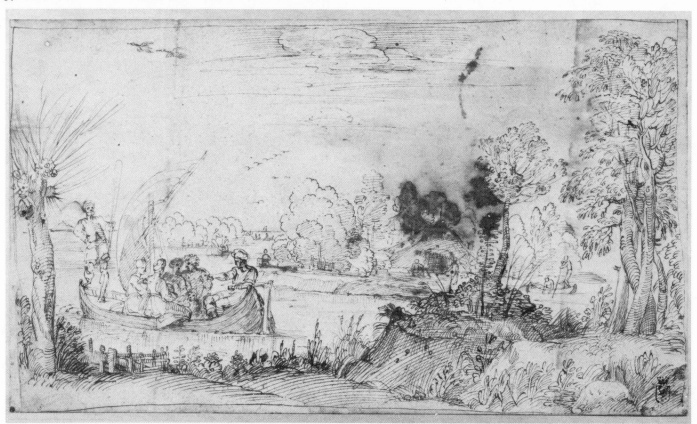

Lodovico Carracci

1555–1619

With his cousins Agostino and Annibale Carracci, Lodovico formed a private school in 1582 in Bologna called the Accademia degli Incamminati.

Lodovico's mature paintings are strong in narrative content, emphatic expression, and corporeal figures of great immediacy. Like the Venetians, he tended toward the painterly. Lodovico's paintings of the late 1580s and 1590s—such as the *Madonna degli Scalzi* of 1593 in the Galleria, Bologna—were in the developing baroque taste with its seriousness and elevated sentiment. In the 1600s his art became more linear and decorative, more ordered and classical, sweeter and more elegant.

Lodovico Carracci

38 *The Holy Family at Table with an Angel*

Pen and gold ink on vellum, 98 × 95 mm., after 1600. Notations: lower left, in pen and gold ink, *LOD. C./F.*; verso of former mount, in blue pencil, *30. Lodovico Carracci Christ with Virgin attended by an Angel.*

The Cleveland Museum of Art, Dudley P. Allen Fund, 72.100.

Provenance: Count Aldrovandi (or Aldrovandus, Rome, late 16th century); Thomas Lawrence (Lugt 2445); Lord Francis Egerton, first Earl of Ellesmere (Lugt 2710b); Unidentified (Lugt 2725a). *Sale:* London, Sotheby, 11 July 1972 (Ellesmere collection), Part I, no. 9, repr. p. 32. *Exhibited:* London, 1836, no. 21; Leicester, 1954, no. 73 (as a copy of a lost engraving by Lodovico); Hamburg, 1972; Cleveland, 1973, no. 147. *Published: Catalogue of the Ellesmere Collection of Drawings at Bridgewater House,* no. 30.

The finished quality and precious nature of this drawing might signify that Lodovico's original intention was to make a presentation piece for a collector. In addition to the careful execution, the use of gold ink on vellum and the prominent signature characterize this drawing as a luxury item highly regarded by its inventor.

The Holy Family at Table with an Angel can be related to another pen drawing on vellum of the same subject.[1] In the latter sheet, however, the angel is pressed against the right border and Mary towers over Christ. Possibly it was an earlier attempt at a subject finally resolved in the Cleveland drawing. Peter Tomory's suggestion that the *Holy Family* was based on another design by Lodovico, *Abraham Entertaining the Angels,* can only be accepted in the broadest possible terms. Even less convincing is his contention that *Holy Family* was a copy of a lost engraving by Lodovico.[2]

The Holy Family ministered to by an angel occurred during the exile in Egypt and had its basis in the Apocryphal Gospels of Pseudo-Matthew.[3] The angel holds a chalice in his left hand and what appears to be a candlestick in his right. Christ seems to be offering Joseph a flower or perhaps figs on a stem,

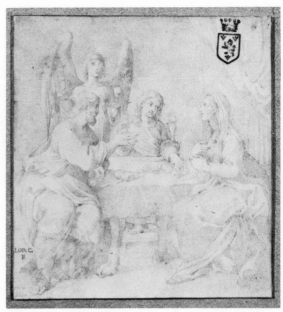

38

while he places a napkin before the Virgin. The bare feet of Christ resting on a platform symbolize in Christian tradition his humanity and the Incarnation.[4] Table legs are given the form of lion's paws, an Old Testament reference to Christ as the Lion of Judah. Christ appears to be close to the age of twelve, the time when the Holy Family was about to return from Egypt after the death of Herod.

1. *The Infant Christ, Virgin Mary and Joseph at Table,* pen and brown ink on vellum, 130 × 117 mm., Holkam Hall, The Earl of Leicester, no. 11, 44.
2. Leicester, 1954, no. 73. L. Carracci, *Abraham Entertaining the Angels,* red chalk, pen and brown ink, 264 × 217 mm., Windsor Castle; Bodmer. 1939, pl. 141. See also Wittkower, 1952, no. 18.
3. James, 1950, pp. 74-76, xxviii-xxxiv.
4. Steinberg, 1973, p. 312.

Giuseppe Cesari, Cavaliere d'Arpino

1568–1640

Giuseppe Cesari was introduced to papal patronage early in his career, working on the loggia of Gregory XIII at the age of thirteen. Seven years later he received a major commission for two frescoes in San Lorenzo in Damaso which were immediately successful. Cesari worked on vault paintings at the Certosa di San Martino, Naples, from 1589 to 1596. His glowing colors, clear, statuesque forms, and use of symmetry added legibility to the intriguing complication of his *maniera* poses. This style of ordered busyness was widely accepted. Around 1591–1593 Cesari returned to Rome to supervise Caravaggio in his decoration of the Contarelli chapel, San Luigi dei Francesi. Cesari's work of the 1590s reflected the classical elegance of Raphael and the anatomical clarity of Michelangelo. A favorite of Pope Clement VIII, he

also worked for Paul V from 1611 to 1616 directing the decoration of the enormous Cappella Paolina, Santa Maria Maggiore. Cesari himself painted the dome pendentives and altar lunette.

Giuseppe Cesari, Cavaliere d'Arpino

39 *Half-Length Figure of a Man Holding a Banner*

Black chalk, 218 × 144 mm., ca. 1595. Notation: on verso, in brown ink, *7/2/p. 28//LA(?),4.*

Janos Scholz, New York.

Provenance: Jonathan Richardson, Sr. (Lugt 2184); L. Lucas (Lugt 1733a). *Exhibited:* Hamburg, 1963, no. 40, fig. 50; Milwaukee, 1964, no. 14; London, 1968, no. 24; Washington, 1973, no. 14, repr. p. 20. *Published:* Scholz, 1976, no. 69, pl. 69.

Little is known about this drawing which has not been related to a specific subject or painting by Cesari. The sketch may date from 1590 when Cesari was associated with Caravaggio and when he developed an interest in Raphael and Michelangelo. Caravaggio's full-bodied naturalism added to Cesari's new appreciation of his native Roman tradition led briefly to a compelling combination of mannerist elegance and normative proportions in his figure studies. Curls of hair at the ears and the suggestions of a panache add an ornamental touch to Cesari's firm outlines and parallel chalk hatching. Voluminous rolling contours define the flexing muscles, and smudged chalk describes shadows beneath the chin and elsewhere.

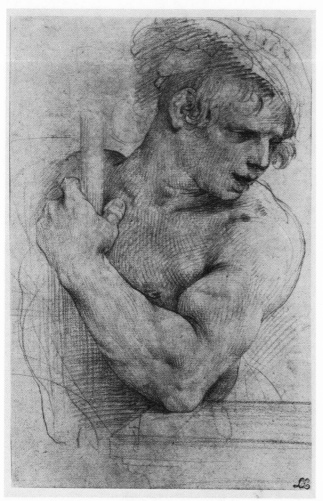

39

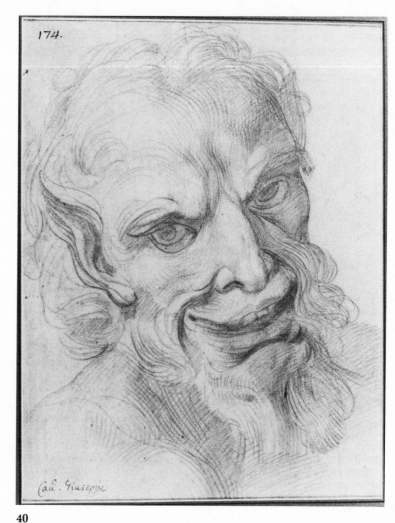

40

Giuseppe Cesari, Cavaliere d'Arpino

40 *Satyr Head*

Red chalk, 285 × 219 mm., ca. 1595. Notations: lower left, in pen and brown ink, *Cav*ᵉ. *Giuseppe*; upper left, in pen and brown ink, *174*. Hole upper left edge.

Museum of Art, Rhode Island School of Design, Museum Works of Art Fund, 58.064.

Provenance: R. E. Lewis, San Francisco. *Exhibited:* Providence, 1961, no. 45; Amherst, 1974, no. 16, repr.

The rhythmic flow of Cesari's chalk line is even more pronounced here than in *Half-Length Figure of a Man Holding a Banner* [39]. Powerful oversized features make this head an engaging image. The drawing's insistent linear sweep adds to the grinning effrontery and unbridled sensuality of the subject. While the study has not been identified with a finished composition, satyrs carrying off nymphs appear in other drawings by Cesari.[1] Grimacing satyrs with outlandish heads were often part of his decorative projects. Several drawings of horses heads have similar bared teeth and humanized eyes and mouths.[2]

1. *Satyr Abducting a Nymph*, red chalk, 196 × 257 mm., Turin, Biblioteca Reale, Bertini, 1958, no. 120, fig. 120. See also *Il Cavaliere d'Arpino*, 1973, no. 103.
2. Bertini, 1958, nos. 117, 118. See also no. 112 for a chalk satyr mask.

Leonardo Cungi

d. 1569

Leonardo Cungi was a native of Sansepolcro and brother of the painter, Giovanni Battista Cungi. His date of birth is unknown, and there are no reports on his early career, but he must have been active by the 1540s since Vasari noted a study of the Sistine Chapel by Cungi among Perino del Vaga's drawings at his death in 1547.[1] Vasari also mentioned Cungi at work on a decorative project for a small palace in the Vatican Belvedere in 1560.[2] This was a significant collaboration for Cungi involving Pirro Ligorio, Taddeo and Federico Zuccaro, Federico Barocci, and Santi di Tito. Cungi continued to work on papal projects receiving a payment from the papal Datario in 1566.[3] Three years later, he was asked to renew the ceiling gilding in the nave of St. John Lateran for Pope Pius IV,

a commission first given to Daniele da Volterra and eventually to Cesar Trapasso. Cungi died before the project could be completed.

1. Vasari-Milanesi, 1878-85, V, 632.
2. Ibid., VII, 91.
3. Thieme-Becker, 1907, VIII, 197.

Attributed to Leonardo Cungi

41 *Christ and the Virgin*

Pen and brown ink, 209 × 153 mm., 1540–1569. Notations: verso, in pencil, *Michel Ange*; recto of mat, *Michelange Buonarroti, 1475–1564, Vente Gosselin 309-1905*; verso of mat, *#A91, 100⁰⁰, 91*. Watermark: Unidentified (bell?). Three horizontal folds.

Private collection.

Provenance: Amédée Michel Besnus (Lugt 78a). *Sale:* Paris, expert Delteil, 8 March 1922 (Besnus collection), no. 37, repr. p. 12 (sold to Daniel for 220 francs, as attributed to M. A. Buonarroti).

Several drawings by Cungi were in Vasari's *Libro dei disegni*.[1] Like Vasari, Cungi was a devoted follower of Michelangelo. Berenson reported a "series of brilliant studies in the Uffizi chiefly after the *Last Judgment* and the Pauline frescoes" by Cungi.[2] A related drawing in a private collection — a

"remarkable sketch . . . perhaps the best" of the series—is after two figures immediately behind and above Charon in the *Last Judgment* (Fig. 41a).[3] It bears comparison with the exhibited drawing which is after Christ and the Virgin in the same fresco. In both, groups of short, quick, parallel lines act as shading. The figures have open, round mouths, and blank eyes, and the feet and hair are summarily indicated by a scalloped outline. In its loose, ornamental line and calligraphic formalism—especially in the lyre-shaped abdomen of the Virgin and the balanced musculature of Christ—the Cleveland sheet must be ranked as one of Cungi's most proficient.

This sheet may have been part of the group of Cungi drawings in Perino del Vaga's collection. They were examined by Armenini, who reported "some nudes from the *Last Judgment*."[4] Perino's family inherited them on his death in 1547. In 1556 his daughter sold them in Rome to the Mantuan merchant and collector, Jacopo Strada.

At the insistence of Pope Paul IV, garments were to be added to the nudes of the *Last Judgment* by Daniele da Volterra in 1559, but it seems that the fresco was not touched until after Michelangelo's death in 1564.[5] Engravings made by Giorgio Ghisi of the fresco—apparently completed before Giorgio's departure for Antwerp (ca. 1550)—depict Christ and the Virgin as garbed, indicating that draperies may have been added to these central figures at the outset by Michelangelo himself. This drawing, therefore, where there are indications of drapery covering the Virgin and Christ, could have been executed in the 1540s, early enough to have been part of Perino's estate.

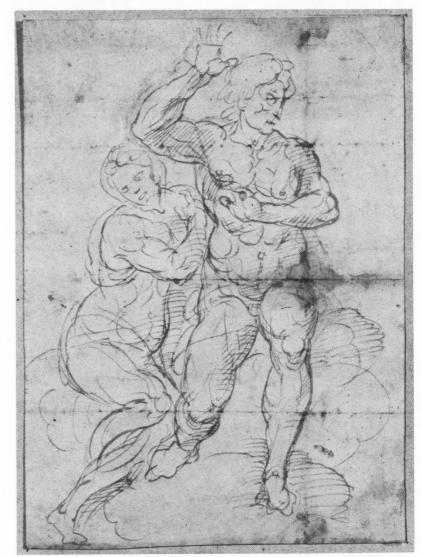

41

Fig. 41a. Three details from *The Last Judgment*, fresco. Michelangelo. Sistine Chapel, Rome.

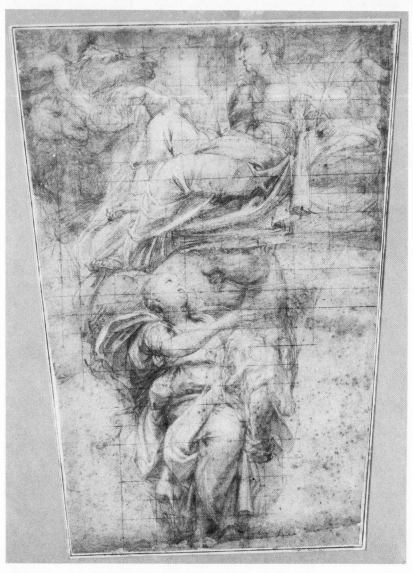

42

1. Collobi, 1974, I, 132, II, figs. 406, 407.
2. Berenson, 1938, I, 264. Unresolved questions remain in the association of these sheets with Cungi. First, the documentary basis for this assignment is unclear, and second, the sheets are not uniform in style.
3. Ibid., II, 243, no. 1745, III, fig. 834. *Man Running while Carrying Another Thrown over His Left Shoulder*, pen and ink, 135 × 100 mm., Walter Gay, Paris. Again, the basis for this attribution is not stated. See also Barocchi, 1962, I, 262-263, no. 210; II, pl. cc-cxx, no. 210 (recto and verso): *Studies of the Last Judgment*, black chalk and pen, 424 × 275 mm., Florence, Uffizi, no. 257 F; on the verso of this drawing appears a sketch of Christ from the *Last Judgment*. The upper third of the recto depicts the Virgin, Christ, and lateral figures from the *Last Judgment*.
4. Armenini, 1977, pp. 134-136, 137 n. 14.
5. Amerson, 1975, p. 36.

Domenico Zampieri, called Domenichino

1581–1641

Domenichino was trained in the Carracci Academy in his native Bologna (ca. 1595) and joined Annibale Carracci in Rome (ca. 1602), where he participated in the Palazzo Farnese decorations. He continued to work in Rome through the next decade, completing a fresco cycle at San Luigi dei Francesi depicting events from the life of St. Cecilia. Domenichino returned to Bologna in 1617 but was soon back in Rome to decorate the apse and pendentives of Sant' Andrea della Valle. Next he was commissioned by Cardinal Scipione Borghese to fresco pendentives with personifications of the four cardinal virtues at San Carlo ai Catinari in Rome. These designs were a muted response to the ebullient Evangelists of his Sant' Andrea della Valle pendentives. In the 1630s he made two trips to Naples.

Fig. 42a *Temperance*, fresco, 1630. Domenichino. San Carlo ai Catinari, Rome.

Fig. 42b. *Reclining Female Figure*, black chalk heightened with white, 264 × 345 mm. Domenichino. Royal Library, Windsor Castle.

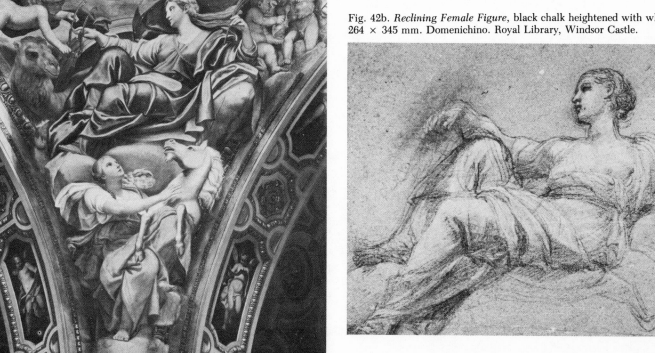

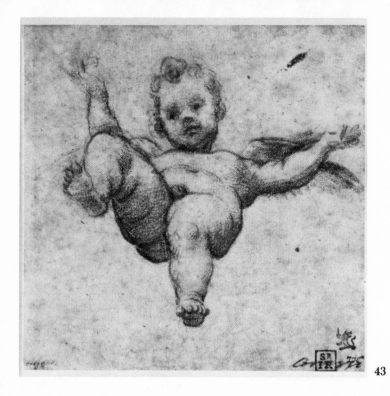

Fig. 43a. *Cupid-Scattering Flowers*, oil on canvas. Annibale Carracci (?) Musée Condé, Chantilly.

43

Domenico Zampieri, called Domenichino

42 An Allegory of Temperance

Black chalk heightened with white chalk, squared in black chalk, 598 × 438 mm., 1630. Notations: on verso of mount, in pencil, *Carlone (Carlo) Scarca 1686–1776 Design for a Sculpture*; in black crayon, *I. 1081, 204, Pelio Cambio (?), from the collection of Lord Barrymore*. Watermark: Unidentified. Four pieces of paper joined, several small holes, soiled and foxed.

The Cleveland Museum of Art, Dudley P. Allen Fund, 64.445.

Provenance: Lord Barrymore; Professor J. Isaacs. *Sales:* London, Sotheby, 27 February 1964 (Professor J. Isaacs collection), no. 24 (as 17th-century Italian School, bought by Porbu). *Exhibited:* Cleveland, 1965, no. 114; Providence, 1968, no. VIII, p. 5, pl. viii; St. Louis, 1972, no. 26, repr. *Published:* Francis, 1965, 174-177, fig. 1; Robertson, 1967, p. 37; Spear, 1967, p. 158, n. 27; Vitzthum, 1971, p. 82, pl. vii; Armenini, 1977, fig. 59.

The drawing is squared in preparation for transferring the design to one of the four pendentives in San Carlo ai Catinari in Rome. Commissioned from Domenichino in 1627 by Cardinal Scipione Borghese, the frescoes were to represent the four cardinal virtues. The pendentive depicting Temperance (Fig. 42a) was completed by a member of Domenichino's studio, Francesco Cozza, when the master left Rome for Naples in 1630.[1]

The Cleveland sheet represents the finished study. It is not, however, a cartoon which would be of equal size to the pendentive fresco.[2] Nor does it completely represent the final statement as one of the two camel heads in the upper left corner of the drawing has been replaced by the full figure of a putto holding a bridle in the fresco. Nine other sheets in Windsor Castle are smaller in scale and represent earlier stages in the development of Domenichino's design, deal-

ing primarily with the pose and attitude of the reclining personifications (Fig. 42b).[3] The study apparently began with a male model in a complicated pose but evolved toward a more tectonic approach. The early ideas imply an illusionistic solution for the pendentive frescoes, but as Stephen Ostrow observed, the planimetric pose became a stabilizing factor in the final design and allowed more room for the accompanying allegorical figures.[4] Style follows iconography, however, as Temperance and Justice are represented as the less aggressive figures. Their gestures are restrained and their movements are directed inward whereas Prudence and Fortitude are more dynamic and extroverted. Domenichino uses exaggerated foreshortening and views *di sotto in su* to a greater degree in these personifications.

Four irregularly shaped sheets of paper were combined for the Cleveland design. Studies of comparable size for *Fortitude* and *Justice* are in the Ashmolean Museum in Oxford.[5] These are similar in style and condition to the Cleveland drawing and are squared for transfer in the same way. There is also a poor copy of *Temperance* which is after the fresco rather than the Cleveland drawing, since there is only one camel in the upper left corner.[6]

Temperance is personified as a reclining female figure holding the palm of victory.[7] The angels in the upper right pour water into wine, one of the traditional symbols of Temperance. The putto holds a bridle to signify restraining the senses, and the camel alludes to abstinence since it can go for extended periods without drinking. Bellori noted that the camel and the unicorn were symbols of San Carlo and of the Borromeo family.[8]

1. Pope-Hennessy, 1948, pp. 79-80.
2. Mariette remarked as early as 1741 how few finished cartoons by Domenichino had survived. Mariette, 1741, p. 56.
3. Pope-Hennessy, 1948, pp. 79-80.
4. Ostrow, 1968, p. 23.
5. Robertson, 1967, pp. 36-37. All three sheets are from the collection of Gemma Donati.
6. *Corpus Graphicum Bergomense*, 1970, II, 34, Tav. 640-GR 113.
7. Ripa, 1767, V, 266-268. Reverdino's engraving of *Temperance* depicts a female mixing water and wine with a camel standing beside. Bartsch, XV, 482, no. 31.
8. Bellori, 1672, p. 331, Spreti, 1969, II, 144–145.

Domenico Zampieri, called Domenichino

43 Study for a Cupid

Red chalk, 140 × 145 mm., ca. 1602. Notations: lower left, in pen and brown ink, *Creggio;* lower right, in pen and brown ink, *Coreggi.* Watermark: Unidentified countermark (similar to countermark of Briquet 512). Soiled.

The Cleveland Museum of Art, Charles W. Harkness Endowment Fund, 29.9

Provenance: Thomas Hudson (Lugt 2432); Joshua Reynolds (Lugt 2364); William Mayor (Lugt 2799). *Published:* Mayor, 1871, no. 108 (as Correggio).

This drawing seems to be a study for a painting that is part of a group of four small canvases of *Cupids Scattering Flowers* (Fig. 43a) now in the Musée Condé.[1] Originally (ca. 1602–1603) they were installed in the garden casino of the Palazzo Farnese but were removed and taken to Parma in 1653.[2] An unpublished inventory of that year in the Parma State Archive describes the contents of the garden *camerini:* "The third room had ten small portraits, and the ceiling consisted of nine paintings, four of which represented Cupids, four larger ones moonlit landscapes, and one in the center a figure of Night in flight."[3]

Carlo Cesare Malvasia reported that the allegories in the casino were painted by Annibale Carracci with the help of assistants, the major one of whom Hans Tietze argued was Domenichino.[4] Posner suggested that the cupid panels may have been executed by an occasional assistant of Annibale, Antonio Maria Panico, since the same open-mouthed, wide-eyed yet expressionless faces can be found in *Erminia and the Shepherd*.[5] The attribution of the Cleveland drawing to Panico is, however, not as simple, since no other drawings associated with the cupid paintings are known, and it has been suggested that Panico may have "benefitted from Annibale's drawings, advice, and perhaps even intervention."[6] It is clear, on the other hand, that the drawing is not a copy, since the hair of the chalk cupid is sketchier in treatment and defined differently than in the painted version where the cupid's hands are foreshortened and hold roses.

For a long time the Cleveland sheet was assigned to Correggio. The use of red chalk, the lack of finish in head and hands, the exaggerated foreshortening, the coal-dot eyes, coy sentiment, and charm are common to many Correggio drawings. The sheet was not accepted by Popham, however, and for good reason.[7] Correggio's drawings rarely approached a fully detailed figure study, serving him instead as rough aids for paintings. Furthermore, the thick contour line defining the underside of the putto's left thigh and buttocks is atypical of him. Even the inclusion in what was once thought to be an important collection of Correggio drawings does not strengthen this attribution. *Study for a Cupid* was once owned by Thomas Hudson and later by the noted English painter, Sir Joshua Reynolds, who had the most impressive collection of drawings attributed to Correggio in eighteenth-century England. Numbering slightly more than fifty, nineteen were tracked down by Popham, who found only nine to be from Correggio's hand.[8]

It would seem reasonable that any designs for the casino would emanate from the master in charge, either Annibale or Domenichino. Drawings by Annibale from the period of the Farnese Gallery differ in significant ways from the Cleveland sheet. In general Annibale's cupids are less infantlike and more idealized, and the homogeneous treatment of surface anatomy lacks the descriptive quality seen here. Domenichino, on the other hand, prefers younger, stockier types for his cupids. While Annibale generalizes hair as a single mass, Domenichino depends upon the suggestive power of a few curls. In addition puffy cheeks, dotted eyes, tousled hair, and fleshy, ham-shaped legs are all elements repeated in other drawings of cupids by Domenichino. The pose of the cupid in the Cleveland sheet is close to that of St. Andrew in a later study,[9] and there are stylistic affinities with several red chalk drawings of putti in Windsor Castle.[10]

I am indebted to Janet Knowles Seiz for research assistance with this drawing.

1. Gruyer, 1900, pp. 133-134, nos. lxiv-lxix.
2. Posner, 1971, I, 142.
3. Salerno, 1952, p. 191, n. 9; Mahoney, 1962, pp. 386-389.
4. Malvasia, 1678, I, 499-500; Tietze, 1906-1907, p. 165.
5. *Erminia and the Shepherd*, London, National Gallery, repr. Posner, 1970, p. 180, fig. 10.
6. Posner, 1971, I, 140-141.
7. Firm statements favoring an attribution to Correggio by Wilhelm E. Suida and Sir Kenneth Clark appear in the curator's file, The Cleveland Museum of Art. Paul J. Sachs disagreed. See Popham, 1957, p. 143, n. 1.
8. Popham, ibid.
9. *Male Nude with Knee Raised and Arms Outstretched* (recto), black chalk heightened with white on gray blue paper, 399 × 242 mm., Pope-Hennessy, 1948, no. 832, pl. 37. Identified as a study for *The Glorification of St. Andrew* in Sant'Andrea della Valle.
10. Pope-Hennessy, 1948, no. 1057, *Flying Putto*, red chalk, 151 × 164 mm. pl. 26; no. 1059, *Putto Carrying a Club*, red chalk, 151 × 142 mm., pl. 25; no. 1520, *Flying Putto Holding a Garland*, black chalk heightened in white on gray blue paper, 126 × 160 mm.; no. 1531, *Flying Putto with Arms Raised*, brown chalk heightened in white on gray blue paper, 162 × 146 mm.

Giovanni Francesco Grimaldi
1606-1680

Grimaldi was a native of Bologna associated with the Carracci school. He journeyed to Rome ca. 1626 and was accepted into the Academy of St. Luke in 1634.[1] Grimaldi gradually became well entrenched in the Holy City, working on commissions for Popes Innocent X, Alexander VII, and Clement IX and prominent families including the Pamphili, Borghese, and Colonna. His greatest success was as a graphic artist and as the major landscape designer of the second generation of Carracci followers.[2]

1. Thieme-Becker, 1922, XV, 40.
2. Bartsch, XIX, 85-117, nos. 1-57.

Fig. 44a. *River Landscape with Boat and Figures*, pen and ink, 258 × 292 mm. Giovanni Francesco Grimaldi. Duke of Devonshire Collection, Chatsworth.

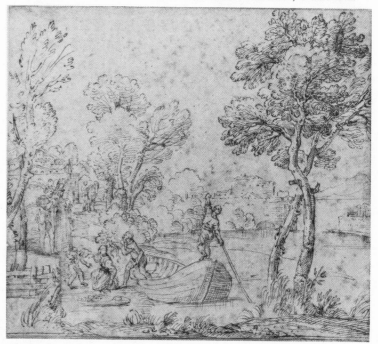

44

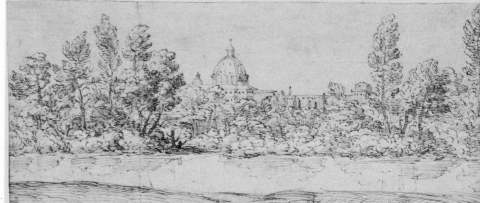

Attributed to Giovanni Francesco Grimaldi

44 *River Landscape with View of St. Peter's, Rome*

This drawing has been associated with Domenichino but can now be attributed to Giovanni Francesco Grimaldi. Pen and brown ink, over traces of black chalk, 114 × 265 mm., after 1660. Watermark: Star in circle, cylinder above (similar to Briquet 6086 with cylinder from 6083). Vertical fold left of center, soiled.

The Cleveland Museum of Art, Purchase, Delia E. Holden Fund, 78.21

Provenance: Richard Cosway (Lugt 628); William Esdaile (Lugt 2617); Eric H. L. Sexton, Rockport, Maine (Lugt 2769c); Mrs. Hanns S. Schaeffer, New York. *Exhibited:* Houston, 1966 no. 26, repr. p. 71; Cleveland, 1979, no. 44, repr. p. 13. *Sales:* London, Christies, 18-25 June 1840 (William Esdaile collection, Part III), no. 634 (as Claude Lorrain).

This view of St. Peter's basilica from across the Tiber exhibited as Domenichino, is not in this master's style.[1] Horizontal strokes shading tree trunks and the impressionistic renderings of the foliage are more typical of Giovanni Francesco Grimaldi (1606–1680) to whom the drawing is now attributed. The loops and scalloped lines that delineate the leaves are conventions found in landscape drawings of Annibale Carracci [36, 37], Girolamo Muziano [56], and Domenico Campagnola [100]. Grimaldi's adaptation of this summary execution of trees is less tightly executed than Muziano's and closer to the freer manner of Campagnola, although less ordered than his. Grimaldi reduced the stylizations of the Carracci to his own short-hand thereby placing his art at a farther remove from nature although touches of naturalism are retained in the reflections in the Tiber. Variations in tonal values allowed him to create effects of space and atmosphere.

The style of *River Landscape with View of St. Peter's, Rome*, is similar to many of Grimaldi's drawings at Windsor Castle and to his prints.[2] A sketch in Besançon, *Landscape with Buildings*, is of comparable draftsmanship and similar horizontal format.[3] Grimaldi's meticulous pen technique is evident in one of the Windsor Castle landscapes.[4] While recalling the sweeping vistas of Campagnola, this drawing has the classicizing spirit of Grimaldi's works in the 1650s, after his return from Paris. The Cleveland sheet is much freer in technique and would seem to be later, after 1660. It is also looser than Grimaldi's *River Landscape* in Chatsworth (Fig. 44a) which contains compositional details from Annibale Carracci [37]. Another landscape in Rome, bolder and broader in technique, illustrates the basic character of Grimaldi's graphic style, seen here in the confident improvisations of *View of St. Peter's, Rome*.[5] The Cleveland design is rare for Grimaldi in the total absence of figures and the depiction of a recognizable rather than imaginary location.

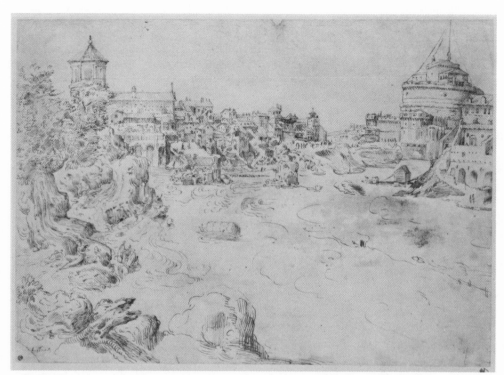

45 Recto

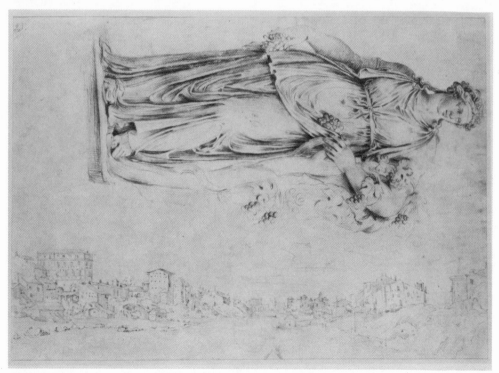

45 Verso

1. Houston, 1966, no. 26.
2. Kurz, 1955, nos. 287-315, pls. 44-52.
3. G. F. Grimaldi, *Landscape with Buildings*, pen and ink, 119 × 361 mm., Besançon, Musée des Beaux Arts, no. 2265.
4. G. F. Grimaldi, *Landscape*, pen and ink, 237 × 341 mm., Windsor Castle, Kurz, 1955, no 312.
5. G. F. Grimaldi, *Landscape*, pen and ink, 204 mm. diameter, Rome, Gabinetto Nazionale, no. 128511.

Etienne Dupérac

ca. 1525–1604

Etienne Dupérac was born and died in Paris, but like so many Northern European artists in the sixteenth century, he was attracted to the art of Italy. Dupérac made two trips to Rome in the 1560s and 1570s, and his *Vestigi dell'antichità di Roma* was published there in 1575. The *Vestigi* comprises views of architectural remnants of ancient Rome—some panoramic in scope—but they are neither mood pieces nor poetic interpretations of Roman light and atmosphere.

Attributed to Etienne Dupérac

45 *View of the Castel Sant'Angelo and the Ospedale di Santo Spirito* (recto); *View of the Tiber and Copy of a Roman Sculpture of a Bacchante* (verso)

Pen and brown ink (recto); pen and brown ink, black chalk (verso), 284 × 416 mm., ca. 1560–1566. Notation: lower left, in pen and brown ink, *tissiano*. Lower left corner missing, stained below the castle, soiled.

National Gallery of Art, Washington, D.C., Ailsa Mellon Bruce Fund, B-26,572.

Provenance: Unidentified collector's mark; Bruce S. Ingram (Lugt 1405a); Carl Winter; Alfred

Brod Gallery, London. *Exhibited:* Washington, 1974, no. 50, repr. pp. 92-93 (recto, verso); Providence, 1978, no. 17.

This drawing can be dated from Dupérac's arrival in Rome after 1560 and before 1566, the date of construction for the new church of Santa Maria in Traspontina. The old church, still visible in the middle ground, was ordered rebuilt by Pope Pius V.[1] More immediately recognizable is the Castel Sant'Angelo on the banks of the Tiber at the upper right. A second view of the Tiber—drawn from the same vantage point but in the opposite direction—appears on the verso. The drawing, then, is a record of Roman landmarks much as *River Landscape with View of St. Peter's, Rome* [44]. Also on the verso is a black chalk copy of a marble Bacchante now in the Louvre.

Diane Bohlin noted stylistic affinities between this design and seven drawings associated with Dupérac in Berlin as well as his etchings for the 1575 *Vestigi dell'antichità di Roma*.[2] While the attribution of this sheet to Dupérac is circumstantial, it is also reasonable.

1. Washington, 1974, no. 50.
2. Ibid.

Giovanni Ambrogio Figino

1548–1608

Giovanni Ambrogio Figino was a pupil in Milan of the painter and art theorist, Giovanni Paolo Lomazzo (1538–1600). His ponderous figural style developed under the influence of Lomazzo and of Pellegrino Tibaldi, who was in Milan in the 1560s. Figino traveled to Rome ca. 1586, where he was affected by Michelangelo and the new seriousness of Roman art. His paintings became heavy in spirit as well as form and represented a suitably rhetorical and didactic expression of Counter-Reformation interests. Many of Figino's drawings are copies of works by Michelangelo.

Giovanni Ambrogio Figino

46 *Sheet of Studies with Copy of Minos from Michelangelo's "Last Judgment"* (recto); *Sheet of Studies* (verso)

Pen and brown ink, brown wash, over traces of red chalk (recto); pen and brown ink over traces of red chalk (verso), 281 × 206 mm., ca. 1586–1590. Tears upper left corner, lower right corner.

Lent by the Metropolitan Museum of Art, Gift of Mrs. David F. Seiferheld, 1961, 61.179.2.

46 Recto

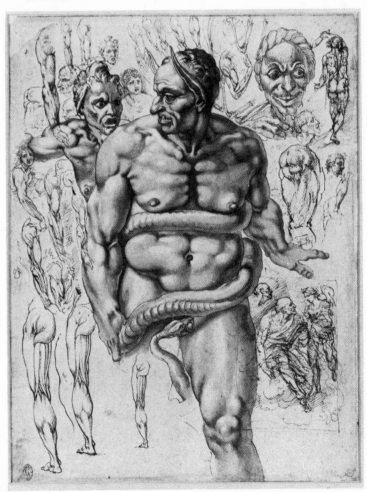

46 Verso

74

Lomazzo described Figino as an eclectic as early as 1584, citing as examples his emulation of Leonardo, Raphael, Michelangelo, and Correggio.[1] In conformity with late sixteenth-century ideas, Figino considered it proper to refer to the great masters of the high Renaissance for models.[2] Gregorio Comanini noted that Figino justified borrowing from his predecessors by restating the observation made by Bernard of Chartres ca. 1100 that "dwarfs placed on the shoulders of giants see farther than their bearers."[3]

The recto of this sheet is dominated by Minos from the lower right corner of Michelangelo's *Last Judgment* in the Sistine Chapel (Fig. 41a). This figure was given the face of the papal chamberlain, Biagio da Cesena, after he criticized the master's work as fit only for a German bath house, a sixteenth-century euphemism for a bordello.[4]

Figino executed numerous other drawings after this famous fresco. A sheet depicting many of the struggling figures pulled towards hell is in Rotterdam,[5] and a study of the right arm of Minos is in the Windsor Castle collection.[6] This is one of 120 drawings mounted in an album for Consul Smith in Venice.[7] Among those pages are other studies after Michelangelo, sketches of limbs, studies after the Laocoön, and about forty variations for *St. Matthew and the Angel*. Roberto Ciardi identified the preparatory studies for *St. Matthew and the Angel* in the church of San Raffaele, Milan.[8] A compositional design for the scene is in the lower right corner of the Metropolitan sheet. As Tomory noted, the figure of St. Matthew was influenced by the prophets on the Sistine ceiling and may have inspired Caravaggio's first version of the subject in 1597.[9]

The remainder of the page is filled with écorché studies of limbs, sketches of heads, and in the upper right corner, a figure with a sword. The bent right arm to the right of Minos's head is repeated in a sheet of *Anatomical Studies of an Arm* in the Janos Scholz collection.[10] Covering a page with trial sketches was an accepted method of practicing drawing and working out designs.[11] Other examples of this practice are by Francesco Vanni [73] and Veronese [109].

The verso of this drawing includes additional studies of heads, torsos, limbs, and standing figures. There is a copy of God the Father from the Sistine ceiling's *Creation of the Sun and the Moon* in the upper left corner and a sketch of a seated cardinal in the lower center. Ciardi has identified this, and other similar sketches in Windsor, as drawings for *Sant'Ambrogio Between Two Saints* in the church of St. Barnaba, Milan, dated after 1576.[12] J. M. Turnure based the St. Matthew studies on Michelangelo's *Moses* for the tomb of Pope Julius II, which would date the sheet to Figino's Roman visit, ca. 1586–1590.[13]

1. Lomazzo, 1584, VI, 438.
2. Armenini, 1977, pp. 59-60.
3. Comanini, 1591; Barocchi, 1962, III, 254; Turnure, 1965, p. 36.
4. Tolnay, 1960, V, 21-22, 46; Vasari-Milanesi, 1878–85, VII, 211.
5. *Group after Michelangelo (Last Judgment)*, pen and wash with white highlights, 380 × 564 mm., Rotterdam, Boymans Museum, no. DN 113/10.
6. *Study of a Right Arm*, black chalk heightened with white on blue paper, 280 × 205 mm., Windsor Castle, no. 6897, Popham and Wilde, 1959, no. 326.
7. Popham and Wilde, 1959, pp. 222-231, nos. 326, 1-121.
8. Ciardi, pp. 38-40, figs. 26, 27, 31, 32, 39. This painting is repr. Turnure, 1965, fig. 5.
9. Sarasota, 1970, no. 20.
10. *Anatomical Studies of an Arm*, red chalk, 425 × 280 mm., New York, Janos Scholz collection, *Pontormo to Greco*, 1954, no. 45.
11. Armenini, 1977, p. 124.
12. Ciardi, 1961, no. 26, figs. 35, 36, 38.
13. Turnure, 1965, p. 40, n. 16.

Giovanni Battista Franco

ca. 1510–1561

Although a native of Venice, Giovanni Battista Franco worked in Rome and Florence. When he was in Rome in the early 1530s, he became an avid student of Michelangelo, and he continued to emulate that master throughout his career. By the end of the decade Franco had gone to Florence under the patronage of Cosimo de' Medici, but returned to Rome in 1541 to paint a fresco for the Oratorio of San Giovanni Decollato. He was next employed by the Duke of Urbino from 1545 to 1551. At first he decorated the vault of the cathedral in Urbino but was finally put in charge of designs for the majolica works at Castel Durante because, as Vasari reports, the Duke recognized Franco's difficulty at working on a large scale.[1] In addition Franco executed engravings and book illustrations. He left Urbino briefly in 1550 to work on a chapel in Santa Maria sopra Minerva, returning to Venice by 1554 where he remained until his death.

1. Vasari-Milanesi, 1878–85, VI, 581.

47

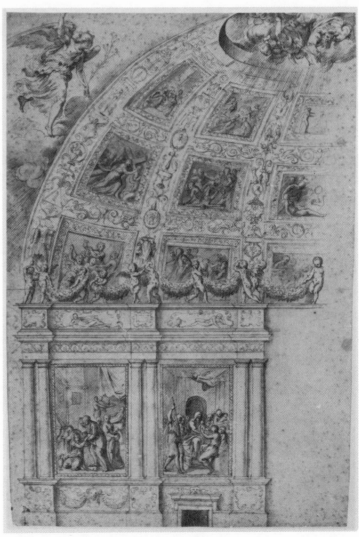

Giovanni Battista Franco

47 *Design for the Decoration of an Apse*

Pen and brown ink, gray wash, over black chalk, 494 × 330 mm., ca. 1550. Notation: on verso, in pencil, *Raphael Urbino.* Watermark: Crowned b with cross (similar to Briquet 8090). Horizontal fold across middle, soiled and foxed.

Alice and John Steiner.

Exhibited: Cambridge, 1977, no. 13; repr. p. 50.

This drawing is a good example of why the Duke of Urbino assigned Franco to design ceramic ware rather than large-scale projects. As Thomas Sylvester has pointed out, the dome decoration is not a single unified composition in the fashion of Correggio's work in Parma or Giulio Romano's *Fall of the Giants* in Mantua; instead the space of the vaulting is broken into numerous small units in typical mannerist fashion.[1] This segmented approach was used again by Franco in the Grimani chapel, a commission executed in 1561 at S. Francesco della Vigna, Venice.[2]

It is not certain if the project represented here was ever executed. It may have been a study for the apse of the cathedral of Urbino which collapsed in 1789. The individual panels contain scenes from the Passion of Christ and diminish in size (and visibility) as they ascend to the illusionistic oculus. The central motif, a dynamic descent of God the Father, was possibly inspired by Pordenone's ceiling of 1520 in the Duomo at Treviso [104]. The scenes are separated by decorative bands of *grottesche;* a border of paired angels supporting swags runs along the bottom. A sheet in the Victoria and Albert Museum depicts the upper portion of the composition and is identical in style.[3]

1. Oberhuber, 1977, pp. 49-51.
2. W. R. Rearick, 1958–59, II, 122-126, fig. 10.
3. *Design for Decoration of a Chapel*, pen and wash with white highlights, 298 × 282 mm., Victoria and Albert Museum, London, n. 97.

Giovanni Battista Franco

48 *Half-Length Skeleton in Profile* (recto); *Sketch of Man's Head* (verso)

Pen and brown ink on paper darkened to tan, incised (recto); pen and brown ink (verso), 234 × 161 mm., ca. 1545. Notations: on verso of mount, in pencil, *4.* Creased and soiled.

The Cleveland Museum of Art, Gift of Mr. and Mrs. Claude Cassirer, 64.381.

Provenance: Thomas Lawrence (Lugt 2445); Samuel Woodburn (Lugt 2584); Boguslaw Jolles (Lugt 381a); Professor Otto Neubauer, Munich and London; Mr. and Mrs. Claude Cassirer, Cleveland. *Sales:* London, Christie, 4-8 June 1860 (Woodburn collection, drawings from Lawrence collection), no. 405; Munich, expert Helbing, 28-31 October 1895 (Jolles collection), no. 240. *Exhibited:* Cleveland, 1964, no. 115. *Published:* Richards, 1965a, pp. 106-112, fig. 1; Richards, 1965b, pp. 406-409, fig. 1.

49 *Rib Cages*

Pen and brown ink on paper darkened to tan, 116 × 238 mm., ca. 1545. Stained.

The Cleveland Museum of Art, Mr. and Mrs. Claude Cassirer, 64.383.

Provenance: Thomas Lawrence (Lugt 2445); Samuel Woodburn (Lugt 2584); Boguslaw Jolles (Lugt 381a); Professor Otto Neubauer, Munich and London; Mr. and Mrs. Claude Cassirer, Cleveland. *Sales:* London, Christie, 4-8 June 1860 (Woodburn collection, drawings from Lawrence collection), no. 405; Munich, expert Helbing, 28-31 October 1895 (Jolles collection), no. 240. *Exhibited:* Cleveland, 1964, no. 115, repr. p. 241. *Published:* Richards, 1965a, pp. 106-112, fig. 5; Richards, 1965b, pp. 406-409; Armenini, 1977, pp. 49 n. 134, 137 n. 12, fig. 34.

Whereas Lodovico Dolce considered Franco "eminent" for his draftsmanship, Vasari blamed him for persisting in the prejudice that a painter need know only drawing and reported how he "wasted time beyond all reason over the minutiae of muscles."[1] The six skeletal drawings in the Cleveland collection are not simply anatomical studies but designs intended, perhaps, as decorative plates or borders for anatomy manuals.[2] *Half-Length Skeleton in Profile* [48] is incised and was used by Franco as part of the design of a print, *Design of Skeleton, Skulls, and Bones.*[3] Like Bartolomeo Torre da Arezzo [66], Franco sometimes presented multiple views of skeletons combining anterior, lateral, and posterior on the same page. This was a conventional arrangement useful for pedagogical purposes in contemporary anatomy manuals.[4] The frieze of ribs and torsos [49] is actually two drawings joined at the center with a V-shaped patch, and the skeletal hand resting on the left shoulder of *Full-Length Skeleton from the Back* (Fig. 49a) was originally attached to the arm of the *Half-Length Skeleton in Profile.* In these drawings decorative patterns are as important as simple description, as in the friezelike torso arrangements or the rhythmic vortices of rib cages [49].

48 Recto

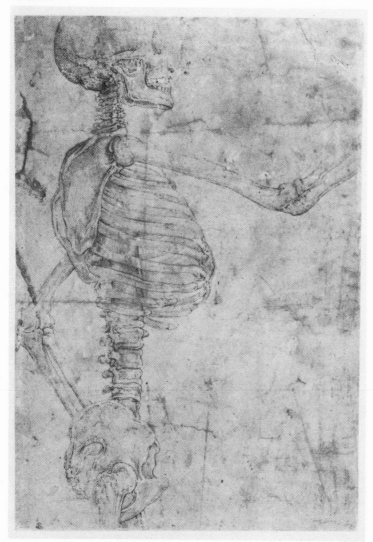

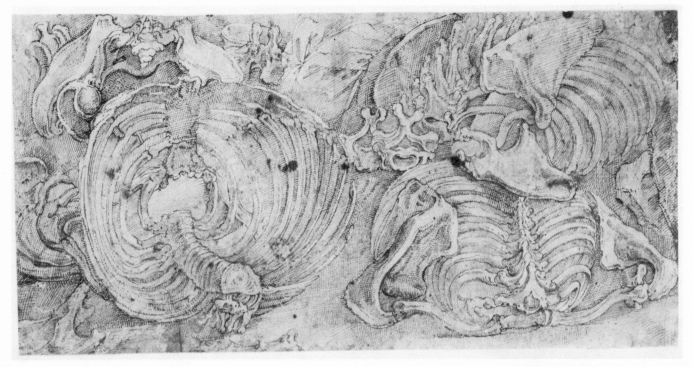

49

I am grateful to Michael Moss for research assistance with these drawings.

1. Dolce, 1557, in Barocchi, 1960–62, I, 206; Vasari-Milanesi, 1875–85, VI, 572.

2. All are pen and brown ink on paper darkened to a tan: *Torsos with Rib Cages*, 119 × 333 mm.; *Arm Bones*, 118 × 367 mm.; *Full-Length Skeleton from the Back*, 422 × 173 mm.; *Lower Half of Skeleton from the Front*, 283 × 126 mm.; The Cleveland Museum of Art, nos. 64.378, 64. 379, 64. 380 and 64.380a, 64.382, respectively.

3. Bartsch, XVI, 141, no. 69; Richards, 1965a, p. 109, fig. 7.

4. For examples see Vesalius's first book on the *De humani corporis fabrica* illustrated in Saunders and O'Malley, 1950, pp. 84-89, pls. 21-23. See also Domenico del Barbiere, *Skeletons and Ecorché*, engraving, 236 × 334 mm., Zerner, n.d., no. DB 10.

Giovanni Battista Franco

50 *Virgin and Child with Two Saints*

Pen and brown ink over red chalk, brown wash, heightened with white opaque water color, on tan paper, lower portion of Madonna pricked, 260 × 262 mm., ca. 1545. Notations: on verso of mount, in pen and brown ink, *Lot 284 Roscoe Sale, Lot 397 Studley Martin, sale L'pool 29 Jan 1889*; on paper pasted to mount, in pen and brown ink, *Battista Franco / born in Venice 1498 died 1561 family name Semolei / This drawing was in collections of / Lord Spencer, and Richardson — bought by / Mr. (s?) Martin at Mr. Roscoes sale 24 Sept. / 1816 No 284 in Catalogue, in July 1862 / the lights were restored by an artist under / the advice of Mr. Colnaghi when the / small figure near the child appeared — this / Mr. Cheney (?) thinks was not part of the design / & purposely rubbed over — "I Pentimenti" in the / Childs head then appeared also — Mr. Colnaghi / remarked upon three styles of Masters studied by / Battista Franco — Michel Angelo Raphael & Parmigiano / in this fine drawing.* Numerous tears, holes, and patches.

The Cleveland Museum of Art, Delia E. Holden Fund, 65.16

Provenance: Jonathan Richardson, Sr. (Lugt 2183); Earl John Spencer (Lugt 1531); William Roscoe (Lugt 2645); Studley Martin, Liverpool; O'Byrne. *Sales:* London, expert T. Philipe, 10-17 June 1811 (Spencer collection), no. 311; Liverpool, expert Winstanley, 23-28 September 1816 (Roscoe collection), no. 284; London, Christie's 1 May 1962 (O'Byrne collection), no. 72, repr. opp. p. 17 (bought by Koblitz). *Exhibited:* Cleveland, 1965, no. 122; New Haven, 1978, no. 2, repr. 29. *Published:* Richards, 1965a, pp. 106-112, repr. 106.

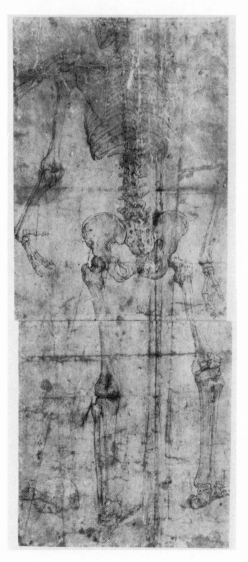

Fig. 49a. *Full-Length Skeleton from Back View*, pen, 240 × 173 mm. Giovanni Battista Franco. The Cleveland Museum of Art, Gift of Mr. and Mrs. Claude Cassirer.

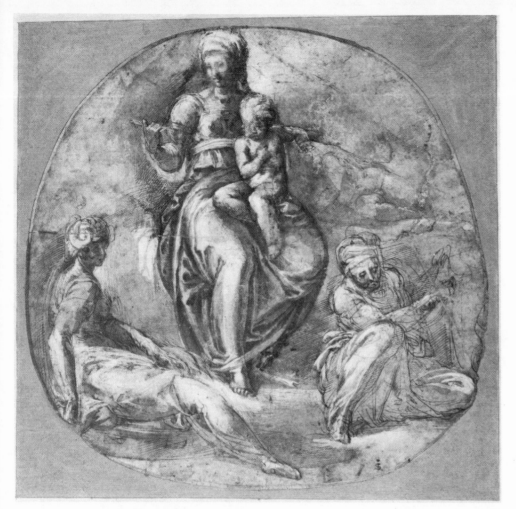

50

In this tondo drawing Franco makes concessions to the circular format, departing from his more typical use of a linear frieze. This may have been one of Franco's many studies for majolica designs when he was employed in the Duke of Urbino's ceramic works at Castel Durante or for a ceiling roundel, several of which in the library of the Palazzo Ducale in Venice have a triangular format like *Virgin and Child with Two Saints*.[1] The legs of the Virgin are pricked for transfer and correspond to those in a print by Franco of the seated Virgin holding a bouquet of flowers.[2] St. John, St. Joseph, and the Christ Child are included in the scene, but the legs of the Virgin remain the only part similar to the drawing.

The Madonna and Child are flanked by two saints. The figure seated on a wheel probably represents St. Catherine while the other, who holds a book in her right hand and has a faintly indicated halo, might be St. Anne. Franco repeated the reclining pose of St. Catherine in the decoration of a dish in the Louvre, where the figure is holding a cornucopia[3] and again in the lower left of a drawing in the British Museum.[4]

Both saints are reminiscent of sibyls from the Sistine ceiling. The one on the right is close to the aged Cumaean sibyl. The exotic headgear of the left-hand figure might sug-

gest one of the oriental female seers such as Persica. Vasari felt that Franco's references to other artists were acceptable as long as "the things borrowed from others [were] so treated as not to be easily recognized."[5] Franco's figural style here is characteristic of his works in the 1540s, a period when the artist was at Urbino.[6] While the poses attest to Franco's interest in Michelangelo, the disjunctive, attenuated forms suggest the influence of mannerism.

This is clearly a working drawing; Franco made many changes on the sheet while positioning the figures. The sleeping Christ Child to the right of the Madonna and Child was apparently covered over by the artist and according to a notation on the verso of the mount only reemerged when the drawing was restored in the nineteenth century. Franco used pen and ink hatching, washes, and white highlights to model his figures so well that the tondo gives the illusion of a carved relief.

1. Gere, 1963a, p. 306.
2. Bartsch, XVI, 128, no. 27. Bartsch also describes a circular engraving (p. 128, no. 26).
3. *Decoration for a Dish*, pen and ink, Paris, Musée du Louvre, no. 4990.
4. *Assembly of Deities*, pen and ink, heightened with white, 117 × 134 mm., London, British Museum, no. 1953-12-12-6.
5. Vasari-Milanesi, 1875–85, VI, 580.
6. Richards, 1965a, p. 107.

Ottavio Leoni

ca. 1580–ca. 1632

According to his biographer Baglione, Ottavio Leoni was trained to do portrait sketches in miniature.[1] He was nominated to the Academy of St. Luke in 1604 and ten years later became its *Principe*. Numerous small portrait drawings, now in a variety of collections, exist from this period. Leoni often numbered and dated them in the lower left corner. His oeuvre also includes oil portraits and altarpieces.

Almost 400 portrait drawings by Leoni were in the Borghese collection. Thomas suggested that these must have been from the artist's estate.[2] Leoni probably kept them to use for engravings since he produced many prints of prominent contemporary Italians, including Pope Urban VIII, Galileo, Giovanni Baglione, Bernini, and Cesare d'Arpino.[3]

Leoni's preferred medium is black chalk on blue paper with touches of red and white chalk, a technique also used by Federico Zuccaro. Leoni is a solid draftsman who presents his sitters in a direct, slightly flattering, and obviously sympathetic manner. His slight tendency to idealize is reflective of late Cinquecento art theory.[4] Leoni portrays his subject with a sense of composure and well-being. He emphasizes the faces of his sitters with decorative accessories which added visual interest and compositional balance rather than information. The reduced scale of Leoni's portraits and his use of color gives them warmth and charm. Perhaps the most expressive and compelling of his portraits is that of Caravaggio.[5]

1. Baglione, 1649, p. 321.
2. Thomas, 1916, pp. 329-330.
3. Bartsch, XVIII, 259, no. 40; 255, no. 27; 251, no. 14; 253, no. 19; 254, no. 23.
4. Armenini, 1977, pp. 257-258. Armenini maintained that the best artists were generally poor portraitists because of their tendency to idealize their sitters at the expense of likeness, and vice versa.
5. This drawing in the Biblioteca Marucelliana, Florence, was not completed as an engraving. Longhi, 1951, pp. 35-39; Kruft, 1969, pp. 449-450.

Ottavio Leoni

51 *Portrait of Comte Anibal Altemps*

Black chalk heightened with white chalk on blue paper, 229 × 153 mm., 1615. Notations: lower left, in pen and brown ink, *33/dicembre*; center, *1615*; on verso, in pen and brown ink, *Conte Anibale Altemps*; on mount, in pen and brown ink, *Comte Anibal Altemps*.
The Cleveland Museum of Art, Gift of Mrs. Malcolm L. McBride, 63.599.

Provenance: Earl of Dalhousie (Lugt 717a); Mr. and Mrs. Malcolm L. McBride, Cleveland. *Exhibited:* Cleveland, 1964, no. 126, repr. p. 247.

This drawing is typical of Leoni's portrait style. Characteristic are the near half-length pose, incised hair, thick lips, shining face, a serene mood, and the habit of numbering and dating the works. Leoni per-

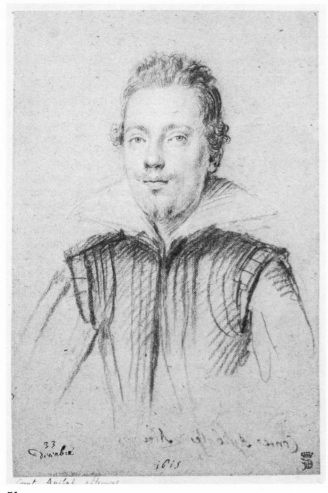

51

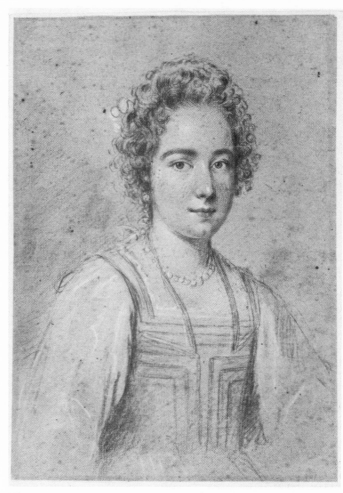

52

sonalizes his sitters most by individualizing the treatment of hair. Instead of developing a stylized formula, he manipulates it to suggest both the general mass of hair as well as particular strands. The figure is silhouetted by means of thick, dark lines with delicate rubbing along the bridge of the nose and left cheek for shadows. If Baglione is correct, this work was intended as a portrait drawing and not as a study for a painting.

Ottavio Leoni

52 *Portrait of a Young Woman with Pearls*

Black and red chalk heightened with white chalk on green (faded) paper, 216 × 153 mm.

The Cleveland Museum of Art, Dudley P. Allen Fund, 23.80.

Exhibited: Cleveland, 1924, p. 141. *Published: The Cleveland Museum of Art Eighth Annual Report*, 1923, p. 53, repr. opp. p. 50.

This portrait is warm, pleasant, and elegant, yet at the same time relaxed and informal. Delicate touches of rubbed red chalk in neck and face work in concert with soft, black descriptive lines with white highlights for relief and animation.

Pirro Ligorio

1513–1583

Upon completion of his artistic apprenticeship in his native Naples, Pirro Ligorio emigrated to Rome where he remained from 1534 to 1569. In 1558 Ligorio became papal architect under Paul IV. He continued under Pius IV, building the casino and teatro in Bramante's Belvedere courtyard. In 1564 he succeeded Michelangelo as architect of St. Peter's basilica. When he fell out of favor with Pius V, he turned to the patronage of Duke Alfonso II d'Este in Ferrara, following Enea Vico as Ducal Antiquary.

Ligorio had always been an avid antiquarian, completing volumes of drawings after ancient monuments. In 1549 he was joined in Rome by Girolamo da Carpi as advisor to Cardinal Ippolito d'Este on collecting antiquities. Pirro continued to share his expertise when the cardinal moved to Tivoli in 1550 and began excavations at Hadrian's villa. He is perhaps best known for his association with the Villa d'Este at Tivoli. Other activities include many façade decorations in Rome (all now lost) and *Dance of Salome* in the Oratorio of San Giovanni Decollato, Rome (1545–1546).

Pirro Ligorio

53 *Seated Sibyl* (recto); *Studies of a Horse's Head* (verso)

Red chalk (recto); pen and brown ink (verso), 244 × 265 mm., ca. 1550. Notation: upper left, in pen and brown ink, 79. A few small tears, soiled.

The Metropolitan Museum of Art, Gustavus A. Pfeiffer Fund, 1962, 62.120.7.

Provenance: Hugh N. Squire, London.
Exhibited: New York, 1965, no. 57, pl. 57 (recto, as Sebastiano del Piombo). *Published:* Bean, 1963, pp. 232, 235, repr. 233 (recto, as Sebastiano del Piombo); Bean, 1964, no. 14, repr. (recto, as Sebastiano del Piombo); Gere, 1971b, pp. 244, 249 n. 25, pl. 15 (recto, as Pirro Ligorio).

This forceful drawing of a sibyl is not connected with any extant work by Ligorio. The seer, viewed in profile, has a thin neck and wide foreshortened shoulders. Holding a book in massive hands, she is inspired to prophesy by her genius. The latter, lightly sketched, hovers in the background and offers a visual foil to the dense, broad form of the sibyl. Inspired by Michelangelo's figures on the Sistine ceiling, Ligorio's sibyl also reflects the repose of many of Raphael's seated figures in the Vatican Stanze.

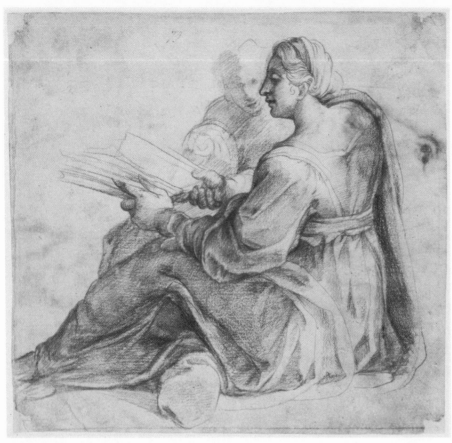

53 Recto

The drawing was attributed to Sebastiano del Piombo until Gere recently offered convincing arguments for an assignment to Ligorio.[1] The amplitude of form and well-drawn arm relate it to a black chalk study of a seated man in Windsor.[2] The oversized hands, malformed wrists, vacant glance, frozen profile, and air of provincial classicism are other traits of the artist's early drawing style. With its pleasing chiaroscuro and decorative drapery patterns, *Seated Sibyl* is the most sensitively handled of Ligorio's early designs.

Gere points out that Ligorio was probably the most prominent specialist in Roman façade decoration in the 1540s and like Polidoro and his followers was dependent upon the spatial conventions of antique reliefs.[3] The Metropolitan drawing, therefore, may be connected with a façade decoration " 'di magnificenze romane' in the manner of Polidoro."[4]

1. Gere, 1971b, pp. 244, 249 n. 25.
2. *A Seated Man*, black chalk, 270 × 364 mm, Windsor Castle, no. 5073 verso, ibid., pl. 14.
3. Ibid., pp. 243-244.
4. Ibid., p. 345.

Attributed to Pirro Ligorio

54 *Mythological Subject*

Pen and brown ink, brown wash, 137 × 203 mm., 1550s. Notations: on verso, in pen and ink, *Paurino del Vaga*, an indecipherable inscription; on mount, in pencil, *14;* on verso of mount, in pencil, *Pierin dell Vaga;* on old mat, in pencil, *no. 5, Valentine coll.*

The Cleveland Museum of Art, Gift of Mrs. R. Henry Norweb, 54.689.

Provenance: Valentine; Mrs. R. Henry Norweb, Cleveland.

This drawing was previously attributed to Perino del Vaga but contains characteristics of style close to Pirro Ligorio.[1] Weightless arms with hands ill-joined at the wrist and faces consisting of dark eyes, thick lips, and broad noses are typical of his early drawing style.[2] Since Ligorio copied drawings of other artists, the distended limbs of these figures may well derive from a lost sheet by Perino del Vaga. A pen sketch of a mythology by Federico Zuccaro, however, is similar in subject, composition, facial types, and other details.[3] While attribution of the present drawing remains speculative, it seems reasonable to suggest this may be a copy by Ligorio of a lost sheet by Federico Zuccaro from the same series as the Louvre design. Gere suggested the attribution, Roman School, ca. 1550, by analogy with a pen drawing in the British Museum.[4] The subject appears to be a mythical or historical narrative, similar in nature to a pen and ink allegory in Berlin.[5]

53 Verso

54

1. Nicholas Turner of the British Museum suggested Pirro Ligorio in December 1977.
2. Gere, 1971b, pp. 239-250.
3. Federico Zuccaro, *Subject from Mythology*, pen and brown ink, 332 × 578 mm., Gere, 1969b, no. 68.
4. John Gere to Curator of Prints and Drawings, 6 December 1978, Curator's file, The Cleveland Museum of Art. Attrib. Pellegrino Tibaldi, pen and brown ink, 158 × 202 mm., London, British Museum, no. 1954-2-19-8.
5. Federico Zuccaro, *Trophy with Victory or Fame*, pen and brown ink, 190 × 110 mm., Kupferstichkabinett, Staatliche Museen, Berlin, Gere, 1971b, pl. 18a.

Michelangelo Buonarroti

1475–1564

A native of Tuscany, Michelangelo Buonarroti entered Ghirlandaio's studio in 1488 and was taken into the care of Lorenzo de' Medici the following year. He traveled to Rome in 1496, where he carved the famous *Pietà* now in the Vatican, and returned to Florence five years later to undertake the equally renowned *David*. Michelangelo's monumental tomb project for Pope Julius II, begun after his return to Rome in 1508, was abandoned in favor of the fresco decorations on the Sistine ceiling, a project which occupied him for four years. He continued to be involved alternately with the tomb of Julius and with the Medici tombs in Florence over the next twenty years. In 1534 Michelangelo began to paint the *Last Judgment* on the altar wall of the Sistine Chapel (Fig. 41a). The last twenty years of his life were spent on the completion of St. Peter's Basilica and in carving figures for his own tomb.

Michelangelo Buonarroti

55 *Study for the Nude Youth over the Prophet Daniel* (recto); *Various Studies of Human Figures* (verso)

Red chalk over black chalk (recto); red chalk (verso), 343 × 243 mm., ca. 1509. Notations: lower right corner, in pen and black ink, crossed out, *55*; verso, upper right corner, in pen and black ink, *V*; top center, in pen and black ink, *Jr.* (?). Very creased, soiled.

The Cleveland Museum of Art, Gift in Memory of Henry G. Dalton by his nephews, George S. Kendrick and Harry D. Kendrick, 40.465.

Provenance: Pierre Jean Mariette (Lugt 1852); Burckel, Vienna; Dr. Alexander de Frey, Temesvar, Romania; Henry G. Dalton, Cleveland; George S. and Harry D. Kendrick, Cleveland. *Sale:* Paris, Galerie Jean Charpentier, 12-14 June 1933 (de Frey collection), no. 7, pl. ii (verso, as school of Michelangelo). *Exhibited:* Providence, 1967, p. 12; Cleveland, 1971, no. 58 repr. (recto, verso, as Alessandro Allori); Tokyo, 1976, no. 22, pl. 22 (recto). *Published:* Berenson, 1938, II, 213, no. 1599A, III, figs. 606 (verso), 616 (recto); Frankfurter, 1939, pp. 181-182, pl. 9 (verso), pl. 10 (recto); Francis, 1943a, pp. 25-26, repr. 22 (recto, verso); Francis, 1943b, p. 63, repr. p. 60 (recto); Tolnay, 1945, II, 211, nos. 19A, 20A, figs. 244 (recto), 245 (verso) (as copy, school of Michelangelo); Milliken, 1958, repr. p. 36 (recto); Dussler, 1959, p. 208, no. 387 (as Michelangelo follower); Barocchi, 1962, I, under nos. 15, 121, 143; Hartt, 1972, pp. 82, 86, nos. 79, 104, respectively, repr. pp. 98 (verso), 108 (recto); Seymour, 1972, repr. p. 60 (recto), fig. 120; Gould, 1975, p. 147; Tolnay, 1975, I, 112, no. 147, pl. 147 (recto, verso); Olszewski, 1976, pp. 12-26, figs. 2 (recto), 3 (verso).

Although the attribution of this sheet to Michelangelo has been questioned, the drawing is now almost universally accepted as an autograph sketch, most recently by Frederick Hartt and Charles de Tolnay.[1] Berenson early recognized it as a study for the nude figure above the prophet *Daniel* in the Sistine ceiling, seen at the top right of Cherubino Alberti's engraving [30].[2]

Red chalk had become Michelangelo's favorite medium by 1508 when he began his studies for the Sistine ceiling. The *ignudo* was first sketched in black chalk, then elaborated in red chalk. In contrast to the finished quality of the body, the head has only been faintly indicated, almost giving the impression of a caricature. This is, however, only an example of Michelangelo's reliance on his studio training where forms were sometimes reduced to geometric shapes. Berenson interpreted the turbaned head inverted in the upper left corner as "perhaps a first idea for one of the sibyls, the Delphica, for instance," although there are also similarities with the lunette figure of Aminadab.[3]

The verso of the sheet was used for various sketches. There are five studies of feet and toes, four of which can be associated with the *ignudo* on the recto. There are two sketches of male figures: The bust-length one at the lower right was identified by Tolnay as a study for the angel under the raised arm of God the Father in the scene of the *Creation of the Sun and the Moon*.[4] The waist-length figure at the top right, whose head is cut off right above the mouth by the edge of the page, may have been a study for the prophet *Jonah*, although Berenson and Cecil Gould found it compatible with the figure of St. John in the National Gallery's *Entombment*.[5] This figure and the slippered heel at the bottom center of the page may have been early ideas for the figure left of center and the leg at the bottom center in the double spandrel of *Moses and the Serpent of Brass*, but the correspondence is not exact.

Although there has been much confusion over the issue, it is possible to pinpoint the date of the drawing. In 1902 Henry Thode maintained that Michelangelo completed the central portion of the ceiling in two campaigns, beginning at the east end of the chapel and working toward the altar.[6] From January 1509 to the following autumn he finished the first five bays and by August 1510 the last four bays. This schedule was generally accepted by German scholars as recently as Herbert von Einem in 1973. Following Thode's chronology the drawing of the *ignudo* would have been executed before 1510, either in the late autumn of 1509 or as early as the summer of 1508.[7] This interpretation was questioned by Tolnay who offered an alternate timetable: Between January and September 1509 the first three histories and accompanying spandrels and figures were completed and by the following September two more bays were done. After a pause of five months, the last five bays were finished by

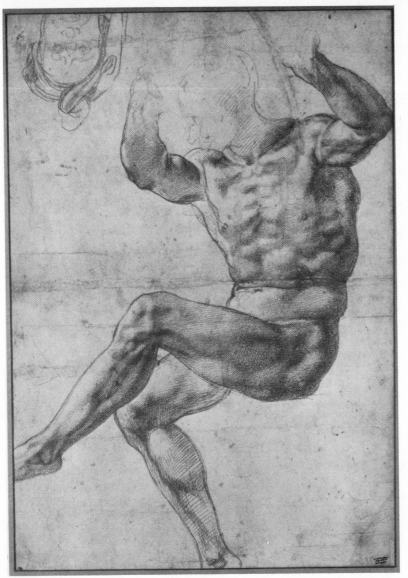

55 Recto

the term *volta*. When referring to the vault of the Sistine Chapel did the artist mean the ceiling and wall lunettes together, or did *volta* mean only the ceiling portion?

Vasari referred to work in the chapel preceeding in two stages, indicating that Michelangelo made fresh cartoons for the second.[10] While it is tempting to assume that the ceiling was painted and then the lunettes, Vasari is not more specific. The dilemma seems resolved, however, by a letter Michelangelo wrote more than a decade after the work was completed.[11] The artist noted that "the vault was nearly finished" before the pope left for Bologna (17 August 1510) and that lacking funds, the project was delayed until he returned to Rome (27 June 1511), whereupon Michelangelo "began to do cartoons for the said work, that is *for the ends and the sides round the said chapel*" (emphasis added). *Volta*, then, meant only the ceiling and not the lunettes. The Cleveland *Ignudo*, therefore, would date from the first stage of preparation, that is, from the second half of 1508.[12]

The Cleveland sheet is one of only nine drawings by Michelangelo in American collections. Although the number is small, it has grown dramatically in the past few years with the identification by Michael Hirst of the Fogg *Ganymede* and the Metropolitan Museum's *Study for a Tomb Project*.[13] They join the Metropolitan Museum's *Studies for the Libyan Sibyl* (Fig. XVI), the ceiling study in Detroit (Fig. 30a), a *Pieta* in Boston's Isabella Stewart Gardner Museum, the Huntington Library's sketch of a leg, a set of small figures in the Pierpont Morgan Library, and the *Goldsmith's Design* in the Fogg.[14]

55 Verso

August 1511. Tolnay's hypothesis presents two possibilities: that all the drawings for the ceiling were prepared before the painting was begun in late 1508-early 1509, or that a final set of drawings was undertaken before the third phase of the ceiling was completed in late 1510 or early 1511. The *ignudo* on the Cleveland drawing is part of this last portion of the ceiling.

These attempts to reconstruct Michelangelo's work on the ceiling were based on his letters. In July 1510 he indicated that one part of the project would be completed within the week and on 5 September 1510 that he was to get 500 ducats "which I've earned" and "as much again which the Pope has to give me to put the rest of the work in hand."[9] Although both Tolnay and Thode agreed that progress on the ceiling included the central narrative scenes and the nudes, prophets, and sibyls, but not the wall lunettes, Tolnay assumed that Michelangelo was half finished only with the ceiling paintings, while Thode felt the artist had completed half of the entire project. The confusion is caused by Michelangelo's use of

I am grateful to Linda C. Meiser for assistance in the research of this drawing.

1. Hartt, 1972, p. 82, no. 79, p. 86, no. 104; Tolnay, 1975, I, 112, no. 147. I was unaware of the publication of Tolnay's corpus of Michelangelo's drawings when my study of the Cleveland *Ignudo* was published in January 1976 (Olszewski, 1976, pp. 12-26). A new study by Alexander Perrig makes no mention of the Cleveland drawing: *Michelangelo Studien*, 4 vols. (Frankfort am Main, 1976–1977).

2. Berenson, 1938, II, 213, no. 1599A.

3. Ibid.; Tolnay, 1945, II, fig. 169.

4. Tolnay, 1945, II, 211, 20A.

5. Berenson, 1938, II, 213, no. 1599A; Gould, 1975, no. 790.

6. Thode, 1902, I, 350, 352-353, 357.

7. Ibid.; Steinmann, 1905, II, 174; Thode, 1912, III, 298; von Einem, 1973, p. 53.

8. Tolnay, 1945, II, 110-111.

9. Ramsden, 1963, I, nos. 52, 53.

10. Vasari-Milanesi, VII, 175-177.

11. Ramsden, 1963, I, no. 157. This letter was called to my attention by Creighton Gilbert: Michelangelo Symposium, Cleveland State University, 2 March 1978, Cleveland, Ohio. See Barocchi and Ristori, 1965, III, 7-9, no. DXCIV.

12. Olszewski, 1976, p. 21.

13. Hirst, 1978, pp. 253-260; Hirst, 1976, pp. 375-382.

14. *Pietà for Vittoria Colonna*, black chalk, 295 × 194 mm., 1538–1540, Isabella Stewart Gardner Museum, Boston; *Sketch of a Left Leg*, black chalk, 289 × 200 mm., 1550–1555, The Huntington Library, San Marino; *Four Sketches of David and Goliath*, black chalk, 1550–1555, The Pierpont Morgan Library, New York; *Goldsmith's Design*, black chalk, 157 × 157 mm., The Fogg Museum of Art, Harvard University, Cambridge, Massachusetts. In my earlier citation of Michelangelo drawings in American collections, I failed to include the sketch of a leg in the Huntington Library, San Marino. Hirst's reattribution of the two Fogg designs had not yet appeared in print, nor had his rediscovery of the Metropolitan Museum's *Study for a Tomb*. See Olszewski, 1976, pp. 24, 26, n. 43; Hirst, 1978, I, 253-260; Hirst, 1976, pp. 375-382. See also Hartt, 1971, pp. 78-114, 323, no. 455, pp. 330-331, as no. 453 (should be no. 463), p. 340, no. 480, p. 376; Tolnay, 1978, III, 86-87, no. 438 recto, fig. 438.

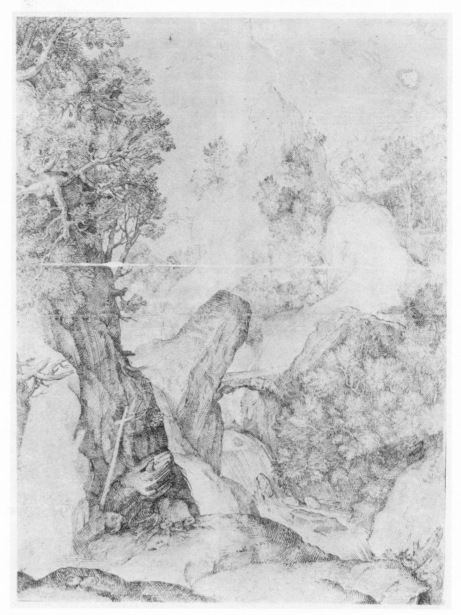

56

Girolamo Muziano

1532–1592

Although born in Brescia and apprenticed in Padua, Girolamo Muziano's artistic activity began in Rome at mid-century. He was influenced by the art of Michelangelo, Sebastiano del Piombo, and Taddeo Zuccaro. His paintings were generally pious in subject and feeling. Muziano was also interested in landscape, and his compositions were reminiscent of Titian. His landscapes, however, were more often utilized only as settings for religious subjects. Muziano worked for Cardinal Ippolito II d'Este in the early 1560s, supervising the landscape frescoes at the Villa d'Este in Tivoli and thereby renewing interest in a genre which had waned since the passing of Polidoro da Caravaggio.

Muziano was patronized by Pope Gregory XIII, who approved the founding of the Academy of St. Luke in 1577 with Muziano as head. Muziano's later paintings, like *Giving of the Keys* of 1585 in S. Maria degli Angeli, are serious works of elevated sentiment and large scale.

Girolamo Muziano

56 *Landscape*

Pen and brown ink, on tan paper, 558 × 374 mm., after 1573. Watermark: shield with M surmounted by a star (Briquet 8390). Three horizontal tears across sheet, other tears and several holes.

Fogg Art Museum, Harvard University, Cambridge, Gift of W. A. White, 1918.15.

Published: Mongan and Sachs, I, no. 130 (as a copy of Uffizi no. 521).

This is a sixteenth-century copy of a drawing in the Uffizi.[1] While close in technique to the Uffizi sheet, occasional randomness in the hatching and a labored effect suggest that the Fogg landscape is a copy after the Uffizi composition rather than a preparatory study for it. Like the relationship between the two versions of Lelio Orsi's *Conversion of St. Paul* [87], it is possible that Muziano himself executed a copy of his own drawing. Although more complete, the Uffizi design contains no saint next to the cross and appears to have been cropped. A third drawing of the scene also exists,[2] but instead of a blank space in the lower left corner it has a figure of a saint.

Landscape can be related to the Great Penitents series of drawings of saintly ascetics in wilderness settings which Muziano executed to be engraved by Cornelis Cort.[3] Cort worked on the suite of seven prints 1573–1575. Although *Landscape* was never engraved, it was probably originally conceived as part of the set, since it is the same size as the prints.[4] It also depicts the same rugged terrain symbolizing the harshness of asceticism where nature is depicted as both threat and refuge. The landscapes—filled to capacity with trees, boulders, and mountain torrents—serve as a *selva oscura* or forest setting for mystical revelations.

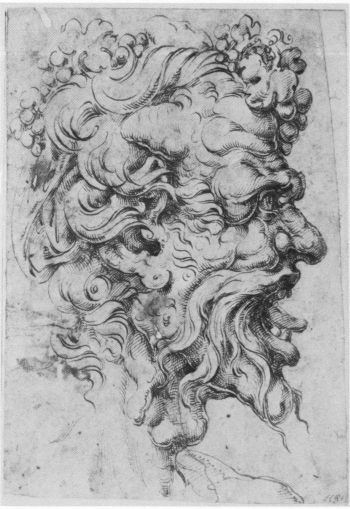

57

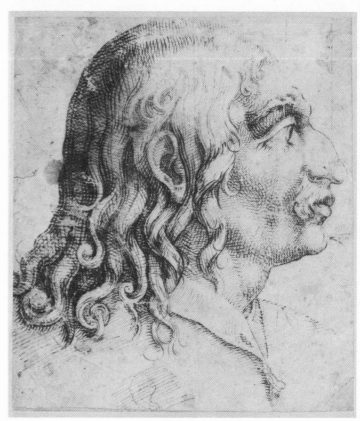

58

1. *Rocky Landscape*, pen and ink, 420 × 280 mm., Florence, Uffizi, no. 521, Mongan and Sachs, I, no. 130; da Como, 1930, repr. p. 33.
2. *A Saint in Front of a Cross in the Landscape*, location unknown, Bierens de Haan, 1948, fig. 31.
3. Ibid., pp. 121-130.
4. Hollstein, 1949, V, 52, nos. 113-119. Three of the Great Penitents drawings were once in the collection of Rubens and then belonged to Pierre Crozat. Jaffé, 1964, p. 385, pls. 12, 13.

Bartolommeo Passarotti

1529–1592

A native of Bologna who studied in the studio of the architect Vignola, Bartolommeo Passarotti left for Rome in 1551 where, like so many artists of his generation, he became an ardent follower of Michelangelo. He supported himself in the Holy City as a portrait painter and was acquainted with Taddeo and Federico Zuccaro. Passarotti returned to Bologna in 1565 and established his own studio; one of his pupils was Agostino Carracci. The workshop was respected for its output of religious paintings, portraits, and genre works reminiscent of Nether-

landish paintings. The tormentors of Christ in his *Ecce Homo* in Santa Maria del Borgo verge on Northern European caricature, but his figures also reflect the robust corporeality of Pellegrino Tibaldi. By the late 1580s Passarotti's domination of the artistic scene in Bologna gave way to that of the Carracci workshop.

Bartolommeo Passarotti

57 *Head of a Satyr in Profile, Facing Right*

Pen and brown ink, incised, 244 × 175 mm. Notation: on verso of mount, in pen and brown ink, *de Carazzi*. Some creases, tears, holes, soiled.

Janos Scholz, New York.

Provenance: Edward Bouverie (Lugt 325); John Charles Robinson (Lugt 1433); Gruner; Wadsworth. *Exhibited:* Indianapolis, 1954, no. 33, repr.; Cambridge, 1962, no. 21; Washington, 1973, no. 50, repr. p. 60. *Published:* Scholz, 1976, no. 54, pl. 54.

This wondrous, fanciful face emerges from a complex of lines and crosshatching with hair evolving into leaves, tendrils, and clusters of grapes. While reminiscent of

Leonardo's caricatures and reflective of the interest in grotesques at the turn of the century, *Head of a Satyr in Profile, Facing Right* is more dependent on the notion popular later in the Cinquecento of *fantasia*. For Federico Zuccaro, *disegno fantastico* was necessary and delightful, marvelous and ornamental, and the source of new inventions for the enrichment of art.[1]

The drawing is several things at once: a mannerist extravagance, the head of a Bacchic disciple, and a composite creature of mythology (although not in the traditional fashion of half-man and half-beast like satyrs and centaurs, but simultaneously human and plantlike). *Head of a Satyr* is the perfect counterpart to Arcimboldo's allegorical portraits[2] and an example of Armenini's belief that such caprices cannot be defined by rules.[3]

1. Heikamp, 1961, p. 225; Zuccaro, 1607, II, 5.
2. Pieyre de Mandiargues, 1978; Kaufmann, 1976, pp. 275-296.
3. Armenini, 1977, p. 62.

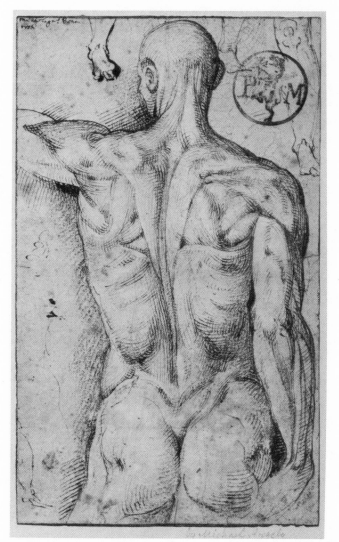

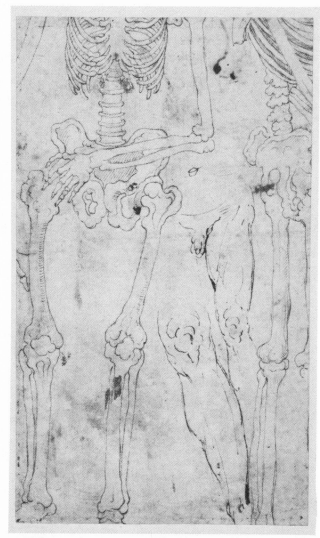

59 Recto **59 Verso**

After Bartolommeo Passarotti

58 *Profile Portrait*

Pen and brown ink, 220 × 175 mm., ca. 1590.
Notation: veso of mount, in pencil, *23-25 = 72,P.*
Some creases and tears, soiled.

Thomas P. Toth.

Provenance: Alister Mathews, Bournemouth.

While *Profile Portrait* is more obviously a
portrait than *Head of a Satyr in Profile,
Facing Right* [57], in both the use of the
pen is related to engraving techniques
where tonal variation is the result of denser
or looser crosshatching and of lines that
swell or taper in response to pressure ap-
plied to the quill. Passarotti's graphic art re-
mains a difficult subject inasmuch as his
style has been neither clearly defined nor
fully distinguished from members of his
workshop. Bartsch listed fifteen etchings by
him, generally of religious subjects.[1] He is
reported to have made portraits of several
popes including Pius V, Sixtus IV, and
Gregory XIII.[2]

Profile Protrait – a much more deliberate
exercise than *Head of a Satyr* – seems to be

the product of a member of the workshop,
perhaps of Passarotti's son, Tiburzio. Based
on the academic nature of this drawing
(where, for example, the eye conforms ex-
actly with samples indicated in artist's
manuals, such as Odoardo Fialetti's *Il modo
vero . . .* [Fig. VIII]), its naturalism, and its
plastic strength (especially evident in the
swelling volumes at the throat, chin, and
cheekbones), it can be dated to late in the
century, perhaps after 1590.

I am grateful to Thomas Toth not only for lending his
drawing but also for his generous assistance in research
on Passarotti.
1. Bartsch, XVIII, 1-7, nos. 1-15.
2. See Venturi, 1933, IX, 6, 733-756.

Circle of Bartolommeo Passarotti

59 *Anatomy Study* (recto);
Skeletal Study (verso)

Pen and brown ink, black chalk (recto); pen and
brown ink over black chalk, pricked (verso), 209
× 126 mm., ca. 1590. Notations: recto, top left
corner, in pen and brown ink, *Michelagn?
Bona/rroti;* on mount, in pencil, *by Michael
Angelo.* Foxed.

Janet S. and Wesley C. Williams.

Provenance: Anonymous, Florence (?) (Lugt
2099).

While the attribution to Michelangelo made
on the drawing is wishful, the drawing style
is close to followers of Michelangelo such as
Raffaelo da Montelupo and Bartolommeo
Passarotti. Heads in two of Passarotti's
drawings, have similar angularities and
swirling rhythms in groups of parallel or
crosshatched lines.[1] The study of muscles on
the recto, where treatment of anatomy is
generally correct, is complemented by two
skeletons on the verso. These seem stiff and
dry in comparison to the remainder of the
sheet. Perhaps they were executed for a
purpose requiring a simple outline drawing.

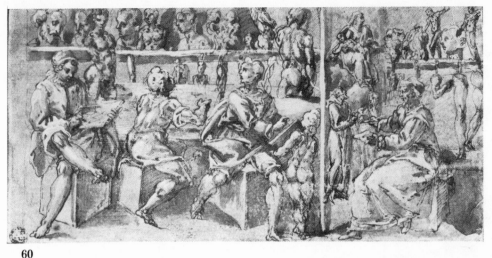

60

1. Barocchi, 1962, I, 264-265, nos. 212, 213; II, pl. cccxxii; *Studies of the Sistine Deluge*, pen and ink, 194 × 212 mm., Florence, Uffizi, no. 617 E; *Figure Studies*, pen and ink with touches of black and red chalk, 293 × 273 mm., Florence, Casa Buonarroti, no. 28 F.

Cesare Pollini

ca. 1560–ca. 1630

Little is known concerning the details of Cesare Pollini's life and career as an artist. He is recognized primarily as a miniature painter active in Perugia.

Cesare Pollini

60 *Workshop of the Artist*

Pen and brown ink, brown wash, heightened with white, on paper prepared with red wash, 102 × 213 mm., ca. 1610.

Museum of Art, Rhode Island School of Design, Purchased and presented by Miss Ellen D. Sharpe, 50.307.

Provenance: Unidentified collector's mark; Albertina (Lugt 174); A. Sims, London. *Exhibited:* Providence, 1961, no. 25; Norton, 1976, no. 1. *Published:* Meder, 1923, repr. p. 264 (as Federigo Zuccaro); "Prints and Drawings: New Acquisitions," Museum of Art, Rhode Island School of Design, *Museum Notes,* VIII (January 1951), 1, fig. 1 (as Federigo Zuccaro); Ames, 1978, I, 225, II, repr. 101.

Once attributed to Federico Zuccaro, this sheet was assigned to Cesare Pollini by Popham.[1] The lumpy nudes with tilted heads and shoulders aslant, the piling up of waves of hair, the nervous line and use of wash to effect a contrast of lights and darks are repeated in other drawings by Pollini.[2]

While the master of the workshop paints a Madonna and Child with Saints, apprentices busy themselves sketching from plaster casts of busts and torsos. Winslow Ames suggested that the unusual use of a red ground is intended to suggest firelight, an allusion to the artists' diligence as they work

late into the night.[3] Vasari mentioned how on many occasions as a youth he worked throughout the night.[4] This is a literary *topos* more reflective of sixteenth- than seventeenth-century attitudes.[5]

1. A. E. Popham, 24 November 1952 and 10 January 1953, Curator's file, Museum of Art, Rhode Island School of Design.
2. *Madonna and Child,* pen and wash over red chalk, 131 × 167 mm., London, The British Museum, no. 1948-2-23-1; *Figure Studies,* red chalk, pen and wash, 70 × 254 mm., Darmstadt, Landesmuseum, no. AE 1587; *Holy Family,* pen and gray wash over red chalk, 198 × 265 mm., Oxford, Christ Church, no. 742.
3. Ames, 1978, II, p. 101, no. 108.
4. Vasari-Milanesi, VII, 653.
5. In his essay of 1517 Vida recommends for the training of the poet pairing the pupil with a companion of the same age so they may compete and spur each other on, persevering in their lessons "late into the night" (*ac sera sub nocte urgere laborem*); Vida, 1976, pp. 20-21.

Raffaello Santi, called Raphael

1483–1520

Raphael was the son of the painter and poet, Giovanni Santi. A native of Urbino, he had access to the sophisticated court and paintings gallery of Federigo da Montefeltro. In the early 1490s he settled in Perugia to work with Perugino, whose style he quickly mastered. Raphael was in Florence ca. 1504 where, as indicated by his drawings, he became aware of the important Quattrocento artists as well as Leonardo da Vinci and Michelangelo. During this period portraits and Madonnas comprised the majority of his works. *Marriage of the Virgin* of 1504 (Brera, Milan), illustrates his placid, compact, and ordered style.

After Raphael settled in Rome at the end of 1508, his compositions became more ambitious and complicated, encompassing large numbers of figures. They still retained the appealing sentiment and balance for which his work is so famous. Raphael worked for Pope Julius II, painting the

Disputa and the *School of Athens* in the *Stanza della Segnatura.* Influenced by Roman art, these frescoes display a new monumentality. From 1511 to 1514 Raphael worked in the second Vatican chamber, the *Stanza d'Eliodoro.* During this period he also painted the *Madonna of Foligno* (Vatican Museum, Rome), the *Sistine Madonna* (Gallery, Dresden), and *Galatea* for Agostino Chigi's villa. His architectural projects included Chigi's chapel in Santa Maria del Popolo.

Work on the third chamber, the *Stanza dell'Incendio,* continued after the death of Julius II and succession of Leo X, and was executed mostly by his workshop. Raphael's efforts were directed toward the cartoons for the Sistine Chapel tapestries. He took charge of the construction of St. Peter's in 1514 after the death of Bramante and was made commissioner of antiquities three years later. The portraits of *Baldassare Castiglione* (Louvre, Paris) and *Leo X with Cardinals Giulio de' Medici and Luigi de' Rossi* (Pitti Palace, Florence) date from this period. Raphael's *Transfiguration* (Vatican Museum, Rome), commissioned by Cardinal Giulio de' Medici in 1517, was not completed when the master died at the end of the decade.

Raffaello Santi, called Raphael

61 *Studies of a Seated Model and a Child's Head; and Three Studies for the Infant Christ*

Metalpoint on pink prepared paper, 119 × 153 mm., ca. 1508.

The Cleveland Museum of Art, Purchase, J. H. Wade Fund, 78.37.

Provenance: Cavaliere Benvenuti, Florence; Grand Duke of Tuscany; The Emperor Charles of Austria; Stefan von Licht (Lugt 789b); Edwin Czeczowiczka, Vienna; Robert von Hirsch, Basel. *Sales:* Berlin, Boerner and Graupe, 12 May 1930 (Czeczowiczka collection), no. 121, repr. frontispiece; London, Sotheby, 20 June 1978 (von Hirsch collection), I, no. 16, repr. 40. *Exhibited:* Cleveland, 1979, no. 101, repr. p. 13. *Published:* Passavant, 1839, II, no. 145; Passavant, 1860, II, no. 161; Ruland, 1876, p. 69, no. XXVI, 7; p. 317, no. XXX, 1; Fischel, 1912, p. 299, no. 6, repr. p. 295; Fischel, 1913 –72, VIII, no. 354, pl. 354; Fischel, 1939, p. 187, pl. III B; Fischel, 1948, I, 129-130, 360, II, pl. 138 B; Kurz, 1948, pp. 100-101, fig. 22; Pouncey and Gere, 1950–67, III, pts. 1-2, under no. 23.

According to Oscar Fischel, this sheet was part of a "pink sketchbook," a group of eleven drawings executed in metalpoint on a pink prepared ground ca. 1508.[1] Pouncey and Gere were less certain that these sheets originated from a single notebook, but agreed that considering the similar themes, technique, and style, they were all from Raphael's early Roman period.[2]

Studies of a Seated Model is closely related to some of the other drawings from this group. The three infants along the bottom of the page are close to *Studies for an*

Infant Christ and *Various Sketches for a Madonna and Child.*[3] The sweet, plump infant, looking upwards, with hints of a pillow beneath and behind him, is similar in all three drawings. At the time Raphael was preoccupied with exploring compositions for paintings of the Madonna and Child and here experiments with poses for a recumbent yet lively infant. A pen and ink drawing (Fig. 61a) covered with similar sketches was used for two paintings ca. 1507, the Bridgewater and Colonna Madonnas.[4] This sheet, which John Pope-Hennessy considered "a document of cardinal importance for Raphael's Florentine years," links the metalpoint drawings discussed above with the period Raphael spent in Florence.[5]

Other factors solidify the connection between *Studies of a Seated Model* and Raphael's early work in Florence. Fischel noted in the child's head at the right a recollection of Leonardo's *Benois Madonna* and a similar attitude to that of St. John in the Burlington House cartoon.[6] Except for its parted lips, the head is identical to the unidentified child saint (the angel Gabriel?) in the *Terranuova Madonna*, one of the first Madonnas Raphael executed in Florence. The influence of Michelangelo is also evident. The infant in his *Taddei Tondo* is the obvious precedent for the Christ Child in Raphael's *Bridgewater Madonna*. The animation of the child seen here, in the *Colonna Madonna* and in the Cleveland drawing, is also typically Florentine. The sense of movement is even more exaggerated in the drawings where the repetition of contours, the result of Raphael's changes, creates the illusion of a squirming child constantly in motion. The origin of this mode of drawing, where details are reworked, is Leonardo's treatise on painting. This approach is rationalized as being analogous to the inventive process of the poet in changing words or deleting lines.[7]

Raphael arrived in Rome sometime during 1508. There is evidence that some of the metalpoint drawings on a pink ground were executed there, for one of them includes a figure for Raphael's Roman fresco, *School of Athens*, executed 1509–1510. Three studies for this project are in metalpoint on a pink ground, proving that Raphael still made use of this technique later during his career.[8] There are further connections between *Studies of a Seated Model* and Raphael's Roman works. The seated female bears a resemblance to the *Madonna della Sedia* (ca. 1514), and the infant at lower center is close to the Christ child in the *Madonna of Loreto* (ca. 1511–1512).[9] It seems, then, that while the Cleveland drawing was done during Raphael's stay in Florence, he returned to these early ideas roughly ten years later in Rome.

The use of metalpoint, because of the nature of the medium, requires self-discipline, technical control, and an innate

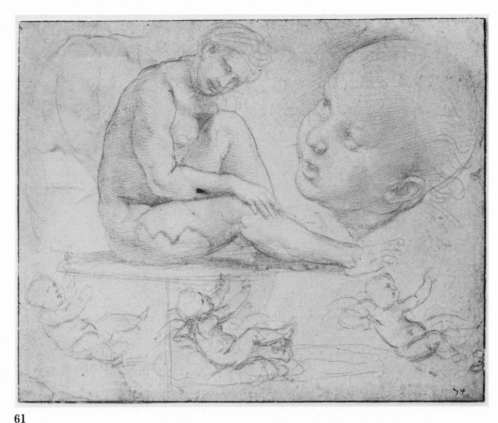

61

Fig. 61a. *Studies of the Madonna and Child*, pen and ink, 254 × 184 mm. Raphael. The British Museum, by Courtesy of the Trustees.

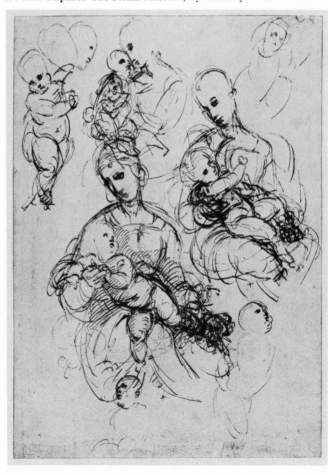

feeling for form. Pentimenti are to be avoided since mistakes can only be corrected by scraping the prepared ground. The limited depth of the stylus also makes plastic effects difficult. In Italy, however, during the generation of Lorenzo di Credi [15], Leonardo da Vinci, and Raphael—as exemplified here—a remarkable freedom was developed in metalpoint sketches by these artists in the use of modeling and shading. In Raphael's *Studies of a Seated Model* both pentimenti and a strong feeling of plasticity confirm the daring technical innovations of his generation and mark the declining importance of metalpoint since these new interests would be better expressed in chalk.

1. Fischel, 1939, p. 182; Fischel, 1948, pp. 129-130, pl. 138 B.
2. Pouncey and Gere, 1950–67, III, pt. 1, p. 20.
3. *Studies for an Infant Christ*, metalpoint on pink prepared paper, 168 × 119 mm., London, British Museum, no. I-72; Pouncey and Gere, 1950–67, III, pt. I, no. 23; III, pt. 2, pl. 28; *Various Sketches for a Madonna and Child*, silverpoint on pink prepared paper, 117 × 144 mm., Lille, Musée Wicar, no. 437.
4. De Vecchi, 1966, nos. 73, 77, both repr. p. 98; Pope-Hennessy, 1970, p. 286, n. 27.
5. Pope-Hennessy, 1970, p. 187.
6. Fischel, 1939, p. 187.
7. Gombrich, 1966, pp. 58-63; Armenini, 1977, p. 46.
8. Pouncey and Gere, 1950–67, III, pt. 1, p. 20.
9. Ruland, 1876, p. 317, no. XXX, 1; Fischel, 1912, p. 299. *Madonna della Sedia*, oil on panel, diameter 710 mm., 1514, Florence, Pitti Palace; de Vecchi, 1966, no. 109, repr. p. 111; *Madonna of Loreto*, original ca. 1511 –1512, now lost, copies Paris, Louvre; Malibu, J. Paul Getty Museum; New York, Metropolitan Museum; de Vecchi, 1966, no. 96, repr. p. 108.

Giulio Romano

1499–1546

Among all his associates and assistants, Raphael had the most confidence in Giulio Romano, who painted portions of the master's *Transfiguration* of 1517 now in the Vatican Museum, Rome, and did much of the work in the Loggia di Psiche of the Villa Farnesina (1518–1519). After Raphael's death in 1520, Romano was responsible for the completion of the Vatican Hall of Constantine. A number of large easel paintings, like the *Madonna della Gatta* now in Naples, were completed at this time as well.

In 1524 Romano left Rome to enter the employ of Federigo Gonzaga, the Marchese of Mantua, and he then participated in several engineering projects such as draining marshes. He was also involved in the construction and decoration of the Palazzo del Te. This project—with its fancifully inventive architecture and frescoes, especially Romano's *Fall of the Giants*—is distinctive as an exceptional example of wit, eccentricity, and humor in sixteenth-century Italian art. Romano succumbed to the *maniera* influence of Parmigianino in the 1530s. One of his last projects was the construction of his own palace in Mantua shortly before his death.

Giulio Romano

62 *A River God*

Pen and brown ink, brown wash, 170 × 273 mm., ca. 1528. Top corners added, soiled and foxed.

National Gallery of Art, Richard King Mellon Charitable Trust, 1973, B-26, 585.

Provenance: Joshua Reynolds (Lugt 2364); Thomas Lawrence (Lugt 2445); Lord Francis Egerton, first Earl of Ellesmere (Lugt 2710b); Thomas Agnew. *Sale:* London, Sotheby, 5 December 1972 (Ellesmere collection, Part II, drawings by Giulio Romano), no. 32. *Exhibited:* Leicester, 1954, no. 93, pl. xxiv; Washington, 1974, no. 16; Washington, 1978, p. 38. *Published: Catalogue of the Ellesmere Collection of Drawings at Bridgewater House*, no. 58; Bodmer, 1939, p. 150, no. 54 (as L. Carracci); Hartt, 1958, I, 140, 297, no. 176.

This drawing was first identified with Giulio Romano by Tomory. Previously Heinrich Bodmer had associated it with Lodovico Carracci.[1] Although not an exact quotation, Hartt related it to a river god in Giulio Romano's *Marriage Feast of Cupid and Psyche* (ca. 1528) for the Sala di Psiche in Federigo Gonzaga's Palazzo del Te, Mantua.[2] Romano's long, whiplike line, free and fluid, and as much decorative as descriptive, evolved in the direction of the calligraphic and ornamental in the following decade. Inspired by Hellenistic river gods, perhaps like that of the *Nile* [75], this *schizzo* is an experiment in pose, with the left leg and arm lacking final resolution.

1. Tomory, 1954, no. 93; Bodmer, 1939, p. 150, no. 54.
2. Hartt, 1958, I, 140.

After Giulio Romano

63 *The Sacrifice of a Goat to Jupiter*

Pen and brown ink, brown wash, over black chalk, 290 × 210 mm., ca. 1536–1540. Watermark: Circle surmounted by a star (Briquet 3120). Top corners clipped, vertical patch downward from top left of center, horizontal crease above center, holes, tears, soiled and foxed.

National Gallery of Art, Ailsa Mellon Bruce Fund, B-26,785.

Provenance: Benjamin West (Lugt 419); Thomas Lawrence (Lugt 2445); Lord Francis Egerton, first Earl of Ellesmere (Lugt 2710b); Richard Day, London. *Sales:* London, Sotheby, 5 December 1972 (Ellesmere collection, part II), no. 48, repr. p. 100 (as Romano, sold to Baskett and Day). *Exhibited:* London, 1836, no. 13; Washington, 1974, p. 200, repr. (as Romano). *Published: Catalogue of the Ellesmere Collection of Drawings at Bridgewater House*, no. 50; Tomory, 1954, no. 100 (as School of Romano); Hartt, 1958, I, 185, 301, no. 227 (as Romano).

Hartt recognized this drawing as a modello for one of the scenes in the Gabinetto dei Cesari of the Palazzo Ducale, Mantua.[1] The painting now at Hampton Court was one of a dozen histories on the Roman emperors to complement the twelve por-

62

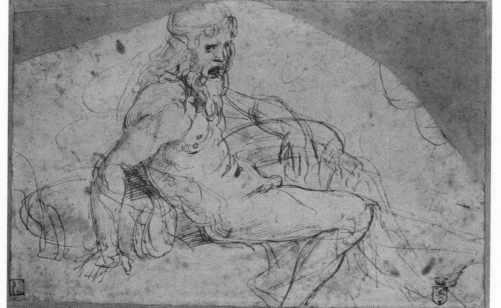

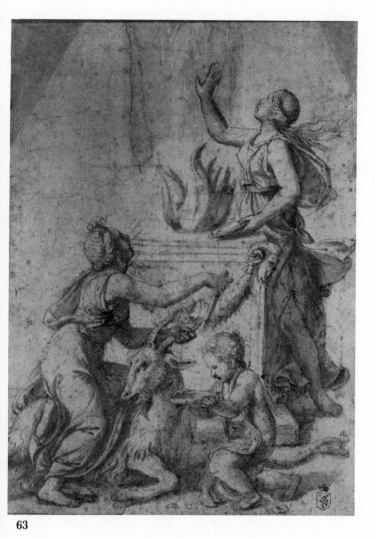

63

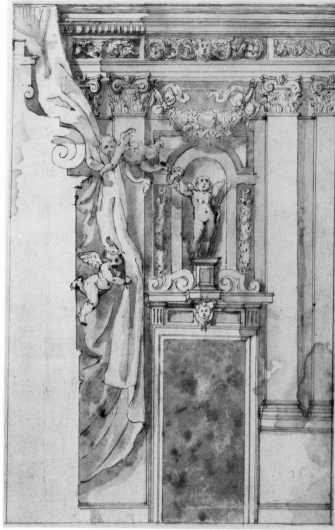

64

traits of the Caesars Federigo Gonzaga had commissioned from Titian.[2] It was executed by a member of Romano's studio, ca. 1536–1540.[3] In the painting a statue of Jupiter looking to the left — his right hand clutching thunderbolts — is in a niche above the scene represented in the drawing. A child is about to pour wine over the head of a goat which two priestesses are on the verge of slaying before the altar.

Tomory maintained that this drawing is also from the hand of a studio assistant.[4] The faces of both women are stylized profiles. The extended arm of the woman standing is poorly drawn and her lower torso is flattened by the uniform wash shading. Her companion's left foot does not connect to her body. The outline of the infant's back and hips is weak and uncertain, and the fluttering drapery extending above his right leg relates ambiguously to the shadow below. Also disconcerting is the distortion of the altar table's architrave so that the horizontal fasciae may connect

with the nose, mouth, and chin of the priestess kneeling on the goat. This jarring note confounds what was a formally cohesive element in the lost original by Romano and which reappears in the painting.

Certain stylizations in the figures, such as oversized hands, thick noses, and frozen profiles, are reminiscent of drawings by Pirro Ligorio [53-54] and the classical subject would have interested him. While no definitive attribution of this sheet is possible, it is true that too many differences exist between it and the painting for the design to be after the painting. It seems, rather, that this is a copy of a lost drawing by Romano; therefore, a more apt designation for the drawing would be "after Romano" rather than "attributed to Romano."

1. Hartt, 1958, I, p. 301, no. 227.
2. Ibid., pp. 170-177.
3. Ibid., pp. 175-176, II, fig. 376.
4. Tomory, 1954, no. 100.

School of Andrea Contucci, called Sansovino
1460–1529

64 Architectural Design

Pen and brown ink, brown and gray wash over pencil, 355 × 228 mm., ca. 1550. Notations: lower right, in pencil, 78; on verso, in pencil, 14, A 3935, T/A/-. Watermark: Bird in circle (similar to Briquet 12210), water stains.

The Cleveland Museum of Art, Gift of the Print Club of Cleveland, 27.363.

Exhibited: Baltimore, 1939.

This study, for a façade painting or an illusionistic interior, was left incomplete as pencil traces faintly indicated along the left margin have not been reinforced in ink. Two putti draw back a curtain while a third figure, perhaps a winged victory, holds a palm in its left hand and a crown or wreath in its right.

Although the drawing was attributed to the school of Andrea Contucci, called Sansovino, it must remain anonymous. The

89

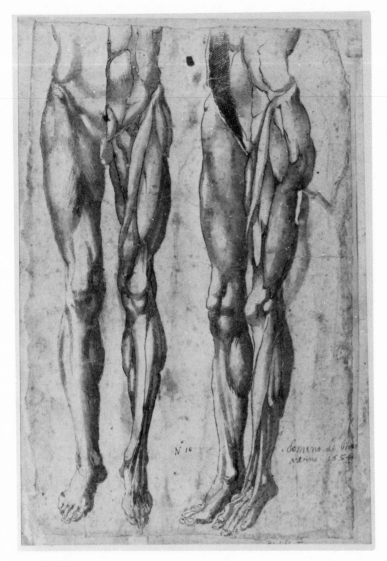

66 Recto

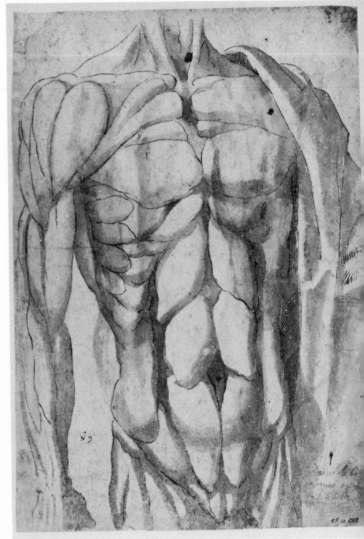

66 Verso

liberties taken with classical principles and architectural details; the illusionism in the swags, drapery, and flying putti; and the fanciful approach in general argue for a date later in the sixteenth century. In its illusionistic touches this drawing matches that of Battista Franco in the Steiner collection [47].

Cesare da Sesto

1477–1523

65 *Design for Decorative Clasps or Hinges*

Although exhibited as Cesare da Sesto, this drawing is here attributed to Giovanni da Udine and listed under his name on page 92.

Bartolommeo Torre da Arezzo or Aretino

ca. 1529–ca. 1554

Bartolommeo Torre da Arezzo is briefly mentioned by Vasari in his biography of Giovanni Antonio Lappoli.[1] Vasari describes Torre as a pupil of Lappoli in Arezzo who departed for the Roman studio of Giulio Clovio. Armenini refers to Torre as most skillful in copying the nudes of Michelangelo's Sistine Chapel.[2] Torre was so taken with the study of anatomy that he developed the wretched habit of storing corpses and human limbs in his house, even keeping them under his bed. He became a recluse and eventually fell victim to his curious living habits, dying shortly after returning to Arezzo at the age of twenty-five.[3]

1. Vasari-Milanesi, 1875–85, VI, 16.
2. Armenini, 1977, p. 139.
3. Felton Gibbon's contention that Torre was active in the 1560s and 1570s is unsubstantiated and contradicted by the little information available on the artist. Gibbons, 1977, I, no. 15; Thieme-Becker, 1934, XXXIII, 295.

Attributed to Bartolommeo Torre da Arezzo or Aretino

66 *Studies of a Flayed Man*

Recto: two figures, pelvis and legs; verso: one figure, torso and arm. Pen and brown ink, brown wash, over black chalk, incised (recto and verso), 406 × 276 mm., 1554. Notations: signed and dated, lower right, in pen and brown ink, *de mano de bart/ aretino 1554;* verso, lower right, in pen and brown ink, *de mano de bar / tolomeo aretino / 1554;* recto, lower center, in pen and brown ink, *No. 10;* verso, in pen and brown ink, lower left, *No. 9,* lower right corner, *N15,* upper right corner, *15.* Very creased, soiled, and foxed.

The Cleveland Museum of Art, L. E. Holden Fund, 75.26.

Provenance: Baskett and Day, London. *Exhibited:* Cleveland, 1976, no. 119. *Published:* Armenini, 1977, pp. 139, 140 n. 21, fig. 54 (verso).

Inasmuch as no paintings by Bartolommeo Torre survive and none is documented, the attribution of this sheet can only be based

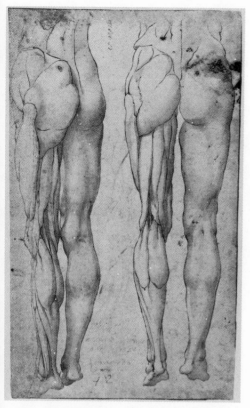
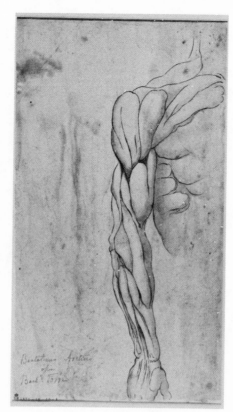

Figs. 66a and 66b. *Ecorché Studies*, pen and wash. Bartolommeo Torre. The British Museum.

a cadaver, this time seen from behind. Again only half of the figure has been flayed.

1. Vasari-Milanesi, 1875–85, VI, 16; Armenini, 1977, p. 139.
2. This procedure is also illustrated on the frontispieces of two early anatomy books, the first edition of Vesalius's *De Humani Corporis Fabrica*, 1543 (Fig. XXIV) and Realdo Colombo's *De Re Anatomica* (1559).
3. Inscribed on a sheet of muscle studies in the Royal Library at Windsor Castle (R. L. 19017R). Keele, 1977, p. 19, fig. 27B.
4. Attributed to Bartolommeo Aretino, *Anatomical Studies and Their Bones*, pen and ink and brown wash, 426 ×·260 mm., The Art Museum, Princeton University, no. 48-757, Gibbons, 1977, I, no. 15, repr. II, 7.

Giovanni dei Ricamatori, da Udine
1487–1564

Giovanni da Udine left his native city in the Veneto to try his fortune in Rome. There he became one of Raphael's most important assistants. According to Vasari, Giovanni rediscovered the ancient technique of stucco after examining the ruins of the Golden House of Nero. He also adopted many of the fanciful decorative designs found there called grotesques because the Golden House, covered with silt over the centuries, was mistakenly thought to be a grotto.[1]

Giovanni established himself as a leading decorator and stucco worker. He worked on the Villa Madama for the Cardinal Giulio de' Medici in 1520. He returned to Udine and Venice in 1522, fleeing the plague as well as the abstemious papacy of the Fleming, Adrian VI, but was back in Rome the next year for the elevation of Cardinal Giulio de' Medici as Pope Clement VII. In 1527 Giovanni again departed for Udine, fleeing the sack of Rome. Clement VII summoned him back to the Holy City in 1531 but allowed him to visit Florence the next year to complete stucco decorations for the Medici chapel in San Lorenzo. At the death of Clement VII, Giovanni returned to Udine where he married and became involved in many artistic projects in the city and its environs.

He made a pilgrimage to Rome for the Jubilee Year of 1550. Although anonymous and on foot, Giovanni was recognized by Giorgio Vasari and reintroduced to artistic circles in the Eternal City. He died in Rome the same year as Michelangelo.

1. Armenini, 1977, pp. 246, 247 n. 1, 248, 250, 251 nn. 8, 9.

upon its inscriptions and the brief literary references by Vasari and Armenini to Torre's obsession with anatomy.[1] Vasari, like Torre, was a native of Arezzo, and he and Armenini were in Rome in the 1550s and seem to have known Torre personally.

It appears that Torre was working from an actual cadaver. Pictures of artists' studios of the period [31] indicate that cadavers and skeletons were suspended at the back of the neck causing the legs and feet to dangle like the two figures on the recto of this drawing. Torre closely observed the flayed body. Although the definition of anatomy is imprecise, it is also generally correct. On the verso, the abdominal, serratus, pectoralis, and deltoid muscles can all be identified in the upper torso; the biceps, triceps, brachialis, and long supinator can be seen in the right arm. The shaded hollows along the linea alba need not imply that the torso was dissected and then reconstructed since the removal of superficial flesh would reveal unconnected muscle. The figure on the right side of the recto, however, appears disemboweled. The first major cavity has been studied, and for reasons of sanitation the organs have been removed.[2] Only half of the recto figures have been dissected. This affords a contrast of the skin with the muscle structure beneath.

Certain characteristics of this sheet are those of a novice. The slow movements of the hard, irregular lines suggest an inexperienced artist glancing frequently at his model. The lines are not always descriptive, becoming uncertain in their deliberate meander. Torre seems more concerned with rhythmic pattern than interior modeling in the use of washes. Muscles dissolve into abstract forms rather than meld in naturalistic fashion. Leonardo's instructions on this point are most apt: "Before you form the muscles make in their place threads which should demonstrate the positions of these muscles; the ends of these (threads) should terminate at the center of the attachments of the muscles to the bones."[3]

Both the recto and verso have been incised. The designs were then transferred to another medium, perhaps serving as engraved illustrations for a medical text. This could also explain why the figure on the verso has been embellished with a cape draped over its left shoulder.

Two other drawings associated with Torre are in Princeton[4] and in the British Museum. The latter (Figs. 66a and 66b) has an inscription similar to the ones on the Cleveland sheet, "de mano de bartomeo aretino 1554." It also has both full and three-quarter views of the torso and legs of

91

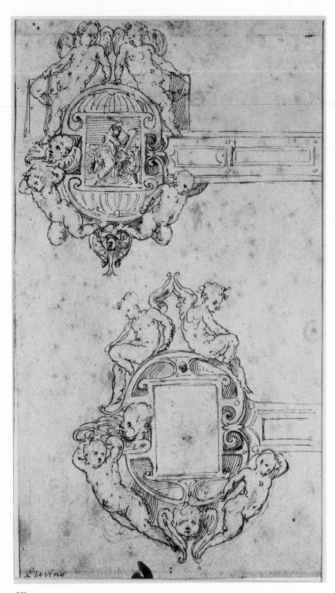

65

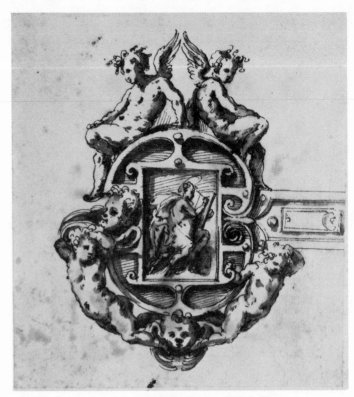

Fig. 65a *Design for a Morse with the Figure of St. Luke*, pen and brown ink and brown wash, 166 × 149 mm. Follower of Perino del Vaga, Italian. Royal Library, Windsor Castle.

Giovanni dei Ricamatori, da Udine.

65 *Design for Decorative Clasps or Hinges*

Pen and brown ink over black chalk, 299 × 175 mm., 1550s. Notations: lower left corner, in pen and brown ink, *Pierino*; on verso, a pen and ink border; on recto of mount, in pen and brown ink, *128*; in pencil, *32, 28, ct*; on verso of mount, in pencil, *A 309*. Watermark: H in circle. Foxed, ink stain bottom center, soiled.

The Cleveland Museum of Art, Dudley P. Allen Fund, 24.586.

Exhibited: Cleveland, 1924 (as Perino del Vaga), p. 141; Detroit, 1959, no. 15 (as circle of Perino del Vaga); Houston, 1960, no. 10 (as circle of Perino del Vaga).

A drawing in Windsor Castle (Fig. 65a) is a more finished version of the design in the lower half of this sheet and includes the evangelist in the center of the one at the top of the Cleveland sketch.[1] It is difficult to be certain, but perhaps this is St. Luke with an ox supporting the easel. The Windsor drawing is identified as a morse (a clasp for a liturgical mantle or cope worn in the Renaissance during ceremonies or by celebrants where the chasuble was not proper, such as burials, Vespers, and Benedictions of the Blessed Sacrament). These clasps were oval or square in shape and generally ornate and embellished with enamel, pearls, or precious gems. They might contain small figures of saints, were often of metal, frequently gold and silver, and detachable.[2] Grigaut, however, identified the objects on the Cleveland study as door hinges.[3] The long, horizontal metal extensions might suggest

hinges for a pair of tabernacle doors which could also accommodate depictions of the four evangelists.

This drawing was at first attributed to Perino del Vaga but Rudolf Berliner could not accept this.[4] Although exhibited as Cesare da Sesto, it seems better to associate it with the workshop of Giovanni da Udine. The definition of eyes, nose, and mouth as tiny arcs, hair suggested by wiry lines, and the use of paired dots or lines for accents occur in a sheet of figure studies in Besançon attributed to Giovanni da Udine.[5]

1. Blunt, 1972, no. 504, fig. 38.
2. "Morse," *The Catholic Encyclopedia* (New York: 1913), X, 577-578.
3. Grigaut, 1959, no. 15.
4. Rudolf Berliner, 16 January 1946, Curator's file, The Cleveland Museum of Art.
5. *Figure Studies*, pen and ink, 119 × 179 mm., Besançon, Musée des Beaux-Arts, no. 1406.

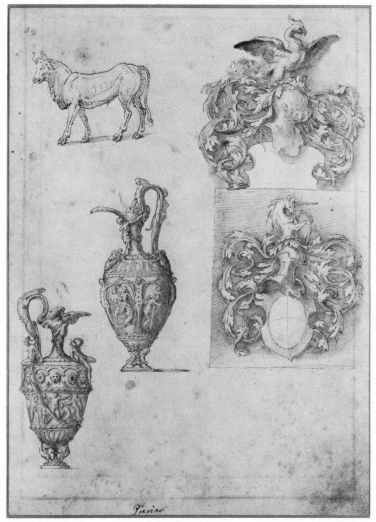

Fig. 67a. *Sheet of Ornamental Designs*, pen and brown ink, 320 × 225 mm. Giovanni da Udine. John and Alice Steiner Collection.

67

Giovanni dei Ricamatori, da Udine

67 *Design for Two Vases,*
Two Coats of Arms, and a Bull

Pen and brown ink, gray wash, over black chalk, 297 × 212 mm., ca. 1510. Notations: bottom center, in pen and brown ink, *Pierino*; verso, pen and ink border; on verso of mount, in pencil, *A3103*. Foxed, soiled.

The Cleveland Museum of Art, Purchase, Dudley P. Allen Fund, 24.589.

Exhibited: Cleveland, 1924 (as Perino del Vaga), p. 141.

Rudolf Berliner related this sheet to similar drawings in the Cooper Union collection.[1] He could not accept an attribution to Perino del Vaga and felt the draftsman was a goldsmith. The drawing can be attributed to Giovanni da Udine on the basis of affinities with a sheet of decorative designs in the Steiner collection (Fig. 67a) and one in the Ashmolean Museum.[2] All share the same swirling rhythms and calligraphic sweep. Of the many drawings attributed to Giovanni da Udine, few are soundly documented. Those most reliably associated with him are gouache nature studies related to work in the Vatican Loggia.[3]

Giovanni's decorative inventiveness is evident from the variety in these studies which reflect his interest in plants and animals as documented by Vasari.[4] In the upper right an eagle or firebird rests on a helmet while below a unicorn resides in a similar spot. Both vases are covered with fanciful creatures. The one at the lower left contains ignudi and caryatid swans at the base. The other has rams' heads, atlantids, and satyrs. A bull in the upper left corner recalls similar subjects by Giulio Romano. The bold relief, parallel hatching, consistent outline, and variety of surface treatment suggest a date early in Giovanni's career when elements of his Northern Italian training were still in evidence.

1. Rudolf Berliner to Henry S. Francis, 10 December and 16 January 1946, Curator's file, The Cleveland Museum of Art.
2. Cambridge, 1977, no. 32, fig. 32; *Ornamental Design* (recto), *Scroll* (verso), pen and ink, 321 × 225 mm., Oxford, Ashmolean Museum, no. 727.
3. Pouncey and Gere, 1950–67, III, pt. 1, no. 184, III, pt. 2, pl. 154.
4. Vasari-Milanesi, 1878–85, VI, 549, 555.

Pietro Buonaccorsi, called Perino del Vaga

ca.1500–1547

Perino del Vaga is perhaps best known as an associate of Raphael. He left the Florentine studio of Ridolfo Ghirlandaio after 1515 and by 1518 was participating in the work on Raphael's Vatican loggias. His frescoes of the early 1520s in the *Sala dei Pontefici* — where flowing lines form complicated patterns — attest to his strengths as a decorative artist.

Perino returned to Florence in 1522 to avoid an outbreak of plague in Rome. Once back in Rome in 1524 he occupied himself with a major project: the fresco decorations of the life of the Virgin in the Pucci chapel of SS. Trinità dei Monti. In these paintings Raphael's style is tempered by knowledge of Pontormo's art. Parmigianino and Rosso, who were also in Rome at this time with Pontormo, were well acquainted and mutually influential. Before fleeing the Sack of Rome, Perino had completed designs for Caraglio's engravings of the *Loves of the Gods*. From 1528 to 1536–1537 he worked in Genoa for Andrea Doria. His *Fall of the*

Giants in the Palazzo del Principe remains the highpoint of this commission. Perino's religious paintings of the 1530s involve a more legible placement of forms, greater quietude, and flashing colors that dissolve into shadows.

After his return to Rome, Perino completed the Massimi chapel in SS. Trinità begun by Giulio Romano, and supplied Jacopino del Conte with a design for the *Preaching of the Baptist* in S. Giovanni Decollato. In his last years he was assisted by Pellegrino Tibaldi in decorating the Pauline apartments of the Castel Sant' Angelo with history scenes of Alexander the Great. Here, bursting figures conflict with their enframements and create congested spaces while respecting the pictorial surface. Perino's death marked the peak of sixteenth-century anti-classicism in Italy.

Pietro Buonaccorsi, called Perino del Vaga

68 *St. Peter*

Pen and brown ink, squared in black chalk, 215 × 315 mm., ca. 1532. Watermark: Unidentified, image in circle. Some ink stains, vertical fold right of center.

Alice and John Steiner.

Exhibited: Cambridge, 1977, no. 33, repr. p. 92.

St. Peter, identified by his keys, is given a cursory halo and seated on a bank of clouds. His book and keys are symbols of the doctrine and authority entrusted to the first pope. The figure, within a triangular frame, is squared for transfer suggesting that the design was intended to fill an architectural space, perhaps the spandrel of a vault. Two other studies also place St. Peter in a triangle. One is a quick sketch of the subject,[1] while the other is closer to a final solution,[2] retaining Peter's pose but with his head turned and book and keys exchanged. Bernice Davidson suggested a date of 1532 or later based upon stylistic affinities with Perino's altar in Celle Ligure and with his St. Erasmus altarpiece in Genoa.[3] Lesley Koenig dated the sheet 1529–1530, closer to Perino's Roman experience and the influence of Michelangelo's heroic figures in the Sistine ceiling.[4] No painting of this subject by Perino survives.

The drawing is a splendid example of Perino's draftsmanship by virtue of the great variety in linear effects, contrasts of shape, and accents of light and dark. Groups of parallel lines alternate with curved, looped, and crosshatched lines; the rectangular geometry of the book and cylindrical hardness of St. Peter's keys are softened by his billowing drapery and the amorphous clouds; open areas of the paper contrast with areas darkened by multiple lines and heavy pressure on the nib of the pen.

1. *St. Peter*, pen and brown ink, 228 × 355 mm., English private collection; Edinburgh, 1969, no. 59, pl. 62.
2. *St. Peter*, pen and ink, gray wash on blue paper, 224 × 353 mm., Vienna, Albertina, no. 2011, Davidson, 1966, no. 25, fig. 20.
3. Ibid.
4. Lesley Koenig in Oberhuber, 1977, p. 93.

68

69

Pietro Buonaccorsi, called Perino del Vaga

69 *Studies of Horses*

Pen and brown ink, 286 × 389 mm., ca. 1532.
Notation: verso, in pen, *Perino del Vaga 18 56.*
Soiled at edges.

Alice and John Steiner.

Provenance: Nicholas Lanier (Lugt 2885); Peter
Lely (Lugt 2092); William Mayor (Lugt 2799);
Lord Roseberry. *Exhibited:* Cambridge, 1977,
no. 34, repr. p. 94.

Leonardo da Vinci's lost fresco of a cavalry
encounter in the Palazzo Vecchio, *The Bat-
tle of Anghiari*, would seem to be the ob-
vious precedent for this subject. Perino del
Vaga's drawing lacks the tightness of
Leonardo's battle composition (as indicated
from surviving copies), since it is a group of
individual studies rather than one composi-
tion.

This most impressive sheet is highly
representative of Perino's loose calligraphy
at once free and precise, with a masterful
play of line. The animation in this sheet is
as much a result of Perino's whiplike line
playing across the surface of the page as it is
the kicking and biting of the rearing horses.
Perino's interest in equine anatomy is in-
dicated by the bone and muscle study
quickly sketched in the upper right corner.
The drawing continues the Florentine tradi-
tion initiated by Pollaiuolo's engraving of
Ten Battling Nudes. Both works deal with
movement, struggle, and multiple views.
By the fourth decade of the sixteenth cen-
tury artistic concern with proportions had
given way to a preoccupation with move-
ment made explicit by mid-century in
treatises and dialogues on art.

Koenig and Oberhuber suggested a date
of the early 1530s, when Perino was involved
in fresco projects for the Palazzo Doria.[1]
The sheet is clearly representative of
Perino's mature style, and the subject ap-
propriate for his grand projects under noble
Doria patronage. The anthropomorphic
quality of the animals, especially the horses'
eyes, may have later influenced the man-
nered creatures of Pellegrino Tibaldi in the
Palazzo Poggi.

1. Lesley Koenig in Cambridge, 1977, p. 95.

Studio of Perino del Vaga
(Luzio Romano?)

70 *Design for a Candlestick*

Pen and brown ink, brown wash over black
chalk, 324 × 146 mm., ca. 1550s. Notations:
bottom center, in pen and brown ink, *Pierino;* on
mount, in pencil, *20;* on verso of mount, in pen-
cil, *A3107.* Watermark: Anchor in circle (similar
to Mosin 389). Soiled.

The Cleveland Museum of Art, Gift of The Print
Club of Cleveland, 27.362.

Michelangelo's Medici tombs in San Lorenzo
serve as a frame of reference for these dec-
orative motifs. A strong tendency to weigh
decorative or functional objects with serious-

70.

minded symbolism became common after
mid-century, as can be demonstrated by
Benvenuto Cellini's account in his autobio-
graphy of the decorative motifs in his salt
cellar. In this instance, the decorative
creatures (bats, owls, rams' heads) are
associated with night, darkness, and death
as appropriate for a candlestick.

John F. Hayward observed that female
figures on projecting ledges comprised a
favorite decorative device of Perino del
Vaga.[1] Although the style is too weak and
dry for Perino, the ambience is clearly his.
This study is similar in many respects to the
left-hand candlestick on a drawing in the
Victoria and Albert Museum which Hay-
ward attributed to the studio of Perino del
Vaga.[2] Both have similar lions' feet and
scroll bases and the pen and wash techniques
are comparable. In the London design figures
are splayed convexly around a decorative
knob like the bats in the Cleveland draw-
ing, and except for her raised right arm, the
female at bottom left of the former sheet

has the same pose as the similarly positioned
figure of the latter.

Although difficult, it may be possible to
isolate the draftsman responsible for these
sheets. Another drawing which is similar to
these, in the British Museum, has been ten-
tatively attributed to Perino's assistant,
Luzio Romano.[3] This artist was a painter
and stucco worker who, according to
Vasari, was among Perino's assistants at the
Palazzo Doria in Genoa (ca. 1528–1533)
and at the Castel Sant'Angelo in Rome
(from 1545).[4] Other drawings, at Windsor
and at the Courtauld Institute, were also
executed by the same hand.[5]

1. Hayward, 1976, p. 344.
2. *Two Candlesticks*, pen and ink and wash, 306 × 185
mm., London, Victoria and Albert Museum, no. 8075,
Hayward, 1976, pl. 56.
3. *Two Designs for a Mace*, pen and brown ink and
wash over black chalk, 314 × 210 mm., British
Museum, no. 1957-9-11-1, Pouncey and Gere, 1950–67,
III, pt. 1, no. 188, III, pt. 2, pl. 158.
4. Vasari-Milanesi, 1878–85, V, 616, 629.
5. Hayward, 1976, p. 344; Pouncey and Gere, 1950–67,
pp. 110-111.

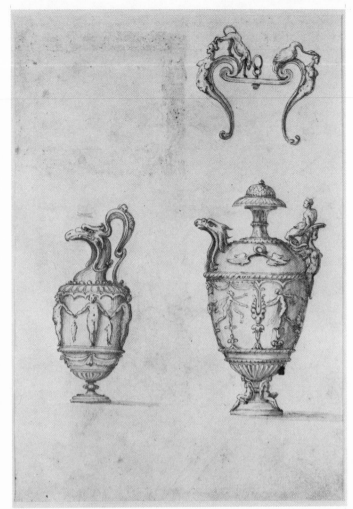

71 Recto

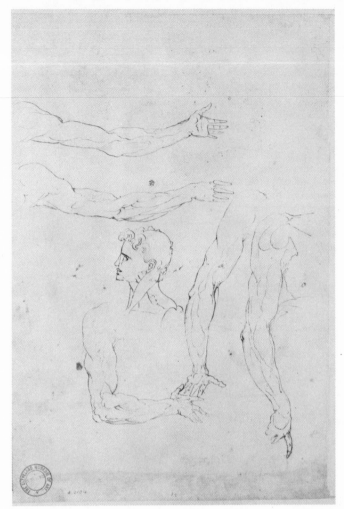

71 Verso

Fig. 71a. *Proportions of the Face*, woodcut.
Luca Pacioli, Italian, 1445–1510.
Divina proportione (Venice, 1509), fol. 25v.

Studio of Perino del Vaga
(Luzio Romano?)

71 *Design for Two Vases and an Ornament*
(recto); *Studies of Five Arms
and a Head* (verso)

Pen and brown ink, brown and gray wash, over
black chalk (recto); pen and brown ink (verso).
317 × 216 mm., ca. 1550s. Notations: bottom
center, in pen and brown ink, *Pierino;* on verso,
in pencil, *A 3104, 12*. Watermark: Anchor in cir-
cle below six-pointed star (similar to Briquet
493). Foxed, soiled.

The Cleveland Museum of Art, Purchase, Dudley
P. Allen Fund, 25.1190.

Published: Armenini, 1977, fig. 33 (verso, as cir-
cle of Perino del Vaga).

Like *Design for a Candlestick* [70], this
sheet can be related to the circle of Perino
del Vaga. The studies for vases on the recto
are similar in style and motifs to the

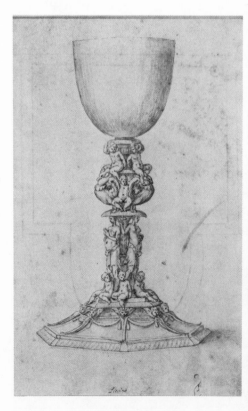

Fig. 71b. *Design for a Chalice*, ink and chalk,
321 × 200 mm. Luzio Romano, attr.
The Cleveland Museum of Art,
Dudley P. Allen Fund.

72 Recto

72 Verso

candlestick, making an attribution to Luzio Romano reasonable for this sheet as well. The *Studies of Five Arms and a Head* on the verso have the crisp, lineal continuity of Perino although not the assurance of the master. The abstract stylization of fingers reinforces the pedigogical nature of these multiple views of arms, the repetitious studio practice confirmed by Armenini.[1]

The figure studies on the verso indicate that this sheet is from a sculptor's hand and follows canons recommended by Pomponius Gauricus in his treatise *De Sculptura*.[2] The proportions of the face whereby the profile head is inscribed within a square and the face within a triangle also follows the geometrical canons of Lorenzo Ghiberti, Leonardo da Vinci, and Fra Luca Pacioli. Gauricus rationalized his geometrical system in terms of Plato's doctrines in the *Timaeus*.[3] The divisions of head and face in this drawing are less rigid and do not conform exactly to the illustration in Luca Pacioli's *De divina proportione* (Fig. 71a).[4]

Another drawing in Cleveland, *Design for a Chalice* (Fig. 71b), is from the same workshop and may be by Luzio Romano also.[5] Like several of the other drawings made for goldsmiths, this design was for an object reserved for liturgical use. Work on such ceremonial objects occupied much of the studio's daily activity.

1. Armenini, 1977, pp. 48, 123-124.
2. Gauricus, 1969, p. 81.
3. Ibid., p. 92.
4. Pacioli, 1509, fol. 25v.
5. *Design for a Chalice*, pen and brown ink, brush and gray wash over black chalk, 321 × 200 mm., ca. 1550s, inscribed in pen and brown ink bottom center: *Pierino*; Cleveland Museum of Art, 24.587.

Francesco Vanni

1563–1610

Francesco Vanni was a native of Siena. It is traditionally accepted that he studied with Passarotti in Bologna before joining the Roman studio of Giovanni de' Vecchi in 1577–1579, but neither of these observations can be documented.[1] Vanni was in Lombardy in 1583 and was a resident of Milan from 1595 to 1601. He was in Siena in 1605 and 1610 when visited there by a close friend, Cardinal Federigo Borromeo. In the 1580s Vanni's style was influenced by Federico Barocci and by Domenico Beccafumi.

1. Riedl, 1976, p. 11.

Francesco Vanni

72 *Madonna with Infant Christ and St. John* (recto); *Madonna and Child* (verso)

Red chalk, pencil (recto); red chalk (verso), 177 × 134 mm., ca. 1590.

Bowdoin College Museum of Art, Brunswick, Maine, 1811.09.

Provenance: James Bowdoin III

An air of refinement and idealization slightly modifies Vanni's naturalistic approach to the traditionally popular Tuscan subject of the Holy Family with St. John. The pose and animation of the squirming infant recall similar figures in works by Raphael and Leonardo at the beginning of the century. The emotional intensity of Pontormo is here tinged by an appealing sweetness. In addition to the descriptive power of Vanni's loosely handled chalk line, his confidence as a draftsman is evident in the calligraphic flow and accents of the black chalk. The negative areas of the drawing are as alluring as the solids. That is, the cavity described by the Virgin's right arm, the space above the arm of St. John, and the soft hollow beneath the Virgin's chin have strong visual appeal. The vacuum resulting from the opening between the Virgin's shoulder and

Christ's head, and that between the heads of both infants create a dynamic tension as Christ lunges forward but glances back.

Francesco Vanni

73 *Sheet of Figure Studies*

Pen and brown ink, brown wash, black chalk, 210 × 289 mm., 1602. Notation: top left, in pen and brown ink, (one illegible letter), *Vanni.* Creases, soiled.

Lent by the Metropolitan Museum of Art, Rogers Fund, 1966, 66.93.4.

Provenance: Mrs. van der Gucht. *Sales:* London, Colnaghi, 19 April-6 May 1966, no. 13.

The vocabulary of pious gestures and attitudes of the twenty-three figures on this page is ubiquitous in Vanni's paintings and drawings. The sheet is filled with studies for female saints, a kneeling bishop, friars, a sleeping Adam, a skeleton curled in the sleep of death, and a female nude. Four of the figures are traced faintly in chalk while the remaining are executed in quick, erratic, angular pen lines, occasionally touched with wash.

This sheet can be dated to 1602 on the basis of its association with *Allegory of the Immaculate Conception* in the church of Santa Margherita, Cortona.[1] The figure of a kneeling bishop with outstretched arms in the lower left corner and left of center is identical to a foreground figure in a drawing in the Uffizi associated with the canvas.[2] Identical figures of St. Margaret appear in the lower right corner of both drawings. Sketches for the kneeling bishop, SS. Francis and Dominic, and St. Margaret, which are related to figures in these sheets, also appear on drawings in Berlin.[3] The figure of the kneeling bishop is close to the cleric in a drawing in Oxford (Fig. 73a) and a figure on a sheet in the Uffizi also containing other figures related to the Oxford composition.[4] The Uffizi design was for the main altar of Santa Maria degli Angeli which Riedl dated late in Vanni's career.[5]

1. Riedl, 1976, no. 33.
2. *Allegory of the Immaculate Conception*, black chalk and wash, 367 × 257 mm., Florence, Uffizi, no. 10808 F; Riedl, 1976, no. 33, fig. 33. A replica of this drawing is in Paris, Louvre, no. 2038.
3. All are in Berlin, Staatliche Museen, *Study for a Kneeling Bishop*, no. KdZ 22010; *Study for SS. Francis and Dominic*, no. KdZ 22013; *Study for Saint Margaret*, no. KdZ 22518r.
4. *Composite Sketch and Particular Studies for a Madonna in Glory Adored by Saints*, pen and ink, 186 × 270 mm., Florence, Uffizi, no. 4818S; Riedl, 1976, fig. 75. See also the kneeling bishop in: *Allegory of the Sacrament*, pen and chalk, 273 × 180 mm., Madrid, Academy of San Fernando, no. 505; Sánchez, 1978, fig. 4.
5. Riedl, 1976, no. 76.

73

Fig. 73a. *The Virgin and Child with Saints*, black chalk, pen, and brown wash, 255 × 172 mm. Francesco Vanni. Ashmolean Museum, Oxford.

Enea Vico

1523–1567

Although Vico was born in Parma, died in Ferrara, and was active in Florence, his interests were strongly conditioned by a visit to Rome in the early 1540s. He was influenced by the graphic artist Agostino Veneziano and eventually produced about 500 prints himself.[1] Vico's best works, characterized by broad, powerful strokes, date from his early years. Later his engravings became more delicate and calligraphic. While in Florence Vico made engravings for Duke Cosimo I after works by Michelangelo. In 1546 the Venetian government awarded Vico copyrights for his engravings. He journeyed to Ferrara in 1563 and remained in the service of Alfonso II d'Este for the last four years of his life.

1. Bartsch, XV, 282-370.

Enea Vico

74 *Academy of Baccio Bandinelli*

Engraving, 302 × 476 mm., 1550. Engraved inscriptions in plate: in book at top right, *Baccius / Bandi / nellus / invent, Enea Vi / go Par / megiano / Sculpsit;* at bottom, *Romae Petrus Paulus Palumbus formis.*

Museum of Fine Arts, Boston, Horatio G. Curtis Fund, 1976.611.

Published: Bartsch, 1818, XV, 305, no. 49.

This scene of an artist's workshop, that of the Florentine sculptor Baccio Bandinelli (1493–1560), reveals the activities of young apprentices. Although the room is illuminated by oil lamps and a fire, this is not necessarily a night scene. No windows are evident and the novices work under conditions of artificial light and in groups in conformance with procedures recommended in art treatises. Alberti advised the artist to work with models in artificial light,[1] and Leonardo suggested working under the critical eye of companions.[2]

Scattered throughout the studio are parts of skeletons and figurines (whether of clay, wax, or bronze is unclear). There is also a pile of books implying the cultured environment of an academy and the learned pursuits of the artist as advised by Alberti.[3] An engraving of 1531 (Fig. IX) by Agostino Veneziano depicts the Bandinelli workshop in the Vatican Belvedere where a group of draftsmen sketch statuettes by candlelight, the flame throwing distorted shadows on the walls. A view of a formal artist's academy where pupils follow a comprehensive and apparently structured program is given in Pierfrancesco Alberti's engraving [31]. It is representative of the baroque studio where the *studiosi* worked in broad daylight and from a variety of models including a cadaver, skeleton, plaster casts of parts of the human body, and artist's primers.

As a tribute to Bandinelli, the insignia of one of the orders of *cavaliere* to which the artist had been elevated by Pope Clement VII and by the Holy Roman Emperor Charles V is displayed above the fireplace in a shield supported by two cherubs. The artist stands at the far right, bearded and wearing a similar emblem.

1. Alberti, 1966, pp. 82, 94.
2. Richter, 1970, I, 249, no. 495.
3. Alberti, 1966, p. 90.

74

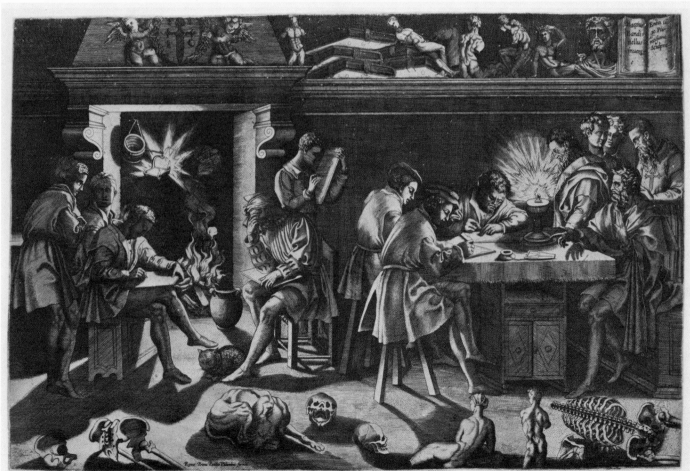

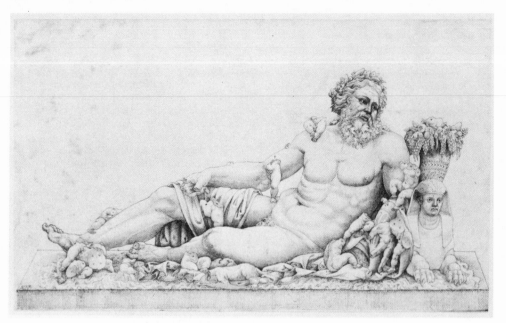

75

Fig. 75a. Detail of *River Nile*, pen and wash.
Amico Aspertini, Italian, 1474–1552. The British Museum.

Enea Vico

75 *The Nile*

Pen and brown ink, 177 × 305 mm., ca. 1545.
Notation: signed at lower left, in pen and brown
ink, *AE. V.* Soiled and foxed.

The Pierpont Morgan Library, New York, IV, 50
(Italian 16, 15).

Provenance: C. Fairfax Murray (under Lugt
1509); J. Pierpont Morgan (Lugt 1509). *Published:* Fairfax Murray, 1905–12, IV, no. 50, pl.
50; Brummer, 1970, p. 195, fig. 181.

The huge marble *River Nile* was uncovered
in 1513 near the church of Santa Maria
sopra Minerva and placed in the garden of
the Belvedere by Pope Leo X.[1] Although the
motifs are Alexandrian, the figure was carved
in Rome for the Temple of Isis and Serapis

during the Imperial period. Its companion
piece, the *Tiber*, now in the Louvre, was
unearthed in January of 1512 and brought to
the Vatican within the month. Vico's drawing of it is also in the Morgan collection.

Both marbles were damaged as the Vico
drawings indicate and were repaired and
supposedly restored in 1524–1525. That the
swarming putti, symbolic of the Nile's fertile abundance, remained mostly damaged
is confirmed by Hendrick Goltzius's drawing of 1591.[2] Goltzius's study could have
been based on an earlier drawing since the
figure is shown restored in sketchbooks by
Martin van Heemskerck (1532–1536),
Amico Aspertini (Fig. 75a), Francisco de
Hollanda (1539–1540), and in an anony-

mous sketchbook now in Cambridge.[3] Many
of the restorations, however, appear to be
fanciful reconstructions by the copyists.
Hollanda's drawing lacks a putto in the
cornucopia, and the one in the Cambridge
sketchbook differs from the presently restored figure in the Vatican. Certain Roman
sketchbooks are notoriously unreliable as
visual records with monuments imaginatively reconstructed by the draftsman from
other similar monuments or based upon
literary descriptions. Such is the case with
many items in Pirro Ligorio's antiquarian
archive.[4]

The drawing is in a tight hand, reflecting
the meticulous technique of an engraver,
and may have been intended for a print.
The delicate fussiness in the pen lines can be
found in other sheets by Vico.

1. Armenini, 1977, p. 131, n. 3; Brummer, 1970, pp.
191-192.
2. Hendrik Goltzius, *The Nile*, K, III, 21, Haarlem,
Teyler's Stichting, Brummer, 1970, p. 195, fig. 183.
3. Martin van Heemskerck, sketchbook I, 79D2, fol.
54r., Berlin, Kupferstichkabinett, Brummer, 1970, fig.
188; Amico Aspertini, sketchbook I, fol. 14 v.-15,
London, British Museum, Brummer, 1970, fig. 47;
Francisco da Hollanda, sketchbook, Cod. 28-I-20, fol.
50r., Madrid, Escorial, Brummer, 1970, fig. 192;
Anonymous sketchbook, Cod. R. 17.3, fols. 17, 18,
Cambridge, Trinity College, Brummer, 1970, figs.
190-191.
4. Mandowsky and Mitchell, 1963, p. 63.

Daniele Ricciarelli da Volterra

ca. 1509–1566

Daniele da Volterra was born in the Tuscan
village of Volterra but trained as an artist in
Siena. He arrived in Rome after the mid
1530s when Michelangelo was working on
the *Last Judgment* in the Sistine Chapel
(Fig. 41a). In Rome Daniele assisted Perino
del Vaga before painting his own masterwork, the *Deposition* in Santa Trinità (ca.
1543). Michelangelo's powerful forms
became even more pronounced in Daniele's
interpretations of them. Michelangelo
became a personal friend of his young admirer, and it was Daniele that Pope Paul IV
trusted to add draperies to the nude figures
of the *Last Judgment*. He seems to have
worked on the project only after Michelangelo's death in 1564.

Daniele Ricciarelli da Volterra

76 *Study of a Male Nude*

Black chalk, 400 × 225 mm., ca. 1550s. Notation: on mount, above center, in pen and brown
ink, *14.* Soiled, many small holes.

E. B. Crocker Art Gallery, 222.

Provenance: Edwin Bryant Crocker. *Exhibited:*
Sacramento, 1971, no. 23, repr. p. 63; Sacramento, 1975, no. 34, repr. p. 36. *Published:*
Bohr, 1958, pp. 136-137, no. 91.

This sketch records one of the nudes among
the resurrected on the left side of Michelangelo's *Last Judgment* (Fig. 41a), before

the addition of drapery to the figures in the 1560s. Taken out of the context of the huge fresco — where the figure is pulled upward (notice the pale indication of a hand grasping his wrist) — the figure seems to be engaged in a curious dance.

Louisette de L'Arbre discussed the attribution of the drawing, once given to Michelangelo, to Daniele.[1] He retains Michelangelo's thickset proportions, and the velvet softness of the blurred interior modeling is like that found in many of Michelangelo's late drawings. The taut, bunched lines and smooth, undulating surface are elements found in other studies by Daniele from the 1550s. Inflated modeling is constrained within a clean, wavy silhouette.

1. Sacramento, 1975, pp. 36-37.

Federico Zuccaro
1540/41–1609

Federico Zuccaro was raised in the studio of his older brother, Taddeo. In 1560 he had a major responsibility for the decoration of the Casino of Pius IV. He worked on the Grimani chapel in S. Francesco della Vigna in 1563 after the death of Battista Franco. The following year Federico studied art in Lombardy and enjoyed the companionship of Palladio. He worked on decorative projects in honor of Giovanna of Austria's trip to Florence in 1565, then returned to Rome a few months before Taddeo's death.

Federico remained quite active on projects in Rome and environs into the 1570s, although his restless nature led to journeys to Lorraine, Holland, and England. Federico returned to Florence to complete the decorations of the cathedral dome, left unfinished when Vasari died in 1574. In 1579 he returned to Rome, but in 1581 Pope Gregory XIII banned him from the city for having painted a caricature of the detractors who criticized his painting of the *Procession of St. Gregory* in S. Maria del Baraccano, Bologna. He was asked, nonetheless, to complete Michelangelo's decorations in the Pauline Chapel in 1583–1584.

Retiring to Urbino, Federico painted histories in the Grand Council Chamber in the Ducal Palace. In 1586 he succeeded Luca Cambiaso in the service of King Philip II at the Escorial. Into the 1590s Federico continued to defend the late Renaissance tradition of formalism against the phenomenal new seriousness of Barocci and the classicizing naturalism of the Carracci. He was elected the first *principe* of the Roman Academy of St. Luke in 1593, from which time he began his theoretical speculations which finally resulted in the publication of *Idea* in Turin in 1607.

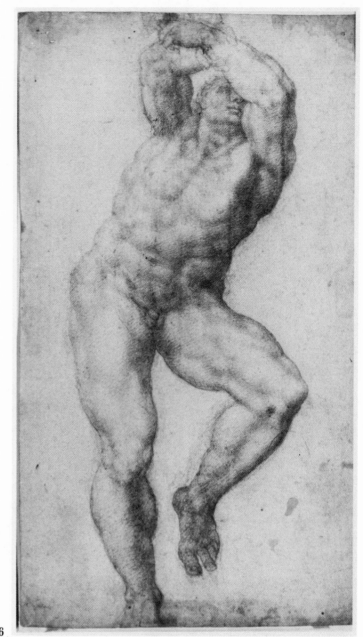

76

Federico Zuccaro

77 *Angels and Putti in the Clouds*

Red and black chalk, squared in red chalk, incised, 397 × 272 mm., ca. 1565. Soiled at edges.
National Gallery of Art, Ailsa Mellon Bruce Fund, 1971, B-25,647. *Provenance:* Ch. Mewes Arch. (stamp); Nathan Chaïkin, Venthône, Switzerland. *Exhibited:* Washington, 1974, no. 18, repr. p. 55.

The fresco of 1566 of the *Annunciation with God the Father and Angels* in the Roman church of Santa Maria Annunziata, for which this drawing was a study, was destroyed in 1626.[1] Diane Bohlin recognized the connection between drawing and fresco based upon an engraving of the composition made by Cornelius Cort in 1571.[2] A drawing similar to the one in the National Gallery is in the Rosenbach Foundation.[3] In addition a preparatory study for the entire scene is in the Uffizi.[4]

1. Körte, 1932, pp. 522-524.
2. Washington, 1974, no. 18. Cornelius Cort engraving after Federico Zuccaro's *Annunciation with God the Father and Angels*, Körte, 1932, fig. 4.
3. *Right Half of a Lunette-Shaped Composition of Angels on Clouds*, red and black chalk, 281 × 233 mm., Philadelphia, Rosenbach Foundation, R.F. 472/22 no. 36; Gere, 1970, p. 128, no. 10, pl. 5.
4. *Study for a Lunette, with the Annunciation Below and God and the Holy Spirit Surrounded by Angels Above*, pen and brown ink, brown wash over red chalk indications, 417 × 477 mm., Florence, Uffizi, no. 818 S; Gere, 1966, no. 49, pl. 37; Gere, 1969b, no. 51.

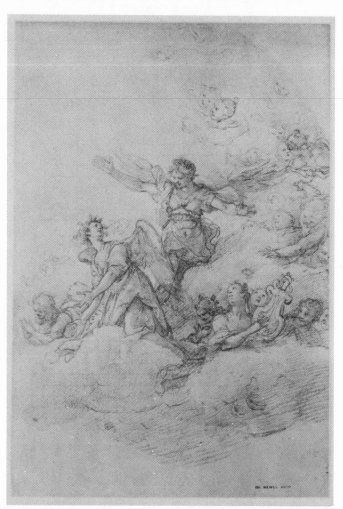

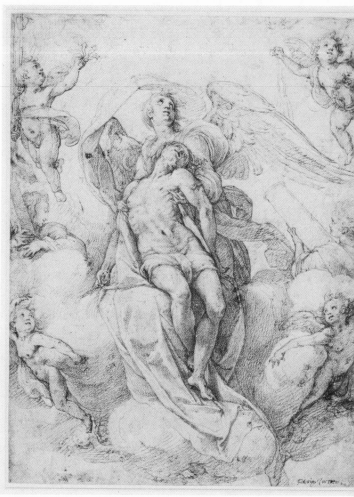

77 78

Federico Zuccaro

78 *The Dead Christ Supported by Angels*

Red chalk, squared in black chalk, 347 × 265
mm., 1563. Notation: lower right corner, in pen
and brown ink, *Federigo Zuccaro*. Watermark:
Anchor in a circle surmounted by a star (similar
to Briquet 485). Soiled.

Yale University Art Gallery, Everett V. Meeks,
B. A. 1901, Fund, 1972.94.

Provenance: H. Schickman Gallery, New York.
Exhibited: New Haven, 1974, no. 34, repr.

Gere discovered other drawings by Federico
of *The Dead Christ Supported by an
Angel.*[1] A sheet in Ottawa represents the
two central figures in reverse, while a
drawing in Budapest depicts a dead Christ
surrounded by angels holding instruments
of the passion.[2] The Budapest sheet with its
arched top seems to have been intended for
an altarpiece, whereas Pillsbury and
Caldwell suggested the Yale drawing may
have been for an easel painting or
engraving.[3]

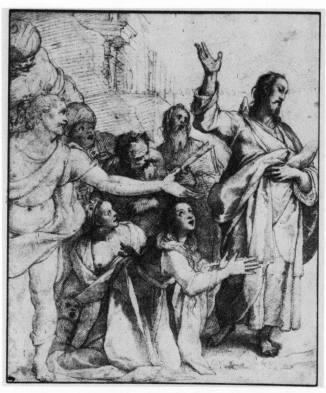

Fig. 78a. *The Resurrection of Lazarus,* black and red chalk.
Federico Zuccaro. Musée du Louvre.

A design in the Uffizi assigned to Taddeo Zuccaro is close in many details to the Yale sheet.[4] Although cherubs holding instruments of the passion replace the more finished angels, the attitudes of the figures, the upper torso of Christ, the angel's left hand supporting Christ's arm, and the angel's fluttering drapery arcing over his head are all similar. The Uffizi drawing is closer in style to Federico Zuccaro and is a variant of the more finished Yale design. The use of wash, freer figure handling, and stylizations of hair, eyes, and mouth are representative of a later phase of Federico's career.

In 1563 two years after Battista Franco died, Federico was summoned to Venice by Cardinal Grimani, where he was charged with completing Franco's decoration of the family chapel in San Francisco della Vigna. The tight, grainy, highly finished style of *The Dead Christ Supported by Angels* is typical of Federico's draftsmanship in this period. The clean outlines, a bit hard and dry, and shading by means of short, parallel strokes with pressure varied on the chalk are characteristic of Federico's early drawings. Another example is the Louvre's *Resurrection of Lazarus* from 1564 (Fig. 78a).[5] Pillsbury and Caldwell identified the models Federico utilized for the *Dead Christ* composition: Dürer's *Trinity* woodcut, Andrea del Sarto's *Puccini Pietà*, Taddeo's *Dead Christ* in the Borghese Gallery, and the same subject in the Pucci chapel, Santa Trinità dei Monti.

1. New Haven, 1974, no. 34.
2. *The Dead Christ Supported by an Angel*, pen and brown ink, 273 × 175 mm., Ottawa, National Gallery of Canada, no. 6572 0.272; Popham and Fenwick, 1965, no. 45, repr. p. 35; Budapest, Museum of Fine Arts, no. 1928.
3. New Haven, 1974, no. 34.
4. Attributed to Taddeo Zuccaro, *Angel Supporting the Dead Christ*, pen and ink and wash, 243 × 165 mm., Florence, Uffizi, no. 813.
5. W. R. Rearick, 1958–59, repr. p. 133.

Federico Zuccaro

79 *The Healing of a Demoniac Woman*

Red chalk, red wash on tan paper, 290 × 220 mm., ca. 1565. Notations: on verso of mount, in brown ink, over an erased inscription, *Domenico Zampieri commonly called Domenichino was born at Bologna in 1581. H a Disciple of the Caracci. He died Ani 1641*; in pen and brown ink, in Barnard's handwriting, *JB N8G 11-½ by 8-¾*; in pencil, *25.00 #50, 25.00*; in a circle and crossed out, *81*. Horizontal fold above center, tears, stained.

The Cleveland Museum of Art, Gift of Robert Hays Gries, 39.662.

Provenance: John Barnard (Lugt 1420); Dr. Daniel A. Heubsch, Cleveland; Dr. Robert Hays Gries, Cleveland.

Gere related this drawing to a composition in the British Museum, *A Monastic Saint Healing a Possessed Woman*, which he suggested was a design by Taddeo Zuccaro

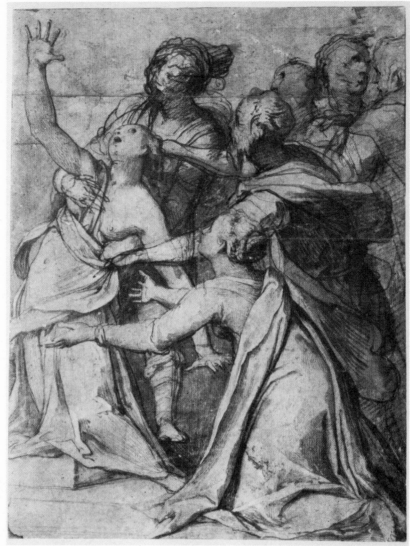

79

for an altarpiece, never executed, for the chapel dedicated to St. Philip in San Marcello al Corso, Rome.[1] This church was the Roman headquarters for the Servite Order founded by St. Philip Benizzi, who was known for healing a demoniac woman, theprobable subject of the altarpiece. The chapel of St. Philip today contains scenes from the saint's life by the seventeenth-century painter, Bernardino Gagliardi.

The close collaboration of Taddeo and Federico Zuccaro during this period complicates the attribution of *The Healing of a Demoniac Woman* which Gere assigned to Taddeo. It is possible that Taddeo was asked to design the altarpiece when he was decorating the adjoining Frangipani chapel, ca. 1557–1566. The Cleveland drawing—a more detailed study of the figures in the lower right of the British Museum sheet—has the same dramatic impetus as scenes in the Frangipani chapel, such as *The Raising of Eutychus, St. Paul Healing the Cripple*, and *The Blinding of Elymas*.[2] In these works broadly executed figures with upturned heads and exaggerated gestures respond intensely to the miracle portrayed. Further, the pose of the demoniac is based upon that of the possessed youth in Raphael's *Transfiguration* (1519–1520) and, like it, is ultimately derived from the *Laocoön*. This conforms with Taddeo's interest in Raphael's tapestries during the period of his work on the Frangipani chapel, as evidenced by his early composition for *The Blinding of Elymas*.[3]

Evidence can also be cited for Federico as author of the sheet. Vasari reported that Taddeo made extensive use of assistants while working on the Frangipani chapel, which was completed by Federico after the death of his older brother.[4] Gere explained that a preparatory study for *St. Paul Healing the Cripple* is a copy by Federico of a drawing by Taddeo: "The technique, a combination of red chalk and red wash, is (so far as I know) without parallel in Federico's drawings, and suggests an attempt to reproduce, by less laborious means, the effect of the red wash medium which Taddeo favored at the period of the

Frangipani chapel."[5] The same media were also used for *The Healing of a Demoniac Woman*, which is close in style to Federico's drawing *The Resurrection of Lazarus* (Fig. 78a), a study for his fresco project of 1565 in the Grimani chapel, San Francesco della Vigna, Venice. In both clearly outlined figures are shaded with parallel strokes of the chalk and have quickly realized "stick" fingers. The face of the Cleveland drawing's possessed woman with upturned eyes and gaping mouth resembles that of the woman left of center, and her bare breast is shaded exactly as in the kneeling figure lower right.

Correspondences also exist with other drawings by Federico. The face of the demoniac woman is similar in shape and attitude to that of the central angel in a *Group of Angels on Clouds;* in another sheet, a figure seen from the back contains accents and lines close to those in the head along the right border of the Cleveland sheet; the heads at the back of the Cleveland drawing are shaped by spidery lines analogous to those defining the head of an angel in a drawing in Cologne although a similar nervousness can be found in drawings by Taddeo.[6] A variation on the possessed figure appears in *St. Paul Healing a Demoniac*, a sketch for one of Federico's tondo paintings of 1580–1584 in the Pauline Chapel.[7] Analogies in terms of technique can also be made with the *Blinding of Elymas* [82] by Taddeo, but the mixture of stylistic elements would suggest that, like the drawing for *St. Paul Healing the Cripple*, the Cleveland sheet is Federico's copy of a lost study by Taddeo for the chapel of St. Philip.

1. John Gere to Curator of Prints and Drawings, 6 December 1978, in Curator's file, The Cleveland Museum of Art. Attributions noted on the drawing's mat over the years by E. O. Fernandez-Gimenez, Mina Gregori, Walter Vitzthum, and Konrad Oberhuber all favor Federico Zuccaro. *A Monastic Saint Healing a Possessed Woman*, pen and ink, brown wash over black chalk, 410 × 277 mm., London, British Museum, no. 1946-7-13-587 recto; Gere, 1969a, no. 106, pl. 105.
2. Gere, 1969a, pls. 85, 89, 91.
3. Ibid., p. 78.
4. Vasari-Milanesi, 1878–85, VII, 84.
5. Gere, 1969a, p. 83.
6. *Group of Angels on Clouds*, pen and ink and wash, 251 × 383 mm., Oslo, National Gallery, no. B 15601; *Draped Male Figure*, black chalk, 371 × 172 mm., Florence, Uffizi, no. 11007; *Angel on Clouds*, pen and ink and wash, 272 × 183 mm., Cologne, Wallraf-Richartz Museum, no. Z 1399b.
7. F. Zuccaro, *St. Paul Healing a Demoniac*, pen and maroon wash, 295 × 276 mm., Florence, Uffizi, no. 11004 F; Gere, 1966, no. 66, fig. 48.

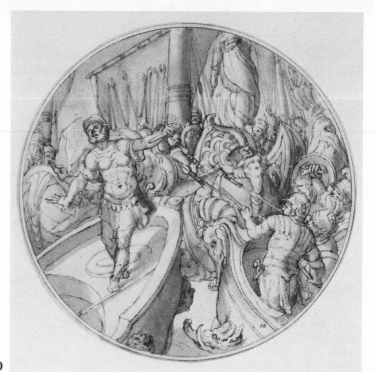

80

81

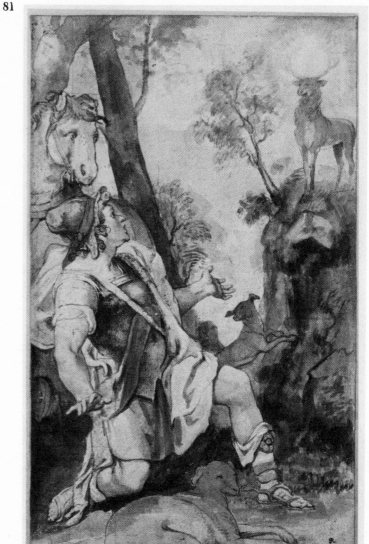

After Federico Zuccaro

80 *Naval Battle*

Pen and brown ink, brown wash over black chalk indications, diam. 189 mm., after 1560. Notation: lower right, in pen and brown ink, *58*.

Thomas P. Toth

Provenance: T. Clifford; Alister Mathews, Bournemouth. *Sale:* London, Sotheby, 23 May 1968, no. 26 (as Follower of Giorgio Vasari) (Bought by T. Clifford for £50).

Although it was first thought that this drawing was after Federico Zuccaro, it can now be shown that it is a studio copy of a sheet in the Hermitage by Taddeo.[1] He executed a group of designs for a majolica service, ca. 1559–1560, a gift to the King of Spain from the Duke of Urbino.[2] The subjects were scenes from the life of Julius Caesar.[3] Gere identified several dishes and cisterns from some of these drawings. Also, five of the designs were adapted to a series of stucco ceiling decorations by Federico Brandini.[4] This scene is one, however, that Gere considered a composition for the Spanish Service, but for which he was not able to locate a corresponding piece of majolica.[5]

I owe thanks to Thomas Toth for lending this drawing and for assisting in its research.

1. *A Naval Battle*, pen and ink, brown wash, 183 mm. diameter, Leningrad, Hermitage, no. 6516; Gere, 1969a p. 93, no. 91; Dobroklonsky, 1940, no. 400.
2. Vasari-Milanesi, 1878–85, VII, 90; Gere, 1963a, p. 306.
3. Gere, 1969a, p. 92; Gere, 1963a, p. 306.
4. Venturi, 1937, X, 3, 982, 986, 988, 989, fig. 862; Gere, 1963a, pp. 306–309.
5. Gere, 1969a p. 93.

Federico Zuccaro

81 *The Vision of St. Eustace*

Pen and brown ink, brown, gray, green, yellow, and red wash, heightened with white, over traces of black chalk, squared in black chalk, 341 × 202 mm., ca. 1560.

Lent by the Metropolitan Museum of Art, Rogers Fund, 1962, 62.76.

Provenance: Jonathan Richardson, Sr. (Lugt 2184); Jonathan Richardson, Jr. (Lugt 2170); Joshua Reynolds (Lugt 2364). *Exhibited:* New York, 1965, no. 140, pl. 140. *Published:* Bean, 1963, p. 232, repr. p. 230; Gere, 1963b, p. 394 n. 12; Bean, 1964, no. 26, repr.; Gere, 1971, pp. 17, 83, pl. xviii.

The fresco for which this drawing was a study is still extant although much damaged and restored. It was one of several depicting scenes from the life of St. Eustace between second-story windows of a palace façade on the Piazza Sant'Eustachio.[1] Vasari reported that this was Federico's first commission, obtained for him by his more successful elder brother, Taddeo, in 1560.[2] Because of the success of the fresco, Taddeo became jealous of his brother and reworked the façade in part causing Federico, in turn, to destroy the changes.[3] Although this project resulted in a temporary falling out between

Taddeo and Federico, the artistic closeness of the brothers can be seen in the pose of St. Eustace which varies only slightly from that of Sergius Paulus in the *Blinding of Elymas* [82].

The *Golden Legend* identified St. Eustace as a Roman centurion known for his charity.[4] During a hunt he noticed an unusually magnificent stag which, as he pursued it, led him deep into the forest away from his companions. Finally the animal mounted a rocky promontory and a crucifix shone brilliantly between its antlers. Eustace addressed by Christ, fell from his horse. In the drawing he is represented kneeling in an act of faith. Eustace was converted to Christianity, but his fidelity was tested by numerous misfortunes like a New Testament equivalent to Job.

An earlier study for the fresco differs from the Metropolitan drawing in the poses of St. Eustace and the horse and the placement of one of the dogs.[5] Cherubino Alberti's print of the subject from 1575 was probably based on the finished fresco rather than the Metropolitan sheet.[6] The hunting dog reclining in the foreground was omitted in the print, the stag is smaller, and the foreground is deeper, pushing the entire scene back farther from the picture plane.

The fresco represented a departure from the conventional monochromatic façades of Polidoro da Caravaggio and Baldassare Peruzzi popular in the 1520s and 1530s. The drawing itself documents the Zuccaro brothers' coloristic interests after mid-century which in turn may have influenced Federico Barocci, who became associated with them about this time [32–34].

1. Bean, 1964, no. 140.
2. Vasari-Milanesi, VII, 89; Borghini, 1584, p. 570.
3. The Richardsons recorded the appropriate passages from Vasari on the back of the drawing's old mat; curator's file, New York, Metropolitan Museum of Art.
4. Voragine, 1941, pp. 555–556.
5. *Conversion of St. Eustace*, pen and ink and wash, squared in chalk, 213 × 138 mm., Florence, Uffizi, no. 11173 F; Körte, 1932, p. 520, fig. 1.
6. Körte, 1932, p. 521, fig. 2; Bartsch, 1818, XVII, 68, no. 52.

Taddeo Zuccaro

1529–1566

Born near Urbino and associated throughout his brief career with Roman art, Taddeo Zuccaro gained an early reputation as a façade painter, although his earliest surviving works are fresco decorations in the Villa Giulia (1553). Despite his mannerist predilections, there are references to Raphael in Taddeo's work throughout his life. His designs for the Farnese villa at Caprarola represent one of the most ambitious fresco decorations in central Italy. This complicated humanistic program was completed after the artist's death by his brother, Federico.

Taddeo Zuccaro

82 *Studies for the Blinding of Elymas and for a Holy Family with the Infant St. John* (recto); *Studies for the Blinding of Elymas and for the Raising of Eutychus* (verso)

Pen and brown and red ink, brown and red wash (recto); pen and brown and red ink, brown and red wash, black chalk (verso), 387 × 274 mm., 1556–1566. Notation: verso, bottom right, in pen and brown ink, *favi = 4*. Horizontal fold at center, tears, holes, soiled.

The Art Institute of Chicago, Gift of Robert B. Harshe, 1928.196.

Provenance: William Young Ottley (Lugt 2662); Thomas Lawrence (Lugt 2445); Samuel Woodburn (Lugt 2584). *Sales:* London, Christie's 4-8 June 1860 (Woodburn collection, drawings from Lawrence collection), no. 108 (as Michelangelo); London, expert Philippe, 6-23 June 1814 (Ottley collection), no. 1492 (as Taddeo Zuccaro). *Exhibited:* Regina, 1970, no. 10, repr. p. 114; St. Louis, 1972, no. 12, repr. (recto); Los Angeles, 1976, no. 113, repr. p. 99 (recto). *Published:* Gere, 1969a, pp. 73-74, no. 22, pls. 94, 95 (recto, verso); Gere, 1971, pp. 17, 83, pl. xvii.

Although originally sold in London in 1814 as a sheet of sketches by Taddeo Zuccaro, when this drawing appeared on the market again in 1860, it was attributed to Michelangelo.[1] Pouncey and Gere recognized it as one of Taddeo's studies for the Frangipani chapel in San Marcello al Corso, Rome, which he worked on from ca. 1557 until he died in 1566.[2]

The frescoes depict events from the life of St. Paul.[3] Almost all of the sketches on the recto, and a few on the verso, are for the episode of the blinding of Elymas.[4] Paul blinded the sorcerer who was harassing him as he tried to preach to the Proconsul, Sergius Paulus. On the recto two sketches at the left test ideas for the entire composition. Taddeo is most preoccupied, however, with defining a pose for Sergius Paulus that expresses his astonishment at this incident. These sketches display the full range of Taddeo's drawing style from the small, rapid notations scattered across the page to the detailed, finished state of the large central figure. His innovative use of brush point and red wash for the most dominant section

105

of the sheet reveals the fascination of the Zuccaro circle with color.

Other sketches on the sheet also relate to the Frangipani chapel. The scene in the upper right corner is for the *Sacrifice of Lystra*, while the central figures on the verso and the chalk study beneath them are probably for the *Raising of Eutychus*.[5] Only the scene lower center on the recto, *Holy Family with the Infant St. John*, is for another project.

Federico completed work on the chapel after Taddeo's death. The figure of Sergius Paulus had an impact on Federico's work.

A black chalk drawing in the Uffizi indicates that Federico was fascinated by the exclamatory gesture of the proconsul in his extended arms and open fingers and the aspect of his being taken aback. Other variations are *Moses and Aaron* in the Vatican Belvedere, the *Dispute of St. Catherine* in Santa Caterina dei Funari, and the *Conversion of the Magdalene* for San Francesco alla Vigna.[6] Even Rubens was fascinated by Taddeo's invention as evidenced by his retouched copy of Taddeo's drawing for the *Blinding of Elymas*.[7]

1. London, expert T. Philippe, (Ottley collection), 6-23 June 1814, no. 1492; London, Christie's, (Woodburn collection), 4-8 June 1860, no. 108.
2. Gere, 1969a, no. 22.
3. Acts, 13: 8-11.
4. Gere, 1969a, pl. 89.
5. Ibid., p. 138, pl. 85.
6. *Draped Figure Seated on a Throne*, black chalk, 205 × 143 mm., Florence, Uffizi, no. 11088; *Moses and Aaron*, pen and ink and brown wash, 360 × 243 mm., 1563, Paris, Louvre, no. 4397, Gere, 1969c, no. 45, pl. ix; *Moses and Aaron before Pharaoh*, black chalk and brown ink, 1562–1563, 388 × 270 mm., Munich, Staatliche Graphische Sammlung, no. 38; Degenhart, 1967, no. 86, pl. 52; *Dispute of St. Catherine*, pen and ink and brown wash, 263 × 366 mm., Paris, Louvre, no. 4449; Gere, 1969c, no. 72, pl. xvi; *The Conversion of the Magdalene*, pen and ink and brown wash, 1563, 418 × 702 mm., Florence, Uffizi, no. 11036 F; Gere, 1966, no. 47, fig. 34.
7. Jaffé, 1965, pl. 14.

82 Recto

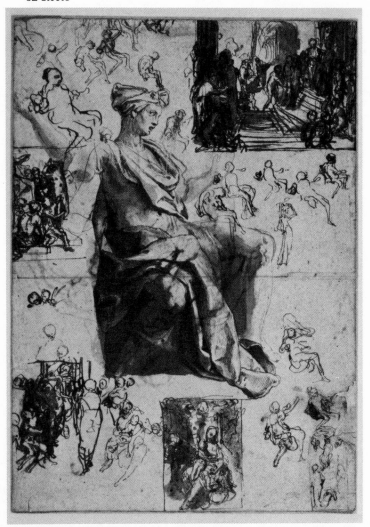

82 Verso

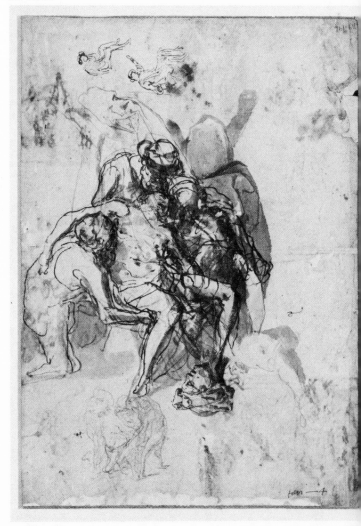

Emilia

The major artistic centers included in the region of Emilia are Bologna, Parma, and Ferrara. Individual styles in this region vary considerably but, in general, Emilian drawings are less plastic and more optical in approach than Florentine or Roman designs, utilizing open line and soft modeling. Slow, graceful movement, quietly ecstatic moods, and a concern for atmosphere are common characteristics. Correggio and his followers preferred chalk, whereas Parmigianino was versatile in all media. The tight, delicate ink hatchings of Lelio Orsi and the broad touches of Passarotti demonstrate the impact of engraving techniques upon Emilian draftsmanship.

Many of the artists from this area, like Bartolommeo Passarotti and the Carracci, were not only affected by their experience of art in Rome but also made significant contributions to its development. Although Girolamo da Carpi spent his early career in Ferrara and Pirro Ligorio ended his years there in the Este court, both artists were so influenced by Roman art that they are considered with the Roman draftsmen. Even the mannerist Pellegrino Tibaldi—whose powerful figure style with its exaggerated foreshortenings and convoluted poses determined the character of Bolognese mannerism—was tremendously impressed by the robust forms of Michelangelo during his years in the Holy City in the early 1550s.

The Emilian center most retaining its individual character was Parma. Correggio's work made Parma a pilgrimage site for Italian and non-Italian artists alike. His soaring figures in the frescoed domes of San Giovanni Evangelista and the cathedral are corporeal yet weightless and, as a result of exaggerated foreshortenings, are depicted *di sotto in su*. They are ecstatic figures ascending into the blinding brilliance of a divine radiance which emanates from a limitless space. The soft, discontinuous, elastic line of Correggio's sketches evolved in the drawings of his follower and rival, Parmigianino, into stylishly graphic rhythmic statements. Parmigianino's graceful and ornate forms tempered the delicate softness of Correggio's works. The lines which delineate the figure in *Minerva Drawing Her Sword from Its Scabbord* [92] have the strength and thinness of silk thread. *Lucretia* [90] displays the new elegance and cold suavity Parmigianino brought back to Parma after his brief flirtation with Roman art at the papal court. How completely he affected draftsmanship in Parma is seen in the smokey chalk studies of Bedoli [85] and *Christ and the Virgin Mary Appearing to St. Francis* [86], attributed to Jacopo Bertoia.

The Conversion of St. Paul [87], associated with Lelio Orsi, in subject reflects the prevailing religious concerns of the late 1500s and in narrative force the influence of Michelangelo. Its tight draftsmanship has more in common with the graphic tradition established by the older Bolognese artists, Marcantonio Raimondi and Bartolommeo Passarotti. Orsi's *The Flight into Egypt* [88], however, retains Correggio's sweetness and the polished finish of Parmigianino's patrician tastes. It was just these qualities that Niccolo dell'Abbate imparted to French art when he settled in the court at Fontainebleau in 1552. He established a workshop there which continued the stylized refinements of his *maniera* as seen in *Mythological Scene* [83] and *Allegorical Figure* [84]. The grace and gentility of the Emilian school were also transported to France by Francesco Primaticcio and the graphics of Parmigianino. A combination of Emilian polish in surface treatment, the *di sotto in su* perspective of Correggio and Tibaldi, and a figural solidity that could as easily be attributed to Tibaldi as to Michelangelo is found in Orazio Sammachini's *Seated Male Figure with Three Putti* [94].

By 1590 Bologna not only eclipsed both Tuscany and Venice in artistic importance, but through the Carracci school returned to Rome in highly refined fashion the characteristics previously borrowed from the Holy City. A linear emphasis resulting from the durable tradition of Bolognese prints was combined with plastic surfaces in the narrative paintings of the Carracci. A greater humanization of mythological and religious subjects as well as landscapes also occurred, especially in the work of Annibale Carracci.

Niccolo dell'Abbate

ca. 1509–1571

A native of Modena, Niccolo dell'Abbate's early career was occupied with decorative projects in his native city and in Bologna from 1547 to 1552. Thereafter he spent the rest of his career in the French court at Fontainebleau where he joined his countryman, Francesco Primaticcio (1504–1570).

Circle of Niccolo dell'Abbate

83 Mythological Scene

Pen and brown ink, brown wash, over traces of black chalk, squared in black chalk, 179 × 203 mm., after 1560. Notation: upper right, in pencil, *No. 2.* Watermark: Paschal lamb (similar to Briquet 47, 50). Tears, surface abraded, soiled.

Lent by the Metropolitan Museum of Art, Rogers Fund, 1961, 61.20.5.

Apollo and Venus can be identified as the main figures in the scene. The firm outlines and Venus's crossed legs and tapering limbs are in the style of Niccolo dell'Abbate, but the handling is that of a follower. Venus's anatomy, especially the feet, knee, and the extension of the hips into the upper body, are poorly handled. Artifice and affectation in Abbate's treatment of hands lead to distortion. The flattening of forms is also atypical of him and suggests, instead, the work of a French follower from the period of his work at Fontainebleau where paintings of mythological narratives abounded.

Follower of Niccolo dell'Abbate

84 Allegorical Figure (recto and verso)

Pen and black ink, gray wash, heightened with white, on tan paper (recto); black chalk on tan paper (verso), 285 × 186 mm., ca. 1550. Notations: verso, at right edge, in pen and brown ink, *27, Fama Majora* (?); at lower right, in pen and brown ink, *Octavio, Perino dell'Vaga.*

The Cleveland Museum of Art, Gift of the Print Club of Cleveland, 74.227.

Provenance: Cyril Humphris, London. *Sale:* London, Yvonne Tan Bunzl, 6-25 April 1970, no. 2. *Exhibited:* Cleveland, 1974b.

This Italianate drawing has been inscribed with Perino del Vaga's name and associated more recently with Niccolo dell'Abbate. The black chalk study on the verso was followed by the more highly finished drawing on the recto executed in pen and black ink and gray wash, heightened with white. Niccolo favored black chalk for quickly noting first impressions, a method continued by his pupils. The images on recto and verso are similar but independent — that is, one is not a tracing of the other.

From 1552 Niccolo adopted the decorative qualities of Parmigianino [90, 92, 93] for his work in the French court at Fontainebleau. Niccolo frequently made use of female personifications who evolved less from the studio model than from the pages of his sketchbooks. A drawing of Abundance from the period of Niccolo's stay at Fontainebleau is another example of a

seated allegorical female with trophies.[1] Typical of his figures are legs crossed at the ankles which, like the wrists, are quite thin; downcast heads; triangular faces with pinched facial features; hands and feet that appear to have atrophied; and rounded shoulders in counterpoise to the lower half of the torso — all of which is delineated with a frenetic, trembling line.

Anne Lockhart observed that such stylizations repeated by pupils and copyists lack the strength of the original.[2] The pen line of this drawing is especially strong and lacks Niccolo's free, nervous groping for contour. Furthermore, emphasis on interior modeling and inflated volume of the figure is more reflective of taste at the end of the sixteenth century. The same characteristics are apparent in a similar drawing which Sylvie Béguin originally attributed to Niccolo but has since concluded to be a copy.[3] Both of the drawings appear to have been executed by an anonymous follower of Niccolo, possibly French, copying a lost work by the master from his early years at Fontainebleau. The female figure may originally have been a study for *Death of Adonis.*[4] If so, she would represent Venus, assisted by Cupid, about to invert the torch signifying extinguished love.

1. *Abundance*, pen and ink, 290 × 290 mm., Musée de Rennes, no. 1884; Béguin, 1962, p. 140.
2. Paper presented at the fourth annual meeting of the Midwest Art History Society, Columbia, Missouri, 1 April 1977.
3. Sylvie Beguin to Anne Lockhart, 5 December 1975, in Curator's file, The Cleveland Museum of Art, "This second drawing appears to have been based on some original sheet by Niccolo and reveals more clearly such details as the flame of the torch and the wings of the cupid;" *Allegorical Figure*, pen and ink, wash, heightened in white chalk, 283 × 195 mm., private collection, France; Paris, 1971, no. 1, repr.
4. *Death of Adonis*, pen and wash, Paris, Louvre, no. 8748. This drawing is related to a canvas, Ottawa, 1973, I, no. 135, repr. p. 154.

Girolamo Mazzola Bedoli

ca. 1505–1569

Girolamo Mazzola Bedoli, who was born in a provincial town barely fifteen miles north of Parma, dominated the artistic scene in Parma after Parmigianino's death and inherited many of his patrons. Bedoli's first paintings date from the 1530s. He worked mainly in Emilia on portraits, frescoes, and altar panels and executed a number of altar paintings for churches in Mantua. The high regard in which Bedoli was held at mid-Cinquecento, including his patronage by the Farnese court, is reflected in Dolce's dialogue on painting of 1557, *l'Aretino.* Indeed the derivative nature of Bedoli's art, dependent for its style and motifs on the work of Parmigianino and Correggio, in part contributed to his success.

83

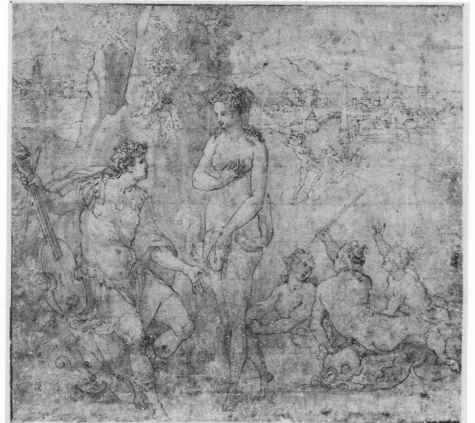

84 Recto

84 Verso

Girolamo Mazzola Bedoli

85 *Studies of the Madonna and Child*

Black chalk on blue paper, 204 × 135 mm., ca.
1535. Notations: on verso of mount, in pencil,
Parmigeano, A 3543, 13; in pen and brown ink
in Jonathan Richardson, Sr.'s handwriting, *L 74
G*.

The Cleveland Museum of Art, Purchase, Dudley
P. Allen Fund, 24.1002.

Provenance: Jonathan Richardson, Sr. (Lugt
2183, 2984).

This sheet of studies of the Madonna and
Child—although dependent upon Parmi-
gianino in terms of style and in the types
and attitudes of the figures—was not in-
cluded by Popham in the corpus of Par-
migianino's drawings.[1] There are some
affinities with drawings by Jacopo Bertoia
(such as *Christ and the Virgin Mary Ap-
pearing to St. Francis* [86]) in the pointed
chins and pinched features, but Bertoia's
manner is more aggressive. Line in the
Cleveland drawing is softer, less angular,
and more homogeneous in character. On

the basis of these qualities, Diane Bohlin
suggested that the drawing is closer in style
to Girolamo Mazzola Bedoli.[2]

Like the sheets of studies by Paolo
Veronese [109] and Francesco Vanni [73],
Bedoli's drawing explores varying poses
and figure arrangements. The kneeling
figure with a staff, drawn over the figure of
the Christ Child in the lower section of the
page, could have been intended as a study
for a resting St. Joseph or an adoring
shepherd in a Nativity. The woman and
infant in the upper left may have served as
an early idea for Bedoli's *Madonna and
Child in a Landscape* (ca. 1536–1537),
while the pair in the upper right may have
been a preliminary study for the Madonna
and Child in the San Martino Polyptych
(1537–1538).[3] Since several details of the
figures in the drawn and painted versions
differ, the Cleveland sheet was a starting
point rather than a final study.

Many characteristics seen here are typical
of Bedoli's early work. The taut lips, pointed

chin, and arclike slits for eyes are also found
in his *Holy Family with Joseph and SS.
John the Evangelist, Francis of Assisi, and
Anthony of Padua* (ca. 1530), while the
open pose of the Christ Child with arms
and legs extended corresponds with the
infants in the San Alessandro Altarpiece
(ca. 1540–ca. 1555), and the San Martino
Polyptych.[4]

1. Popham, 1971. In a letter of 7 July 1965 in the
Curator's file, The Cleveland Museum of Art, Popham
rejected the Parmigianino attribution but did not offer
an alternative.
2. Diane Bohlin to Edward J. Olszewski, 13 April 1978.
3. *Madonna and Child in a Landscape*, Fogg Art
Museum, Harvard University, Cambridge,
Massachusetts; Milstein, 1978, p. 50, fig. 26; *San Mar-
tino Polyptych*, Parma, National Gallery; Milstein,
1978, p. 51, fig. 28.
4. *Holy Family with Joseph and SS. John the
Evangelist, Francis of Assisi, and Anthony of Padua*,
Naples, Capodimonte; Milstein, 1978, p. 19, fig. 1;
*Madonna and Child with Angels, SS. Giustina, Alessan-
dro and Benedetto*, Parma, San Alessandro, Milstein,
1978, p. 61, fig. 36.

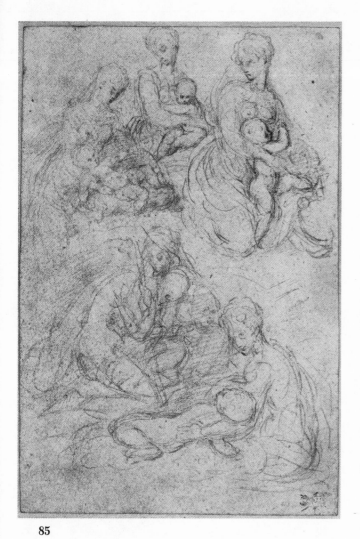

85

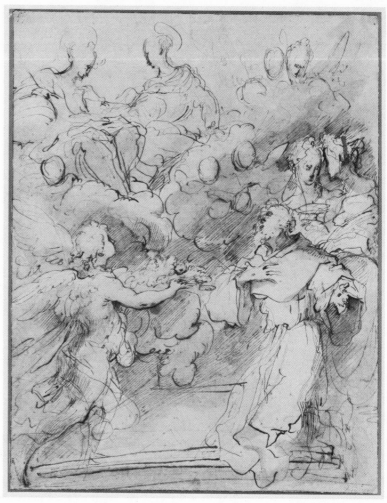

86

Jacopo Zanguidi, il Bertoia

1544–1574

Bertoia was a native of Parma. He was trained as an artist in Bologna, but his style is so close to that of Parmigianino that works of the two artists are often confused. The major projects of his brief career date from the late 1560s such as the Sala del Bacio, Palazzo del Giardino, Parma. Here illusion and fantasy are utilized in the best mannerist tradition. The last years of his life were spent commuting between Parma and Rome where he began decorations for the Oratorio del Gonfalone. Bertoia also worked briefly at Caprarola assisting Federico Zuccaro in the Hall of Hercules.

Attributed to Jacopo Zanguidi, il Bertoia

86 *Christ and the Virgin Mary Appearing to St. Francis*

Pen and brown ink, gray wash, over traces of black and red chalk, 322 × 252 mm., ca. 1570. Notation: lower right, in pen and brown ink, *Parmesan;* upper left, in pen and brown ink, *1759.* Round stain beneath the arm of the foreground angel, rectangular stain on hair of woman to right in foreground.

Yale University Art Gallery, Maitland F. Griggs, B.A. 1896, Fund, 1972.92.

Provenance: C. G. Boerner, Düsseldorf. *Sale:* Düsseldorf, C. G. Boerner, Lagerliste 60, 1972, no. 6 (attributed to Bertoia by E. Schaar). *Exhibited:* New Haven, 1974, no. 51, repr. (as North Italian, about 1600).

No consensus exists for an attribution of this sketch except to put it in the ambiance of Parmigianino. Although Schaar assigned it to Bertoia, Pillsbury and Caldwell found it closer in technique to Giulio Cesare Procaccini but labeled the drawing simply as North Italian, ca. 1600, because it lacks Procaccini's sense of rhythm and solidity.[1]

Without a known painting of this subject by Bertoia, connoisseurship and intelligent speculation remain the only bases for an attribution. This lively drawing is characterized by delicate washes, parallel pen strokes to vary tone, and lines which are rapid, angular, and swelling. In addition there are formless or unfinished extremities, and bodies devoid of density and substance with similar simplified features. The heads are conventional stereotypes, attached to partially defined bodies, often paired, and

in attitudes that are mutually reciprocated. As such, they serve the artist as his primary vehicle of expression. Many of the same qualities can be found in Bertoia's *Music-Making Figures and Lovers* in the Metropolitan Museum of Art and *Group of Figures with a Deity* in the British Museum.[2]

1. Düsseldorf, C. G. Boerner, Lagerliste 60, 1972, no. 6; Pillsbury and Caldwell, 1974, no. 51.
2. *Music-Making Figures and Lovers,* pen and brown ink and wash with white highlights over traces of black chalk, 131 × 244 mm., New York, Metropolitan Museum of Art, no. 66.32; *Group of Figures with a Deity,* pen and wash with white highlights, 156 × 226 mm., London, British Museum, F.f. 1-81.

Lelio Orsi

1511–1587

Lelio Orsi was born in Novellara and was active in Emilia. He pursued a style dependent upon Correggio but mannerist in its eccentricities. He did illusionistic paintings on house façades in his native city and in neighboring Reggio. His art matured into one of powerful forms with a polished hardness, especially after his visit to Rome in 1555 where he saw the work of Michelangelo. In the 1560s Pellegrino Tibaldi and Daniele da Volterra were his only rivals in propagating an art of Michelangelesque figures and explosive energy. The desiccated forms and vapid expressions of his late paintings reveal how seriously Orsi's art had atrophied in the last fifteen years of his life.

After Lelio Orsi

87 *The Conversion of St. Paul*

Pen and brown ink, brown wash, 473 × 332 mm., ca. 1580. Notation: lower right corner, in pen and brown ink, *Michelangelo Bonarata f.* Horizontal crease across center, soiled and foxed, many small tears and holes.
The Cleveland Museum of Art, John L. Severance Fund, 51.348.

Provenance: Richard Cosway (Lugt 628); Unidentified collector's stamp. *Published:* Parker, 1956, II, 564 (as copy of Orsi); Popham, 1967, IV, part I, 32 (as copy of Orsi); Bean, 1968, p. 520 (as copy of Orsi).

The Conversion of St. Paul was a popular Counter-Reformation theme in the last half of the sixteenth century since it signified not only the miraculous rescue of the church from persecution but the conversion of her enemies as well. As recorded in the Acts of the Apostles, Paul was journeying to Damascus to denounce followers of Christ in the synagogues, when a blinding light heralding the voice of Christ startled him and he fell to the ground.[1] In three days Paul was converted to Christianity and his sight restored. This drawing records the moment of his encounter with Christ, although the biblical account makes no reference to Paul being thrown from a horse or to the actual appearance of Christ.[2]

Orsi was a meticulous craftsman, working slowly, testing ideas, and often repeating himself, a procedure well established in the sixteenth-century Italian studio. The composition for the *Conversion of St. Paul*, therefore, seems to have evolved slowly over a period of years and reveals that Orsi borrowed ideas from numerous sources. His composition was based upon elements taken from Michelangelo's Sistine ceiling and *Conversion of St. Paul* in the Pauline chapel. The figure of Christ was taken from Cherubino Alberti's engraving (Fig. 87a) of Taddeo Zuccaro's *Conversion of St. Paul* painted in San Marcello, Rome.[3] The rearing horse may ultimately have been inspired by an

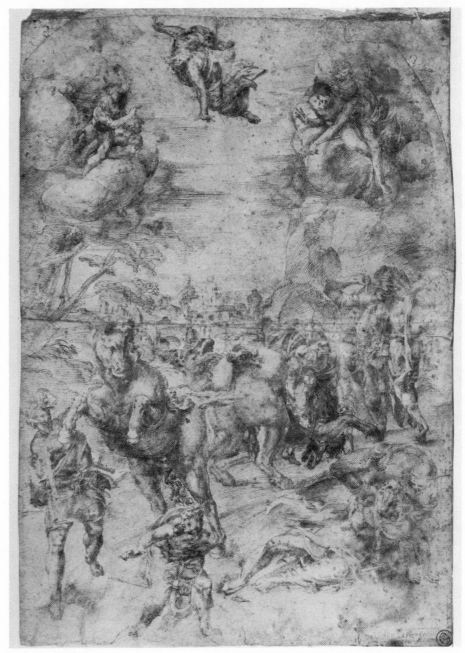

87

engraving by the Master of 1515 (Fig. 87b), although Orsi also relied upon those in his own compositions like *St. George* (even to the extent of retaining the fluttering sash of the absent St. George), *Battle of Nude Horsemen and Lions*, and *Rape of the Sabines*.[4] The combination of soldier and frightened animal is reminiscent of the famous Dioscuri horsemen in Rome which Orsi would have seen on his trip there in 1555 after their restoration on the Quirinale hill.[5] When returning from Rome to Novellara, Orsi may have seen Pellegrino Tibaldi's frescoes of ca. 1555 in San Giacomo Maggiore, Bologna. In Tibaldi's *Conception of the Baptist* the sudden lunge of the angel through a break in the clouds exceeds the bounds of propriety. No doubt inspired by Michelangelo's fresco of the *Conversion of St. Paul*, the divine messenger in this case is an angel and is taken instead from God the Father in Michelangelo's Sistine ceiling *Creation of Adam*. In 1559 Orsi sent a letter to Rome requesting a drawing of the Pauline chapel.[6] Orsi may not, however, have finally decided on the pose for the figure of Christ until Cherubino Alberti's print appeared in 1575. The precursor of the soldier just left of center in the foreground is a figure in a similar spot in

111

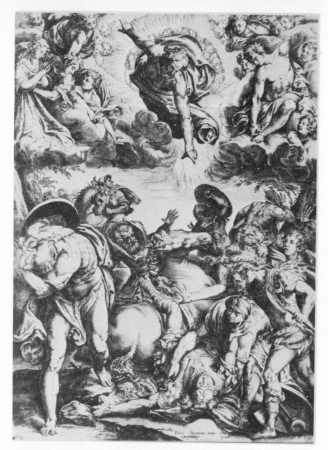

Fig. 87a. *Taddeo Zuccaro's "Conversion of St. Paul,"*
engraving. Cherubino Alberti, Italian, 1553–1615.

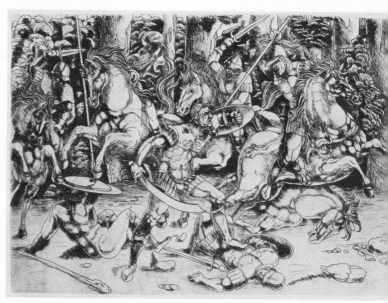

Fig. 87b. *Battle in a Wood*, engraving, 219 × 320 mm. Master of the Year 1515,
Italian. The Cleveland Museum of Art, Dudley P. Allen Fund.

Fig. 87c. *Conversion of St. Paul*, pen and brown ink, squared
in pencil, 457 × 301 mm. Lelio Orsi. Ashmolean Museum, Oxford.

Fig. 87d. *A Man Holding a Rearing Horse* (recto), pen and brown ink,
227 × 177 mm. Lelio Orsi. The British Museum, London.

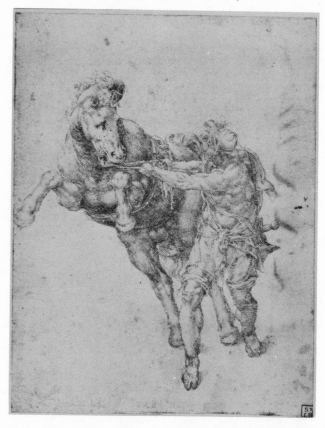

Francesco Salviati's *Conversion of St. Paul* (1545) engraved by Enea Vico.[7] Orsi copied the position of the lower half of the body and even retained the tight, shin-length leg coverings.

No painted work of this subject survives by Orsi, although a highly finished drawing squared for transfer is in the Ashmolean Museum (Fig. 87c) and would seem to be the final study of this subject.[8] It dates from ca. 1580 — the last decade of Orsi's career, which was characterized by a decided dynamism in his compositions.[9] The Cleveland drawing appears to be a hesitant copy of it. The pen technique is close to that of Orsi but not quite as tight, and contours are described with a continuous stiff line suggesting the concerns of a copyist for correct duplication. Further, the Cleveland composition is slightly off center, cropped along the left border, and does not fit readily into the arched frame. Too much space was left between St. Paul's foot, the horse's hoof, and the soldier (which necessitated moving the lance so that it now points downward) destroying the tension of the original version.

Other studies for *Conversion of St. Paul* include tight pen sketches in the British Museum of a warrior struggling to control a rearing horse (Fig. 87d) and a fallen St. Paul being assisted by a soldier (Fig. 87e).[10] Another version of the full composition, a parchment miniature, is an inferior copy and departs from the Ashmolean drawing

in several ways, most noticeably by omission of the central foreground figure.[11] It is also closer to the rearing horse and soldier in the British Museum sketch. The fallen Paul has the bent right knee of the British Museum figure but the raised right arm of Paul in the Ashmolean sheet. Another interpretation of the *Conversion* exists in a pen and wash drawing in the Louvre (Fig. 87f).[12] This is a splendid variant by Orsi and the most energetic, with Christ jackknifing forward, Paul's horse collapsed toward the viewer on its front legs, and Paul thrown over the horse's shoulder, scrambling on his chest and elbows to avoid being trampled. The existence of the Louvre version suggests that the parchment copy may have been taken from still another composition by Orsi now lost.

On the verso of one of the British Museum sheets is a freely executed sketch of a horseman with Christ descending from the sky,[13] identical to the Christ in the Louvre drawing. Other designs, both original and copies of lost Orsi compositions, reveal how he developed the pose of St. Paul.[14]

I am grateful to Susan Bostwick for research assistance with this drawing.

1. *Acts*, 9:1-22; 22:3-21, 26:9-19; Voragine, pp. 126-128.
2. The evolution of pictorial representations of this subject is discussed in Steinberg, 1975, pp. 22-28; Friedlaender, 1965, pp. 68-71; Friedlaender, 1955, pp. 3-28.

3. Bartsch, XVII, 70, no. 57; Taddeo Zuccaro, *Conversion of St. Paul*, Rome, San Marcello (smaller version Rome, Galleria Doria).
4. Hind, 1938–48, V, pt. 2, 285, no. 17, VII, pl. 870; *St. George*, oil on canvas, 600 × 480 mm., Naples, Pinacoteca Nazionale, no. 84526; Venturi, 1933, IX, 6, 641, fig. 386; *Battle of Nude Horsemen and Lions*, pen and brown ink, 275 × 406 mm., London, Christie's, 25 June 1968; *Rape of the Sabines*, pen and brown ink and brown wash, 525 × 300 mm., London, Courtauld Gallery.
5. Pastor, 1923, XII, 563-581.
6. Toschi, 1900, p. 3; "nel poscritto ad una lettera (inedita) del 1559, nel quale chiede che gli si mandi da Roma un disegno della *capella paolina*."
7. Francesco Salviati, *Conversion of St. Paul*, Rome, Galleria Doria; Friedlaender, 1957, pl. 29; engraved by Enea Vico, Bartsch, XV, 286, no. 13.
8. Parker, 1956, II, 563-564, no. 420.*
9. Hoffman, 1975, pp. 114-118.
10. Popham, 1967, IV, pt. 1, no. 51, pl. 46; a copy of this drawing is in the collection of Prof. G. Oprescu, Bucharest, 1932, no. 246, pl. XXIII. Popham, 1967, IV, pt. 1, no. 50, pl. 45.
11. After Lelio Orsi, *Conversion of St. Paul*, miniature on parchment, 367 × 257 mm., Modena, Galleria Estense; Estense, 1950, no. 42 repr.
12. Paris, 1964, no. 104.
13. *Horseman with a Figure Descending from the Sky*, pen and brown ink, 227 × 177 mm., London, British Museum, no. 1946-7-13-38 verso; Popham, 1967, IV, pt. 1, no. 51.
14. *Studies of Soldiers for the Conversion of St. Paul*, black chalk, pen and brown ink, 270 × 405 mm., Urbania, Biblioteca Comunale, no. 238 I, recto, *Study for the Figure of St. Paul and Other Studies*, pen and brown ink, verso, *Cento disegni della Biblioteca Comunale di Urbania*, Rome, Gabinetto Nazionale delle Stampe, 1959, no. 87, pls. 101A, 101B, 102; Copy of Lelio Orsi? *Conversion of St. Paul*, black chalk heightened in white, 182 × 205 mm., Munich, Staatliche Graphische Sammlung, no. 3099.

Fig. 87f. *Conversion of St. Paul*, pen and brown ink, brown wash, over black chalk, heightened with white gouache. Lelio Orsi. Musée du Louvre.

Fig. 87e. *St. Paul Being Raised from the Ground*, pen and brown ink, 156 × 194 mm. Lelio Orsi. The British Museum, London.

88

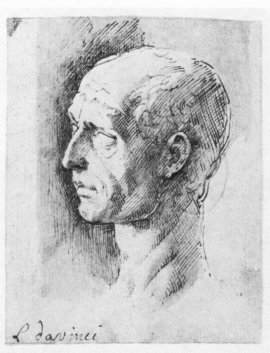

89

Lelio Orsi

88 *The Flight into Egypt*

Pen and brown ink, brown wash over black chalk, 279 × 303 mm., 1570–1575. Notations: lower left, in pen and brown ink, *Novellara Lelio Orsi;* lower right, in red ink, *13;* on verso, in pencil, *1446, From Dr. Chauncey's Collection.* Foxed.

The Pierpont Morgan Library, New York, No. I, 51.

Provenance: Nathaniel Hone (Lugt 2793); Dr. Chauncey; Charles Fairfax Murray (under Lugt 1509); John Pierpont Morgan (Lugt 1509). *Exhibited:* New York, 1965, no. 105, pl. 105; Poughkeepsie, 1968, no. 16; Rome, 1972, no. 50, repr. p. 76. *Published:* Murray, 1905–12, I, no. 51, pl. 51; Venturi, 1933, IX,6, 635-637, repr. 639; Hoffman, 1975, pp. 192-193, no. 43, fig. 70.

Venturi considered this drawing Orsi's masterpiece.[1] Although his sheets are frequently of a pictorial character, this composition with its wash effects is more painterly than normal. Generally his pen technique is linear and has the tightness and precision of an engraving.

The story of the sojourn in Egypt appears in the Apocryphal Gospel of Pseudo-Matthew, with the rest on the flight and the Holy Family in flight the two episodes most frequently depicted in the visual arts.[2] According to the account of Pseudo-Matthew, several miracles occurred as the Holy Family fled the murderous troops of Herod; idols fell, animals were tamed, a palm bent its branches, and a spring gushed forth.

The unusual setting adds an even more precarious note to the already dangerous situation of the fleeing Holy Family. Albrecht Dürer's woodcut of ca. 1505 showing the Holy Family in a wilderness setting and crossing a bridge may have been Orsi's model.[3]

In a striking departure from conventional iconography, Joseph is riding an ass. This drawing seems to have established a precedent for bolder variations of traditional themes.

1. Venturi, 1933, IX, 6, 635-636.
2. James, 1950, pp. 74-76, xxviii-xxxiv.
3. Kurth, 1963, p. 26, fig. 187.

Francesco Mazzuoli, called Parmigianino

1503–1540

A native of Parma, Parmigianino arrived in Rome in 1524 carrying with him (as Vasari relates) a self-portrait on a convex tondo, apparently a virtuoso piece to serve as his entry into the papal court. Freedberg has indicated that Parmigianino's conception of art was "to convey exquisite and excitant sensation" to which end the artist was free to reshape appearance arbitrarily.[1]

Parmigianino remained under Correggio's influence after this artist's return to Parma, ca. 1519. It may have been partly the profound effect the art of Michelangelo

and Raphael had on the master and partly the realization that Correggio controlled the artistic scene in Parma that led to Parmigianino's departure for Rome. There he entered the papal court of Clement VII de' Medici and encountered the artists Rosso, Pontormo, and Perino del Vaga, among others. *The Vision of St. Jerome* in the National Gallery was painted just before he fled the sack of 1527. Its lavish enameled figures reflect the influence of Michelangelo's robust forms, although tempered by his more elegant taste. Parmigianino then went to Bologna for four years where his paintings became moodier and his colors took on greater intensity. The *Madonna with the Long Neck* (Uffizi, Florence) represents the refinement of his work during his last years in Parma.

Parmigianino was a rare early practitioner of etching and an artist of great versatility who did landscape drawings, portrait paintings, and miniatures.

1. Freedberg, 1970, p. 142.

Francesco Mazzuoli, called Parmigianino

89 *Head of Julius Caesar*

Pen and brown ink, brown wash, heightened with white, traces of red chalk, 86 × 70 mm., ca. 1531. Notation: lower left, in pen and brown ink, *L. davinci*.

Museum of Art, Rhode Island School of Design, Gift of Mrs. Gustav Radeke, 20.517.

Provenance: Willem Isaack Hooft (Lugt 2631); Mrs. Gustav Radeke (under 2053d). *Exhibited:* Providence, 1973, no. 39, repr. p. 38; Northampton, 1978, no. 23. *Published:* Rhode Island School of Design, 1961, no. 34 (as 17th-century, anonymous); Popham, 1967, IV, pt. 1, under no. 213 (as 17th-century copy); Bean, 1968, p. 520, fig. 43; Popham, 1971, I, no. 564, III, pl. 446.

A combination of short, arced, broken pen lines and wash describes the plastic character of this head. Subtle nuances of surface ranging from creases in the skin to rolling folds of flesh in the neck, depend upon the meld of lines and wash. Pen is especially apt for describing the complicated systems of projections, cavities, and textures found in the human head. This study has the sensitivity and delicacy of a miniature as does the tiny head in the Smith College Museum of Art [91] and the drawing of the *Nativity* [93]. These sheets, with *Minerva* [92] and *Lucretia* [90] reveal the range and versatility of Parmigianino as a draftsman.

John Shearman first associated this drawing with Parmigianino, an attribution confirmed by Bean.[1] The subject was identified as a bust of Julius Ceasar, the blank eyes clearly indicating a sculpted head as prototype.[2] The shaded area at the left suggests that the statue may have been placed in a niche when Parmigianino made his copy of it. The model may have been in the collection of the Cavaliere Francesco Baiardo, who was a friend of Parmigianino and

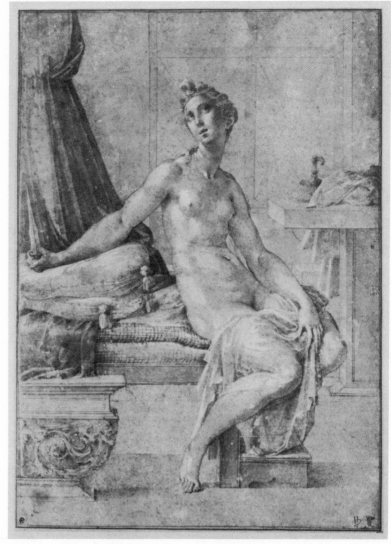

90

a collector of art works and antiquities.[3] The style is characteristic of Parmigianino's draftsmanship after he returned to Parma in 1530–1531.[4]

There is a copy of this drawing in The British Museum.[5] A drawing in profile of the same head by Parmigianino is at Windsor[6] as well as a copy of this sheet, although here the head is seen from a slightly different angle.[7]

1. Popham, 1971, I, no. 564; Bean, 1968, p. 520.
2. Providence, 1973, no. 39.
3. Freedberg, 1949, pp. 230, 233.
4. Providence, 1973, no. 39.
5. *Head of Julius Caesar,* pen and brown wash on brownish paper, 83 × 65 mm., London, British Museum, no. Pp. 2-180; Popham, 1967, IV, pt. 1, no. 213, IV, pt. 2, pl. 134C; Popham, 1971, I, no. 564.
6. *Profile of a Clean-Shaven Man, from the Antique,* pen and brown ink, 102 × 74 mm., Royal Library, Windsor, no. 0580; Popham, 1971, I, no. 646, II, pl. 445; Popham and Wilde, 1949, no. 578.
7. *Man's Head in Profile to the Left,* pen and brown ink, 189 × 143 mm., Royal Library, Windsor, no. 2279; Popham and Wilde, 1949, no. 652; Popham, 1971, I, under no. 646; II, pl. 445.

Francesco Mazzuoli, called Parmigianino

90 *Lucretia*

Black chalk, orange, rose, ocher, green, and violet water color, heightened with white, 300 × 212 mm., ca. 1538. Drawing continued on mount lower left, surface abraded.

National Gallery of Art, Gift of Mrs. Alice Kaplan, 1972, B-25,839.

Provenance: Nourri; Marquis Charles de Valori (Lugt 2500); Eugène Rodriques (Lugt 897); Henri Delacroix; J. Seligman; Mr. and Mrs. Jacob M. Kaplan. *Sale:* Paris, 24 February-16 March 1785 (Nourri collection), no. 433. *Exhibited:* Notre Dame, 1970, no. D6, repr. p. 97 (as Girolamo Mazzola Bedoli); Washington, 1974, no. 19, repr. p. 57 (as Parmigianino). *Published:* Popham and Di Giampaolo, 1971, no. 71 (as Bedoli).

Lucretia, the wife of Tarquinius, committed suicide after revealing that she had been violated by Sextus, a leader of the rival Tarquins. A popular uprising followed which resulted in the expulsion of the Tarquins from Rome. This sheet was apparently the

finished drawing for a painting Parmigianino was commissioned to do in his late years.[1] Oberhuber suggested it may have been a presentation piece, beautifully finished to give the patron an idea of the forthcoming painting.[2] Although Vasari informs us that the project was completed, the painting has since disappeared.[3] An inferior engraving by Enea Vico, inscribed FRAN. PAR. INVENTOR, seems to have been taken from the painting.[4]

Although Popham associated *Lucretia* with Bedoli, the drawing is clearly Parmigianino's.[5] As a drawing with color, this sheet is unique in Parmigianino's *oeuvre*, but in character it matches the highly finished patina of many of his paintings. It is obvious after careful examination of the sheet that the color is contemporary with the design. The delicate and varied touches of color serve decorative rather than descriptive purposes. Compared to the pale, warm colors, the strong highlights on Lucretia's body give her a cold and even marblelike appearance.

The figure of Lucretia is distinctly Parmigianino's belonging to the same family of forms as the *Madonna with the Long Neck* and the *Minerva* [92]. The balanced stance of Minerva has its counterpart in the delicate equilibrium of Lucretia where the weight, delicately balanced on the toes of her right foot, adds an element of grace borrowed from Michelangelo's *Studies for the Libyan Sibyl* (Fig. XVI). The definition of the torso, the treatment of hips and breasts, and the swelling volumes in the arms reflect the same hand. Short, evenly spaced contour lines are used in both. The same mental frame, or *disegno interno*, is evident in the concave curve along the ankle to the big toe.

Two other drawings are related to this one. An early study for it is in Stockholm, while a nude woman on the verso of a pen drawing of Lucretia in Budapest, although standing, is identical to the seated figure of this design in the attitude of her head and upper torso.[6]

91

Francesco Mazzuoli, called Parmigianino

91 *Male Head*

Pen and brown ink, 38 × 32 mm., after 1530. Soiled.

Smith College Museum of Art, Northampton, Massachusetts, 1963:1.

While this head has much of the flavor of Parmigianino's draftsmanship and it was attributed to him, it was not included by Popham in his monograph on the master's drawings and should be considered "after Parmigianino."[1] The miniature scale is typical of his work [89], but the crosshatching in the face is unprecedented in Parmigianino's drawings of heads, and the confusion in delineating the ear is atypical of him. The sketch lacks the subtle technique and relief of similar autograph drawings.[2] This work was inspired by a Parmigianino sketch of a head such as one in the lower right of a sheet in Parma or one in the lower right of a sheet in the Horne Museum.[3]

Francesco Mazzuoli, called Parmigianino

92 *Minerva Drawing Her Sword from Its Scabbard*

Pen and black ink over incised lines, 200 × 108 mm., 1530s. Notation: lower left corner, in pen and black ink, *r /*. Stained upper right and on left leg, soiled at edges.

Alice and John Steiner.

Provenance: Peter Lely (Lugt 2092); Joshua Reynolds (Lugt 2364). *Exhibited:* Cambridge, 1977, no. 26, repr. p. 77.

Parmigianino's terse, uniform hatching imparts a shimmering quality and surface sheen to this elegant figure. Delicate modeling, clear, reflective light, fluttering drapery, the hip-slung contrapposto stance, and the push-pull mechanism of sword against scabbard animate the figure. The sureness of handling and ornate brilliance of *Minerva* argue for a late date in the master's career, later than the *Nativity* [93] and close to the refined *Lucretia* [90].

Popham would agree with dating *Minerva* late in Parmigianino's career. He listed a red chalk (offset) drawing in the Louvre of *Minerva* as one of the copies of drawings in the Jabach collection which are not necessarily in the same technique as the originals.[1] Although Popham was unaware of the existence of the original (the Steiner sheet), he was correct in assuming that the copy reproduced a late Parmigianino drawing in reverse.[2]

1. This is not to be confused with another painting of *Lucretia* in Naples which Freedberg assigned to Bedoli (Freedberg, 1950, pp. 221-222). If the present drawing is any reflection of the lost painting, it was indeed "cosa divina e delle migliori che mai fusse veduta di sua mano" (Vasari-Milanesi, 1875-85, V, 233).
2. Washington, 1974, p. 56.
3. Vasari-Milanesi, 1875-85, V, 232-233.
4. Bartsch, XV, 289, no. 17; Freedberg, 1950, p. 238.
5. Popham, 1971, I, 28, n. 1. This seems to be the sheet Popham refers to as "a drawing by Bedoli on the Paris market."
6. *Lucretia, Seated on a Bed about to Stab Herself*, pen and brown wash heightened with white, 83 × 69 mm., Stockholm, National Museum, no. 245/1863; Popham, 1971, I, no. 578, II, pl. 184; Freedberg, 1950, p. 222; *Studies for a Lucretia*, pen and brown ink, 188 × 96 mm., Budapest, Musée des Beaux-Arts, no. 1883; Popham, 1971, I, no. 25, III, pl. 402.

1. Popham, 1971.
2. *Profile of a Bearded Man*, black chalk with touches of gray wash, 106 × 73 mm., Oxford, Ashmolean Museum, no. 445, Popham, 1971, I, no. 339, III, pl. 450; *Portrait Head of Valerio Belli*, red chalk, 155 × 93 mm., Rotterdam, Boymans-van Beuningen Museum, no. I.392, Popham, 1971, I, no. 569, III, pl. 430.
3. *Male and Female Heads; Dead Mouse*, pen and brown ink, 192 × 137 mm., Parma, Galleria Nazionale, no. 510/16, Popham, 1971, I, no. 544 (recto), II, pl. 98; *Studies of Five Heads and of a Hand*, pen and ink on red-tinted paper, 73 × 55 mm., Florence, Fondazione Horne, no. 5636, Popham, 1971, I, no. 132, II, pl. 165.

92

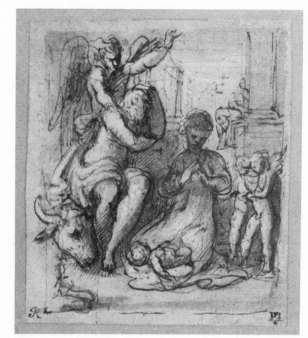

93

There is a relationship between this drawing and a sketch in Parma which could be an early idea for *Minerva*.[3] Although the pose has been changed and been made more dynamic, all the basic elements of the figure are already present. An allegorical figure in the lower right of Parmigianino's *Portrait of Count San Secondo*, dated 1533–1535, also resembles *Minerva* but is more static.[4]

1. *Minerva Drawing Her Sword from Its Scabbard*, red chalk (offset), 162 × 91 mm., Paris, Louvre, no. 6592, Popham, 1971, I, 238, no. 28, III, pl. 394.
2. Popham, 1971, I, 238, no. 28.
3. Andrea E. Kaliski in Oberhuber, 1978, p. 77; *Figure in Armor, Turned to the Left, Unsheathing His Sword*, pen and grayish brown ink, 96 × 42 mm., Parma, Galleria Nazionale, no. 511/18; Popham, 1971, I, no. 558, III, pl. 394.
4. Andrea E. Kaliski in Oberhuber, 1978, p. 78; *Portrait of Pier Maria II Rossi, Count San Secondo*, Madrid, Prado; Freedberg, 1951, pp. 212-213, fig. 139.

Francesco Mazzuoli, called Parmigianino

93 *The Nativity*

Pen and brown ink, brown wash, heightened with white (oxidized), 85 × 75 mm., ca. 1528–1530. Notations: verso, indecipherable; recto of mount, in pen and brown ink, *Parmeggiano*; in pencil, *15, 19*; verso of mount, in pencil, *A 3541*; in Jonathan Richardson, Sr.'s handwriting, in pen and brown ink, *45 L36 I55 AA42 A*.
The Cleveland Museum of Art, Dudley P. Allen Fund, 24.1003.
Provenance: Peter Lely (Lugt 2092); Jonathan Richardson, Sr. (Lugt 2184). *Published:* Popham, 1971, I, no. 61, III, pl. 256.

The subject of this drawing appears to be the second dream of St. Joseph, who—when Herod ordered the death of all first-born sons of the Israelites—was warned by an angel to flee to Egypt. The account of the Nativity and the Flight to Egypt is presented in the Gospel of St. Matthew.[1]

The ox appears here in its traditional role as symbol of the chosen people, the Jews, that is, as the Old Law bowing to the New. The Virgin is a Madonna of Humility kneeling on the ground in adoration of the Christ

Child. Two angels holding a chalice minister to Christ, the chalice also serving as an allusion to the blood of Christ to be shed in the passion.

No painting or engraving by Parmigianino survives for which this drawing may have been a study, although there are similarities with other works.[2] The angel behind the sleeping Joseph is like a shepherd in the Galleria Doria-Pamphili *Nativity* in its extended arm, spread fingers, and windblown hair.[3] The top half of the slumbering Joseph is repeated in a figure on the verso of a drawing in Windsor. The recto of the sheet is a copy of Raphael's *School of Athens* and would suggest Parmigianino's Roman period, before the sack of 1527.[4] A drawing of the *Adoration of the Shepherds*—which can be dated to about 1526 on the basis of Caraglio's engraving after it—is similar stylistically.[5] The way the Virgin's hair is defined by loose, randomly scalloped lines and the facial type are seen again in the *Virgin and Child in a Lunette*.[6]

94

I am indebted to Susan Bostwick for assistance in the research of this drawing.

1. Matthew, 2:13.
2. Popham, 1971, I, no. 61.
3. *Nativity: Adoration of the Shepherds*, Rome, Galleria Doria-Pamphili, no. 279; Freedberg, 1950, p. 170, fig. 46.
4. *Various Slight Sketches*, pen and brown ink, 235 × 415 mm., verso, *Copy of Raphael's School of Athens*, pen and brown ink and brown wash over black chalk, recto, Windsor, Royal Library, no. 0533; Popham, 1971, I, no. 666, II, pls. 206 (verso), 205 (recto).
5. *The Adoration of the Shepherds*, pen and ink and wash, heightened with white, 188 × 245 mm., Weimar, Graphische Sammlung, no. KK 7393; Popham, 1971, I, no. 631, II, pl. 144; Bartsch, XV, 68, no. 4.
6. *The Virgin and Child in a Lunette*, red chalk over stylus, 112 × 156 mm., London, British Museum, no. 1947-11-8-2; Popham, 1971, I, no. 170, II, pl. 59.

Orazio Samacchini

1532–1577

Orazio Samacchini left his native Bologna in the early 1560s and joined Pope Pius IV's project to decorate the Vatican's Sala Regia, where he encountered Taddeo Zuccaro. He was back in Bologna by the end of the decade where his robust figural style — influenced by his experience of Michelangelo's art in Rome and of Pellegrino Tibaldi's paintings — finally yielded to the mannerism of Giorgio Vasari.

Orazio Samacchini

94 *Seated Male Figure with Three Putti*

Pen and brown ink, brown wash, 258 × 398 mm., ca. 1560. Notation: lower left, in black chalk, indecipherable. Several holes, soiled and foxed, patched upper left corner.

Janos Scholz, New York.

Provenance: Savoia-Aosta (under Lugt 47a). *Exhibited:* Washington, 1973, no. 49, repr. p. 59.

Dark washes provide a strong contrast with the white of the paper and yield hard, volumetric figures which are as much Roman as Emilian in origin. The influence of Taddeo Zuccaro is evident in the loose handling of the curls of the putti and in another drawing by Samacchini, *Madonna and Holy Children.*[1] The closeness of Samacchini and the Zuccaro brothers can be demonstrated by *Religious Scene*, once attributed to Samacchini but now assigned by Popham to Federico Zuccaro.[2]

Seated Male Figure with Three Putti was related by Pouncey to drawings in the Louvre and Albertina associated with Samacchini's ceiling fresco in S. Abbondio, Cremona.[3] The strong contrasts and vigorous draftsmanship, however, caused Oberhuber and Walker to speculate whether the design was not, instead, by Bartolommeo Passarotti, Samacchini's compatriot who was also influenced by Roman art and Taddeo Zuccaro. They suggested, therefore, that the sheet may be by Passarotti or strongly influenced by him.[4]

1. *Madonna and Holy Children*, 266 × 224 mm., pen and ink and wash on tinted paper, London, Victoria and Albert Museum, no. 174.
2. *Religious Scene*, pen and ink, wash, water color, squared, 149 × 251 mm., Florence, Uffizi, no. 12178.
3. Washington, 1973, p. 61; *Prophet*, pen and brown ink, wash, chalk, 243 × 389 mm., Vienna, Albertina, no. 1966; Stix and Spitzmüller, 1926-41, VI, no. 41, pl. 11; Paris, Louvre, no. 10.263.
4. Washington, 1973, p. 61.

Venice

Nothing offends the gaze such as contour lines,
which should be avoided
(since nature does not produce them) . . .

LODOVICO DOLCE

Venetian painting is characterized in general by an interest in rich surface effects, optical sensation, and truth to appearances. Great concessions are made to the sense of sight in the emphasis on qualities of texture, color, light, and atmosphere—qualities rendered with greater or lesser success and often with astonishing results in drawings. Brittle and friable chalks yield crumbling lines and rippling light effects. Line becomes autonomous, variable, and if not absent, on the verge of fragmenting or dissipating. It functions more in terms of its suggestive powers and is often brushed onto colored paper. Forms emerge from running washes and are a function of the flow of ink against the inertia of the paper. Untouched areas serve as glowing lights causing forms to shimmer, creating atmosphere, light, and texture.

The masters who dominated Venetian art and defined the character of painting there—such as Titian, Tintoretto, Veronese, and Jacopo Bassano—revealed the range of their talents in their drawings. The few examples represented here include Titian's powerful *Trees Near Some Water* [108], outstanding for its compactness and tonal range. Pen and ink permits indications of shadows and reflections which suited Titian's desire to express density and light. On the other hand, Veronese's compositional inventiveness is obvious in the sheet of explosive pen and ink and wash sketches [109], while the opulence and patrician splendor of his paintings are encapsulated in the small *Study of a Fur Cape* [110] attributed to the master. The brown wash and white highlights of the drawing related to the *Isrealites Gathering Manna* [107] capture the dramatic impact and local color of Tintoretto's painting, whereas the *Samson and the Philistine* [106] associated with his studio betrays an obsession with figure studies unique in the Venetian context. Tintoretto more often drew with charcoal, and if it seemed to John Ruskin that Tintoretto painted with a broom, then he must have drawn with a breadstick.

Venetian painting was sustained in many ways by an influx of provincial artists who brought with them the influences of other regions in Italy as well as new ideas. Bernardino Parentino is noteworthy in this respect. The gritty surface texture of his decorative pen studies [116] reflects the influence of Mantegna and is more appropriate to late Quattrocento tastes. Parentino's *Roman Triumphal Procession* [117], inspired by the antiquarian circles of Mantua and Ferrara, anticipated an important current of Cinquecento Roman art. Here the impact of Roman relief

sculpture accounts for the almost obsessive filling of the sheet. Domenico Campagnola also covers the surface of his drawings [100], although his pen and ink technique is freer than Parentino's. Campagnola's treatment of space is more expansive and makes a major contribution to the development of landscape in Venice.

Titian often derived inspiration for poses and elements of composition from the paintings of Lorenzo Lotto, Pordenone, and Paris Bordone. The innovations of these provincial artists, frequently rustic and heavy handed, were fully realized in the urbane, sophisticated, and more profound statements of Titian. Lotto was an excellent portraitist, his works distinguished by a Venetian softness and fondness for surface appearances, as in his chalk *Head of a Bearded Man* [115]. Pordenone's *God the Father With Angels* [104] is one of several extant studies for his innovative ceiling frescoes where the generalized anatomy and distorted forms are sanctioned by the swirling movements and dramatic urgency of the scene. In Paris Bordone's black chalk *Study for a Figure of Christ* [97] form dissipates under glittering white chalk highlights, resulting in a misty, wraith-like figure.

Battista del Moro's *The Three Graces* [95]—with its substantial forms and generous draperies, its even lighting and refinement—reveals the influence of Veronese. Moro was also a native of Verona and, although a mature artist on his arrival in Venice, chose to follow the sumptuous style of his countryman. The sense of elegance in his works is as often attributed to the influence of Schiavone, whose *Apollo and Marsyas* [105] is highly decorative and arbitrary in its treatment of human proportions. It is through Schiavone, who was influenced by Parmigianino, that Emilian elegance was introduced to Venice.

Jacopo Palma il Giovane's *Apollo and the Muses Awakened by the Call of Fame* [102] is an example of the Venetian concern with the structural force of a composition rather than with line, contour, or figure studies. Man and nature form a harmonious relationship and reinforce the Venetian notion of the benevolence of nature. Palma il Giovane was an inveterate draftsman, and most of his drawings seem to have been executed for the sheer pleasure of sketching. Only a small number have been related to paintings. A similarly pictorial approach to the *Apollo* is taken in Palma's pen and wash *Baptism of Christ* [103]. The Venetians favored pen for its range and versatility, from the tight strokes of Campagnola and the descriptive tics and hooks of Titian to the broad, painterly washes of Veronese and Palma.

The practice of keeping record books and model books in the Venetian studios enabled the sons and daughters of such painters as Tintoretto, Veronese, and Bassano to maintain their studios for decades. Carletto Caliari's *Studies of Hands* [99] represents the atomization of form routinely followed in the academies and outlined by artist's manuals in the early seventeenth century, such as that of Odoardo Fialetti (Figs. VII, VIII). Caliari's compositional *studio* [98], typically lush and pictorial in the Venetian idiom, can be related to at least two paintings of the Judgment of Paris.

The Venetian drawing was generally a quick throwaway sketch or keepsake for the studio's record book. It was less important for the preferred Venetian technique of oil painting than for fresco or panel painting inasmuch as the canvas could be attacked directly by the artist with errors or motifs painted over or scraped away. Drawings were, nonetheless, treasured in the Venetian studio and acquired by collectors. In a letter of 1581 to the collector Niccolo Gaddi, Bassano warned him not to be disappointed in the drawings he requested noting that he and his family were painters and not draftsmen.[1] This illustrates the notion that Venetian artists were unaccustomed to refining their drawings. While the focus of *disegno* for the Florentine Giorgio Vasari was the human figure, for the Venetians it meant design in the broader sense of involving overall form and composition. Whether contours were soft or sharp, they were nonetheless sufficiently asserted in Venetian drawings. In the end these factors were sufficient in Dolce's mind for him to laud Titian as unsurpassed in draftsmanship.[2]

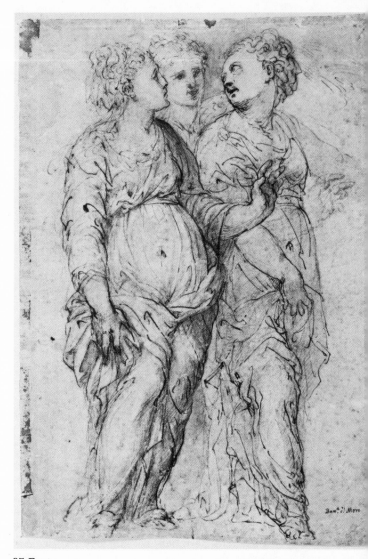

95 Recto

95 Verso

1. Bottari and Ticozzi, 1822, III, 265-267; see also, Tietze and Tietze-Conrat, 1944, p. 47.
2. Roskill, 1968, p. 185; see also, Barocchi, 1960-62, I, 200.

Battista Angolo del Moro
ca. 1514–ca. 1574

Battista Angolo del Moro was a painter and graphic artist who was born in Verona and trained there with Francesco Torbido del Moro, whose name he adopted. He was active in Verona and in Venice, where he was influenced by Titian and Veronese. Moro's major activity involved decorative wall paintings for churches and palaces such as the Palazzo Trevisano in Murano. Bartsch listed thirty-six prints for Moro, while Vasari mentioned a series of fifty engraved landscapes on which he collaborated with Battista Vicentino (Pittoni) but of which no evidence survives.[1]

1. Bartsch, XVI, 177-199, nos. 1-35; Vasari-Milanesi, 1878–85, V, 423-424.

Battista Angolo del Moro

95 *The Three Graces* (recto);
Study of a Winged Figure (verso).

Pen and brown ink, pencil, heightened with white (recto); gray wash and pencil (verso), 284 × 195 mm., ca. 1570. Notation: lower right corner, in pen and brown ink, *Batt.ᵃ el Moro*. Tears, creases, soiled.

Stanford University Museum of Art, Gift of Mrs. Louis Sloss, 54.29.

Exhibited: Washington, 1974b, no. 27, pl. 27 (recto).

So few drawings by Angolo del Moro survive that it is difficult to characterize him as a draftsman. Several of his sheets were identified by the Tietzes.[1] One of these, *Madonna in Glory*, has been related to *The Three Graces*.[2] The influence of Veronese is evident in these reserved, sculpturesque figures which have the stateliness and noble bearing of Roman matrons. The device of fingers dissolving in drapery folds is in the Emilian idiom of Parmigianino and Girolamo da Carpi. If the subject of the Stanford drawing is the Three Graces, they are not in their traditional poses.

1. Tietze and Tietze-Conrat, 1944, nos. A33-39; Ballarin, 1971, pp. 92-118, figs. 130, 132, 139-142.
2. *Madonna in Glory*, pen and black ink, heightened with white, on yellowish-brown tinted paper, 370 × 220 mm., Milan, Ambrosiana, Resta collection; Washington, 1974b, p. 18; Tietze, 1944, no. 36.

Jacopo da Ponte, called Bassano
1517/18–1592

Jacopo da Ponte was active largely in Bassano where he practised painting in a style that was both eccentric and provincial. He trained briefly in Venice ca. 1534 in the studio of Bonifazio de' Pitati. He would have been familiar with the work of Pordenone and Titian, who were major figures in Venice at this time. His colors are strong, sometimes arbitrary, and simultaneously hard and painterly.

Bassano's prominence paralleled that of Schiavone and of Tintoretto in the 1550s.

96

An outstanding example of his *maniera* tendencies in this decade is *Lazarus and the Rich Man* in The Cleveland Museum of Art. The *Adoration of the Shepherds* in the Galleria Nazionale, Rome, reflects Titian's warm colors and Bassano's renewed descriptive interests in the 1560s. In the 1570s he began to rely more heavily on studio assistants to the point of stereotyped forms appearing in repetitive combinations. Rustic subjects became more common as a concession to effects of realism.

Jacopo da Ponte, called Bassano

96 *Head of a Bearded Old Man*

Black, brown, red, ocher, and white chalk, 273 × 187 mm., 1563–1564. Notations: lower right, in pen and brown ink, *Bassano*; verso, upper left, in red chalk, *A*; upper center, in pen and black ink, *7*; upper right, in graphite, *lyons*; in blue ink, *Com*; left center, in black chalk, *Sp*; lower right center, in pen and brown ink, *B. B. n.º 58.*

The Janos Scholz Collection, The Pierpont Morgan Library, New York, 1973.43.

Provenance: Borghese Collection, Rome? (Lugt 2103a); Maurice Marignane (Lugt 1872); Hubert Marignane (Lugt 1343a); Janos Scholz (Lugt 2933b). *Exhibited:* Oakland, 1959, no. 5, repr.; New York, 1960; Columbia, 1961, no. 1; New York, Seiferheld Gallery, 1961, no. 3, repr.; Hamburg, 1963, no. 10; New Haven, 1964, no. 25; New York, 1965, no. 113; Middleton, 1969, no. 19; New York, 1971, no. 4; Washington, 1973, no. 108, repr. p. 134. *Published:* Scholz, 1976, no. 56, pl. 56.

As much interested in the texture of his medium as he is in descriptive surface, Bassano creates an impressive head and a forceful drawing. The sheet is an example of his full maturity as a draftsman when the Counter-Reformation fostered an interest in naturalism. In its use of colored chalks *Head of a Bearded Old Man* is a Venetian counterpart to the Roman drawings of Taddeo Zuccaro. Roger Rearick has related this head to that of St. Peter in *St. Peter and St. Paul* in the Galleria Estense, Modena, more in terms of technique than pose. This would date the sheet 1563–1564.[1]

1. Washington, 1973, no. 108; SS. *Peter and Paul*, Modena, Galleria Estense; Arslan, 1960, figs. 106, 108.

121

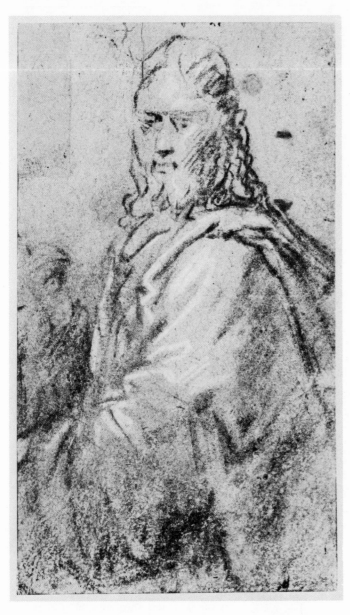

97

Walker cited two paintings by Bordone of half-length figures of Christ blessing for which this sheet may have been an early idea.[1] Muraro considered the linear emphasis in the head and shoulders typical of Bordone's style.[2] Pignatti noted the stylistic affinity with another sheet by Bordone, *Senator*, of the 1550s. A similar treatment of strands of hair and thick, dark outlines occurs in his drawing of a half-length naked Christ.[3] While the modest but consistent linear interests of Bordone separate him from the more optical approach of Savoldo [122], his draftsmanship is, for its quality of line, several times removed from such Tuscans as Bronzino [8,9] or even the more painterly Naldini [19].

1. Washington, 1973, no. 97. *Christ Blessing*, The Hague, Mauritshuis; Canova, 1964, fig. 65; *Christ Blessing*, London, National Gallery, Canova, 1964, fig. 66.
2. Venice, 1957, no. 18.
3. *Senator*, black and white chalk on gray-blue paper, 285 × 198 mm., New York, Cooper-Hewitt Museum of Decorative Arts and Design, no. 1938.88.2120; Washington, 1974b, no. 15, pl. 15. *Naked Christ*, black chalk on blue paper, 222 × 205 mm., Florence, Uffizi, no. 15019, Tietze and Tietze-Conrat, 1944, no. 396, pl. lxxxvi, p. 2.

Carletto Caliari

1570–1596

Carletto Caliari's brief life is summarized by Ridolfi (1648) and by Boschini (1660) who lamented his early death.[1] Veronese had hopes of a promising future for the younger of his two sons and sent him to the Venetian studio of his rival, Jacopo Bassano, to be trained. Fiocco maintained that Carletto was probably put under the tutelage of Francesco Bassano, as the father, Jacopo, had stopped painting after 1581.[2]

Carletto retained elements of Veronese's and Bassano's styles in his paintings. His *Annunciation* in Reggio Emilia was derived from Veronese's painting of the same subject in Detroit;[3] Bassano's influence is especially evident in the pastoral touches and kneeling figures of Carletto's *Nativity* of about 1588 in Brescia and the *Adoration of the Shepherds* in the Accademia in Venice.[4] Other outstanding works by Carletto are *Angelina and Medoro* in Padua and the Uffizi's four canvases dealing with the subject of Adam and Eve.

1. Ridolfi, 1914, I, 353-358; Boschini, 1660, p. 434.
2. Fiocco, 1928, p. 95.
3. Larcher, 1967, p. 115.
4. Larcher attributed the Academia *Adoration* largely to Carletto, disagreeing with Hadeln's assignment of it to Veronese's brother, Gabriele. It is signed "Haeredes Pauli" and is, therefore, another example of the division of labor in the late years of Veronese's shop. Hadeln, 1911, V, 391; Larcher, 1967, p. 113.

Paris Bordone

1500–1571

A native of Treviso, Paris Bordone spent his youth in Venice where he received his artistic training, for a period in Titian's workshop. His first commission at the age of eighteen was appropriated by Titian. Under the influence of his provincial origins, he soon turned to the directness and inflated forms of Pordenone. Bordone worked in Lombardy in the late 1520s. In 1534 a major commission for the Scuola di San Marco reveals a departure from the descriptive clarity of his Lombard phase and a return to the sfumato effects and mellow light of Titian. Bordone joined Rosso and Primaticcio in Fontainebleau for a period in 1538. He returned to Italy in 1540 and resided in Milan for three years. His paintings then had scintillating colors and gritty textures which reflected the interest in decorative surface of the Fontainebleau artists and the examples of central Italian mannerism Bordone encountered there. In the next decade he was influenced by the art of Tintoretto and became adept at painting allegorical portraits.

Paris Bordone

97 *Study for a Figure of Christ*

Black chalk heightened with white chalk on blue paper, 200 × 120 mm., ca. 1550. Upper left corner patched, soiled.

Janos Scholz, New York.

Provenance: Moscardo (Lugt 2990a); Calceolari, Verona. *Exhibited:* Venice, 1957, no. 18, pl. 18; Bloomington, 1958, no. 41, fig. 41; Oakland, 1959, no. 11; Hagerstown, 1960, no. 18; Milwaukee, 1964, no. 8; Washington, 1973, no. 97, repr. p. 121; Montgomery, 1976, no. 18.

Whether this drawing represents Christ, an apostle, or is a quick study for a portrait is not certain, although Oberhuber and

Carletto Caliari

98 *The Judgment of Paris*

Pen and brown ink, brown and gray wash,
heightened with white, over black chalk, on blue
(faded) paper, 393 × 515 mm., ca. 1585. Nota-
tions: in pencil, *100, 334 fu;* verso of mount, in
pencil, *Paolo Caliari.* Large vertical tear center,
several tears, holes, creases.

The Cleveland Museum of Art, Dudley P. Allen
Fund, 46.216.

Provenance: Unidentified collector's mark, recto;
Italico Brass, Venice. *Exhibited:* Toronto, 1960,
no. 47 (as Paolo Veronese); Birmingham, 1972,
p. 9, repr. p. 52 (as Carletto Caliari). *Published:*
Francis, 1947, pp. 176-177, repr. p. 162 (as Paolo
Veronese).

The Greek myth of the Judgment of Paris
begins when the Nereid, Thetis, failed to in-
vite Eris, the goddess of strife, to the wed-
ding feast celebrating her marriage to the
mortal, Peleus. When Eris came upon the
marriage scene, she became angry at hav-
ing been slighted and, in revenge, rolled a
golden apple with the inscription "For the
Fairest" across the banquet table. The feast
ended in confusion as each goddess tried
to claim the golden apple. To resolve the
conflict, Paris was asked to choose the fair-
est among Juno, Minerva, and Venus. He
picked Venus because she bribed him with
the gift of Helen (the wife of Menelaus),
whom he carried off to Troy. This resulted
in the Trojan War and its aftermath, as re-
counted by Homer in the *Iliad* and the
Odyssey and which ultimately became the
basis for Virgil's epic of the founding of
Rome, the *Aeneid.*

Rodolfo Pallucchini felt that *The Judg-
ment of Paris* "has some parts that are very
beautiful together with the general effect
which makes one think of Paolo: certain
other particulars on the other hand seem
to be more stiffly treated with a meticulous
quality that might be by the son Carletto."[1]
The attribution to the young Carletto
makes sense in terms of some of the awk-
ward passages in the sheet, a sign of the
tentativeness of a young artist. The legs of
the central female are poorly drawn, the
nude to the left is ill-proportioned, and the
faces could be more pleasing (although the
central portion of the grouping is a later
restoration). In his favor Carletto provides
a lush setting, a sweeping vista of a pastoral
scene at the left, and interesting genre touches
in the goat and sleeping dog.

The subject was described by Ridolfi as
appearing in a series of mythological scenes
painted by Carletto and his brother Bene-
detto in the Fondaco dei Tedeschi, Venice.[2]
A drawing of Medea, Jason, and the Golden
Fleece connected with this series is in the
same style.[3] Two paintings of this subject
also must be considered. The attribution to
Carletto of the one at Bucknell University is
qualified by the fact that the canvas is in
such bad condition it is difficult to be sure.
Shapley wrote that "if painted by him it is
perhaps to be dated in the earlier part of

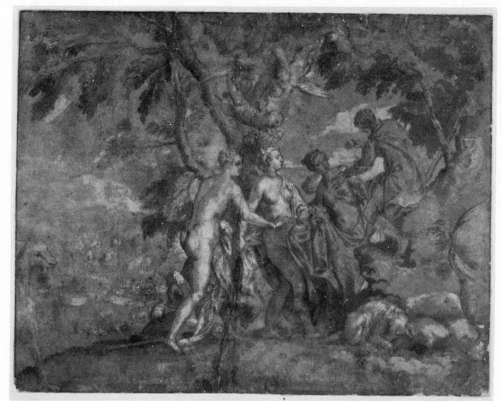

98

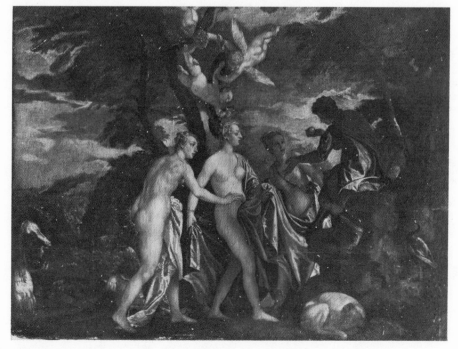

Fig. 98a. *Judgment of Paris*, oil on canvas. Carletto Caliari.
Earl of Wemyss Collection, Gosford House, Longniddry, Scotland.

123

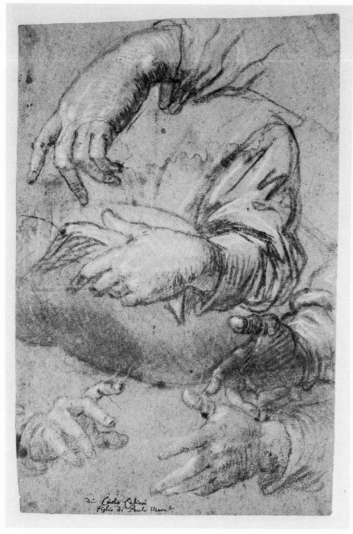

99 Recto

99 Verso

his activity, about 1590, when his figures are more agitated in movement than later."[4] A version in the Earl of Wemyss Collection, Scotland (Fig. 98a), attributed to the studio of Paolo Veronese, is eleven inches wider than the Bucknell picture and includes a goat at the left and Juno's peacock at the right, lost when the smaller canvas was cut down.[5]

I am grateful to Jane Boruff for research assistance with this drawing.

1. Rudolfo Pallucchini to Henry Francis, 6 May 1947, curator's file, The Cleveland Museum of Art.
2. Ridolfi, 1914, I, 357.
3. Toronto, 1960, no. 47; *Mythological Scene*, pen and brown ink and wash, 181 × 353 mm., London, Victoria and Albert Museum, no. Dyce 250; Tietze and Tietze-Conrat, 1944, no. 2204, pl. clxvii.
4. *The Judgment of Paris*, 1016 × 1166 mm., Lewisburg, Pennsylvania, Bucknell University, Study Collection, no. BL-K8; Shapley, 1966–73, III, 44-45, fig. 81.
5. Shapley, 1966-73, III, 45.

Carletto Caliari

99 *Studies of Hands* (recto);
Sketch of a Child's Head (verso)

Black chalk heightened with white chalk on blue paper (recto); black chalk on blue paper (verso), 275 × 177 mm., ca. 1586. Notations: recto lower left, in pen and brown ink, *di Carlo Caliari figlio di Paulo Verone*; verso, in pen and brown ink, *Amor di mertrice / Carletos Calliari e morto / Agneta 153 / Amordimerelirt / Aabcdefg*; in pencil, *262*. Watermark: scale in circle surmounted by a star (similar to Briquet 2520).

The Cleveland Museum of Art, Dudley P. Allen Fund, 29.549.

Exhibited: Cleveland, 1956, no. 64; Birmingham, 1972, repr. 54. *Published:* Tietze-Conrat, 1944, no. 2199, pl. clxiv, fig. 1; Francis, 1947, p. 177, repr. p. 162.

The attribution to Carletto appears sound on the basis of the inscription on the verso where no attempt is made to link the sheet with a more prestigious master like Titian, Bassano, or even Carletto's father, Veronese. This would seem to be a drawing from early in the artist's brief career, since it reveals a pedagogical interest in careful observation of multiple views, the painterly approach Carletto would have been taught in

the Venetian studio of Bassano, as well as the awkwardness of a beginner. Sleeves are described more confidently than the hands which vary in treatment. Carletto is uncertain about how the white accents should function on the upper two hands which also lack structure. Those below are more convincing because contours are rendered more accurately and they are more fully modeled. While hands in similar attitudes can be found in a number of Carletto's paintings, none corresponds exactly with any in the drawing.

Concentrating on human extremities in training novices was strongly emphasized at the end of the Cinquecento by the Carracci academy in Bologna, and the practice quickly made its way to Venice as indicated by Odoardo Fialetti's primer of 1608, *On the True Method of Drawing Every Part of the Human Figure* (Figs. VII-VIII). Indeed, Fialetti's etchings of anatomical details in various stages of completion were based upon drawings by Agostino Carracci.[1]

The research assistance of Jane Boruff is gratefully acknowledged.

1. Lewine, 1967, p. 27.

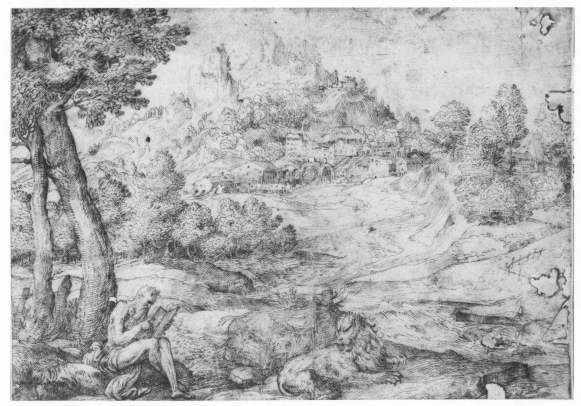

100

Domenico Campagnola
1500–1564

For so prolific a graphic artist surprisingly little is known about Domenico Campagnola. He seems to have been born in Venice of German parents and was later adopted by the important engraver, Giulio Campagnola, whose name he assumed. Many of his large-scale works have been lost, and his graphic style is frequently confused with Titian's. Clear distinctions between the drawing styles of the two artists have been made by Oberhuber, who finds Campagnola more interested in movement and action than Titian.[1] Campagnola's landscapes were extremely popular and widely circulated, known in the north to Pieter Bruegel the Elder, and emulated later in the century by the Carracci.

1. Levenson et al., 1973, p. 415.

Domenico Campagnola

100 *Landscape with St. Jerome*

Pen and brown ink, 246 × 365 mm., ca. 1530. Notations: on recto of mount, in pencil, *61, 236, 3, 8930, Cl/q, Titian*. Large holes along right side, small holes and tears.

The Cleveland Museum of Art, Charles W. Harkness Endowment Fund, 29.557.

Provenance: George Donaldson. *Exhibited:* Cleveland, 1956, no. 65. *Published:* Tietze and Tietze-Conrat, no. 452 (as Shop of Campagnola).

The attribution of this drawing to Campagnola was first made by Henry S. Francis and confirmed by the Tietzes.[1] No known work based upon this composition has been identified although similar elements appear in woodcuts by Campagnola from the 1530s such as *St. Jerome with the Fighting Lions* (Fig. 100a).[2] These include the use of small-scale figures, repoussoir trees, and panoramic vistas extending beyond a central depression. Since the sheet has the character of a finished drawing rather than a *schizzo*, it is possible that it was intended for a collector. Marcantonio Michiel reported pen drawings by Campagnola in the Paduan collection of Marco Benevides in 1537.[3]

Campagnola was a prolific landscapist. A large number of surviving drawings and woodcuts indicate an extensive receptive audience for this genre. Because of sparse documentation, secure dates for his works are rare. His paintings, which are largely figure compositions, add little information about the artist's landscape interests. Both the drawn and printed landscape compositions have been dated to the 1530s because of their dependence upon Titian.[4] The model for *St. Jerome with the Fighting Lions* was Titian's woodcut of the same subject of 1525–1530.[5] Campagnola reduces the size of the figures and gives the landscape even greater prominence. Jerome and the lion are made part of nature. Both fit into the foreground as part of a shady frame

for the panoramic view beyond. Jerome and the lion add a note of quietude and reverie to the undulating, energetic lines of the background which provide a model for the frenetic vibrations of Etienne Dupérac's view of the Tiber [45]. Nature appears here as a vital force, sustaining Jerome in his meditation, as it supports all other forms of life. More than just a generalized vision of nature, Campagnola presents its effects in the manner of *natura naturans* or creative nature. The rise and fall of landscape illustrates nature in process, sustaining life and growth to the extent that the placid mood of the absorbed mystic and relaxed lion comprises an ontological statement on the part of Campagnola. His landscapes do not appear threatening like Orsi's [88] or Muziano's [56]. It is perhaps the benign anthropomorphic character of Campagnola's settings that made his views so suitable a model for Annibale Carracci's ideal landscapes [36,37].

The tonal range of the drawing is extensive considering it is achieved with only pen and ink. A linear emphasis is to be expected of Campagnola, whose drawings often served the purpose of designs for woodcuts. He seems to have been more responsible than anyone in Italy for establishing landscape as an independent category, but the appreciation of this genre was made explicit only at the end of the century in the treatises of Sorte and Lomazzo.[6]

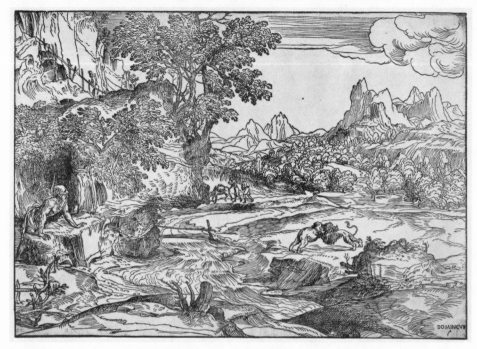

Fig. 100a. *St. Jerome with the Fighting Lions*, woodcut, 287 × 418 mm. Domenico Campagnola. The Cleveland Museum of Art, Dudley P. Allen Fund.

101

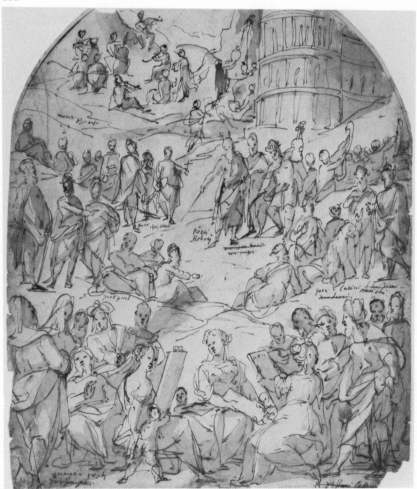

I am indebted to Roslynne Wilson for research assistance with this drawing.

1. Tietze, 1944, no. 452. In a verbal communication in 1974 Fritz Heinemann concurred with the Campagnola attribution and the date of ca. 1530, Curator's file, The Cleveland Museum of Art.
2. Bartsch, XIII, 385, no. 2; Washington, 1976, no. 26, repr. p. 159.
3. Michiel, 1969, p. 33.
4. Washington, 1976, p. 158.
5. Ibid., Titian, *St. Jerome in the Wilderness*, woodcut, 390 × 532 mm., Passavant, VI, 235, no. 58, Washington, 1976, no. 22, repr. p. 147.
6. C. Sorte, *Osservazioni nella pittura* (Florence: 1584), published in Barocchi, 1960, I, 275-301; Lomazzo, 1584, 473-475.

Parrasio Micheli

1516–1578

Parrasio Micheli was initially a pupil of Titian and later a follower of Veronese. Micheli visited Rome in 1547. His earliest works date from 1550.[1] Micheli's painting of the Doge Lorenzo Priuli in the company of ten senators with personifications of Fortune and Venice was completed in 1563 and destroyed by fire in 1574. Micheli corresponded with Philip II of Spain and was associated with some of the period's most prominent men of letters, such as Paolo Giovio and Pietro Aretino.[2]

1. Thieme-Becker, 1930, XXIV, 528-529; Ridolfi, 1914, II, 137-138; Venturi, 1901-40, IX, 4, 1047-1054.
2. Hadeln, 1928, p. 17.

Parrasio Micheli

101 *Study for an Allegory of Learning*

Pen and brown ink, brown wash, over traces of black chalk, 321 × 274 mm., ca. 1565. Notations: upper left, in pen and brown ink, *mont p...naso*; center, in pen and brown ink, *poeti christiani*; in another hand, in grayish ink, *Poeti/Hebrii*; in pen and brown ink, crossed out, *Moses et David / con profeti*, below center, left, in pen and brown ink, *poeti greci*; below center, right, in pen and brown ink, *poeti latini* crossed out, *Christini moderni*, in grayish ink, *...ichi*; bottom left in pen and brown ink, *gramatica g...* crossed out, *profetti* (?) *greci*; bottom right, in pen and brown ink, crossed out, *proffetti Lattini*; verso above, in brown ink, *3-3*; bottom, in pencil, *Nº291*. Watermark: hand surmounted by flower (similar to Briquet 10681). Lower right corner missing, lower left corner wrinkled, tears along edges.

Mr. and Mrs. Stephen C. Kollmar

This ambitious design was probably intended as a study for a wall decoration for the library of some humanist or academician. The didacticism in the inscriptions, the presence of Apollo and the Muses on Mt. Parnassus, and the inclusion of grammarians and Hebrew and Christian poets have parallels in the founding of the Accademia Olimpica in Vicenza in 1555 and the Accademia Veneziana in 1557. That the program has not been fully defined can be seen in Micheli's replacing the inscription, "Moses and David with prophets" with "Hebrew poets," suggesting that additional

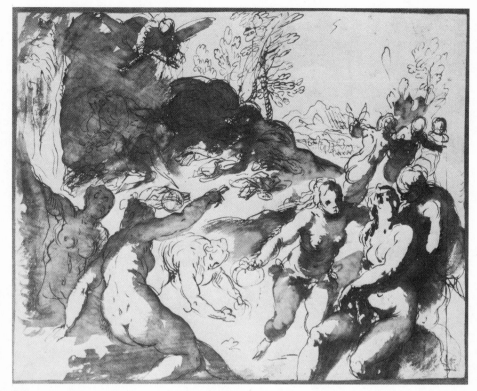

102

form and are overwhelmed by light brown and gray washes.[2]

In this carefully regimented design the composition is dominated by slanting diagonals in the manner of Tintoretto and depends upon a subordination of elements to the whole. Top half is clearly divided from bottom half, and left half from right. An emphatic diagonal moves from the lower left to the upper right through the right arm of the pointing Muse; the Muses are arranged as three groups in clusters of three.

1. Erwin Panofsky to Henry S. Francis, 8 May and 21 May, 1936, Curator's file, The Cleveland Museum of Art. The same subject exists in a drawing by Naldini in Munich; Voss, 1920, II, 310, fig. 107.
2. Tietze and Tietze-Conrat, 1944, p. 197.

Jacopo Palma il Giovane

103 *Baptism of Christ* (verso); *Allegorical Figures with a View of Venice* (recto)

Pen and brown ink, brown wash, over traces of black chalk (verso); pen and brown ink, brown wash (recto), 287 × 225 mm., 1613. Notation: verso, pen and brown ink, *1613 no[ri]*.

Janos Scholz, New York.

Provenance: William Mayor (Lugt 2799); Max A. Goldstein (Lugt 2824). *Exhibited:* Oakland, 1969, no. 47, fig. 47 (recto); Washington, 1974b, no. 34, pls. 34 (recto, verso); Providence, 1978, no. 19.

Baptism of Christ, dated 1613, was associated by Pignatti with a painting at the Oratorio degli Crociferi in Venice. The drawing on the recto is a preparatory sketch for Palma's painting of 1615 in the Doge's Palace which depicts the adoration of the Virgin by the Doge Marcantonio Memmo. Other sketches connected with pictures of a Doge are similar in style.[1]

Baptism of Christ is a free variation of Tintoretto's canvas of the same subject painted after 1580 and now in The Cleveland Museum of Art (Fig. 103a). Jacopo's approach in this sketch is iconic and conceptual in the sense that descriptive realism and detailed anatomy yield to ritual poses and generalized statement. His technique with its pictorial character, rippling surfaces, twisting volumes, and uniform touches of wash is more suited to broad statements of dogma rather than simple narrative.

1. *A Doge,* charcoal, heightened with white, on blue paper, 277 × 183 mm., Florence, Uffizi, no. 12939, Tietze and Tietze-Conrat, 1944, no. 917, pl. clxxiii, fig. 2; *Sketch for a Votive Painting of a Doge,* pen and brown ink and wash, 192 × 235 mm., Windsor, Royal Library, no. 4800, Tietze and Tietze-Conrat, 1944, no. 1246, pl. clxxiv, fig. 2.

groupings may have been intended for other walls in a project of broader scope.

This drawing can be associated with a design related to Micheli's lost painting in the Doge's palace where the figures are identified by names placed above their heads.[1] As in the *Study for an Allegory of Learning,* there is a cursory definition of faces, pointed noses, and short slashes for eyes.

1. *Group of Senators* (recto); *Senators and a Putto* (verso), pen on white paper, 247 × 402 mm., Berlin, Kupferstichkabinett, no. 2369, Hadeln, 1926, pp. 19-20, no. 20, pls. 20-21.

Jacopo Palma il Giovane

1544–1628

Jacopo Palma il Giovane was put in the care of the Duke of Urbino ca. 1559 and sent to study in Rome for eight years. A nephew of the Venetian artist Giacomo Palma il Vecchio, he settled in Venice ca. 1568. Palma completed Titian's *Pietà* (Accademia, Venice), left unfinished at the master's death in 1577. He seems to have had dealings with Tintoretto, recording his gratitude to the family in his will and leaving Domenico Tintoretto four drawings.

Ridolfi reported Palma sketched as much for the pure pleasure of it as for working toward a painting.[1] He was a prolific draftsman, and there are many drawings which

cannot be related to known works. In the earliest sheets of the 1560s, working quickly in either black chalk or pen, he devised a terse shorthand with calligraphic flourishes to suggest figures.

1. Ridolfi, 1914, II, 203.

Jacopo Palma il Giovane

102 *Apollo and the Muses Awakened by the Call of Fame*

Pen and brown ink, brown wash, over pencil, 204 × 261 mm., 1590s. Notations: recto of mount, in pen and brown ink, *Palma giovan;* verso of mount, in pencil, *Jonathan Richardson, 23.*

The Cleveland Museum of Art, Dudley P. Allen Fund, 26.265.

Provenance: Jonathan Richardson, Sr. (Lugt 2183); William Mayor (Lugt 2799); John Postle Heseltine (Lugt 1507); P. & D. Colnaghi & Co. (Lugt 2075). *Exhibited:* Cleveland, 1956, no. 75; Toledo, 1940, no. 84. *Published: Original Drawings,* 1906, no. 18, repr.; Tietze and Tietze-Conrat, 1944, p. 201, no. 878.

In 1936 Panofsky confirmed the attribution to Palma il Giovane and identified the subject as Apollo and the nine Muses near the Castilian spring, suggesting the revival of the arts after a period of stagnation.[1] Fame, identified by wings and a trumpet, attempts to awaken a slumbering Apollo lost in the shadows of rocks and bushes. This drawing shows the technique favored by Palma in the 1590s; touches of pen and ink suggest

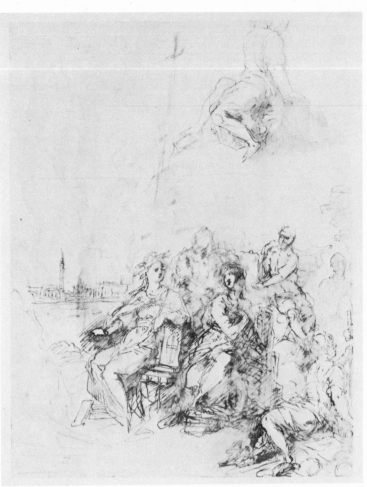

103 Recto

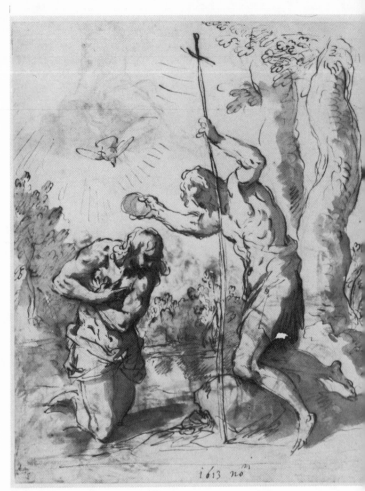

103 Verso

Giovanni Antonio de Sacchis, il Pordenone

1484–1539

Pordenone's early paintings were in the late Quattrocento spirit and style, but by 1510 his work showed an awareness of contemporary trends in Venice. In 1518 he painted an altar fresco at Alviano near Rome. Although he adopted the powerful forms and directness of Roman painting, his art remained provincial. Pordenone's inventiveness became apparent in his design for the cupola of a chapel in the cathedral in Treviso (1520). He worked there in the company of Titian, who was asked to paint an *Annunciation* for the altar wall below. In that same year Pordenone replaced Romanino in the execution of frescoes dealing with Christ's Passion for the cathedral in Cremona. The emotional strain, descriptive realism, and rhetorical use of light in the *Crucifixion* suggest the influence of Northern European painting. Most radical in its illusionism, however, is the *Pietà* with its extension of figures into the space of the spectator.

Fig. 103a. *Baptism of Christ*, oil on canvas, 1690 × 2514 mm. Tintoretto, Italian, 1518–1594. The Cleveland Museum of Art, Gift of Hanna Fund.

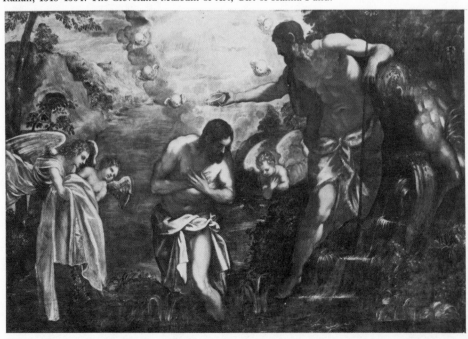

In 1527 Pordenone moved to Venice. The former impetuousness of his work was tempered with grace and subtlety, but only relative to Pordenone's earlier style and not current Venetian taste. He painted the dome of the Pallavicini chapel at Cortemaggiore (1529–1530), a scene of God the Father, with a daring expansion of pictorial space. Pordenone became a serious rival of Titian in the 1530s. His numerous decorations in the Palazzo Ducale, Venice (1535–1538), were lost in the fire of 1577. Outstanding examples of his work at this time survive at Santa Maria di Compagna, Piacenza, and the *Annunciation* in Murano (1537), which replaced a painting by Titian the patrons considered too expensive. Pordenone's artistic heirs in the environs of Venice are Tintoretto and Jacopo Bassano.

Giovanni Antonio de Sacchis,
il Pordenone

104 *God the Father with Angels*

Pen and brown and black ink, brown and gray wash, heightened with white on blue paper, oval border incised, 381 × 259 mm., ca. 1529. Notations: verso, in pen and brown ink, *Di Pordenone/A*; bottom, *Di mano propria di gio. Antº. Liuno detto il Pordenone*; above in pencil, *NBRGG/Lionio, Gio. Antonio (Pordenone)*. Watermark: indecipherable. Badly rubbed, horizontal fold at center.

The Detroit Institute of Arts, Gift of the William H. Murphy Fund, 34.150.

Provenance: Heinrich Wilhelm Campe (Lugt 1391); Herman Voss, Berlin. *Published:* Schwarzeweller, 1935, p. 137, no. 15; Fiocco, 1943, pp. 88, 90, 112, 125; Tietze and Tietze-Conrat, 1944, no. 1307.

Antecedents for the general subject and formal treatment of this drawing can be found in the creation scenes of Michelangelo's Sistine ceiling, in Raphael's *Transfiguration* (ca. 1519–1520), and in Titian's *Assumption* (ca. 1518). Based on these precedents, Pordenone developed his own conception of the scene.

This design was a study for the cupola in Santa Maria di Campagna, Piacenza, executed ca. 1530–1536.[1] The slender forms, smooth surface treatment, rapid transitions from light to dark, occasional ragged contours, and helical extension of figures are characteristic of Pordenone's draftsmanship in the early 1530s. The swirling flight of God the Father causes his bodily distortions. Twice before Pordenone had used the same subject for the decoration of a cupola: first in the Malchiostro chapel in the cathedral in Treviso (now destroyed), 1520, and again in the Pallavinci chapel of the Franciscan church at Cortemaggiore, 1529–1530.[2] The dome at Treviso—remarkable for the electrifying flight of God the Father accompanied by a score of angels—shortly antedates Correggio's dome of San Giovanni Evangelista in Parma. In Cortemaggiore the scene is striking for its daring illusionism, excitement, and energetic

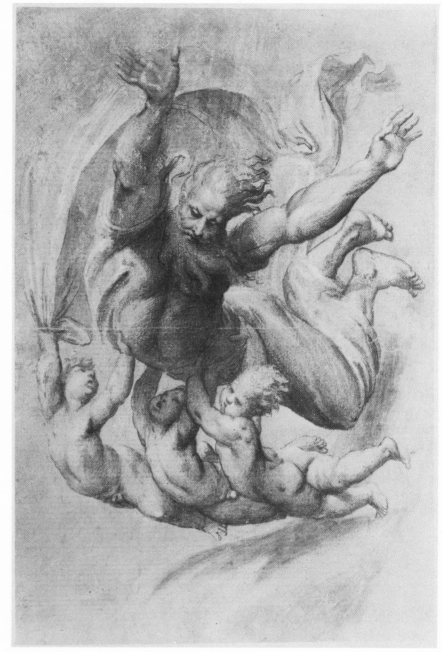

104

movement. A preparatory drawing (Fig. 104a) similar in style to the Detroit sheet, shows God the Father turning forward and breaking out of the picture plane.[3] In the painting this effect is even more exaggerated and the figure projects into the spectator's space while the putti have burst out of the frame and tumble downward. Pordenone continued to utilize this subject, and with slight variations, the Detroit design may also have served as a model for the top half of the *Annunciation* painted in 1537 for Santa Maria degli Angeli, Murano.[4]

1. Cupola, Santa Maria di Campagna, Piacenza, Fiocco, pls. 166, 168.
2. *God the Father*, Cupola, Malchiostro Chapel, Cathedral, Treviso, Freedberg, 1971, pl. 124; *God the Father in Glory*, cupola, Church of the Franciscans, Cortemaggiore; Fiocco, 1943, pls. 141, 142.
3. Fiocco, 1943, pl. 140.
4. *Annunciation*, Santa Maria degli Angeli, Murano; Freedberg, 1971, pl. 127.

Fig. 104a. *The Almighty Supported by Angels*, red chalk, 218 × 217 mm. Il Pordenone. Duke of Devonshire Collection, Chatsworth.

Andrea Meldolla, il Schiavone

1522–1563

The date and circumstances of Schiavone's arrival in Venice are not certain, but he was active there by 1540. His work clearly indicates his debt to Parmigianino, whose mannerist style he adopted. By the late 1540s the example of Tintoretto became more evident in his paintings, and in the following decade he turned to Jacopo Bassano for ideas.

Andrea Meldolla, il Schiavone

105 *Apollo and Marsyas*

Pen and brown ink, brown wash, over black chalk, heightened with white, on blue paper, 273 × 265 mm. Wrinkled.

Janos Scholz, New York.

Provenance: Moscardo (Lugt 2990a-h); Calceolari (under Lugt 2990a). *Exhibited:* Indianapolis, 1954, no. 50; Oakland, 1959, no. 64; New Haven, 1960, checklist no. 48; New York, 1961, no. 19; Cambridge, 1962, no. 36; Hamburg, 1963, no. 146, pl. 72; New York, Scholz collection, 1965; London, 1968, no. 90; Middletown, 1969, no. 9; New York, 1971, no. 55, repr. p. 27; Norton, 1971; Montgomery, 1976, no. 23, repr. p. 51. *Published:* J. Scholz, 1976, no. 64, pl. 64.

The fable of Apollo and Marsyas was popular in the sixteenth century for its moral overtones concerning the sin of pride and overwhelming ambition. Here Apollo, the god of music, plays the fiddle in a triumphant response to the arrogant piping of

Fig. 105a. *Apollo and Marsyas*, pen and ink. Parmigianino. The Pierpont Morgan Library.

105

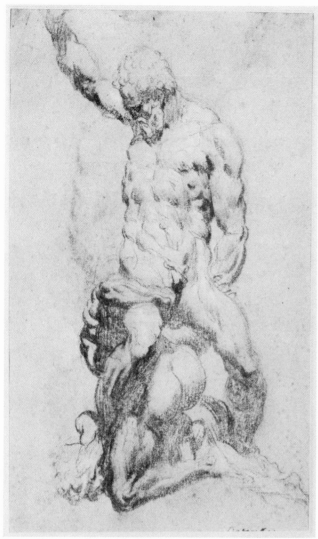

106 Recto

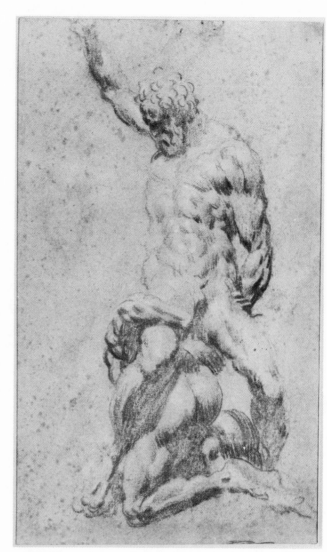

106 Verso

Marsyas, who challenged him to a music contest. The result was the satyr's defeat and his punishment of being flayed alive.

Schiavone's sketch has long been recognized as based on an oval drawing of the same subject by Parmigianino (Fig. 105a) which was a study for a chiaroscuro woodcut.[1] The subject was also repeated in an etching by Antonio Fantuzzi who was active at Fontainebleau.[2] The pulsating undulation of Schiavone's line is perhaps intended to reinforce the dissipating vibrato of the piece Apollo has just ended, as he withdraws the bow and triumphantly elevates his viol. The awkward horizontal elevation of the instrument may allude to Apollo's playing the instrument reversed, a feat Marsyas could not duplicate with his pipes; but the freedom taken with human proportions, and the disinterest in sharply defined details indicate Schiavone's decorative intentions and his striving for visual effects.

1. Indianapolis, 1954, no. 50; Fairfax Murray, 1905–12, IV, no. 44, pl. 44.
2. Zerner, n.d., pl. A.F.76a.

Jacopo Robusti, called Tintoretto

1518–1594

Few facts of Tintoretto's early training are known, his first surviving works dating from the early 1540s. His departure from the classicizing tendencies of Titian may be explained by the influx of Florentine and Roman prints and clay models into Venice and by a trip to Rome in 1540.[1]

Tintoretto preferred strong contrasts of light and dark for dramatic effects. His compositions frequently consist of boxlike but recessive spaces filled with distended, swaying figures often with an emphatic verticality. To a large extent this derives from his practice of arranging wax models within a box and using candles to manipulate lighting effects.[2] Tintoretto worked rapidly and achieved additional force by means of exaggerated perspective. The *Miracle of St. Mark* of 1548 (Accademia, Venice), a ceiling painting initially refused by its patrons, established Tintoretto as a major painter. The *Presentation of the Virgin* of 1552–1556 (Santa Maria dell'Orto, Venice)

used the oblique setting of Titian's *Pesaro Madonna* (Frari, Venice) as a point of departure. From 1565 for a period of twenty years, he worked on decorations for the Scuola di San Rocco. Tintoretto's facility for working on a large scale is evident in the *Crucifixion* in the Doge's Palace, which is over forty feet in length. One suspects that a response to the monumental paintings of the Vatican Stanze and Sistine Chapel was as strong a motivation for him as the need to fill large spaces.

1. Freedberg, 1971, p. 353.
2. Ridolfi, 1914, II, 15.

After Jacopo Robusti, called Tintoretto

106 *Samson and the Philistine* (recto); *Samson and the Philistine* (verso)

Black chalk heightened with white on blue paper (recto, verso), 382 × 235 mm. Notations: lower right, in pen and brown ink, *Tintoretto*; added later beneath, *Dietro a questo vi e lo stesso gruppo.* Holes top center, soiled.

Fogg Art Museum, Harvard University, Cambridge, Massachusetts, Bequest, Meta and Paul J. Sachs, 1965.424.

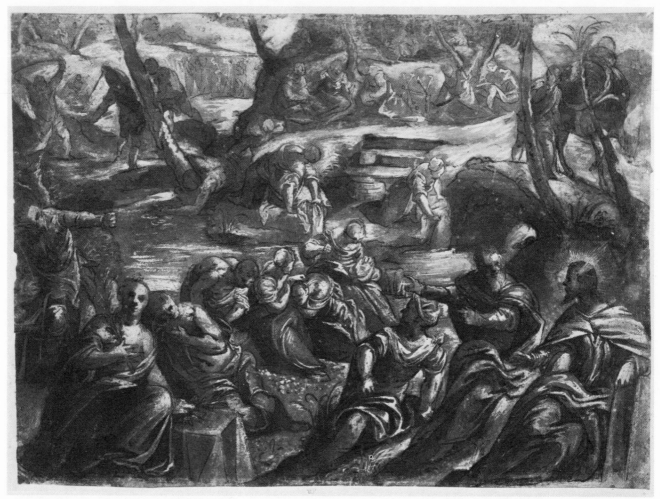

107

Provenance: Charles Loeser (under Lugt 936a); Paul J. Sachs (Lugt 2091). *Exhibited:* Northampton, 1957; Newark, 1960, no. 26, repr. (recto, as Tintoretto); Birmingham, 1969, no. 11. *Published:* Mongan and Sachs, 1940, I, no. 186, II, fig. 98 (recto, as Tintoretto).

Numerous drawings by Tintoretto after monuments of Michelangelo have survived. Generally they depict figures from Michelangelo's Medici tombs at San Lorenzo in Florence or struggling figures from other projects.[1] Several of these studies which deal with the theme of victor and vanquished have been published by Rossi.[2] This subject reflects the Italian Renaissance interest in the *psycomachia*. Michelangelo's *Victory* in the Palazzo Vecchio became a model for such works which represent the triumph of virtue over vice and the struggle within the individual for mastery of the senses by the intellect.

Here Tintoretto drew Michelangelo's sculptural group of *Samson and the Two Philistines*, the same piece also sketched by Naldini [19]. Although the original is now lost, several bronze copies survive.[3] It is known that Tintoretto owned models of works by Michelangelo, Sansovino, and Giovanni da Bologna in addition to casts of the Belvedere torso, the Medici Venus, and

Fig. 107a. *The Israelites Gathering Manna*, oil on canvas, 3770 × 5760 mm. Tintoretto, Italian, 1518–1594. San Giorgio Maggiore, Venice.

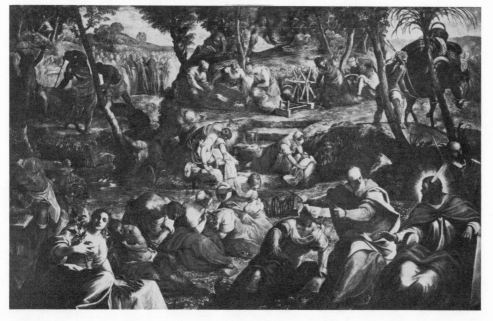

busts of emperors. A second Tintoretto drawing in the Fogg of this same subject [4] shows a vertical strut supporting Samson, indicating that the artist was using a clay or wax model.[5] The process of drawing replicas, recommended in art treatises from Alberti to Armenini as an aid to the novice, is illustrated in engravings of Bandinelli's Academy (Fig. IX, [74]).[6] For an accomplished master like Tintoretto, studying a sculpture from various angles would provide numerous possibilities for poses to be used later in paintings.

Obviously this group by Michelangelo held great interest for Tintoretto. Several other studies of it exist as well as the two sheets in the Fogg, both of which also have drawings of the sculpture on recto and verso.[7] In explaining the existence of so many sheets of the same subject, Luitpold Dussler noted how, "the much interlaced group . . . offers so many possibilities from various angles, and so many new and fascinating views of the contours, the movement, the apparent changes of surface and mass and the play of light and shade bound up with these, and finally of the general composition, that a draughtsman like Tintoretto would inevitably feel himself impelled to return again and again to the subject."[8]

Although accepted as an autograph Tintoretto by Mongan and Sachs, this drawing has not received as wide an acceptance as its counterpart in the Fogg collection.[9] The union of knee and thigh in the right leg of Samson is poor and unconvincing, although the Philistine's arm causes a similar disruption in the Bargello bronze.[10] The treatment of musculature in Samson's lower abdomen is weak and the transition of the sartorius muscle in the left leg across the iliac crest is especially mechanical and incorrect.

1. Virch, 1956, pp. 111-116.
2. Rossi, 1975, figs. 23-35.
3. Tolnay, 1945, III, 186, figs. 277-278.
4. Rossi, 1975, figs. 27-28. Study of Michelangelo's *Samson and the Philistines*, Cambridge, Massachusetts, Fogg Art Museum, no. 185, recto, verso.
5. Rossi, 1975, figs. 27, 28.
6. Alberti, 1956, pp. 94-95; Armenini, 1977, p. 128.
7. Rossi, 1975, figs. 30-31, 34, 35. All are studies of Michelangelo's *Samson and the Philistines*, Berlin, Staatliche Museum, no. 5228, recto, verso; Rotterdam, Museo Boymans-van Beuningen, no. I 224; Oxford, Christ Church, no. 0360.
8. Dussler, 1927, p. 32.
9. Mongan and Sachs, 1940, I, no. 186; Rossi, 1975, figs. 27, 28.
10. Tolnay, 1945, III, fig. 278.

Copy after Jacopo Robusti, called Tintoretto

107 *Israelites Gathering Manna*

Pen and brown and red ink, brown and red wash, blue chalk, heightened with white, on tan paper, 316 × 441 mm., after 1594. Notations: lower right, in pencil, *J RO(?)*; recto of mount, in pencil, *Tintoretto*; verso of mount, in pencil, *From the Robert Low Coll. P.D.C. 1910 TR/66/1.*

The Cleveland Museum of Art, Dudley P. Allen Fund, 29.534.

Provenance: Robert Low (Lugt 2222). *Exhibited:* Cleveland, 1956, no. 72 (as Italian, Venetian School, 16th century).

Tintoretto painted *The Israelites Gathering Manna* (Fig. 107a) in the presbytery of San Giorgio Maggiore, Venice, to the left of the main altar, opposite his *Last Supper*.[1] Dating from 1592–1594, these are two of three works for the Venetian church and the last paintings of his life. *The Israelites Gathering Manna* is almost entirely autograph.[2] The miraculous appearance of food for the wandering tribes of Jews is recounted in Exodus 16:14-35 and makes a fit companion piece to the establishment of the Eucharist in the *Last Supper*.

The drawing is a sketchier treatment of the scene than the original painting. The copyist retains Tintoretto's stark contrast of light and dark but changes the direction of the light source from Moses at the right to the front, aligning it with the spectator. He imitates the colorful effect of the painting by using red ink and wash, blue chalk, and white highlights.

The copyist has not been identified although Michelangelo Muraro suggested Antonio Vasilacchi, called Aliense (1556–1629).[3] Aliense was an assistant of Veronese before joining the studio of Tintoretto. He remained an avid follower of Tintoretto into the seventeenth century. Several of his drawings are characterized by a looseness in figural definition in a manner close to that in the present drawing. In other respects, however, it must be admitted that Aliense's style diverges from that in this copy.

1. Bernari and de Vecchi, 1970, no. 292A, pl. lvii.
2. Newton, 1952, p. 204.
3. Curator's file, The Cleveland Museum of Art.

Tiziano Vecellio, called Titian

ca. 1490–1576

Titian was barely ten years old when he entered the studio of Gentile Bellini. He later worked in the studio of the more modern Giovanni Bellini. Lodovico Dolce reported Titian assisting Giorgione on a fresco project for the German merchants' guild in Venice in 1508.[1] His first large-scale commission was the *Assumption of the Virgin* of 1516–1518 (Frari, Venice) which firmly established his reputation as a major master. This painting was preceded by *Sacred and Profane Love* in the Villa Borghese and followed by three exuberant canvases of Venus and Bacchus for Alfonso d'Este, Duke of Ferrara. Throughout Titian's career, religious subjects alternated with mythological paintings.

From 1519 to 1526 Titian devoted his time to a monumental altarpiece of the Madonna sixteen feet in height which commemorated the Turkish defeat of 1502 by Jacopo Pesaro, commander of the Papal galleys. In the 1530s Titian painted the ceremonial *Presentation of the Virgin* for the Scuola della Carità and the boldly engaging *Venus of Urbino* (Uffizi, Florence) for Guidobaldo della Rovere, both of which demonstrate his versatility and inventiveness. By 1542 and the three scenes for the ceiling of Santo Spirito, Isola, Titian shed the reserve of his previous style for an art of twisting figures, dramatic contrasts, and charged emotions.

Gradually Titian's brushwork became freer; forms were more broadly handled, lost substance, and dissolved in color. Titian's *Pietà* of 1576 (Accademia, Venice), intended for his own tomb, included a self-portrait as the kneeling St. Jerome. It was finished by Palma il Giovane when Titian succumbed to the plague that raged through Venice that year. In 1533 Titian was made a count. He was twice summoned to Augsburg as court painter, and he was made a Roman citizen.

1. Roskill, 1968, p. 187.

Tiziano Vecellio, called Titian

108 *Trees Near Some Water*

Pen and brown ink, brown wash, black chalk, 243 × 207 mm., ca. 1530.

Alice and John Steiner.

Exhibited: Venice, 1976, no. 36 bis, pl. 36 bis; Cambridge, 1977, no. 31, repr. p. 87.

If not unique among Titian's landscape drawings, this sheet is certainly one of his most outstanding. It is a powerful study, no less monumental for representing only a landscape detail. The drawing is in excellent condition and is visually impressive for its richness of texture and varied contrasts of hollows and volumes.

Julien Stock first connected *Trees Near Some Water* with *A Group of Trees* long recognized as a work of Titian.[1] Since the

Steiner sheet comprises a less particularized representation of foliage than *A Group of Trees*, it would be later in the master's career. Indeed the handling of foliage is closer to the woodcut *Stigmatization of St. Francis*, ca. 1530.[2] The glitter of light reflected from the leaves is a quality the sheet has in common with another landscape drawing which was used for the background of a woodcut of ca. 1525–1530, *St. Jerome in the Wilderness*.[3]

1. Venice, 1976, p. 90; Cambridge, 1977, p. 88; *A Group of Trees*, pen and brown ink on brownish paper, 217 × 319 mm., New York, Metropolitan Museum of Art, no. 08.227.38; New York, 1965, I, no. 58, pl. 58.
2. Cambridge, 1977, p. 88; *The Stigmatization of St. Francis*, woodcut, 293 × 433 mm.; Passavant, 1860-64, VI, 235, no. 59; Washington, 1976, no. 23, repr. p. 151.
3. Cambridge, 1977, p. 88; *St. Jerome in the Wilderness*, woodcut, 390 × 532 mm.; Passavant, 1860-64, VI, 235, no. 58; Washington, 1976, no. 22, repr. p. 147; *Wooded Hill with Houses in the Background*, pen and faded brown ink, 248 × 267 mm., Edinburgh, National Gallery of Scotland, no. RSA 20; Venice, 1976, no. 37, pl. 37.

Paolo Caliari, called Veronese

1528–1588

Veronese received his artistic training in his native Verona, then moved to Venice at mid-century, where he encountered the mature styles of Titian and Tintoretto. In 1553 Veronese received his first official commission for ceiling paintings in the Palazzo Ducale. The powerful, clearly illuminated, foreshortened forms are exemplary of Venetian ceiling decoration. The solidity of the figures and illusionism of the scenes reveal the influence of Roman art. In 1560 Veronese visited Rome and the next year began fresco decorations for Palladio's Villa Barbaro in Maser. Its classical architecture provided suitable frames for the artist's allegories. His naturalism was the closest approach in sixteenth-century Venice to a return to the journalism of Carpaccio, but with a patrician class consciousness. This is especially evident in *Marriage at Cana* (1562) for the refectory of San Giorgio Maggiore. Veronese used the architectural background to stabilize and order the large composition (over thirty-feet wide) which is filled with a multiplicity of figures. In 1573 Veronese was called before the Inquisition to comment on the improprieties of his *Last Supper*. He satisfied the tribunal by adding a few figures and changing the title to the *Feast in the House of Levi* (Accademia, Venice).

Veronese's commissions through the 1580s were essentially the products of the family workshop as he delegated greater responsibility to his sons, Gabriele and Carletto, and his brother, Benedetto. After his death the studio members worked together as a team, identifying their productions with the signature, "Haeredes Pauli."

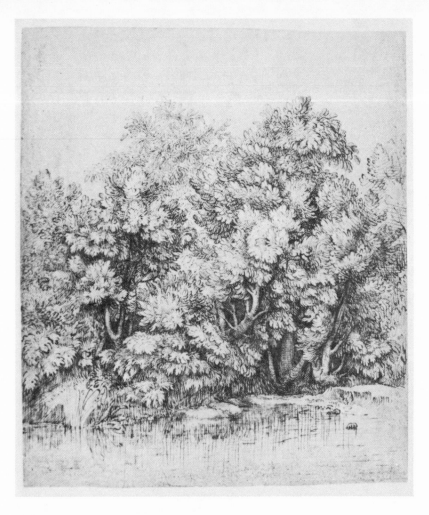

108

109

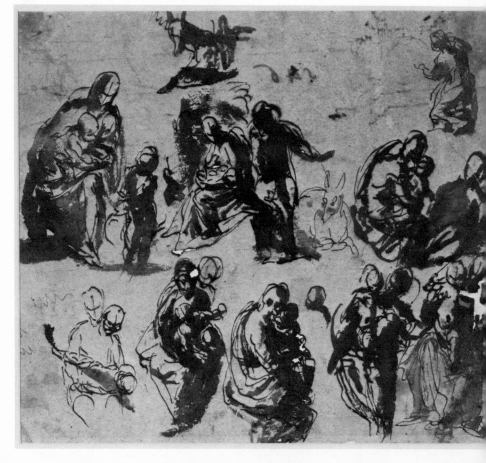

134

Paolo Caliari, called Veronese

109 *Various Sketches of the Madonna and Child*

Pen and brown ink, brown wash on blue paper, 205 × 234 mm., 1565-1570. Notation: on verso, in pen and ink, *246*. Several holes within drawing where ink has reacted with paper, creases.

The Cleveland Museum of Art, Gift of Robert Hays Gries, 39.670.

Provenance: Dr. Daniel Huebsch, Cleveland; Robert Hays Gries, Cleveland. *Exhibited:* Birmingham, 1972, p. 7, repr. p. 44. *Published:* Scholz, 1967, p. 295 n. 34 (as Carlo Saraceni); Rosand, 1971, pp. 204, 206-209, fig. 3; Shapley, 1966-73, III, 44 (as attributed to Paolo Veronese); Pignatti, 1976, I, under A5, repr. II, fig. 722; Armenini, 1977, fig. 17.

This sheet was apparently drawn quickly and at one time as indicated by the scribbling at the lower left to initiate the flow of ink in a fresh pen, the mule scratched out at the top, and the cross in some faces — a shorthand device defining the intersection of eyes and nose. Heads are described as simple ovals; quick, repetitive lines suggest drapery; and the double heads test varying attitudes. It would seem that Veronese had no specific work in mind as the subjects include the Virgin and Child alone as well as with St. John the Baptist and the Holy Family resting on the flight into Egypt. Veronese uses washes to provide tonal contrast and plasticity. The lighting is consistent throughout the page which adds visual strength and formal unity to the otherwise independent groupings.

The sheet seems to have been intended as a type of pattern book offering ideas for future compositions for the studio or for prospective patrons.[1] It was apparently used as a reference and guide by several members of the family workshop since groupings similar to ones here appear in their work.[2] Richard Cocke observed that it is often the case that a single Veronese sheet can be related to more than one painting.[3]

The central sketch of the Rest on the Flight into Egypt is the basic idea for a chiaroscuro design in the British Museum and for two paintings — one in the High Museum of Art, Atlanta, attributed to Veronese's studio and the other in the National Gallery of Canada, Ottawa, given to Veronese himself.[4] A copy of the Madonna and Child from this composition was exhibited at Arnold Seligmann, New York, in 1936.[5] A variant of the Virgin nursing the Child, but with Joseph now seated at her left, appears in a painting in the John and Mable Ringling Museum of Art, Sarasota.[6] A drawing by Benedetto, after this canvas, was discovered by Cocke.[7] The grouping left of center of the Madonna and Child and St. John evolved into a larger, more finished drawing attributed to Benedetto (with a copy of it in Turin), whereas a chiaroscuro drawing in the Fogg Art Museum (Fig. 109a) was based upon the Holy Family arrangement right of center in the Cleveland sketch.[8]

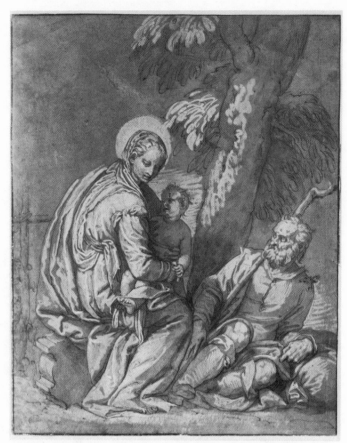

Fig. 109a. *The Rest on the Flight to Egypt*, pen and brown ink, black chalk, heightened with white, 248 × 198 mm. Veronese. Fogg Art Museum, Harvard University, Bequest of Meta and Paul J. Sachs.

Although a much debated drawing, first J. Q. van Regteren Altena, then David Rosand and Hugh Macandrew agreed on Veronese.[9] Dating the sheet is complicated by the relatively fixed character of Veronese's draftsmanship throughout his career, the Venetian tendency to institutionalize style, and the repeated reliance upon sketchbooks in the family workshop.[10] Veronese was the one major Venetian master to favor pen. His early style is characterized by pen and ink hatching, the use of washes coming later until finally line became subordinate to wash. On the basis of style Rosand has suggested a date of 1580 for the Cleveland drawing noting similarities with *St. Herculanius and an Angel*, a preparatory study for an altarpiece for which Veronese received a commission in 1583.[11] As a single composition exclusively in wash, the *St. Herculanius and an Angel* differs in basic ways. Indeed the painting of the same subject was attributed to Carletto Caliari.[12]

Other factors lend credence to dating the sheet 1565-1570. A drawing for the *Martyrdom of St. George* of 1566 for San Giorgio Maggiore in Verona contains the same pen and wash technique, clustered figural groupings, and stylized figurations found in *Various Sketches of the Madonna and Child* as does a sheet associated with frescoes in the Palazzo Trevisan from before 1568.[13] Inasmuch as Vasari described these paintings in the second edition of *Lives of the Artists* (1568), the sketches could be as early as 1557.[14] *Rest on the Flight to Egypt* in the National Gallery of Canada has been dated probably 1560-1570, the painting in Sarasota is from ca. 1571, while a correspondence exists between the kneeling figure in the upper right corner, and the figure of St. Catherine in *The Madonna and Child with SS. Elizabeth, John, and Catherine* of 1565-1570.[15]

I am indebted to Jane Boruff for research assistance with this drawing.

1. Rosand, 1971, p. 206.
2. Perhaps *246* on the verso of the drawing, like inscriptions on other Veronese drawings, is evidence of the workshop organization; Rosand, 1971, p. 208.
3. Cocke, 1973, pp. 141-143.
4. Rosand, 1971, pp. 204-206; all are *The Rest on the Flight into Egypt*, pen and brown ink, wash, black chalk, heightened with white on gray prepared paper, 316 × 237 mm., London, British Museum, no. 1854-6-28-4, Tietze and Tietze-Conrat, 1944, no. 2090; Studio of Paolo Veronese, 1270 × 959 mm., Atlanta, High Museum of Art, no. 58.34, Shapley, 1966-73, III, 43-44, fig. 78; 1651 × 2642 mm., Ottawa, National Gallery of Canada, no. 4268, Hubbard, 1957, I, 44, repr.
5. *Madonna and Child*, present location unknown, Frankfurter, 1936, p. 5, repr. p. 4.

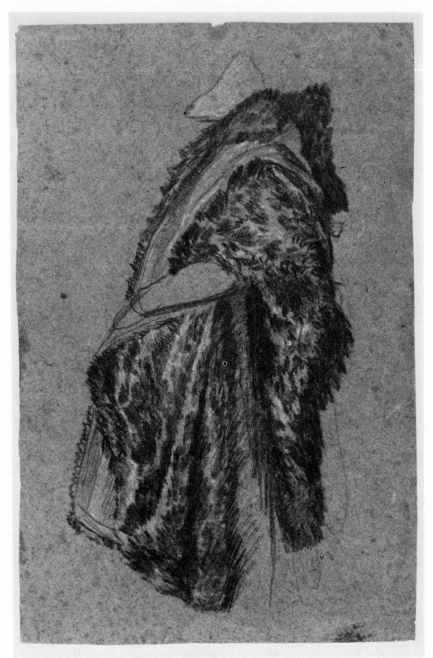

110

Attributed to Paolo Caliari, called Veronese

110 *Study of a Fur Cape*

Black and white chalk on blue paper, 322 × 212 mm., ca. 1550.

The Janos Scholz Collection, The Pierpont Morgan Library, New York, 1976.36.

Provenance: Unidentified Italian collector, eighteenth century; Argosy Bookstore, New York, 1941; Janos Scholz (Lugt 2933b). *Exhibited:* Hamburg, 1963, no. 171, fig. 77; New York, 1971, no. 94, repr. p. 23; Norton, 1971; Washington, 1973, no. 107, repr. p. 132; Montgomery, 1976, no. 27. *Published:* Scholz, 1976, no. 63, pl. 63.

The visual as well as the tactile effects of surfaces appealed to Veronese, and although he favored saturated colors primarily for purposes of optical sensation, his use of them with uniform lighting lent texture to surfaces. *Study of a Fur Cape* is consistent with Veronese's preference for opulent subjects, although it has not been associated with a similar garment in a painting. Since it is not typical of Veronese's drawings to stress contrasts and busyness of surface, Terisio Pignatti felt this sheet was an early work by the artist.[1] As an example of his interest in rich surfaces, it should be compared with his studies of armor in Berlin.[2] In the absence of concrete evidence, the association of this drawing with Veronese, although reasonable, must remain speculative.

1. Washington, 1973, no. 107.
2. *Study for Armor*, brush and wash, white highlights, on paper prepared with a gray ground, 381 × 253 mm., Berlin, Kupferstichkabinett, Staatliche Museen, no. 5120; Hadeln, 1926, no. 55, repr.

6. *The Rest on the Flight into Egypt*, 2343 × 1606 mm., Sarasota, John and Mable Ringling Museum of Art, no. SN82, Tomory, 1976, no. 124, pl. 124.
7. Benedetto Caliari, *The Rest on the Flight into Egypt*, pen and brown ink, brown wash, Rotterdam, Museum Boymans-van Beuningen, no.I.408; Cocke, 1973, p. 145, pl. 13.
8. Rosand, 1971, p. 204; Benedetto Caliari, *Madonna and Child with St. John the Baptist*, pen and brown ink, black chalk, heightened with white, on gray-green prepared paper, 220 × 169 mm., Berlin, Kupferstichkabinett, Staatliche Museen, no. 1549; Tietze and Tietze-Conrat, 1944, no. 2192; copy of Paolo Veronese, *Madonna and Child with St. John the Baptist*, pen and ink, heightened with white, on blue paper, 211 × 149 mm., Turin, Biblioteca Reale, no. 16091; Bertini, 1958, no. 434; (the insipid expressions of the figures and the pedestrian quality of the line suggests that the chiaroscuro drawing in the Fogg may be by Benedetto).
9. Numerous scholars suggested a variety of attributions including Palma il Giovane, Francesco Maffei, Marcantonio Bassetti, Giovanni Baglione, and Carlo Saraceni. Curator's file, The Cleveland Museum of Art; Rosand, 1971, p. 204.
10. Tietze and Tietze-Conrat, 1944, p. 338; Vertova, 1960, p. 68; Cocke, 1973, p. 139.
11. Rosand, 1971, p. 204; *St. Herculanius Visited by an Angel*, brush and iron gall ink on blue paper, 290 × 128 mm., The Art Museum, Princeton University, no. 44-6; Gibbons, 1977, I, no. 73; II, pl. 73.
12. Crosato-Larcher, 1967, p. 115.
13. *Study for the Martyrdom of St. George*, pen and ink, wash, Paris, collection Mr. Emile Wauters; Hadeln, 1926, pl. 24; *Various Studies*, pen and ink, wash, 120 × 110 mm., London, Collection Mr. P. M. Turner; Borenius, 1921, p. 59, no. 6, pl. IIc.
14. Borenius, 1921, p. 59, no. 6, pl. e; Vasari-Milanesi, VI, 372.
15. Hubbard, 1957, p. 44; Cocke, 1973, p. 145; *The Madonna and Child with Saints Elizabeth, John and Catherine*, 1029 × 1568 mm., San Diego, Putnam Foundation, Timken Art Gallery; Pignatti, 1976, I, no. 129, II, pl. 373.

Lombardy

Cinquecento Lombardy, with its important center at Milan, also encompassed Brescia and Cremona. The art of the region combined the descriptive naturalism of northern Europe with stylistic characteristics of its major master Leonardo da Vinci.

Giovanni da Lodi, Giampietrino, and Bernardino Luini, among others, adopted aspects of Leonardo's taste and style—such as his soft light, his figure types, and poses—so that pointed chins, downcast eyes, and thin noses became recognizable stereotypes of the master. An interest in highlights tended to dissolve forms and reduce their substance in spite of suggestions of interior modeling. The pair of heads [114] by Giovanni da Lodi, for example, is in the great portrait tradition established by Leonardo and exemplified by his *Mona Lisa*. They are drawn in the red chalk Leonardo is credited with introducing to Italy, have the softness of his work, and although portrait likenesses, have a similar morphology. Other formal qualities of the master can be observed in Bernardino Lanino's *Adoration of the Magi* [113] where several figures have the coiling movements observed in the master's *Adoration* of the early 1480s. Lanino's Christ Child is reminiscent of Leonardo's infant in the *Benois Madonna* in terms of its full, rounded form and animation.

The ghostly forms of Giovanni Pedrini's *The Virgin and Child* [118] are directly related to many compositions painted by members of Leonardo's school. Pedrini's figures are voluminous but lack substance because forms become murky as extremities and contours dissolve. Highlights obscure surface articulation and one gray area melds with another.

Also grouped with the Lombard school are the native Brescians, Girolamo Savoldo and Girolamo Romanino. While Brescia was under the political influence of Lombardy in the sixteenth century, its artists were more attracted to developments in Venice, although elements of both regions can be found in Brescian art. Savoldo was in Venice by 1520 and attracted to the art of Titian, but the strong *sfumato* and chiaroscuro of *Man's Head and Hand* [122] are clearly in the Lombard tradition. This drawing reveals an interest in descriptive naturalism, light effects, and the Venetian concern for texture but rendered here in a generalized fashion. Romanino also borrowed ideas from Titian, but he adopted the painterly approach of the Venetians only in his late years. *Back View of a Soldier* [119] of the 1520s is as typically Lombard as Brescian.

The later *Romulus and Remus* [121] with its interest in landscape and the related *Nude Male Figure* [120], so painterly in figural handling, reveal the increasing importance of Venetian art for Romanino.

Important artistic contributions were made in Lombardy in the second half of the century by members of the Campi family from Cremona in the southeast. Giulio, Antonio, and Bernardino Campi all worked in Milan for a period. Giulio's drawing of *Susanna and the Elders* [111] is a finished composition used by Antonio for a commission in Brescia. Bernardino's *Holy Family with St. Lucy* [112] is also a completed study in which the impasto highlights represent a hardening of Leonardo's chiaroscuro.

Leonardo's influence in Lombardy was preserved through the portraits and madonnas of such followers as Giampietrino and Giovanni da Lodi. His notebooks were also a reference source for artists, like Giorgio Vasari, who examined them during a visit to Milan in 1564. Leonardo's notebooks were preserved by his pupil, Francesco Melzi, who inherited them and made them available to interested artists. They were, therefore, copied extensively, and following generations of painters—from the immediate pupils of Leonardo like Bernardino Luini to G. P. Lomazzo and Simone Peterzano—pursued the inventions of Leonardo through the century. Often their use of *sfumato* would be drier and more anemic than the master's and their treatment of light and dark contrasts less subtle, but ultimately they preserved a tradition that resulted in the daring tenebrism of the native Lombard, Caravaggio, which had such dramatic impact on Roman baroque painting after that artist's arrival in the Holy City in the 1590s.

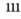

Antonio Campi 1520/5–1587
Bernardino Campi 1522–1591
Giulio Campi 1502–1572

In the city of Cremona in Lombardy, sixteenth-century painting was dominated by a single family, the Campi, made up of three brothers, Giulio, Antonio, and Vicenzo, and their distant cousin, Bernardino.

Giulio's father was the painter Galeazzo Campi in whose workshop he was trained. Giulio's first works of the 1530s are murky and strongly influenced by Emilian examples. In 1537 he was engaged in the church of St. Agatha, Cremona, depicting scenes from that saint's life. Five years later Giulio's style became slightly more mannered and obviously eclectic as evidenced in the transept frescoes for San Sigismondo. The influences on his art at this time included Pordenone, Parmigianino, Michelangelo, Correggio, and Giulio Romano. Through the 1560s Giulio did numerous altar panels for the cathedral in Cremona.

Bernardino studied with Giulio and then in Mantua, returning to Cremona in 1541. He was in Milan from 1550 to 1556. Influences from the art of Mantua, Parma, and Ferrara are evident in Bernardino's painting, especially that of Parmigianino whose distended figures he adopted. Bernardino painted *Glory of Saints* for the

dome of San Sigismondo, Cremona (1570), and also worked in Mantua, Parma, and Reggio where he died in the last decade of the century.

Antonio also studied with Giulio. His first major commission was in 1564 for the church of San Paulo, Milan. These frescoes were in the contemporary *maniera* idiom, but only two years later, his *Pietà with Saints* for the cathedral in Cremona was in a clear, direct style. He used broad, light areas in heavy impasto to create a dramatic nocturne. By the 1580s Antonio's paintings contained large figures, now more naturalistic but in posturing attitudes.

Antonio Campi

111 *Susanna and the Elders*

Pen and brown ink, on tan paper, 261 × 415 mm., ca. 1570. Notations: lower left in pen and brown ink, *Titiano;* verso, various inscriptions.
Worcester Art Museum, 1956.32.

Provenance: Karl Eduard von Liphart (Lugt 1687); private collection, Paris. *Exhibited:* Providence, 1968, no. VI,1, pl. VI,1 (as Giulio Campi); Storrs, 1967; Detroit, 1960, no. 41, repr. 37; Worcester, 1958; Amherst, 1956. *Published:* Tietze-Conrat, 1939, pp. 160-163, repr. p. 161; Vey, 1958a, no. 87; Vey, 1958b, p. 18, fig. 7; Bailey, 1977, pp. 116, 117, fig. 15.

Susanna and the Elders was a significant subject for the Counter-Reformation church. The event was rejected as apocryphal by Protestants.[1] Since the story involves the triumph of virtue over lust and deceit, for Catholics it symbolized the falsehood of the Reformation churches. Two elders entered Susanna's garden to seduce her. When she refused their advances, they accused her of adultery. Susanna was tried and sentenced to death. The young Daniel cross-examined the men separately, causing them to contradict each other, thereby exposing their true motives. Susanna was exonerated, and the elders sentenced to her fate. The subject proved especially popular among the Venetians and appeared in many paintings by Veronese and Tintoretto.

This drawing was a study for one of eight *Scenes of Justice* for the Sala dei Dottori in the judicial college of the Municipal Palace, Brescia.[2] These date from ca. 1570 and were given by tradition to Antonio Campi. Erica Tietze-Conrat and Horst Vey, therefore, assigned this study to Antonio, but Pouncey suggested Antonio's father Giulio as draftsman.[3] Stephen Ostrow agreed, noting that the sheet matched Giulio's drawing style of the 1540s and that

112

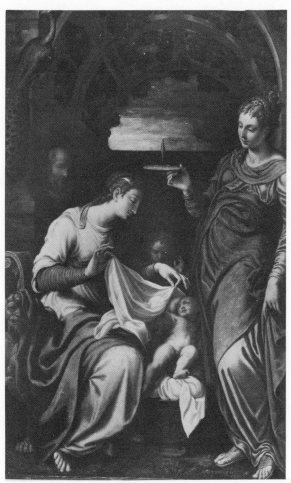

Fig. 112a. *Holy Family with St. Lucy*, oil on canvas, 1977 × 1254 mm. Bernardino Campi. John and Mable Ringling Museum of Art, Sarasota, Florida.

other drawings in the Uffizi for this series bear inscriptions to Giulio.[4]

Ostrow felt the differences between the drawing and the painting result from the fact that the drawing is from Giulio's hand, while the painting is by Antonio who probably made additional studies before executing the final version.

1. Daniel, 13: 1-64. The story was excised from the beginning of the Book of Daniel in the Greek and Latin bibles by St. Jerome because he did not find it in the Hebrew.
2. *Susanna and the Elders*, tempera on canvas, 2040 × 2950 mm., Brescia, Pinacoteca Tosio-Martinengo, no. 14; Ostrow, 1968, no. VI, 2, pl. VI, 2.
3. Tietze-Conrat, 1939, p. 160; Vey, 1958b, p. 18.
4. Ostrow, 1968, no. VI.

Bernardino Campi

112 *Holy Family with St. Lucy*

Pen and brown ink, brown wash, heightened with white on tan paper, 373 × 249 mm., 1555–1560. Notation: lower left, in pen and brown ink, illegible inscription. Horizontal tear across center, tears and patched holes.

John and Mable Ringling Museum of Art, Sarasota, Florida, SN. 720.

Provenance: Lucien Goldschmidt, New York.
Exhibited: Sarasota, 1978, no. 46, repr. p. 13.
Published: Tomory, 1976, no. 41.

This drawing is the final study for a painting also in the Ringling Museum collection which differs from it only slightly (Fig. 112a).[1] In the painting a plate held by St. Lucy has eyes and a needle on it but the lamb has been deleted, and St. Joseph, who gazes toward the Virgin in the drawing, now looks out toward the spectator.

Ferdinando Bologna had attributed the painting to Antonio Campi.[2] The association with Antonio is understandable in com-

paring it with the *Visitation* in Cremona (1567).[3] The face peering at the viewer from the background of Antonio's painting is like that of St. Joseph in *The Holy Family with St. Lucy*. The facial features of the Virgin and the pronounced drapery folds are also the same in both. It seems, however, that Antonio was influenced by Bernardino after the latter's return from Milan in 1556. Indeed, Federico Zeri gave the drawing to Bernardino and Tomory assigned the painting to him as well.[4]

Typically Lombard are the white impasto highlights used for the draperies which have been softened and made less calligraphic in the painting. The trellis setting is in the Emilian tradition, while the elongated proportions are derived from Parmigianino. The mechanical gestures of the drawn figures combined with the refinement and decorative polish of those in the painting would argue for a date early in Bernardino's career, perhaps at the end of his stay

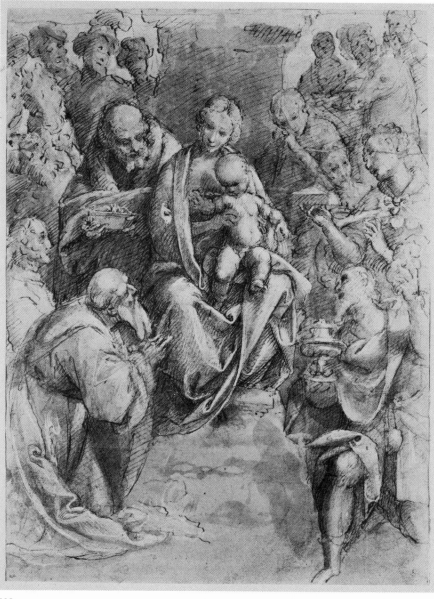

113

in Milan in 1556, a period still characterized by the exaggerated proportions and dessicated spirit of a decorative idiom.

1. Tomory, 1976, no. 41.
2. Bologna, 1953, p. 49.
3. Antonio Campi, *Visitation*, Cremona, Museo Civico; Perotti, n.d., fig. 27.
4. Tomory, 1976, no. 41.

Bernardino Lanino

1510/15–ca. 1583

Bernardino Lanino was in the workshop of Gaudenzio Ferrari from 1530 to 1534, leaving to take a commission for an altarpiece in Ternengo. His work through the 1540s was in the style of his former master, Ferrari, in terms of composition, figure handling, color, and tonality. This changed in 1546 when he executed a fresco, *Martyrdom of St. Catherine*, in S. Nazzaro, Milan. After that his paintings began to take on characteristics of Leonardo's style. In 1547 he completed *Pietà* for San Giuliano in Milan and in 1550 *Adoration of the Magi* for Santa Croce in Mortara. He worked as a heraldic painter in the service of the Dukes of Savoy in 1559. Through the 1560s Lanino painted numerous frescoes and altar paintings for provincial churches. Man-

nerist and protobaroque elements became evident in his works after 1570 when his handling of figures and color schemes became more arbitrary.

Bernardino Lanino

113 *Adoration of the Magi*

Pen and brown ink, brown wash, over black chalk, heightened with white (accidental touches of pink), 274 × 205 mm., after 1550.

Janos Scholz, New York.

Provenance: Savoia-Aosta (under Lugt 47a). *Exhibited:* Vercelli, 1956, pp. 76-77; Oakland, 1956, no. 28; Hagerstown, 1960, no. 24; New York, 1961, no. 24; Notre Dame, 1964, no. 23; Notre Dame, 1967, no. 16; Norton, 1971; Washington, 1973, no. 71, repr. p. 87. *Published:* Rodolfo, 1927, pl. vii.

This sheet was long attributed to Gaudenzio Ferrari until Oberhuber and Walker discovered it to be a preparatory drawing for Lanino's fresco in the cathedral in Novara.[1] Originally in the chapel of St. Joseph, the fresco is now in the lower sacristy. The subject is important not merely as a narrative from the New Testament, but theologically the *Adoration of the Magi* represents Christ's first contact with the gentiles. Included in this religious grouping is a profile portrait of the patron at the left border.

In its central placement of the Madonna and Child, the composition departs from the conventional asymmetrical arrangement of Magi and Holy Family. This departure from tradition can be traced back to Botticelli in the late Quattrocento, but more immediately to Leonardo, who was with Botticelli in Verrocchio's studio. The pose of Lanino's Madonna and Child, their central position with an open space in front of them, and the circular pattern of the Magi leaning inward are all found in Leonardo's *Adoration of the Magi* in the Uffizi, left unfinished in Florence when he departed for Milan after 1480.[2] The long nose and pointed chin of the Virgin and the large head of the Christ Child are also typical of Leonardo. Lanino relies upon the contrast of white highlights and pen and ink crosshatching to project volumes into relief. Shadows and cavities serve as his graphic counterpart to Leonardo's chiaroscuro. The arclike folds of drapery develop curved rhythms which tighten the composition.

1. Washington, 1973, no. 71.
2. Leonardo da Vinci, *Adoration of the Magi*, Florence, Uffizi; Ottino della Chiesa, 1967, pl. xix.

114

Giovanni Agostino da Lodi

active 1490–1510

114 Head of a Bearded Old Man; Head of a Young Man

Red chalk, 58 × 74 mm., 54 × 59 mm., ca. 1500. Hole lower left corner (Head of a Bearded Old Man).

The Janos Scholz Collection, The Pierpont Morgan Library, New York, 1973.35:1-2.

Provenance: Maurice Marignane (Lugt 1872); Hubert Marignane (Lugt 1343a); Janos Scholz (Lugt 2933b). *Exhibited:* Oakland, 1956, nos. 6, 7; Bloomington, 1958, nos. 22, 23, figs. 22, 23; New York, 1960; Detroit, 1960, no. 28 (*Head of a Young Man*), fig. 28; New York, 1961, no. 5 (*Head of a Young Man*); Hamburg, 1963, nos. 86, 87, figs. 17, 18; New Haven, 1964, nos. 5, 6; New York, Scholz collection, 1965; Los Angeles, 1967, nos. 25, 26; New York, 1971, no. 50 (*Head of a Bearded Old Man*); Washington, 1973, no. 65, repr. 79. *Published:* Scholz, 1976, nos. 19A, 19B, pls. 19A, 19B.

These portraits bear the influence of Leonardo not only in terms of facial types and techniques, but they also exemplify the master's comments on softness in portraiture: "Shadows must be softly graduated to give grace to a face."[1] Red chalk is ideal for

developing Leonardo's invention of *sfumato* or blurring of edges.[2] The delicate texture of the chalk, simultaneously smooth and grainy, allowed soft effects by rubbing the drawing with the finger tip or a piece of cotton, a popular technique in the Renaissance studio.[3] Tonal gradations of wide range and delicacy allow the artist to depict the reflective surface of skin against bone in the forehead of the young man, the softer features of flesh in the old man's face, as well as velvet springiness in the hair.[4] Oberhuber and Walker noted the pefection of the miniaturist in the treatment of these portraits, especially "in the tight, round, plastic volumes."[5]

The attribution of these sheets to Agostino da Lodi was made by Pouncey and supported by the observation of Oberhuber and Walker of similarities with heads of apostles in Agostino's painting in the Accademia in Venice, *Christ Washing the Feet of the Apostles*, dated 1500.[6] The faces of a youth and old man are paired in Lodi's portraitlike *St. Augustine and St. John*.[7] Little is known of the career of Agostino da Lodi. He receives no mention in Vasari's *Lives of the Artists*, nor in the later supplementary biographies of Raffaelo Borghini, the Lombard treatise of Lomazzo, nor in Giulio Mancini's supplement to Vasari.[8]

1. Cited in Alazard, 1968, p. 64.
2. Dolce had noted in 1557 that "nothing offends the gaze such as contour lines, which should be avoided (since nature does not produce them). . . ." Translation from Roskill, 1968, pp. 154-155; Barocchi, 1960, I, 184.
3. Armenini, 1977, p. 127.
4. Variations in the quality of light upon surfaces as dependent upon the nature of the object receiving the light is noted by Lomazzo, 1584, p. 227, and Lomazzo, 1590, pp. 75-76, ch. 22.
5. Washington, 1973, no. 65.
6. Ibid.; *Christ Washing the Feet of the Apostles*, Accademia, Venice; Venturi, 1901-40, VII, 4, fig. 667.
7. Venturi, 1901-40, VII, 4; 985, fig. 666; *SS. Augustine and John*, Milan, Brera.
8. Borghini, 1584; Lomazzo, 1584; Mancini, 1956, I, 164-235.

Lorenzo Lotto

ca. 1480–ca. 1556

Lorenzo Lotto first worked in Treviso and reflected elements of the Bellini workshop. His natural predilection for detail was reinforced by the prints of Albrecht Dürer and Jacopo de' Barbari. In 1509 he journeyed to Rome where he participated in the Vatican Stanze projects as a member of the Raphael workshop. He was back in the northern provinces by 1512, after a brief visit to Florence during the height of Fra Bartolommeo's activity. Lotto settled for a time in Bergamo. His large paintings of the early 1520s are busy with figures, clouds, breaking folds of drapery, and highly keyed color — all constrained within an ordered matrix in the high Renaissance mode. Expression and narrative became more provincial as he approached the rusticity of Pordenone.

Lotto returned to Venice in 1526. Although he remained there until 1549, he seemed unable to compete with the urban sophistication of Titian, and most of his commissions were outside the city. While borrowing on occasion from Titian throughout his career, Lotto was also a significant innovator, often introducing ideas whose full potential were realized in Titian's art. His greatest success was in the art of portraiture. Although uneven in this genre, he was often sensitive and innovative. Lotto retired to the Santa Casa in Loreto in 1552 where he became an oblate two years before his death.

Lorenzo Lotto

115 Head of a Bearded Man with Eyes Closed

Black chalk, heightened with white, on blue paper, 185 × 128 mm., ca. 1550. Notation: at lower left, in pen and brown ink, *Tiziano*. Right edge and upper left corner added, small patch upper left, tears, soiled.

Janos Scholz, New York.

Exhibited: Oakland, 1959, no. 30, fig. 30; New York, 1960; Hagerstown, 1960, no. 10; New York, 1961, no. 10; Hamburg, 1963, no. 88; New Haven, 1964, no. 38; New York, Scholz collection, 1965; London, 1968, no. 55; New York, 1971, no. 51; Washington, 1973, no. 96, repr. p. 118. *Published:* Scholz, 1976, no. 30, pl. 30.

In a fashion characteristic of Venetian drawings, rubbed chalk fuses the contours of the image with the paper, while the white highlights project it from the page. The impressionistic rendering of light and volume is typical of Lorenzo Lotto's drawing style. Notations on the mount by both Popham and Pouncey attributed *Head of a Bearded Man with Eyes Closed* to Lotto. Scholz agreed, assigning it to late in the artist's career.[1] Muraro's opinion — also written on the mount — that Paris Bordone was the author of the sheet, led to some equivocation by Oberhuber and Walker, who were uncertain of Lotto and more sympathetic to the Bordone association.[2]

1. Scholz, 1976, no. 30.
2. Washington, 1973, no. 96.

Bernardo Parentino

ca. 1437–1531

Few details survive concerning the life of Bernardo Parentino. He is identified with Bernardo da Parenzo, a native of Istria who was active in Padua.[1] He appears to have been influenced by the art of Andrea Mantegna and Cosimo Tura. Parentino's paintings are in collections in Modena, Milan, Verona, and Venice.

1. Thieme-Becker, 1932, XXVI, 231-232; Crowe and Cavalcaselle, 1912, II, 61, n. 1.

115

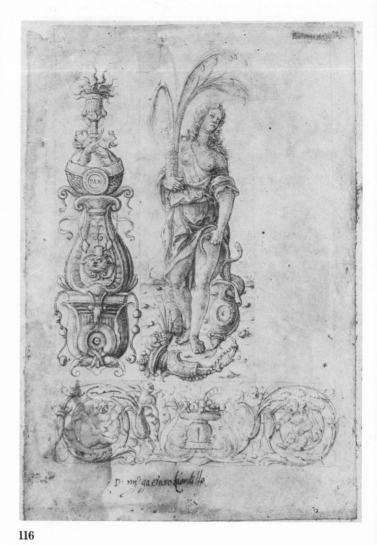

116

Bernardo Parentino

116 *Three Allegorical Designs*

Pen and brown ink, 254 × 171 mm. Notation: at bottom, in pen and brown ink, *D. mis gaetano Laordillo*. Large stain lower left, soiled.

The Cleveland Museum of Art, Purchase, John L. Severance Fund, 56.41.

Provenance: Moscardo (Lugt 2990c); Calceolari (under Lugt 2990a). *Exhibited:* Detroit, 1959, no. 6. *Published:* CMA Bulletin, 45 (March 1958), repr. p. 66 (as School of Andrea Mantegna); Francis, 1958, pp. 199-200, repr. p. 194; Wazbinski, 1963, p. 24, fig. 21.

Henry Francis suggested that this sheet of allegorical designs was probably part of a sketchbook.[1] As such it would have provided models for various decorative uses in the studio. Possibly the designs were conceived as ornamental borders for manuscript pages; the rectangular divisions of the sheet (one horizontal and three vertical) would leave adequate space for text if any one decoration were transferred to a page. The designs need not be associated. While the device at the left could easily be adapted for use as a candlestick or crozier, the central figure stands in an embellished setting

which would make it less suitable for a three-dimensional object. The horizontal design at the bottom of the sheet could be used for a carved relief or a manuscript illumination.

The woman in the center may be an allegory of Abundance. The cornucopia, date palm, bare breasts, and serpents symbolize prosperity, fertility, and health. Her thick features, the gritty surface texture, and tactile forms are some of the characteristics of Parentino's style also noticeable in *Roman Triumphal Procession* [117]. Other drawings by Parentino which are alike in style and similarly antiquarian can be found in several collections.[2]

1. Francis, 1958, pp. 199-200.
2. For example: *Allegory of a Roman Triumph*, pen and brown ink, 261 × 205 mm., Oxford, Christ Church, no. 0267; Shaw, 1976, I, no. 696, II, pl. 398; *Venus and Cupid*, pen and ink, London, Victoria and Albert Museum, no. DYCE 149; Wazbinski, 1963, fig. 25.

Bernardo Parentino

117 *Roman Triumphal Procession*

Pen and brown ink, 324 × 416 mm., after 1490. Notation: Lower right corner, in pen and brown ink, *Pietro di St. Sepulcro*. Vertical tear right of center.

Janos Scholz, New York.

Provenance: Earls of Pembroke (Lugt 2636b); Charles Fairfax-Murray (under Lugt 1509); L. D. Cunliffe. *Sale:* London, Colnaghi (Exhibition of Old Master Drawings), 1950, no. 3, pl. ii. *Exhibited:* Venice, 1957, no. 5, pl. 5; Bloomington, 1958, no. 6, fig. 6; Oakland, 1959, no. 48; Detroit, 1960, no. 16, fig. 16; New York, 1960; Hagerstown, 1960, no. 4; New York, 1961, no. 4; Hamburg, 1963, no. 105, pl. 12; Los Angeles, 1967, no. 38; London, 1968, no. 65; Middletown, 1969, no. 61; New York, 1971, no. 61; Montgomery, 1976, no. 6, repr. p. 27. *Published:* Scholz, 1976, no. 17, pl. 17.

Creighton Gilbert observed that this sheet may have been a response to Andrea Mantegna's *Triumphs of Julius Caesar* which were engraved and circulated ca. 1490 and much paraphrased.[1] Decorative in its filling of the surface, the design has a Gothic flavor in its lack of attention to

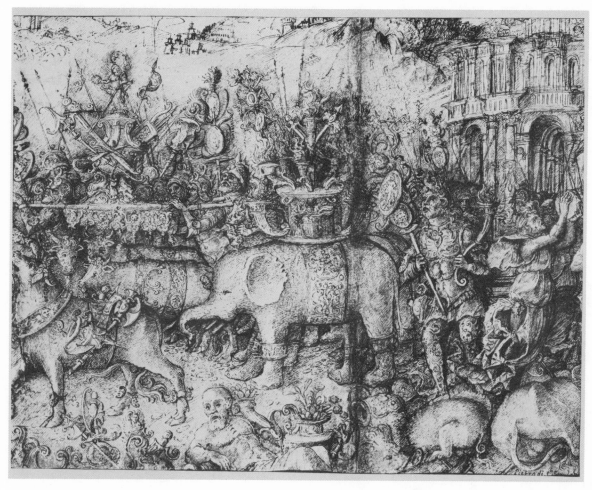

117

scale. In archaeological character and dryness of execution, it can be associated with the antiquarian circle of Mantegna.

Except for Giuseppe Fiocco's suggested attribution of Jacopo Ripanda,[2] there is a concensus of opinion in the literature associating the drawing with Parentino. *Roman Triumphal Procession*, which may have been cropped,[3] has the tight pen technique of Parentino's drawing, *Allegorical Subject*, in the British Museum.[4] Facial features strained to the point of grimace and large heads with deep eyes and wide mouths are also characteristic of his style.

1. Bloomington, 1958, no. 6, Andrea Mantegna, *Triumphs of Julius Caesar*, engraving, Bartsch, 1811, XIII, 234-237, nos. 11-14: l. Venturi, 1931, pp. 204-207.
2. Venice, 1957, no. 5.
3. Ibid.
4. *Allegorical Subject*, pen and ink, 244 × 208 mm., London, British Museum, no. 1919-5-10-1.

Giovanni Pedrini, called Giampetrino

Active 1520–1540

Giampetrino's career is poorly documented, although an altar painting dated 1521 is in the cathedral in Pavia. Giampetrino became popular as a painter of madonnas,

basing many of them on inventions of Leonardo da Vinci, such as the *Madonna Litta* (Hermitage, Leningrad). Many were done for churches in Milan and environs. Other works by Giampetrino include half figures of saints with Leonardesque landscapes and allegorical and mythological paintings.

Giovanni Pedrini, called Giampetrino

118 *The Virgin and Child*

Black chalk, 330 × 234 mm., ca. 1520. Rubbed, soiled.

Janos Scholz, New York.

Exhibited: Oakland, 1956, no. 42; Bloomington, 1958, no. 21, fig. 21; Detroit, 1960, no. 31; Hagerstown, 1960, no. 28; New York, 1961, no. 29; Hamburg, 1963, no. 69; Milwaukee, 1964, no. 19; Notre Dame, 1967, no. 17; New York, 1971, no. 40, repr. p. 24; Washington, 1973, no. 64, repr. p. 78.

David Brown noted the resemblance between Giampetrino's drawing of *The Virgin and Child* and a painting by Francesco Napolitano, another follower of Leonardo (Fig. 118a).[1] The composition was probably based on a sketch by Leonardo, the *Madonna and Child and St. Anne*, in the Louvre.[2] The drawing is also close to

a group of paintings associated with Giampetrino.[3]

The downcast eyes of the Virgin, her high forehead, the complicated pose of the squirming infant, and the blurred drawing technique are all Leonardesque. The treatment of hands in both figures is tentative, however, and Giampetrino's weak handling of chiaroscuro tends to flatten the forms.

1. Brown, 1949, no. 64.
2. Leonardo da Vinci, *Madonna and Child and St. Anne*, Paris, Louvre, no. C.R.F. 460; Heydenreich, 1933, repr. p. 211.
3. Washington, 1973, no. 64; especially, *Virgin and Child*, Milan, Museo Poldi Pezzoli; Suida, 1929, fig. 273.

Girolamo Romani, called Romanino

ca. 1485–1559/61

Romanino's early style remained essentially provincial and conservative even after repeated encounters with the Venetian art of Titian. His series of frescoes, *Passion of Christ*, in the cathedral in Cremona (1519–1520) combines a careful record of sensory data with brilliant effects of color. Through the 1520s, Romanino was alternately influenced by Titian and Pordenone

143

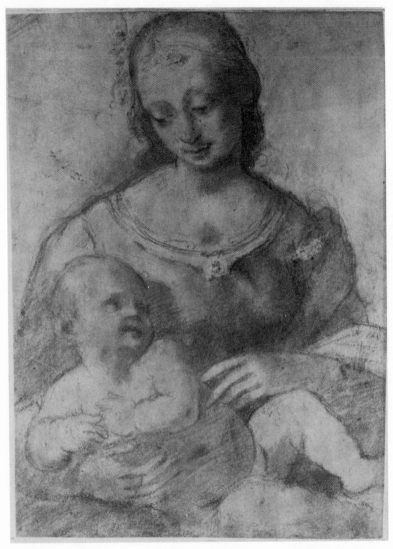

118

Fig. 118a. *Madonna and Child*, oil on panel,
673 × 308 mm., ca. 1500. Francesco Napolitano, Italian.
The Cleveland Museum of Art, Holden Collection.

and by his collaborator, Moretto. He joined
Battista and Dosso Dossi in a project of
secular decorations in Trento (1531–1532).
His late works continued this provincial
journalistic tradition.

Girolamo Romani, called Romanino

119 *Back View of a Soldier
with a Plumed Hat
and Sketch of Another Soldier*

Red chalk, 288 × 201 mm., ca. 1520–1527.
Notation: bottom, in red chalk, *Hieronimo
Romanino da Bressa.* Watermark: High crown.
Stained above soldier's right arm, soiled.

The Janos Scholz Collection, The Pierpont
Morgan Library, New York, New York, 1973.38.
Provenance: Moscardo Collection, Verona; Janos
Scholz (Lugt 2933b). *Exhibited:* Oakland, 1956,
no. 75; Venice, 1957, no. 14, pl. 14; Bloom-
ington, 1958, no. 30, fig. 30; Oakland, 1959, no.
59; Hamburg, 1963, no. 136, fig. 19; Brescia,
1965, no. 123, pl. 209; New York, 1965, no. 55,
pl. 55; London, 1968, no. 83; Middletown, 1969,
no. 16. *Published:* Scholz, 1958, p. 416, fig. 4;

Ferrari, 1961, opp. pl. 30; Kossoff, 1963, p. 77;
Peters, 1965, pp. 149, 155, fig. 99; Pignatti,
1970, p. 82, pl. xi; Scholz, 1976, no. 50, pl. 50.

While this study is clearly a drawing from
nature, the second figure at the right, lightly
sketched, would suggest that it was also
directed toward a larger composition.
Muraro thought this sheet might be related
to Romanino's frescoes of Christ's Passion in
the cathedral in Cremona (1519–1520)
where the garb of German mercenaries is
used for Christ's Roman persecutors.[1]
Florence Kossoff suggested a later date for
the drawing and related it to a warrior in
one of the battle scenes in the Castello Col-
leoni, Malpaga (1527), which she and
Antonio Morassi assigned to Romanino.[2]
Maria Ferrari argued that this project was
by Fogolino.[3] In any case, the attribution is
unquestioned and the drawing dated to ca.
1520–1527. For Hans Peters the sheet is a
clear example of Romanino's mature drafts-
manship.[4]

1. Venice, 1957, no. 14. *The Passion of Christ,*
Cremona, cathedral, Ferrari, 1961, pls. 29, 30, 32, 33.
2. Kossoff, 1963, p. 77. *A Battle Scene,* Malpaga,
Castello Colleoni; Morassi, 1931, pl. 1A.
3. Ferrari, 1961, p. 309.
4. Peters, 1965, p. 149.

Girolamo Romani, called Romanino

120 *Nude Male Figure*

Brush and brown ink and wash over traces of
black chalk, 294 × 167 mm., ca. 1535. Nota-
tions: upper right corner, in pen and brown ink,
Gerolamo Romanino Prattico / Pittore Bresciano;
below this an erased inscription. Large patch
lower left by figure's legs, other patches
throughout, soiled.

Metropolitan Museum of Art, Rogers Fund,
1961, 61.123.3.

Exhibited: New York, 1965, no. 56, pl. 56; Los
Angeles, 1976, no. 41, repr. p. 47. *Published:*
Morassi, 1959, p. 190, fig. 39; Bean, 1962, p.
163, fig. 6; Gilbert, 1962, p. 201, fig. 232;
Kossoff, 1963, p. 77, fig. 52.

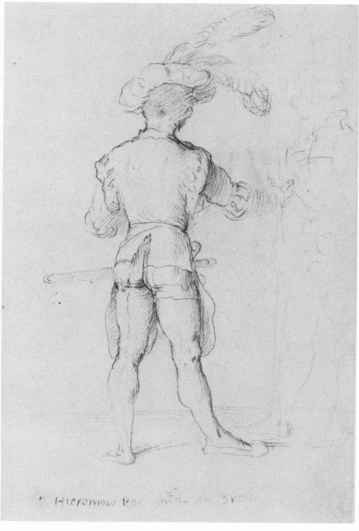

119

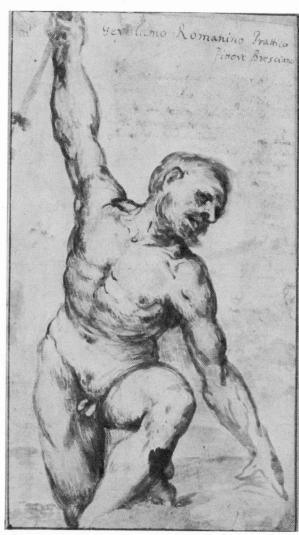

120

Kossoff noted that *Nude Male Figure* is similar in style and figural type to Adam in Romanino's fresco of 1534, *Christ in Limbo*, in Santa Maria della Neve, Pisogne.[1] Although she could not accept the drawing as a preliminary study for the fresco— because the poses varied too greatly—they may well date from the same time.[2] The figure is closer to the herdsman at the right side of *Romulus and Remus* [121]. The ascending motion, raised left knee, wispy beard, and three-quarter view of the head turned to the left are the same in both.

1. Kossoff, 1963, p. 77. *Christ in Limbo*, Pisogne, Santa Maria della Neve; Ferrari, 1961, pl. 79.
2. New York, 1965, I, no. 56.

Girolamo Romani, called Romanino

121 *Romulus and Remus*

Pen and brown ink over black chalk (accidental smudges of red chalk), 163 × 248 mm., ca. 1535. Notation: upper right corner, in pen and black ink, *LVO;* verso, in pen and brown ink, circles. Watermark: circle with tower, SM below. Large stains down from top center and lower left on trees and wolf, horizontal crease at top, creases, soiled.

The Cleveland Museum of Art, Purchase, Dudley P. Allen Fund and Delia E. and L. E. Holden Funds, 63.87.

Exhibited: Cleveland, 1963, no. 142, repr. p. 267. *Published:* Richards, 1964, pp. 193-195, fig. 5 and cover; Peters, 1965, p. 154, fig. 96.

According to the writings of Dionysus of Halicarnassus, Romulus and Remus—the twins who were destined to found Rome— were discovered by the royal herdsman Faustulus when the exposed infants were being nursed by a wolf as her own offspring. Faustulus and his fellow shepherds "thought they were beholding a supernatural sight and advanced in a body, shouting to terrify

the creature."[1] Perhaps this episode had a personal meaning for Romanino, whose name is translated as "little Roman." No mention has been found of a commission for this subject in Romanino's work.

The pictorial character of *Romulus and Remus* with interest in landscape reflects the pastorial tradition of Venetian painting at the turn of the century and explains Pignatti's association of the drawing with the hand of Titian. Although Pignatti suggested a Titian attribution for this drawing, Sherman E. Lee recognized it as Romanino.[2] W. R. Rearick argued in favor of an early date for the sheet, and Peters dated it as pre-1525.[3] Kossoff's reasons for a date after the 1520s seem acceptable, however, as the figure style is close to that of *Nude Male Figure* [120] dated 1534 by Bean.[4] This also coincides with the Loggia of Buonconsiglio, Trento, where Romanino began work in the autumn of 1531. The same figure style of ragged contours and full-bodied rustic forms in *Romulus and Remus* approximates a frescoed *ignudo* and the *Promethius* in the

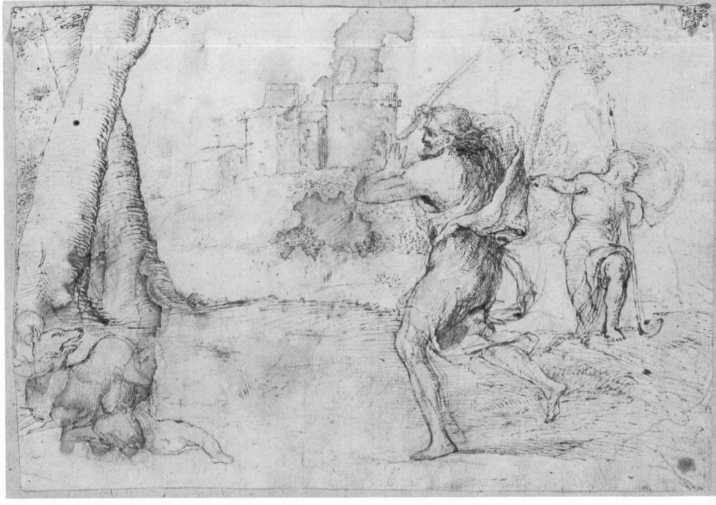

121

Castello del Buonconsiglio, Trento.[5] It was also at this time that Romanino painted many historical and classical subjects.[6] Furthermore, Adam — in *Christ in Limbo* in Santa Maria della Neve, Pisogne (1534) — is similar in pose to the shepherd at the right, and there are other correspondences between the drawing and the figure of the Good Thief in the *Crucifixion*.[7]

Nude Male Figure [120] has not previously been associated with *Romulus and Remus* but may have been a study for it. The figure is close in terms of glance, raised left knee, directional impetus, and shepherd's staff to the herdsman ascending the knoll at the far right.

1. Dionysius of Halicarnassus, *Roman Antiquities*, I, 79.
2. Verbal communication, 18 November 1963, Curator's file, The Cleveland Museum of Art.
3. W. R. Rearick, 25 January 1967, "Definitely an early Romanino," Curator's file, The Cleveland Museum of Art; Peters, 1965, p. 154, n. 120.
4. Memo from Florence Kossoff, 19 June 1978, Curator's file, The Cleveland Museum of Art, New York, 1965, no. 56.
5. *Ignudo*, Loggia, Trento, Castello del Buonconsiglio; Passamani, 1965, repr.; *Promethius*, Corridoio della Cucina, Trento, Castello del Buonconsiglio, Passamani, 1965, repr.
6. Thieme-Becker, XXVIII, 551.
7. *Christ in Limbo*, Pisogne, Santa Maria della Neve; Ferrari, 1961, pl. 79, *Crucifixion*, pl. 76.

Girolamo Savoldo

ca. 1480–1548

It is difficult to place Girolamo Savoldo in the early years of his career. He is entered in the rolls of the Florentine painters' guild in 1508 and documented in Venice by 1520. His early works, however, have the descriptive literalism of Lombard painting. Savoldo's art always remained one of large forms and restrained feelings, strong light, and persistent colors.

In Venice he came under the influence of Titian, Palma il Vecchio, and especially Lorenzo Lotto with whom he had much in common in terms of artistic origins and interests. By the 1530s Savoldo had attained complete assurance and even virtuosity in his work. Freedberg has given a concise summation of Savoldo's style at this point: "he creates powerful effects of life, but wholly in terms of illumined paint: his means are an exaggeratedly abundant drapery, strong in colour and brightly lit, disposed around plastically large but inert forms. Neither the design of forms — not even of the foldings of the drapery — nor the ordering of colour evinces the working of a

synthesizing mind. Beneath the new complexity the essential experience is what it had been long before: of dense substances in additive relation and of colour of compelling force, perceived primarily in local fields."[1]

1. Freedberg, 1971, p. 227.

Girolamo Savoldo

122 *Man's Head and Hand*

Black and white chalk on blue paper, 245 × 170 mm., 1513–1515.

Janos Scholz, New York.

Provenance: Geiger. *Exhibited:* Oakland, 1956, no. 81; Venice, 1957, no. 12, pl. 21; Bloomington, 1958, no. 42 (as Paris Bordone); Oakland, 1959, no. 10 (as Paris Bordone); New York, 1960; Hagerstown, 1960, no. 9; New York, 1961, no. 9; Hamburg, 1963, no. 144; New Haven, 1964, no. 48; Milwaukee, 1964, no. 9 (as Paris Bordone); London, 1968, no. 89; Washington, 1973, no. 79, repr. 97; Montgomery, 1976, no. 13. *Published:* Scholz, 1976, no. 31, pl. 31.

The Tietzes assigned this sheet to Savoldo, relating it to drawings of *St. Peter* in the Uffizi and a head in the Skippe collection, a sheet Popham had given to Bordone.[1] Creighton Gilbert questioned the attribution of *Man's Head and Hand* to Savoldo, suggesting Paris Bordone instead.[2] Alfred Neumayer and Jack Wasserman agreed.[3] However, Oberhuber and Walker related *Man's Head and Hand* to Savoldo's studies of heads in the Uffizi and Louvre.[4] The painterly approach — where chalks are rubbed and blended and where only the barest reference is made to line — is more characteristic of Savoldo than Bordone. The choice of appearance over particularized reality achieved by strong chiaroscuro and dissolving contours is also typical of Savoldo's draftsmanship. Wolf Stubbe dated this sheet to 1513-1515.[5]

1. Scholz, 1976, no. 31. *Bust of a Bearded Man*, black chalk, heightened with white on blue paper, 268 × 194 mm., Malvern, Herefordshire, collection Mrs. Julia Rayner Wood (Skippe coll.); Tietze, 1944, no. 1412, pl. lvii, fig. 3; *Study for the Head of St. Peter*, charcoal heightened with white on gray paper, 275 × 212 mm., Florence, Uffizi, no. 12805; Tietze, 1944, no. 1408.
2. Bloomington, 1958, no. 42.
3. Oakland, 1959, no. 10; Milwaukee, 1964, no. 9.
4. Washington, 1973, no. 79. *Female Head*, charcoal heightened with white on brown paper, 250 × 190 mm., Florence, Uffizi, no. 12806, Tietze, 1944, no. 1409, pl. lvii, fig. 2; *Head of a Bearded Man*, charcoal on gray paper, 315 × 230 mm., Paris, Louvre, no. 5525, Tietze, 1944, no. 1415, pl. lvii, fig. 1.
5. Hamburg, 1963, no. 144.

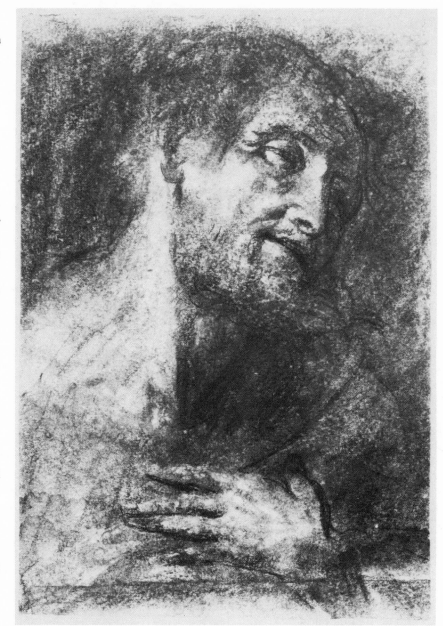

122

Genoa

Sixteenth-century Genoese painting was influenced by the mannerism and ebullient line of Perino del Vaga and dominated by the artistic personality of Luca Cambiaso. The insistent calligraphy of the Florentine Perino del Vaga during and after his eight-year stay in Genoa left a profound influence on native Genoese artists, including the impressionable Cambiaso who was ten years old when Perino left Genoa for Rome. From ornate prodigiousness to stylized geometry, Cambiaso's draftsmanship evolved from designs dominated by accelerating line to an art of broadly washed planes complemented by tics, hooks, and squiggles of the pen of great suggestive power. Cambiaso's architectonic stylizations in combination with the thick, pliant line of a quill pen made his art pedagogically appealing, and his style became the model for the Genoese school. His natural drawing style, then, linear and flowing, was highly decorative and reflected Perino's mannerist bias.[1] It was, however, a spontaneous style and one not readily assimilated by followers.

Two events after mid-century were responsible for the modification of Cambiaso's draftsmanship: his association with the architect Giovanni Battista Castello (almost twenty years his senior) and his burgeoning popularity. The demands upon Cambiaso's time made it necessary for him to build a workshop and train apprentices, and the architectural renderings of his close friend, Castello, with the new artist's manuals from the north,[2] provided a basis for his geometric stylizations. Cambiaso's innovative cubic formalism resulted in a figural shorthand that was more easily taught to apprentices. The striking *Martyrdom of St. Lawrence* [125], with its interlocking planes and volumes, demonstrates Cambiaso's geometric reductions at the peak of his maturity. In his *Temptation of St. Anthony* [126] Cambiaso's geometry is the result of broad washes and touches of line, revealing complete assurance in his new pictorial mode. Genoese art through the end of the sixteenth century saw Cambiaso's followers—such as Lazzaro Tavarone, Ottavio Semino, and G. B. Paggi—so overwhelmed by the quality of Cambiaso's line and by his formal principles that their designs tend to be less pictorially successful. *Madonna and Child with Angels and Saints* [129], attributed to Paggi, is essentially a line study for a composition, whereas the slightly later unrestrained *Annunciation* [128] is still linear in conception although more dynamic. In both sheets his dependence upon Cambiaso is evident in the exaggerated stylizations of the open circles for eyes, the rectangular demarcation of figures, and swelling contours.[3] The most obvious aspects of the master's shorthand became hyperbole in his followers. Even his collaborator, Giovanni Battista Castello [127], demonstrates how easily Cambiaso's contemporaries could be persuaded by his redoubtable style.

With the return of Paggi to Genoa at the end of the Cinquecento and the arrival of Rubens shortly thereafter, Genoese art in the next century developed in the direction of sentiment, dramatic rhetoric, and descriptive naturalism. Cambiaso's style remained vital in the centuries following only in the hands of pupils and pedagogues in the academies.

1. An example of the young Cambiaso's unrestrained lineality is his *Hercules*. See Los Angeles, 1976, no. 128, fig. 128.
2. Vogtherr's volume was so popular that it appeared in several editions and several languages within thirty years of its first publication. Vogtherr, 1538; Schön, 1538; Lautensack, 1564.
3. Although Paggi was a native Genoese, his *Standing Archer* [130] can only be explained by the fact of his exile in Tuscany for twenty years. The stronger naturalism, solid volumes, and coherent anatomy of the soldier reflect the Tuscan preoccupation with figurative art.

Luca Cambiaso

1527–1585

The young Luca Cambiaso was influenced by Perino del Vaga's frescoes in the Palazzo Doria, Genoa, and others, now lost, by Beccafumi and Pordenone. His earliest paintings were completed in collaboration with his father, Giovanni. He then executed fresco decorations in the Doria Palace and Doria church of San Matteo. The directness and spontaneity of Luca's style was modified in the 1550s as his reputation became clearly established. After mid-century he developed close associations with the Perugian architect, Galeazzo Alessi, and the painter and architect from Bergamo, Giovanni Battista Castello. By 1565 Luca reached the epitome of his career as a fresco painter, his numerous commissions creating the need for a large studio. During the 1560s and 1570s he was, with Pellegrino Tibaldi, the most successful painter in Northern Italy.

Trips to Florence and Rome may have been made in 1575, but Luca's presence in Rome in 1583 is certain. In that year he was invited to Madrid by Philip II to be court painter at the Escorial.

As a draftsman Luca was, from his earliest years, a precocious, prolific, and inventive virtuoso. His prodigious calligraphy and explosive geometry crystalized into a rectangular formalism as he established his reputation. Works after 1570, dry in style and simplistic in subject, seem atonement for the aggressiveness of his youthful artistic personality.

123

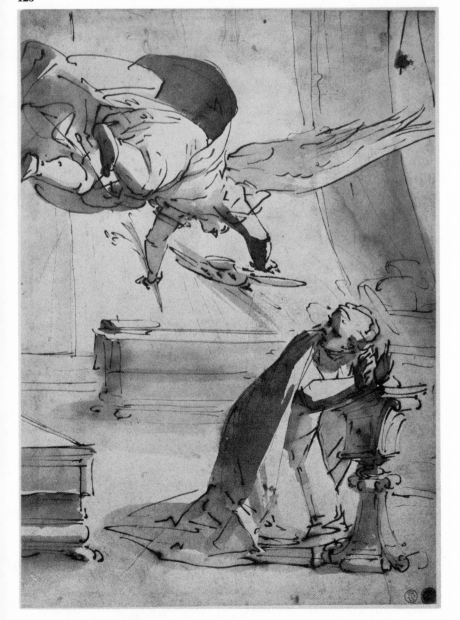

Luca Cambiaso

123 *The Annunciation*

Pen and brown ink, gray wash, 295 × 207 mm., 1568. Hole upper left, tears lower left, lower right.

The Cleveland Museum of Art, Gift of the Folio Club in memory of Mrs. William G. Mather, 59.200.

Provenance: Count Gelozzi (or Gelosi) (Lugt 545); Charles Greville (Lugt 549); Earl of Warwick (Lugt 2600). *Exhibited:* Cleveland, 1959, p. 230, repr. p. 220; St. Louis, 1972, no. 10, repr. *Published:* Manning, 1967, under no. 21; Houston, 1974, under no. 21; Armenini, 1977, fig. 36.

In the late 1550s, Luca Cambiaso was employed in decorating several lunettes in the church of SS. Annunziata di Portoria, Genoa. An Annunciation (Fig. 123a) was commissioned on Christmas eve, 1568, for fifty scudi by Antonio de Franchi in the name of Battista Grimaldi.[1] Numerous drawings have been associated with it, the closest of which is a sheet in the Steiner collection [124]. There is little question that the drawing in The Cleveland Museum of Art is also an early idea for the Genoese canvas since the Virgin is almost identical in pose to the Steiner drawing. The lack of exact correspondence between the painting and the Cleveland design suggests intermediary sketches between the two. A drawing in the Louvre (Fig. 123b) may be the first for the composition,[2] where the Virgin is in an impressive architectural setting, and swarms of angels dart from the clouds above. Both drawings are motivated by an emphatic diagonal through the angel, dove, and Virgin, but figure scale is increased in the Cleveland *Annunciation*. A sketch in Chatsworth emphasizes the arrival of the angel by virtue of his dynamism and divine radiance; the pose of the angel agrees closely with that in the painting.[3] The mood of the Annunciation becomes more quiescent in a sheet in Genoa (Fig. 123c), which also contains a combination of elements from the Cleveland and Chatsworth drawings.[4] The figures are based on simple geometric shapes, a style most likely derived by Cambiaso through German manuals under the tutelage of his early associate, Giovanni Battista Castello.[5] Other versions, in the Uffizi and Christ Church, are more restrained.[6]

Byam Shaw suggested that the Christ Church sheet may date from Cambiaso's tenure in Spain.[7] *Angel Gabriel and the Virgin Annunciate* was painted in fresco for San Lorenzo el Real of the Escorial, 1583–1585. The Christ Church sheet cannot be related to it, however, since Cuevas's description of the painting indicates that Gabriel and the Virgin are separated by a large central window.[8]

Copies of drawings by Cambiaso, usually of inferior draftsmanship, abound. Studio practice in the Cinquecento required the

149

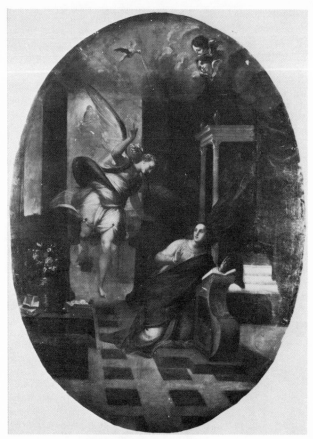

Fig. 123a. *Annunciation*, oil on canvas. Luca Cambiaso. SS. Annunziata di Portoria, Genoa.

Fig. 123b. *The Annunciation*, pen and ink, 687 × 490 mm. Luca Cambiaso. Musée du Louvre.

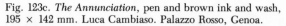

Fig. 123c. *The Annunciation*, pen and brown ink and wash, 195 × 142 mm. Luca Cambiaso. Palazzo Rosso, Genoa.

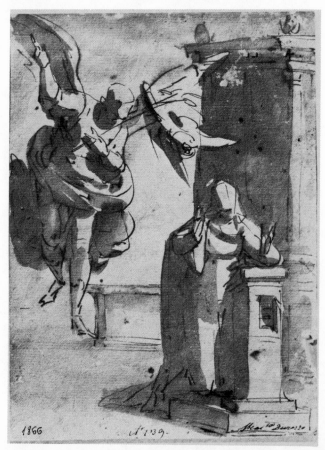

young artist to study from drawings of accepted masters copying them until the two versions could not be distinguished.[9] The large corpus of drawings associated with Cambiaso's painting of *The Annunciation* can be reduced by recognizing that a number of these sheets are copies of Cambiaso's works some of which no longer exist. A second drawing in the Louvre is in some respects a reversal of the Genoese painting.[10] The Suidas claimed Ottavio Semino used this drawing for his *Annunciation* fresco in Santa Maria di Carignano, Genoa (formerly attributed to Cambiaso by Venturi).[11] Possibly the drawing should also be associated with Semino. Two others in the Courtauld and Uffizi collections are apparently facsimiles of the same lost drawing, and a third sheet in Cologne reproduces the *Annunciation* in the Palazzo Rosso, Genoa.[12] A design in the Pennsylvania Academy of Fine Arts [127] is close to the arrangement of figures in this version, reversed, and may be by Giovanni Battista Castello who collaborated with Cambiaso in the 1550s and 1560s. Another drawing in the Pennsylvania Academy of Fine Arts [128] is lunette shaped (other works by Cambiaso in SS. Annunziata are in lunettes) and has some of the precocious daring of Cambiaso's early style. It may

represent an early idea for the *Annunciation* which was later abandoned. The quality of line in the drawing suggests a workshop piece, perhaps by Giovanni Battista Paggi, and, therefore, a later copy of a lost original.

The variety of compositions for the *Annunciation* painting can be explained by a passage from Lodovico Dolce's *l'Aretino* of 1557 in which he advised the artist to make numerous drawings for a project beginning anew each time as a challenge to his inventiveness.[13] The best of several studies, then, was to be chosen for the final work. Armenini elaborated upon this procedure in his treatise of 1586, explaining that since human nature is imperfect, the artist cannot possibly devise a satisfactory composition in his first sketch.[14]

I am grateful to Brenda Dawes for research assistance with this drawing.

1. Manning and Suida, 1958, p. 39, pl. cxlv, fig. 234.
2. Ibid., pl. cxliii, fig. 231. An inferior copy was at London, Sotheby's, 10 March 1977, no. 164, repr. p. 50.
3. *The Annunciation*, pen and ink and wash over traces of black chalk, 299 × 211 mm., Chatsworth, Duke of Devonshire Collection, no. 1956; Manning and Suida, 1958, p. 180, pl. cxliv, fig. 233.
4. Ibid., p. 39. A weak copy of this drawing is after Luca Cambiaso, *The Annunciation*, pen and brown ink and gray wash, 224 × 189 mm., New York, collection of Bertina Suida and Robert L. Manning; Manning, 1967, no. 21, repr.
5. One such manual which appeared between 1538 and 1572 in eight editions and three languages is Heinrich Vogtherr, *Ein Fremde und Wandbarliches Kunstbüchlin.*
6. *The Annunciation*, pen and ink and wash, 200 × 150 mm., Florence, Uffizi, no. 13759 F, Manning and Suida, 1958, p. 185, pl. cxliii, fig. 232; *The Annunciation*, pen and brown wash, 143 × 134 mm., Oxford, Christ Church; Byam Shaw, 1976, I, no. 1225, II, pl. 731.
7. Byam Shaw, 1976, I, 306.
8. Cuevas, 1932, I, 7, II, 2.
9. Armenini, 1977, p. 124:
10. *The Annunciation*, 475 × 335 mm., Paris, Louvre, no. 9208; Manning and Suida, 1958, pp. 56-57.
11. Ibid.; Venturi, 1901-40, IX, 7, 853.
12. After Luca Cambiaso, *The Annunciation*, pen and brown ink and brown wash over black chalk, 294 × 225 mm., London, Courtauld Institute of Art, no. 4575; After Luca Cambiaso, *The Annunciation*, 380 × 260 mm., Florence, Uffizi, no. 13778, Manning and Suida, 1958, p. 39. After Luca Cambiaso, *The Annunciation*, pen and ink and wash, 212 × 151 mm., Cologne, Wallraf-Richartz Museum, no. 1953/1; Krönig, 1964, repr. p. 127.
13. Roskill, 1968, p. 129.
14. Armenini, 1977, p. 144.

Luca Cambiaso

124 *The Annunciation*

Pen and brown ink, gray wash, 290 × 205 mm., 1568. Notation: top right, in pen and brown ink, *Bellissima.* Corners patched top and bottom right.

Alice and John Steiner.

Sale: London, Sotheby, 25 November 1971, no. 146, repr. *Exhibited:* Cambridge, 1977, no. 4, repr. p. 30. *Published:* St. Louis, 1972, under no. 10.

This sheet — one of several extant studies for Cambiaso's canvas in the SS. Annunziata di

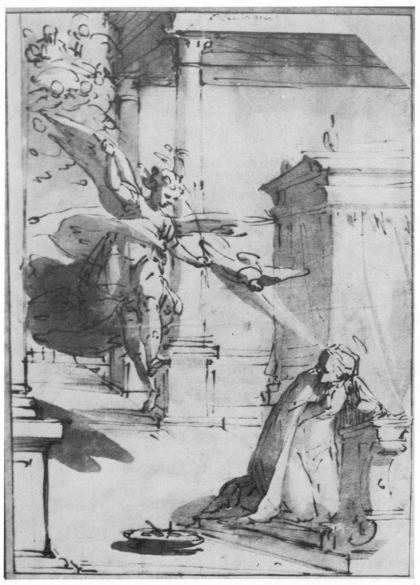

124

Portoria, Genoa (1568) — is closest to the final composition (Fig. 123a).[1] The drawing is also similar to the *Annunciation* in Cleveland [123], especially in the nearly identical figures of the Virgin.

A carefully conceived system of verticals and horizontals is one of several elements contributing to the tectonic character of this highly pictorial drawing. Terse lines and broad washes create light and shadow. The boldness in Cambiaso's deft touches of pen and brush underscores the spontaneity of Gabriel's arrival, as does the strong diagonal from upper left to lower right. Such a linear extrapolation from God in the heavens through Gabriel and the Holy Spirit to the Virgin completes a visual statement so consistent that it could only be the result of extensive preparation.

1. Andrea Kaliski in Oberhuber, 1977, no. 4.

Luca Cambiaso

125 *The Martyrdom of St. Lawrence*

Pen and brown ink, brown wash, 388 × 244 mm., ca. 1580. Notations: lower right, in black chalk, *Cangiaso;* lower left corner, in pen and brown ink, *No. 45.* Tear on left from top, other tears.

The National Gallery of Art, Washington, Ailsa Mellon Bruce Fund, 1972, B-25,825.

Provenance: Paul Drey Gallery, New York. *Exhibited:* Washington, 1974, no. 22, repr. p. 61; Washington, 1978, repr. p. 47.

This is a study for a painting of the *Martyrdom of St. Lawrence* which was sent to Philip II of Spain in 1581 for the high altar of the basilica of the Escorial.[1] This subject is especially appropriate considering the Spanish origins of the saint and the fact that he was ordained archdeacon by Philip, the first emperor to accept the Christian faith.[2] The emperor's son, also named Philip, gave his father's treasure to St. Lawrence for

distribution to the poor. Lawrence was martyred for refusing to yield the treasure to Decius, a general who murdered the emperor and then succeeded him as ruler.

This striking sheet is a good example of Cambiaso's shorthand mode of stylization in the treatment of figures. As is often the case with his work, many drawings of this subject are known.[3] These sheets have a horizontal format and may be studies for other versions of this subject such as the one in San Lorenzo della Costa, Ruta.[4] The associations are complicated by Cambiaso's habit of making numerous sketches of a subject before deciding upon the final composition which might often be a composite of some of them. The studies for his *Annunciation* (Figs. 123b, 123c; [123, 124, 127, 128]), for example, are nearly square or rectangular sheets, while the finished altarpiece has an oval format. The arched frame in this instance was not retained in the finished painting.

1. *The Martyrdom of Saint Lawrence*, San Lorenzo el Real, the Escorial; Manning and Suida, 1958, p. 125, pl. ccli, fig. 426.
2. Voragine, 1941, pp. 437-438.
3. Manning and Suida, 1958, p. 125; all are *The Martyrdom of St. Lawrence*, Genoa, Palazzo Rosso; Princeton, New Jersey; Florence, Uffizi, no. 13705; pen and brown ink and brown wash, 260 × 380 mm., Florence, Uffizi, no. 69965, ibid., pl. ccl, fig. 424; London, Courtauld Institute of Art, ibid, pl. ccl, fig. 425; Haarlem, Teyler Museum; van Regteren Altena, 1966, p. 91, fig. 62; pen and brown ink, 230 × 350 mm., Genoa, Gabinetto Disegni e Stampe, no. 1853; Genoa, 1956, no. 92, repr.; pen and brown ink and brown wash, 238 × 317 mm., Ottawa, National Gallery of Canada, no. 6130; Popham and Fenwick, 1965, no. 35, repr. p. 29.
4. Diane DeGrazia Bohlin in Washington, 1974, no. 22; Manning and Suida, 1958, pl. ccil, fig. 423.

Luca Cambiaso

126 *Temptation of St. Anthony*

Pen and brown ink, brown wash, over traces of black chalk, 402 × 283 mm., late 1570s. Notations: on mount, in ink, *2, Luca Cangiaggio;* in pencil, *8, n, A 3514.* Surface abraded lower right.

The Cleveland Museum of Art, Dudley P. Allen Fund, 29.540

The story of St. Anthony's temptation is recorded in the *Golden Legend* of the thirteenth-century Italian monk, Jacobus de Voragine.[1] The saint led a life of prayer and fasting in the Egyptian desert where, when devils in the form of a variety of beasts tore "at him with their teeth, their horns and their claws," a divine radiance appeared to effect his rescue. Since St. Anthony was considered the father of monasticism, he wears a robe and hood. He is depicted with a crutch because of his advanced age and the long years spent fasting in the wilderness.

No mention is made in the Suidas' monograph on Luca Cambiaso of the artist having dealt with the *Temptation of St. Anthony*.[2] The subject exists in several prints and drawings, most of which can be shown to be copies. The cubic formalism found in Cambiaso's mature drawings made them easy to copy and, thus, pedagogically ideal and well suited to translation into prints. Indeed, Cambiaso may have developed his geometric stylizations and abandoned the precocious calligraphy of his early career when it became necessary to train studio assistants.

It was already a popular procedure in the seventeenth century to copy drawings in prints as evidenced by the etchings made by the Earl of Arundel's artists after drawings by Parmigianino.[3] Several prints by Johann Theophil Prestel after drawings by Cambiaso are in the Museum of Fine Arts in Boston.[4] Of particular interest is Arthur Pond's collaboration with Charles Knapton to reproduce a number of drawings in the collection of Hugh Howard. One of these, an etching with three woodblocks, dated 1736, *St. Anthony Pursued by Demons*, is based on a lost study by Cambiaso.[5] The composition is similar to the Cleveland drawing (and not in reverse), except that there is an architectural rather than a forest setting, the demon whose back is turned to the saint now approaches him, and St. Anthony holds his staff in his left hand.

A version more like the Cleveland sheet is in Copenhagen.[6] There are a few minor compositional changes, but the execution is too busy to be Cambiaso's. The limp curves intended as interior modeling have little to do with anatomy. A drawing in Boston is a less spirited and drier copy of this sheet (Fig. 126a).[7] The drawing style is similar to that of the inferior *Apollo Flaying Marsyas* (Fig. 126b), presumably based upon a study by Cambiaso now lost.[8] Another sheet, in

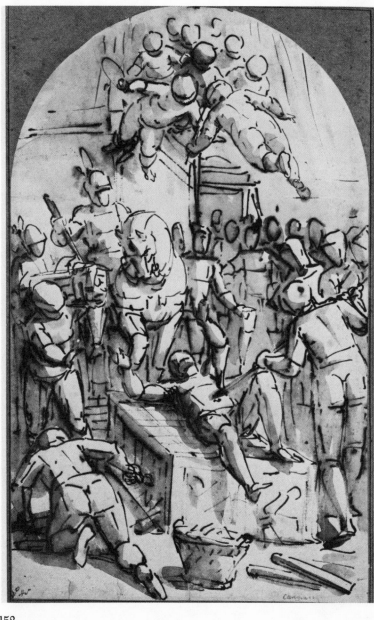

125

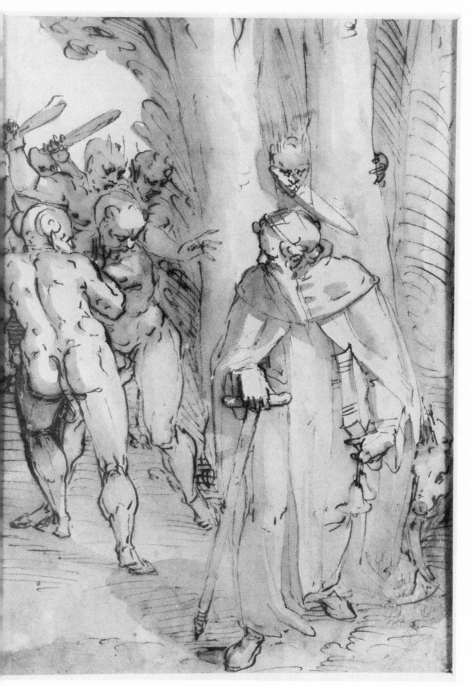

126

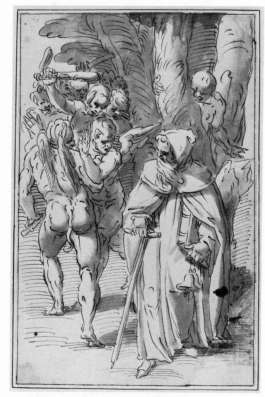

Pavia, attributed to Lodovico Carracci, is closest to the one in Copenhagen except for one detail.[9] Instead of a hood St. Anthony wears a cap and has a halo as in the Cleveland sheet.[10] Line in the Cleveland *Temptation of St. Anthony* is surer and firmer, and the composition is tighter and more confident.

The Cleveland study is one of Cambiaso's most splendid drawings. The trees frame the saint and provide a stable setting against which the figures twist and turn. Modeling is far more subtle as volumes are defined by the tonal nuances of the washes rather than by the intersection of planes as in the *An-*

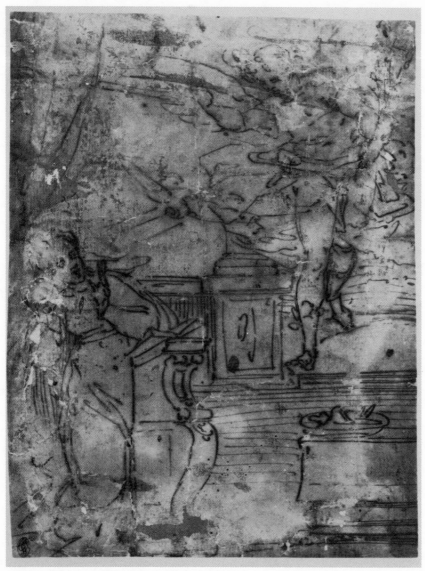

127

Giovanni Battista Castello, il Bergamasco

1509–1569

Giovanni Battista Castello, called il Bergamasco after his birthplace in Bergamo, arrived in Genoa in 1531. There he collaborated with Luca Cambiaso in the 1550s and 1560s. Castello arrived at the court of King Philip II of Spain in 1567 and died in Madrid two years later. He was the first in a series of Italian artists to join the Spanish court in the sixteenth century, followed by Luca Cambiaso, who entered Philip's patronage in 1583, then by Pellegrino Tibaldi and Federico Zuccaro.

Attributed to Giovanni Battista Castello

127 *The Annunciation*

Pen and brown ink on tan paper, 267 × 200 mm., ca. 1567. Notations: verso of mount, in brown crayon, *N 284;* in pencil, *L Cambiagio, 43.* Holes, tears, surface abraded, soiled.
Lent by The Pennsylvania Academy of Fine Arts, 435.
Provenance: Giuseppe Vallardi (Lugt 1223).

This design is close to drawings of *The Annunciation* by Luca Cambiaso (Figs. 123b, 123c; [123, 124]). The widely spaced parallel lines and hollow-eyed figures approach Cambiaso's style, but details lack the articulation and sureness of the master. Mary Newcome also rejected the Cambiaso attribution and assigned the drawing, instead, to Giovanni Battista Paggi.[1] Another artist who was associated with Cambiaso in the 1560s, when he was involved in the Annunciation and other subjects for SS. Annunziata di Portoria, Genoa, Giovanni Battista Castello, is an even likelier possibility. It may be Castello's copy of a lost study by Cambiaso from this period as the dry, wavering line implies a draftsman checking his sketch against a finished drawing. Relative to the other preparatory studies for the *Annunciation* (see [123]), the Virgin is shifted to the left side of the page, although continuing to face right, and Gabriel is reversed in mirror image.

1. Ann Percy to Edward J. Olszewski, 21 January 1977.

Giovanni Battista Paggi

1554–1627

Giovanni Battista Paggi entered the Genoese studio of Luca Cambiaso at an early age. Although he was born and died in Genoa, Paggi was banished from the city in 1579 for killing a nobleman in a quarrel and spent the next twenty years in Pisa and Florence where he formed a close association with Jacopo Ligozzi, Lodovico Cardi, and Domenico Passignano.

Paggi's speculations on art were assembled in 1607 in the form of a short treatise, *Definitione e divisione della pittura.* He did frescoes and altarpieces for several churches

nunciation [123]. The play of light and shadow is more important than line as where the face of one demon peers between the trees right of center and through the halo. Such technical maturity would argue for a late date in Cambiaso's career, perhaps in the late 1570s.

1. Voragine, 1941, p. 100.
2. Suida, 1958.
3. Popham, 1953, p. 7.
4. *The Holy Family, The Descent from the Cross, Two Men with an Urn, Truth Triumphing over Envy,* "Acquisitions," *Museum of Fine Arts [Boston] Bulletin,* xx (February 1922), p. 14.
5. After Luca Cambiaso, *St. Anthony Pursued by Demons,* etching and woodblock, original drawing from collection Hugh Howard, 432 × 286 mm.; Hake, 1922, p. 338, repr. p. 331.
6. Anonymous, *The Temptation of St. Anthony,* pen and wash over black chalk, 414 × 277 mm., Copenhagen, The Royal Museum of Fine Arts, no. Mag. III c/16.
7. This may be the drawing from Hugh Howard's collection, reproduced as a print by Pond and Knapton, *Annual Report 1963, Museum of Fine Arts, Boston;* Boston, 1963, p. 77.
8. Cleveland, 1966, no. 79, repr. p. 208 (as Luca Cambiaso).
9. Lodovico Carracci, *The Temptation of St. Anthony,* pen and ink wash, 385 × 270 mm., Pavia, Musei Civici, no. 188; Soriga, 1912, no. 13, repr.
10. There are two other versions, locations unknown, which were listed as Luca Cambiaso; pen and brown ink and brown wash, 440 × 260 mm., London, Sotheby, 8-10 May 1929 (collection Vicomte Bernard D'Hendecourt), no. 164 (from collection Count von Fries); Paris, F. Guichardt, 30 April 1855 (collection M. F. van den Zande), no. 2943.

and convents in Genoa and Florence, including the Santissima Annunziata in both cities.

Attributed to Giovanni Battista Paggi

128 *The Annunciation*

Pen and brown ink on tan paper, 350 × 203 mm., ca. 1575. Notations: lower right, in pencil, *Cambiagi*; in blue crayon, £4; on mount, upper right, in pen and brown ink, *Luca Combiagnò*; on verso of mount, in brown crayon, *M246*; in pen and brown ink, *Cambagio*. Holes where ink acted on paper; horizontal fold at center; horizontal tear; bottom, patched lower left; soiled.

Lent by The Pennsylvania Academy of Fine Arts, 371.

Provenance: Giuseppi Vallardi (Lugt 1223); G. Locarno (Lugt 1691); Pacini (Lugt 2011).

Since Luca Cambiaso was commissioned to paint an *Annunciation* for SS. Annunziata, Genoa (Fig. 123a), where the earlier frescoes he executed were lunette shaped, it would seem reasonable to interpret the present sheet as a preliminary study for that project. Although the final version is an oval canvas, the sheet is an important link between the painting and the Cleveland drawing [123], where the same indecorous spontaneity of the angel's arrival has been preserved. The drawing style of the sheet, however, lacks the linear assurance of Cambiaso. The forms are too inflated and the negative spaces too expansive for Cambiaso himself. Newcome speculated that this sketch may be by Giovanni Battista Castello, a logical alternative since he collaborated with Cambiaso at SS. Annunziata in the 1560s.[1] The drawing is, however, close in style to the open, linear handling of *Communion of a Saint* which is associated with Giovanni Battista Paggi.[2] The wild hair of the Virgin in *The Annunciation* is especially like that of the angels in the Paggi design. As Paggi was still a child when Cambiaso worked on the SS. Annunziata commission, this is probably his copy of one of Cambiaso's first studies (now lost) for the *Annunciation*. Paggi also did several paintings of the Annunciation. Venturi mentions five, of which three were for churches in Genoa.[3]

1. Ann Percy to Edward J. Olszewski, 21 January 1977.
2. Giovanni Battista Paggi, *Communion of a Saint*, pen and brown ink, traces of black chalk, 280 × 204 mm., New York, Collection Janos Scholz; Binghamton, 1972, no. 21, fig. 21.
3. Venturi, 1901-40, IX, 7, 864-865.

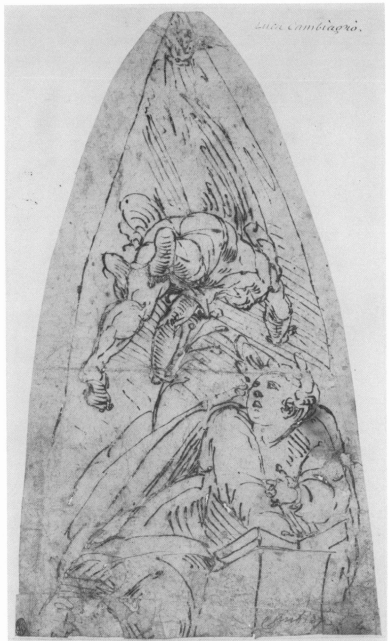

128

Attributed to Giovanni Battista Paggi

129 *Madonna and Child with Angels and Saints*

Pen and brown ink over traces of black chalk, on tan paper, 304 × 210 mm., ca. 1570. Notations: verso of mount, in pencil, *1-109, C & O, TEAUM, K 1931, £30,42*. Holes where ink acted on paper, other holes, tears, soiled.

Janet S. and Wesley C. Williams.

Provenance: Anonymous, Italian (?) (Lugt 2079b); Anonymous (Lugt 486b).

As a simple pen drawing consisting of studied, descriptive line, free of hatching, this design seems to be from early in Paggi's career. Compared with Paggi's drawing, *Communion of a Saint*, which is dated to his Genoese period, after 1600, this design is less spontaneous, lacking decorative tics in the draperies and the cursive, rounded shapes of the angel's wings, although it does have the same tubular fingers and coal dot eye sockets.[1] The flatness of form and lack of interior modeling argue for a date before the artist's Florentine sojourn, ca. 1570.

The composition has not been identified with any painting. Below the Madonna and Child three saints, who are not easily identified, hold various attributes. The one at the left carries a palm and a book; the center figure holds spheres and a crozier and may be St. Nicholas; and the figure at the right in monk's robes, possibly a Dominican, has a flowering branch (perhaps lilies) and a book.

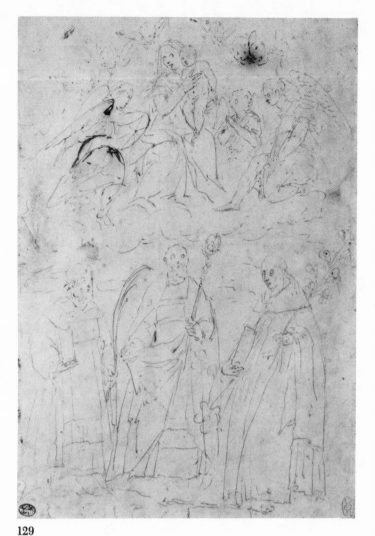

129

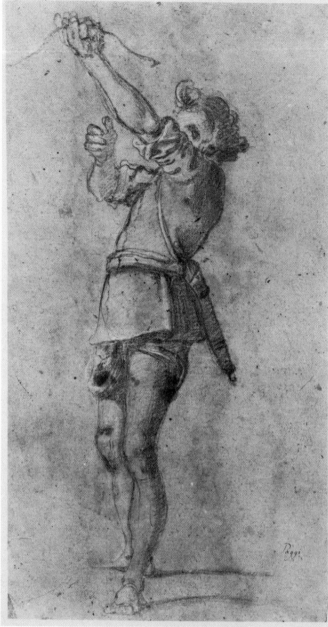

130

1. *Communion of a Saint*, pen and brown ink, traces of black chalk, 280 × 204 mm., New York, Collection Janos Scholz, Newcome, 1972, no. 21, fig. 21.

Giovanni Battista Paggi

130 *Standing Archer*

Black chalk heightened with white, on tan paper, 406 × 220 mm., 1598. Notation: lower right, in pen and brown ink, *Paggi*. Watermark: circle. Lower left corner patched, a few creases.

Janos Scholz, New York.

Provenance: Isaacs, London. *Exhibited:* Binghamton, 1972, no. 20, repr. p. 20; Washington, 1973, no. 42, repr. p. 52.

Paggi's clear, strong draftsmanship is evident here in one of his rare chalk studies. In terms of figure style and technique, Newcome has compared *Standing Archer* to red chalk drawings in Copenhagen, the Uffizi, and the Manning collection.[1] Paggi resided in Florence from 1579 for twenty years; the powerful influence Tuscan art had on his style, such as the example of Jacopo Chimenti's treatment of drapery, can be observed in this drawing.

1. Two studies for *Christ Child Holding an Apple*, red chalk, Copenhagen, Royal Collection, Tu. 7, 2c; *Study for the Return from Egypt*, red chalk, Florence, Uffizi, no. 2152 F; *Standing Saint*, red chalk, New York, Manning collection, Newcome, 1972, no. 20.

Bibliography

Ackerman, 1966: James S. Ackerman. *Palladio*. Baltimore, MD: Penguin.

Alazard, 1968: Jean Alazard. *The Florentine Portrait*. New York: Schocken Books.

Alberti, 1965: Leon Battista Alberti. *Ten Books on Architecture*, ed. J. Rykwert. London: Alec Tiranti.

Alberti, 1966: Leon Battista Alberti. *On Painting*. Trans. John R. Spencer, New Haven, CT: Yale University Press.

Amerson, 1975: see Sacramento, 1975.

Ames, 1963: Winslow Ames. *Drawing of the Masters, Italian Drawings from the 15th to the 19th Century*. New York: Shorewood Publishers.

Ames, 1978: Winslow Ames, trans. *Joseph Meder The Mastery of Drawing*, 2 vols. New York: Abaris Books.

Amherst, 1956: Amherst College, Massachusetts, Exhibition of Renaissance Art.

Amherst, 1974: Amherst College, Five College Roman Baroque Festival: Major Themes in Roman Baroque Art from Regional Collections.

Armenini, 1977: Giovanni Battista Armenini. *On the True Precepts of the Art of Painting*. Trans. and ed. Edward J. Olszewski. New York: Burt Franklin.

Arslan, 1960: Edoardo Arslan. *I Bassano*, 2 vols. Milan: Casa Editrice Ceschina.

Assunta, 1961: R. Assunta. "Education and Art Teaching," IV: 561-564, in *Encyclopedia of World Art*, 15 vols. New York: McGraw-Hill, 1959-1968.

Atlanta, 1958: Atlanta Art Association Galleries, Georgia, Italian Paintings and Northern Sculpture from the Samuel H. Kress Collection. Cat. by Wilhelm Emile Suida.

Bacou, 1964: see Paris, 1964.

Bacou, 1968: Roseline Bacou. *Great Drawings of the Louvre Museum*, 3 vols. New York: George Braziller.

Bacou, 1974: see Paris, 1974.

Baer, 1973: Curtis O. Baer. *Landscape Drawings*. New York: Harry N. Abrams.

Baglione, 1649: Giovanni Baglione. *Le vite de' pittori scultori et architetti*. Rome: Manelfo Manelfi.

Bailey, 1977: Stephen Bailey. "Metamorphoses of the Grimani 'Vitellius,'" *The J. Paul Getty Museum Journal*, V: 105-122.

Baldinucci, 1845-47: Filippo Baldinucci. *Notizie de' professori del disegno*, 5 vols. Florence: V. Batelli e compagni.

Ballarin, 1971: Alessandro Ballarin. "Considerazioni su una mostra di disegni veronesi del Cinquecento," *Arte Veneta*, XXV: 92-118.

Baltimore, 1939: Baltimore Museum of Art, Maryland, Architectural Renderings from the Renaissance to Le Corbusier.

Baltimore, 1961: Baltimore Museum of Art, Bacchiacca and His Friends, Florentine Paintings and Drawings of the Sixteenth Century.

Barasch, 1978: Moshe Barasch. *Light and Color in the Italian Renaissance Theory of Art*. New York: New York University Press.

Barocchi, 1960-62: Paola Barocchi. *Trattati d'arte del cinquecento*. 3 vols. Bari: Gius. Laterza e figli.

Barocchi, 1962: Paola Barocchi. *Michelangelo e la sua scuola, i disegni di Casa Buonarroti e degli Uffizi*, 2 vols. Florence: Leo S. Olschki.

Barocchi, 1971-77: Paola Barocchi. *Scritti d'arte del cinquecento*, 3 vols. Milan: Riccardo Ricciardi Editore.

Barocchi and Ristori, 1965: Paola Barocchi and Renzo Ristori, eds. *Il Carteggio di Michelangelo*, 6 vols. Florence: Sansoni.

Barolsky, 1978: Paul Barolsky. *Infinite Jest: Wit and Humor in Italian Renaissance Art*. Columbia: University of Missouri Press.

Bartsch, 1808-21: Adam von Bartsch. *Le peintre graveur*, 22 vols. Vienna: Degen.

Bean, 1962: Jacob Bean. "The Drawings Collection," *Metropolitan Museum of Art Bulletin*, XX: 157-175.

Bean, 1963: Jacob Bean. "Form and Function in Italian Drawings: Observations on Several New Acquisitions," *Metropolitan Museum of Art Bulletin*, XXI: 225-239.

Bean, 1964: Jacob Bean. *100 European Drawings in the Metropolitan Museum of Art*. New York: The Metropolitan Museum of Art.

Bean, 1968: Jacob Bean. "Draughtsmen from Parma." *Burlington Magazine*, CX (Sept.): 519-520.

Bean, 1973: see New York, 1973.

Bean and Stampfle, 1965: see New York, 1965.

Béguin, 1962: Sylvie Béguin. "Niccolo dell'Abbate en France," *Art de France*, II: 112-145.

Bellori, 1672: Giovanni Pietro Bellori. *Le vite de' pittori scultori et architetti moderni*. Rome: Successore al Mascardi.

Bembo, 1548: Pietro Bembo. *Le prose*. Florence.

Berenson, 1938: Bernard Berenson, *The Drawings of the Florentine Painters*, 3 vols. Chicago: University of Chicago Press; 1970 reprint also available.

Berenson, 1961: Bernard Berenson. *I Disegni dei Pittori Fiorentini*, 3 vols. Milan: Electa editrice.

Bernari and de Vecchi, 1970: Carlo Bernari and Pierluigi de Vecchi. *L'opera completa del Tintoretto*. Milan: Rizzoli.

Bernheimer, 1942-43: Richard Bernheimer. "A Drawing by Francesco Salviati," *Pacific Art Review*, II (Winter): 23-27.

Bertelà, 1975: see Florence, 1975.

Bertini, 1958: Aldo Bertini. *I disegni italiani della Biblioteca reale di Torino*. [Rome]: Instituto Poligrafico dello Stato.

Bialostocki, 1963: Jan Bialostocki. "The Renaissance Concept of Nature and Antiquity," II: 19-30, in *Acts of the Twentieth International Congress of the History of Art*, 4 vols. Princeton, NJ: Princeton University Press.

Bianchi, 1959: Lidia Bianchi. *Cento disegni della Biblioteca comunale di Urbania*. [Rome]: Gabinetto Nazionale delle Stampe.

Bianchi, 1972: see Rome, 1972.

Bierens de Haan, 1948: J. C. J. Bierens de Haan. *L'Oeuvre Gravé de Cornelius Cort, Graveur Hollandais, 1533-1578*. La Haye: Nijhoff.

Binghamton, 1972: University Art Gallery, State University of New York at Binghamton, Genoese Baroque Drawings. Cat. by Mary Newcome.

Birmingham, 1969: Birmingham Museum of Art, Alabama, Italian Drawings, Modern Paintings, and Treasures from the Vatican.

Birmingham, 1972: Birmingham Museum of Art, Veronese and His Studio in North American Collections. Cat. by David Rosand.

Bloomington, 1958: Indiana University Art Museum, Drawings of the Italian Renaissance from the Janos Scholz Collection. Cat. ed. by Creighton Gilbert.

Blunt, 1972: Anthony Blunt. "Supplement to the Catalogue of Italian Drawings," in *The German Drawings in the Collection of Her Majesty the Queen at Windsor Castle*. London and New York: Phaidon.

Bodmer, 1934: Heinrich Bodmer. "Drawings by the Carracci: An Aesthetic Analysis." *Old Master Drawings*, VII–VIII (March): 51–66.

Bodmer, 1939: Heinrich Bodmer. *Lodovico Carracci*. Leipzig: August Hopfer Verlag.

Bologna, 1953: Ferdinando Bologna. "Antonio Campi: la 'Circoncisione' del 1586," *Paragone*, IV (May): 46–51.

Bologna, 1956: Palazzo dell'Archiginnasio, Mostra dei Carracci Disegni. Cat. vol. I by Gian Carlo Cavalli et al., vol. II by Denis Mahon.

Bologna, 1975: Museo Civico, Mostra di Federico Barocci. Cat. by Andrea Emiliani and Giovanna Gaeta Bertelà. Bologna: Edizioni Alfa.

Bohr, 1958: R. H. Bohr. "The Italian Drawings in the E. P. Crocker Art Gallery, Collection, Sacramento." Ph.D. dissertation, University of California, Berkeley.

Borenius, 1921: Tancred Borenius. "A Group of Drawings by Paolo Veronese," *Burlington Magazine*, XXXVIII (Feb.): 54–59.

Borghini, 1584: Raffaelo Borghini. *Il Riposo*. Florence: Giorgio Marescotti, 1584.

Boschini, 1660: Marco Boschini. *La carta del navegar pitoresco*. Rome: Instituto per la collaborazione culturale [1966]; orig. publ., Venice.

Bottari and Ticozzi, 1822: Giovanni Bottari and Stefano Ticozzi. *Raccolta di lettere*, 8 vols. Milan: Giovanni Silvestri, 1822–1825.

Brandi, 1934: Cesare Brandi. "Disegni inediti di Domenico Beccafumi," *Bollettino d'Arte*, XXVII (Feb.): 350–369.

Brescia, 1965: Duomo Vecchio, Mostra di Girolamo Romanino. Cat. by Gaetano Panazza.

Brown, 1949: see Los Angeles, 1949.

Brown, 1960: G. Baldwin Brown, ed. *Vasari on Technique*, trans. Louisa S. Maclehose. New York: Dover.

Brummer, 1970: Hans Henrik Brummer. *The Statue Court in the Vatican Belevedere*. Stockholm: Almquist & Wiksell.

Bucci et al., 1959: see San Miniato, 1959.

Bucharest, 1932: Muzeul Roma Stelian. Desenul Expositie in Secolele al XVI-lea-XIX-lea.

Bullock, 1928: W. L. Bullock. "The Precept of Plagiarism in the Cinquecento," *Modern Philology*, XXV: 293–312.

Busse: 1911: Kurt Heinrich Busse. *Manierismus und Barockstil*. Leipzig.

Byam Shaw, 1955: see London, 1955.

Byam Shaw, 1976: James Byam Shaw. *Drawings by Old Masters at Christ Church, Oxford*, 2 vols. Oxford: The Clarendon Press.

Cambridge, 1962: Fogg Art Museum, Harvard University, Massachusetts, Anxiety and Elegance – The Human Figure in Italian Art, 1520–1580.

Cambridge, 1974: Fogg Art Museum, Rome and Venice, Prints of the High Renaissance. Cat. by Konrad Oberhuber.

Cambridge, 1977: Fogg Art Museum, Renaissance and Baroque Drawings from the Collections of John and Alice Steiner. Cat. ed. by Konrad Oberhuber.

Canedy, 1976: Norman Wigton Canedy. *The Roman Sketchbook of Girolamo da Carpi*. London: The Warburg Institute; Leiden: E. J. Brill.

Canova, 1964: Giordana Canova. *Paris Bordone*. Venice: Alfieri.

Cardi, 1628: G. Beatrice de Cardi, *Vita di Ludovico Cardi* (1628), ed. by G. Batelli and Kurt Busse. Florence, 1913.

Carroll, 1976: Eugene A. Carroll. *The Drawings of Rosso Fiorentino*, 2 vols. New York: Garland Publishing.

Carroll, 1978: Eugene A. Carroll. "A Drawing by Rosso Fiorentino of Judith and Holofernes," *Los Angeles County Museum of Art Bulletin*, XXIV: 25–49.

Castiglione, 1959: Baldassare Castiglione. *The Book of the Courtier*, trans. Charles S. Singleton. Garden City, N.Y.: Doubleday.

Catalogue of the Ellesmere Collection of Drawings at Bridgewater House. London: Bridgewater House, 1898.

Cellini: Benvenuto Cellini. *The Autobiography*, trans. John Addington Symonds. New York: Modern Library, n.d.

Cennini, 1960: Cennino Cennini. *The Craftsman's Handbook*, trans. Daniel V. Thompson, Jr. New York: Dover.

Chappell, 1978: Miles Chappell. "Letter to the Editor," *Art Bulletin*, XL (June): 395-396.

Chelazzi-Dini, 1963: Giulietta Chelazzi-Dini. "Aggiunte e precisazioni al Cigoli e alla sua cerchia," *Paragone*, XIV, no. 167: 51–65.

Choulant, 1920: Johann Ludwig Choulant. *History and Bibliography of Anatomic Illustration*. Chicago: University of Chicago Press.

Ciardi, 1961: Roberto P. Ciardi. "Disegni di Ambrogio Figino," *Critica d'Arte*, VIII, no. 48: 32–55.

Ciasca, 1922: Raffaele Ciasca, ed. *Arte dei Medici e Speziali*. Florence.

Clapp, 1914: Frederick Mortimer Clapp. *Les dessins de Pontormo*. Paris: E. Campion.

Cleveland, 1924: The Cleveland Museum of Art, Ohio, An Exhibition of Drawings. Cat. by T. Sizer, CMA *Bulletin*, XI (July): 140–144.

Cleveland, 1956: The Cleveland Museum of Art, 1956. Venetian Tradition. Cat. by Henry S. Francis.

Cleveland, 1959: The Cleveland Museum of Art, Year in Review. Cat. CMA *Bulletin*, XLVI (Dec.).

Cleveland, 1960: The Cleveland Museum of Art, Year in Review. Cat. CMA *Bulletin*, XLVII (Dec.).

Cleveland, 1962: The Cleveland Museum of Art, Year in Review. Cat. CMA *Bulletin*, XLIX (Nov.).

Cleveland, 1963: The Cleveland Museum of Art, Year in Review. Cat. CMA *Bulletin*, L (Dec.).

Cleveland, 1964: The Cleveland Museum of Art, Year in Review. Cat. CMA *Bulletin*, LI (Dec.).

Cleveland, 1965: The Cleveland Museum of Art, Year in Review. Cat. CMA *Bulletin*, LII (Nov.).

Cleveland, 1966: The Cleveland Museum of Art, Golden Anniversary Acquisitions. Cat. CMA *Bulletin*, LIII (Sept.).

Cleveland, 1970: The Cleveland Museum of Art, Year in Review. Cat. CMA *Bulletin*, LVII (Jan.).

Cleveland, 1971: The Cleveland Museum of Art, Florence and the Arts, Five Centuries of Patronage. Cat. by Edmund P. Pillsbury.

Cleveland, 1973: The Cleveland Museum of Art, Year in Review. Cat. CMA *Bulletin*, LX (March).

Cleveland, 1974: The Cleveland Museum of Art, Year in Review. Cat. CMA *Bulletin*, LXI (Feb.).

Cleveland, 1974b: The Cleveland Museum of Art, Art for Collectors.

Cleveland, 1975: The Cleveland Museum of Art, Year in Review. Cat. CMA *Bulletin*, LXIII (Feb.).

Cleveland, 1979: The Cleveland Museum of Art, Year in Review. Cat. CMA *Bulletin*, LXVI (Jan.).

Cocke, 1973: Richard Cocke. "Observations on Some Drawings by Paolo Veronese," *Master Drawings*, XI: 138–149.

Colasanti, 1905: Arduino Colasanti. "Il memoriale di Baccio Bandinelli," *Repertorum für Kunstwissenschaft*, XXVIII: 406–443.

Collobi, 1974: Licia Ragghianti Collobi. *Il libro de' disegni del Vasari*, 2 vols. [Florence]: Vallecchi.

Colonna, 1449: Francesco Colonna. *Hypnerotomachia Poliphili*. Venice.

Columbia, 1961: Museum of Art, South Carolina, Italian Baroque Drawings. Cat. preface by A. Hyatt Mayor.

Colvin, 1909: Sidney Colvin. *Vasari Society*, V (1909/10), no. 9.

Comanini, 1591: Gregorio Comanini. *Il Figino*. Mantua, 1591; reprinted in Barocchi, 1960, III, 237–379.

Condivi, 1553: Ascanio Condivi. *Vita di Michelangelo Buonarroti*. Rome.

Condivi, 1976: Ascanio Condivi. *The Life of Michelangelo*, trans. Alice S. Wohl, ed. Hellmut Wohl. Baton Rouge: Louisiana State University Press.

Cooney and Malafarina, 1976: Patrick J. Cooney and Gianfranco Malafarina. *L'opera completa di Annibale Carracci*. Milan: Rizzoli.

Corpus Graphicum Bergomense, II, 1970: Bergamo: Edizione "Monumenta Bergomensia," 1969–1970.

Cropper, 1976: Elizabeth Cropper. "On Beautiful Women, Parmigianino, *Petrarchismo*, and the Vernacular Style," *Art Bulletin*, LVIII: 374–394.

Crosato-Larcher, 1967: Luciana Crosato-Larcher. "Per Carletto Caliari," *Arte Veneta*, XXI: 108–124.

Crowe and Cavalcaselle, 1912: Joseph Archer Crowe and Giovanni Battista Cavalcaselle. *A History of Painting in North Italy*, 3 vols. New York: Scribner's.

Cuevas, 1932: J. Z. Cuevas. *Pintores Italiannos en San Lorenzo el real de el Escorial*. Madrid.

Da Como, 1930: Ugo da Como. *Girolamo Muziano*, 1528–1592. Bergamo: Instituto italiano d'arti grafiche.

Dacos, 1977: Nicole Dacos. *Le Logge di Raffaello*. [Rome]: Instituto Poligrafico dello Stato.

Davidson, 1966: see Florence, 1966a.

Degenhart, 1932: Bernhard Degenhart. "Die Schüler des Lorenzo di Credi," *Münchner Jahrbuch der Bildenden Kunst*, IX: 95–161.

Degenhart, 1937: Bernhard Degenhart. "Zur Graphologie der Handzeichnung. Die Strichbildung als stetige Erscheinung innerhalb der italienischen Kunstkreis," *Kunstgeschichtliches Jahrbuch der Biblioteca Hertziana*, I: 223–343.

Degenhart, 1955: Bernard Degenhart. "Dante, Leonardo und Sangallo," *Römisches Jahrbuch fur Kunstgeschichte*, VII: 101–287.

Degenhart, 1967: Bernhard Degenhart. *Italienische Zeichnungen 15–18. Jahrhundert*. Munich: Staatliche Graphische Sammlung.

Della Pergola, 1969: Paola della Pergola. *The Borghese Gallery in Rome*. [Rome]: Libreria dello Stato.

Detroit, 1958: Detroit Institute of Arts, Michigan, Decorative Arts of the Italian Renaissance, 1400–1600. Cat. intro. by Paul L. Grigaut.

Detroit, 1960: Detroit Institute of Arts, Master Drawings of the Italian Renaissance. Cat. by Nicholas Snow.

Detroit, 1965: Detroit Institute of Arts, Art in Italy 1600–1700. Cat. ed. by Frederick Cummings; intro. by Rudolf Wittkower.

De Vecchi, 1966: Pierluigi de Vecchi. *The Complete Paintings of Raphael*. New York: Harry N. Abrams.

Die Rubenszeichnungen der Albertina, intro. by Erwin Mitsch. [Vienna]: Albertina.

DiPietro, 1913: see Florence, 1913.

Dobroklonsky, 1940: Mikhail Dobroklonsky. *Catalogue of XV and XVI Century Italian Drawings in the Hermitage*. Leningrad: Hermitage.

Dolce, 1557: Lodovico Dolce. *Dialogo della pittura intitolato l'Aretino*. Venice: Gabriel Giolito de'Ferrari, 1557: reprinted in Barocchi, 1960, I, 141–206.

Dolce, 1968: see Roskill, 1968.

Dreyer, 1971: Peter Dreyer. *Tizian und sein Kreis*. Berlin: Staatliche Museen.

Dussler, 1927: Luitpold Dussler. "Two Unpublished Drawings by Giacomo Tintoretto," *The Burlington Magazine*, LI (July): 32–33.

Dussler, 1959: Luitpold Dussler. *Die Zeichnungen des Michelangelo*. Berlin: Verlag Gebr' Mann.

Edgerton, 1975: Samuel Y. Edgerton. *The Renaissance Rediscovery of Linear Perspective*. New York: Harper and Row, Icon.

Edinburgh, 1969: Merchant's Hall, Edinburgh Festival Society and Scottish Arts Council, Italian 16th-Century Drawings from British Private Collections. Cat. intro. by Keith Andrews.

Emiliani and Bertelà, 1975: see Bologna, 1975.

Estense, 1950: Mostra di Lelio Orsi. Cat. by Roberto Salvini and Alberto Mario Chiodi.

Ettlinger, 1961,: L. D. Ettlinger. "Exemplum Doloris: Reflections on the Laocoön Group," in *Essays in Honor of Erwin Panofsky*, 2 vols. New York: New York University Press.

Evans, 1973: R. J. W. Evans. "Rudolf and the Fine Arts," in *Rudolf II and His World*. Oxford: Clarendon Press.

Fahy, 1966: Everett Fahy. "The Beginnings of Fra Bartolommeo," *Burlington Magazine*, CVIII (Sept): 456–463.

Fairfax Murray, 1912: C. Fairfax Murray. *Collection J. Pierpont Morgan: Drawings by the Old Masters*, 4 vols. London: privately printed, 1905–1912.

Feinblatt, 1976: see Los Angeles, 1976.

Fern and Jones, 1969: Alan Maxwell Fern and Karen F. Jones. "The Pembroke Album of Chiaroscuro Woodcuts," *The Quarterly Journal of the Library of Congress*, XXVI (Jan.): 8–20.

Ferrari, 1961: Maria Luisa Ferrari. *Il Romanino*. Milan: Bramante Editrice.

Ferri, 1913: Pasquale Nerino Ferri. *I disegni della R. Galleria degli Uffizi* Florence: L. S. Olschki.

Fialetti, 1608: Odoardo Fialetti. *Il modo vero et ordine per dissegnar tutte le parti et membra del corpo humano*. Venice: Justus Sadeler.

Fiocco, 1928: Giuseppe Fiocco. *Paolo Veronese, 1528–1588*. Bologna: Apollo.

Fiocco, 1943: Giuseppe Fiocco. *Giovanni Antonio Pordenone*. Padua: "Le tre venezie."

Fischel, 1912: Oskar Fischel. "Some Lost Drawings by or Near to Raphael," *Burlington Magazine*, XX (Feb.): 294–295.

Fischel, 1913–72: Oskar Fischel. *Raphaels Zeichnungen*, 9 vols. Berlin: G. Grote.

Fischel, 1939: Oskar Fischel. "Raphael's Pink Sketch-Book," *Burlington Magazine*, LXXIV (April): 181–187.

Fischel, 1948: Oskar Fischel. *Raphael*, 2 vols. London: Kegan Paul.

J. Fleming, 1958: John Fleming. "Mr. Kent, Art Dealer, and the Fra Bartolommeo Drawings." *Connoisseur*, CXLI (May): 227.

Florence, 1913: Instituto micrografico italiano, Disegni sconosciuti e disegni finora non identificati di Federigo Barocci negli Uffizi. Cat. by Filippo DiPietro.

Florence, 1959: Gabinetto disegni e stampe degli Uffizi, Mostra di disegni di Andrea Boscoli. Cat. by Anna Forlani.

Florence, 1962: Gabinetto disegni e stampe degli Uffizi, Mostra di disegni di Jacopo da Empoli. Cat. by Anna Forlani and Adelaide Bianchini. Florence: Leo S. Olschki.

Florence, 1966a: Gabinetto disegni e stampe degli Uffizi, Mostra di disegni di Perino del Vaga e la sua cerchia. Cat. by Bernice F. Davidson. Florence: Leo S. Olschki.

Florence, 1966b: Gabinetto disegni e stampe degli Uffizi, Mostra di disegni degli Zuccari. Cat. by John A. Gere. Florence: Leo S. Olschki.

Florence, 1970: Gabinetto disegni e stampe degli Uffizi, Mostra di disegni di Allessandro Allori. Cat. by Simone Lecchini Giovannoni. Florence: Leo S. Olschki.

Florence, 1975: Gabinetto disegni e stampe degli Uffizi, Disegni di Federico Barocci. Cat. by Giovanna Gaeta Bertelà. Florence: Leo S. Olschki.

Forbes, 1965: Thomas R. Forbes. "Addendum: Franco's Osteology," *Journal of the History of Medicine and Allied Sciences*, XX: 409.

Forlani, 1964: Anna Forlani. *I disegni italiani del Cinquecento*. [Venice]: Sodalizio del libro.

Forlani and Bianchini, 1962: see Florence, 1962.

Fort Worth, 1965: Fort Worth Art Center, The School of Fontainebleau: An Exhibition of Paintings, Drawings, Engravings, Etchings, and Sculpture 1530–1619. Cat. by Marian Davis with Sam Cantey.

Fracastoro, 1924: Girolamo Fracastoro. *Naugerius, sive de poetica dialogus*, intro. by M. W. Bundy, trans. R. Kelso. University of Illinois Studies in Language and Literature, IX, no. 3. Urbana: University of Illinois.

Francis, 1943a: Henry S. Francis. "A Drawing in Red Chalk by Michelangelo," CMA *Bulletin*, XXX (March): 25–26.

Francis, 1943b: Henry S. Francis. "A Drawing in Red Chalk by Michelangelo," *Art Quarterly*, VI (Winter): 63.

Francis, 1947: Henry S. Francis. "The Judgment of Paris, A Drawing Attributed to Paolo Veronese," CMA *Bulletin*, XXXIV (June): 176–177.

Francis, 1958: Henry S. Francis. "A Design for a Candelabrum by Bernardo Parentino," CMA *Bulletin*, XLV (Oct.): 199–200.

Francis, 1965: Henry S. Francis. "Domenichino, Preparatory Drawing of Temperance," CMA *Bulletin*, LII (Dec.): 175–177.

Frankfurter, 1936: Alfred M. Frankfurter. "A Century of Venetian Art Presented in Fine Display," *Art News*, XXXIV, pt. 1 (Jan.): 3–5.

Frankfurter, 1939: Alfred M. Frankfurter. "Master Drawings of the Renaissance, Notable and New Items in American Collections," *Art News Annual*, XXXVII (Feb.): 97–100, 180–185.

Freedberg, 1949: Sydney J. Freedberg. "Further to Lord Stafford's Parmigianino," *Burlington Magazine*, XCI (Aug.): 230–233.

Freedberg, 1951: Sydney J. Freedberg. *Parmigianino: His Works in Painting*. Cambridge, MA: Harvard University Press.

Freedberg, 1971: Sydney J. Freedberg. *Painting in Italy: 1500–1600*. Baltimore, MD: Penguin Books.

Friedlaender, 1955: Walter Friedlaender. *Caravaggio Studies*. Princeton, NJ: Princeton University Press.

Friedlaender, 1957: Walter Friedlaender. *Mannerism and Anti-Mannerism in Italian Painting*. New York: Columbia University Press.

Friedlaender, 1965: Walter Friedlaender. *Mannerism and Anti-Mannerism in Italian Painting*. New York: Schocken.

Frölich-Bum, 1929: L. von Frölich-Bum. "Die Landschaftzeichnungen Tizians," *Belvedere*, VIII: 71–78.

Gauricus, 1969: Pomponius Gauricus (Gaurico). *De Sculptura*, ed. and trans. André Chastel and Robert Klein. Geneva: Librairie Droz.

Genoa, 1956: Palazzo dell'Accademia, Luca Cambiaso e la sua Fortuna. Cat. by Giuliano Frabetti and Anna Maria Gabbrielli, intro. by Caterina Marcenaro.

Gere, 1963a: John A. Gere. "Taddeo Zuccaro as a Designer for Maiolica," *Burlington Magazine*, CV (July): 306–315.

Gere, 1963b: John A. Gere. "Two Panel-Pictures by Taddeo Zuccaro and Some Related Compositions — II: The 'Agony in the Garden' in the Strossmayer Gallery, Zabreb," *Burlington Magazine*, CV (Sept.): 390–395.

Gere, 1966: see Florence, 1966b.

Gere, 1969a: John A. Gere. *Taddeo Zuccaro, His Development Studied in His Drawings* London: Faber and Faber.

Gere, 1969b: see Paris, 1969.

Gere, 1970: John A. Gere. "The Lawrence-Phillipps-Rosenbach 'Zuccaro Album,'" *Master Drawings*, VIII (Summer): 123–140.

Gere, 1971a: John A. Gere. *Il manierismo a Roma*. [Milan]: Fratelli Fabbri editori.

Gere, 1971b: John A. Gere. "Some Early Drawings by Pirro Ligorio," *Master Drawings*, IX (Autumn): 239–250.

Gibbons, 1977: Felton Lewis Gibbons. *Catalogue of Italian Drawings in the Art Museum, Princeton University*, 2 vols. Princeton, NJ: Princeton University Press.

Gilbert, 1958: see Bloomington, 1958.

Gilbert, 1962: Creighton Gilbert, "Una Monografia sul Romanino," *Arte Veneta*, XVI: 199–202.

Gilio, 1564: Giovanni Andrea Gilio. *Due dialoghi*. Rome.

Giovannoni, 1970: see Florence, 1970.

Glaser, 1959: Mary T. Glaser. *Great Master Drawings of Seven Centuries*. New York: M. Knoedler.

"Golden Anniversary Acquisitions." CMA *Bulletin*, LIII (Sept.): 181–276.

Goldscheider, 1951: Ludwig Goldscheider. *Michelangelo Drawings*. London: Phaidon Press.

Gombrich, 1960: Ernst H. Gombrich. *Art and Illusion*. Princeton, NJ: Princeton University Press.

Gombrich, 1963: Ernst H. Gombrich. "The Style *all-antica*: Imitation and Assimilation," in *Studies in Western Art*, II. *The Renaissance and Mannerism*, 4 vols. Princeton, NJ: Princeton University Press.

Gombrich, 1966: Ernst Hans Gombrich. *Norm and Form*. London: Phaidon.

Gombrich, 1976: Ernst H. Gombrich. "Light, Form and Texture in Fifteenth-Century Painting," in *The Heritage of Apelles*. Ithaca, NY: Cornell University Press.

Gould, 1975: Cecil Hilton Gould. *National Gallery Catalogues, The Sixteenth-Century Italian Schools*. London.

Grayson, 1972: Cecil Grayson, ed. *Leon Battista Alberti: On Painting and On Sculpture*. London: Phaidon.

Grigaut, 1959: see Detroit, 1959.

C. Gronau, 1957: C. Gronau. Preface to *Catalogue of Drawings of Landscapes and Trees by Fra Bartolommeo*. London: Sotheby and Company, 20 November 1957.

Gruyer, 1900: François Anatole Gruyer. *Chantilly Musée Condé: Notice des Peintures*. Paris: Plon-Nourrit.

Günther, 1969: Hubertus Günther. "Uffizien 135A — Eine Studie Baroccis," *Mitteilungen des Kunsthistorischen Institutes in Florenz*, XIV: 239–246.

Hadeln, 1911: Detlev von Hadeln. "Gabriele Caliari," in *Thieme-Becker*, vol. 5. Leipzig: 1911.

Hadeln, 1922: Detlev von Hadeln. *Zeichnungen des Giacomo Tintoretto*. Berlin: Cassirer.

Hadeln, 1926: Detlev von Hadeln. *Venezianische Zeichnungen der Spätrenaissance*. Berlin: Paul Cassirer.

Hadeln, 1927: Detlev von Hadeln. *Titian's Drawings*. London: Macmillan.

Hadeln, 1928: Detlev von Hadeln. "Parrasio Michieli," *Apollo*, VII (Jan.): 17–21.

Hagerstown, 1960: Washington County Museum of Fine Arts, Maryland, Four Centuries of Italian Drawings from the Scholz Collection. Cat. by J. Scholz.

Hake, 1922: Henry M. Hake. "Pond's and Knapton's Imitations of Drawings," *Print Collector's Quarterly*, IX (Dec.): 323–349.

Hall, 1959: Vernon Hall, Jr. *Renaissance Literary Criticism*. Gloucester, MA: Peter Smith.

Hamburg, 1963: Kunsthalle, Italienische Meisterzeichnungen vom 14. bis zum 18. Jahrhundert aus amerikanischem Besitz die Sammlung Janos Scholz, New York. Cat. by Wolf Stubbe.

Hamburg, 1972: Kunsthalle, The Ellesmere Collection of Drawings by The Carracci and Other Bolognese Masters.

Hartford, 1946: Wadsworth Atheneum, Connecticut, The Nude in Art. Cat. intro. by W. G. Constable.

Hartt, 1958: Frederick Hartt. *Giulio Romano*, 2 vols. New Haven, CT: Yale University Press.

160

Hartt, 1970: Frederick Hartt. *Michelangelo Drawings*. New York: Harry N. Abrams.

Hartt, 1971: Frederick Hartt. *History of Italian Renaissance Art*. Englewood Cliffs, NJ: Prentice-Hall.

Hayward, 1976: John F. Hayward. *Virtuoso Goldsmiths and the Triumph of Mannerism, 1540–1620*. [London]: Sotheby Parke Bernet.

Heikamp, 1957: Detlef Heikamp. "Vincende di Federico Zuccari," *Rivista d'arte*, (32) 3d ser., VII: 200–215.

Heikamp, 1961: Detlef Heikamp. *Scritti d'arte di Federico Zuccaro*. Florence: Leo S. Olschki.

Heseltine, 1913: John Postle Heseltine. *Original Drawings by Old Masters of the Italian School Forming Part of the Collection of J. P. Heseltine*. London: privately printed.

Heydenreich, 1933: Ludwig-Heinrich Heydenreich. "La Sainte Anne de Léonard de Vinci," *Gazette des Beaux-Arts*, X: 205–219.

Hibbard, 1974: Howard Hibbard. *Michelangelo*. New York: Harper and Row.

Hind, 1910: Arthur Mayger Hind. *Catalogue of Early Italian Engravings Preserved in the Department of Prints and Drawings in the British Museum*. 2 vols., ed. by Sidney Colvin. London: The British Museum.

Hind, 1938-48: Arthur Mayger Hind. *Early Italian Engraving*, 7 vols. London: B. Quaritch.

Hirst, 1976: Michael Hirst, "A Project of Michelangelo's for the Tomb of Julius II," *Master Drawings*, XIV (Winter): 375–382.

Hirst, 1978: Michael Hirst. "A Drawing of the Rape of Ganymede by Michelangelo," I: 253–260. in *Essays Presented to Myron P. Gilmore*, 2 vols. Florence: La Nuova Italia.

Hoffman, 1975: Joseph Robert Hoffman. "Lelio Orsi da Novellara (1511–1587), A Stylistic Chronology," Ph.D. dissertation, University of Wisconsin.

Hollstein, 1949: F. W. H. Hollstein. *Dutch and Flemish Etchings, Engravings and Woodcuts ca. 1450–1700*, 20 vols. Amsterdam: Menno Hertzberger, 1949– .

Houston, 1960: The Museum of Fine Arts, Texas, The Lively Arts of the Renaissance. Cat. foreword by Jermayne MacAgy.

Houston, 1966: The University of St. Thomas Art Department, Texas, Builders and Humanists: The Renaissance Popes as Patrons of the Arts. Cat. intro. by Raymond Marcel.

Houston, 1974: The Museum of Fine Arts, Texas, The Genoese Renaissance, Grace and Geometry: Paintings and Drawings by Luca Cambiaso from the Suida-Manning Collection. Cat. by Bertina Suida Manning and Robert L. Manning.

Hubbard, 1957: Robert Hamilton Hubbard, ed. *The National Gallery of Canada, Catalogue of Paintings and Sculpture*, vol. I. Ottawa and Toronto: University of Toronto Press.

Hülsen and Egger, 1913: Christian Hülsen and Hermann Egger. *Die römischen Skizzenbücher von Marten van Heemskerck*, 2 vols. Berlin: J. Bard, 1913 and 1916.

Il Cavaliere d'Arpino. Rome: Da Luca Editore, 1973.

Il Paesaggio, 1972: see Rome, 1972.

Indianapolis, 1954: The John Herron Art Museum, Indiana, Pontormo to Greco: The Age of Mannerism.

Jaffé, 1964: Michael Jaffé. "Rubens as a Collector of Drawings, Part One," *Master Drawings*, II: 383–397.

Jaffé, 1965: Michael Jaffé. "Rubens as a Collector of Drawings, Part Two," *Master Drawings*, III: 21–35.

James, 1950: Montague Rhodes James. *The Apocryphal New Testament*. Oxford: Clarendon Press.

Jeudwine, 1957: W. R. Jeudwine. "Fine Works on the Market, a Volume of Landscape Drawings by Fra Bartolommeo," *Apollo*, LXVI (Nov.): 132–133, 135.

Johnson, 1885: Henry Johnson. *Catalogue of the Bowdoin Art Collections*, vol. I: *The Bowdoin Drawings*. Brunswick, ME: Bowdoin College Library.

Karpinski, 1971: Caroline Karpinski, ed. *Italian Chiaroscuro Woodcuts*. University Park: The Pennsylvania State University Press.

Kaufmann, 1976: Thomas DaCosta Kaufmann. "Arcimboldo's Imperial Allegories," *Zeitschrift für Kunstgeschichte*, XXXIX: 275–296.

Keele, 1977: K. D. Keele. Leonardo da Vinci, Anatomical Drawings from the Royal Collection. London: Royal Academy of Arts.

Keller, 1967: Rolf E. Keller. *Das Oratorium von San Giovanni Decollato in Rom*. Neuchatel: Paul Attinger.

R. W. Kennedy, 1959: Ruth Wedgwood Kennedy. "A Landscape Drawing by Fra Bartolommeo," *Bulletin of the Smith College Museum of Art* [Northampton, MA], no. 39, pp. 1–12.

Körte, 1932: Werner Körte. "Verlorene Frühwerke des Federico Zuccari in Rom," *Mitteilungen des Kunsthistorischen Institutes in Florenz*, III (Jan.): 518–529.

Koschatzky et al., 1972: Walter Koschatzky, Konrad Oberhuber, and Eckhart Knab. *I grandi disegni italiani dell'Albertina di Vienna*. Milan: Silvana editoriale d'arte.

Kosoff, 1963: Florence Kosoff. "A New Book on Romanino," *Burlington Magazine*, CV (Feb.): 72–77.

Krönig, 1964: Wolfang Krönig. "Zeichnungen von Luca Cambiaso in Köln," *Arte Lombarda*, IX: 125–129.

Kruft, 1969: Hanno Walter Kruft. "Ein Album mit Porträtzeichnungen Ottavio Leonis," *Storia dell'arte*, IV: 447–458.

Kurth, 1963: Willi Kurth. *The Complete Woodcuts of Albrecht Dürer*. New York: Dover.

Kurz, 1948: Otto Kurz. *Fakes: A Handbook for Collectors and Students*. New Haven, CT: Yale University Press.

Kurz, 1955: Otto Kurz. *Bolognese Drawings of the XVII and XVIII Centuries in the Collection of Her Majesty the Queen at Windsor Castle*. London: Phaidon.

Kusenberg, 1931: Kurt Kusenberg. *Le Rosso*. Paris: A. Michel.

Larcher, 1967: Luciana Crosato Larcher. "Per Carletto Caliari," *Arte Veneta*, XXI: 108–124.

Larner, 1971: John Larner. *Culture and Society in Italy 1290–1410*. London: B. T. Batsford.

Lautensack, 1546: Heinrich Lautensack. *Des Circkels unnd Richtscheyts Underweisung*. Frankfort am Main.

Lee, 1967: Rensselaer Lee. *Ut pictura poesis: The Humanistic Theory of Painting*. New York: W. W. Norton, 1967.

Leicester, 1954: The museums and art galleries, The Ellesmere Collection of Old Master Drawings. Cat. by P. A. Tomory.

Levenson et al., 1973: Joy A. Levenson, Konrad Oberhuber, and Jacquelyn L. Sheehan. *Early Italian Engravings from the National Gallery of Art*. Washington, DC: National Gallery of Art.

Levey, 1971: Michael Levey. *National Gallery Catalogues, The Seventeenth- and Eighteenth-Century Italian Schools*. London: The National Gallery.

Levey, 1975: Michael Levey. *High Renaissance*. Baltimore, MD: Penguin.

Lewine, 1967: Milton J. Lewine. "The Carracci: A Family Academy," pp. 19–27, in *The Academy*. New York: Macmillan.

Ligorio, 1553: Pirro Ligorio. *Libro de Pyrrho Ligorio Napoletano delle Antichità di Roma*. Venice.

Liphart Rathshoff, 1935: Rinaldo de Liphart Rathshoff. "Un libro di schizzi di Domenico Beccafumi," *Rivista d'Arte*, 2d ser., XVII: 33–70.

Lodge, 1953: Rupert Clendon Lodge. *Plato's Theory of Art*. London: Routledge and Kegan Paul.

Lomazzo, 1584: Giovanni Paolo Lomazzo. *Trattato dell'arte de la pittura*. Milan: Paolo Gottardo Pontio.

Lomazzo, 1590: Giovanni Paolo Lomazzo. *Idea del Tempio della Pittura*. Milan: Paolo Gottardo Ponto.

London, 1836: The Lawrence Gallery, A Catalogue of One Hundred Original Drawings by Julio Romano, Primaticcio, Leonardo da Vinci, and Perino del Vaga, Collected by Sir Thomas Lawrence, Late President of The Royal Academy, Fifth Exhibition.

London, 1938: Royal Academy of Arts, 17th-Century Art in Europe.

London, 1953: Royal Academy of Arts, Drawings by Old Masters. Preface by Gerald Kelly.

London, 1955: P. & D. Colnaghi & Co., A Loan Exhibition of Drawings by The Carracci and Other Masters from the Collection of The Earl of Ellesmere. Cat. by James Byam Shaw.

London, 1959: P. & D. Colnaghi & Co., Loan Exhibition of Drawings by Old Masters from the Collection of Dr. and Mrs. Francis Springell.

London, 1968: British Arts Council Gallery, Italian Drawings from the Collection of Janos Scholz. Cat. by C. White.

London, 1977: Royal Academy of Arts, Leonardo da Vinci: Anatomical Drawings from the Royal Collection. Cat. by Kenneth D. Keele.

Longhi, 1951: Roberto Longhi. "Volti della Roma Caravaggesca," *Paragone*, II, no. 21: 35–39.

Los Angeles, 1949: Los Angeles County Museum of Art, California, Leonardo da Vinci. Cat. by David Brown.

Los Angeles, 1967: Los Angeles County Museum of Art, Tuscan and Venetian Drawings of the Quattrocento from the Collection of Janos Scholz. Cat. by Ebria Feinblatt.

Los Angeles, 1976: The Los Angeles County Museum of Art, Old Master Drawings from American Collections. Cat. by Ebria Feinblatt.

Lugt, 1921: F. Lugt. *Les Marques de Collections de dessins et l'estampes*, 2 vols. Amsterdam.

Mahon, 1953: Denis Mahon. "Eclecticism and the Carracci: Further Reflections on the Validity of a Label," *Journal of the Warburg and Courtauld Institutes*, XVI: 303–341.

Mahoney, 1962: Michael Mahoney. "Some Graphic Links Between the Young Albani and Annibale Carracci," *Burlington Magazine*, CIV (Sept.): 386–389.

Malstrom, 1968-69: Ronald E. Malstrom. "A Note on the Architectural Setting of Federico Barocci's *Aeneas' Flight from Troy*," *Marsyas*, XIV: 43–47.

Malvasia, 1678: Carlo Cesare Malvasia. *Felsina pittrice: vite de pittori bolognesi*, 2 vols. Bologna, 1678; reprinted by P. Brascaglia, 1971.

Malvasia, 1841: Carlo Cesare Malvasia. *Felsina pittrice*. Bologna: Tip Guidi all' Ancora.

Mancini, 1956: Giulio Mancini. *Considerazioni sulla pittura*, ed. Adriana Marucchi, 2 vols. Rome: Accademia Nazionale dei Lincei.

Mandowsky and Mitchell, 1963: Erna Mandowsky and Charles Mitchell. *Pirro Ligorio's Roman Antiquities*. London: The Warburg Institute.

Manning, 1967: see New York, 1967.

Manning and Manning, 1974: see Houston, 1974.

Manning and Suida, 1958: Bertina Suida Manning and William Suida. *Luca Cambiaso, la vita e le opere*. Milan: Casa Editrice Ceschina.

Mariette, 1741: P. J. Mariette. *Description sommaire des desseins des grands maistres d'Italie des Pays-Bas, et de France, du cabinet de feu M. Crozat*. Paris.

Mariette, 1853: Pierre-Jean Mariette. *Abecedario de Pierre-Jean Mariette et autres notes inédites de cet amateur sur les arts et les artistes*. Paris: MM. Ph. de Chennevières et A. de Montaiglon.

Mather, 1913: Frank Jewett Mather. "Drawings by Old Masters at Bowdoin College," *Art in America*, I.

Mauroner, 1943: Fabio Mauroner. *Le incisioni di Tiziano*. Padua: Le Tre Venezie.

Mayor, 1871: William Mayor. *A Brief Chronological Description of a Collection of Original Drawings and Sketches, by the Most Celebrated Masters of the Different Schools of Europe, from the Revival of Art in the XIIIth to the Middle of the XVIIIth Century; Formed by and Belonging to Mr. Mayor*. London.

McComb, 1928: Arthur Kilgore McComb. *Agnolo Bronzino: His Life and Works* Cambridge, MA: Harvard University Press.

McMurrich, 1930: J. Playfair McMurrich. *Leonardo da Vinci, The Anatomist (1452–1519)*. Baltimore, MD: Williams and Wilkins.

Meder, 1923: Joseph Meder. *Die Handzeichnung: Ihre Technik und Entwickllng*. Vienna: A Schroll.

Meder, 1978: Joseph Meder. *The Mastery of Drawing*, trans. Winslow Ames, 2 vols. New York: Abaris Books.

Meijer, 1974: Bert W. Meijer. "Early Drawings by Titian: Some Attributions." *Arte Veneta*, XXVIII: 75–92.

Meiss, 1963: Millard Meiss. "French and Italian Variations on an Early Fifteenth-Century Theme: St. Jerome and His Study," *Gazette des Beaux-Arts*, LXII: 147–170.

Meiss, 1964: Millard Meiss. *Giovanni Bellini's St. Francis*. Princeton, NJ: Princeton University Press.

Meiss, 1976: Millard Meiss. "Scholarship and Penitence in the Early Renaissance: The Image of St. Jerome," in *The Painter's Choice*. New York: Harper & Row.

Michiel, 1969: Marcantonio Michiel. *The Anonimo*, ed. George C. Williamson, trans. Paolo Mussi. New York: Benjamin Blom.

Middletown, CT, 1969: Davison Art Center, Wesleyan University, Connecticut, Italian Master Drawings from the Collection of Janos Scholz.

Milan, 1912: Museo Civico, I disegni del Museo Civico: Collezione Malaspina. Cat. by Renato Sòriga. Milan: Alfieri and Lacroix.

Milliken, 1958: William M. Milliken. *The Cleveland Museum of Art*. New York: Harry N. Abrams.

Milstein, 1978: Ann Rebecca Milstein. *The Paintings of Girolamo Mazzola Bedoli*. New York: Garland Publishing.

Milwaukee, University of Wisconsin, 1964: Italian Drawings, To Commemorate the 400th Anniversary of the Death of Michelangelo. Cat. by Jack Wasserman.

Minturino, 1559: Antonio Minturino. *De poeta libri sex*. Venice.

Mongan, 1949: Agnes Mongan, ed. *One Hundred Master Drawings*. Cambridge, MA: Harvard University Press.

Mongan and Sachs, 1940: Agnes Mongan and Paul J. Sachs, *Drawings in the Fogg Museum of Art*, 3 vols. Cambridge, MA: Harvard University Press.

Montgomery, 1976: Montgomery Museum of Fine Arts, Alabama, Venetian Drawings from the Collection of Janos Scholz. Cat. by Diane J. Gingold.

Morassi, 1931: Antonio Morassi. "The Other Painter of Malpaga," *Burlington Magazine*, LVIII (March): 118–129.

Morassi, 1959: Antonio Morassi. "Alcuni disegni inediti del Romanino," pp. 189–192 in *Festschrift Karl M. Swoboda*. Vienna: Rudolf M. Rohrer Verlag.

Morgan Library, 1976: *Seventeenth Report to The Fellows of The Pierpont Morgan Library, 1972–1974*. New York.

Moskowitz, 1962: Ira Moskowitz, ed. *Great Drawings of All Time*, 4 vols. New York: Shorewood Publishers.

Mostra di disegni dei fondatori dell'Academia delle Arti del disegno. Florence, 1963.

Munich, 1967: Staatliche Graphische Sammlung, 4 May–6 August, Italienische Zeichnungen, 15.-18. Jahrhundert. Cat. by Konrad Oberhuber.

National Gallery, General Catalogue, 1973: *The National Gallery, Illustrated General Catalogue*. London: The National Gallery.

Neilson, 1972: see St. Louis, 1972.

Newark, 1960: The Newark Museum, New Jersey, Old Master Drawings. Cat. intro. by Elaine Evans Gerdts and William H. Gerdts.

Newcastle upon Tyne, 1961: King's College, The Carracci, Drawings and Paintings. Cat. by Ralph Holland.

New Haven, 1960: Yale University, Connecticut, Musical Instruments from the 15th to 20th Centuries. Cat. by Sybil Marcuse.

New Haven, 1964: Yale University Art Gallery, Italian Drawings from the Collection of Janos Scholz. Cat. by Egbert Haverkamp-Begeman and Ellen Sharp.

New Haven, 1974: Yale University Art Gallery, Sixteenth-Century Italian Drawings, Form and Function. Cat. by Edmund Pillsbury and John Caldwell.

New Haven, 1978: Yale University Art Gallery, The Graphic Art of Federico Barocci. Cat. by Edmund Pillsbury and Louise S. Richards.

Newton, 1952: Eric Newton. *Tintoretto*. New York: Longmans, Green and Co.

New York, 1953: The Pierpont Morgan Library, Landscape Drawings and Water Colors, Bruegel to Cézanne.

New York, 1959: M. Knoedler and Co., Great Master Drawings of Seven Centuries. Cat. by Mary Todd Glaser, intro. by Winslow Ames.

New York, 1960: Grolier Club, Fifty Personalities: Masters of Italian Drawing, 1400-1800.

New York, 1961: Staten Island Museum, Italian Drawings from the Janos Scholz Collection. Cat. by Janos Scholz.

New York, Seiferheld Gallery, 1961: Bassano Drawings.

New York, 1965: The Metropolitan Museum of Art and The Pierpont Morgan Library, Drawings from New York Collections, I: The Italian Renaissance. Cat. by Jacob Bean and Felice Stampfle.

New York, Scholz Collection, 1965: The Metropolitan Museum of Art, Italian Drawings from the Collection of Janos Scholz.

New York, 1967: Finch College Museum of Art, Drawings of Luca Cambiaso. Cat. by Robert L. Manning.

New York, 1969: The Metropolitan Museum of Art. Florentine Baroque Art from American Collections. Cat. by Joan Nissman, intro. by Howard Hibbard.

New York, 1971: The New School Art Center, One Hundred Italian Drawings from the Fourteenth to the Eighteenth Centuries from the Janos Scholz Collection. Cat. by Janos Scholz.

New York, 1973: Metropolitan Museum of Art, Drawings and Prints by The Caracci. Cat. by Jacob Bean.

New York, 1974: Pierpont Morgan Library, Drawings: Major Acquisitions of the Pierpont Morgan Library, 1924-1974. Vol. II, cat. intro. by F. Stampfle.

Northampton, 1941: Smith College Museum of Art, Massachusetts, Italian Drawings 1330-1780. Cat. by Ruth Wedgwood Kennedy.

Northampton, 1957: Smith College Museum of Art, Michelangelo's "Figura Serpentina."

Northampton, 1978: Smith College Museum of Art, Antiquity in the Renaissance. Cat. by Wendy S. Sheard.

Norton, 1971: Watson Art Center, Wheaton College, Italian Renaissance Drawings from the Janos Scholz Collection.

Norton, 1976: Watson Gallery, Wheaton College, Process of Perfection.

Notre Dame, 1964: Art Gallery, University of Notre Dame, Indiana, The Life of Christ: Drawings from the Janos Scholz Collection. Cat. by Janos Scholz.

Notre Dame, 1967: Art Gallery, University of Notre Dame, The Life of the Virgin Mary: Drawings from the Janos Scholz Collection. Cat. by Dean A. Porter.

Notre Dame, 1970: Art Gallery, Notre Dame University, The Age of Vasari.

Oakland, 1956: Mills College Gallery, California, Drawings from Lombardy and Adjacent Areas, 1480-1620. Cat. by Alfred Neumeyer.

Oakland, 1959: Mills College Art Gallery, Venetian Drawings 1400-1630. Cat. by Alfred Neumeyer.

Oakland, 1961: Mills College Art Gallery, Drawings from Tuscany and Umbria 1350-1700. Cat. by Alfred Neumeyer.

Oberhuber, 1966: Oberhuber. *Graphische Sammlung Albertina, Die Kunst der Graphik*. Vol. III: *Renaissance in Italien 16. Jahrhundert*. Vienna: Arno/Worldwide.

Oberhuber, 1974: see Cambridge, 1974.

Oberhuber, 1976: see Venice, 1976.

Oberhuber, 1977: see Cambridge, 1977.

Oberhuber, 1978: Konrad Oberhuber. "Charles Loeser as a Collector of Drawings," *Apollo*, CVII (June): 464-469.

Oberhuber, 1979: Konrad Oberhuber, ed. *Old Master Drawings: Selections from the Charles A. Loeser Bequest*. Cambridge, MA: Fogg Art Museum.

Oberhuber and Walker, 1973: See Washington, 1973.

Olsen, 1962: Harald Olsen. *Federico Barocci*. Copenhaggen: Minksgaard.

Olsen, 1965: Harald Olsen. "Some Drawings by Federico Barocci," *Artes*, I (Oct.): 17-34.

Olszewski, 1976: Edward J. Olszewski. "A Design for the Sistine Chapel Ceiling," CMA *Bulletin*, LXIII (Jan.): 12-26.

Olszewski, 1977: see Armenini, 1977.

Original Drawings, 1906: *Original Drawings by Old Masters of the Schools of North Italy in the Collection of John Postle Haseltine*. London: Privately printed.

Ostrow, 1968: See Providence, 1968.

Ottawa, 1973: The National Gallery of Canada, Fontainebleau, Art in France 1528-1610. Cat. intro. by André Chastel.

Ottino della Chiesa, 1967: Angela Ottino della Chiesa. *The Complete Paintings of Leonardo da Vinci*. New York: Abrams.

Ottokar, 1937: Nicola Ottokar. "Pittori e contratti d'apprendimento presso pittori a Firenze alle fine del dugento," *Rivista d'arte*, XIX: 55-57.

Pacioli, 1509: Luca Pacioli. *De divina proportione*. Venice.

Pallucchini, 1969: R. Pallucchini. *Tiziano*. Florence: G. C. Sansoni.

Panofsky, 1940: Erwin Panofsky, *The Codex Huygens and Leonard da Vinci's Art Theory*. London: The Warburg Institute.

Paris, 1964: Musée du Louvre, Dessins de l'Ecole de Parme: Corrège, Permesan. Cat. by Roseline Bacou.

Paris, 1969: Musée du Louvre, Dessins de Taddeo et Federico Zuccaro. Cat. by John A. Gere.

Paris, 1971: Galerie Claude Aubry, Dessins français et italiens du XVIe et du XVIIe Siècle dans les collections privées françaises.

Paris, 1974: Musée du Louvre, Cartons d'artistes du XV au XIXe siècle. Cat. by Roseline Bacou.

Parker, 1956: K. T. Parker. *Catalogue of the Collection of Drawings in the Ashmolean Museum*, 2 vols. Oxford: Clarendon Press.

Passamani, 1965: Bruno Passamani. *Gli affreschi del Romanino al Buonconsiglio di Trento*. Trent.

Passavant, 1839: Johann David Passavant. *Rafael von Urbino*, 2 vols. Leipzig.

Passavant, 1860: Johann David Passavant. *Raphael d'Urbin et son pére Giovanni Santi*, 2 vols. Paris: Paul Lacroix.

Passavant, 1860-64: Johann David Passavant. *Le peintre-graveur*, 6 vols. Leipzig: Weigel.

Passeri, 1772: Giovanni Battista Passeri. *Vite de' pittori scultori ed architetti che anno lavorato in Roma Morti dal 1641 fino 1673*. Rome.

Pastor, 1923: Ludwig von Pastor. *The History of the Popes*. 40 vols. London: Kegan Paul, 1902-1953.

Pedretti, 1964: Carlo Pedretti. *Leonardo da Vinci on Painting, A Lost Book (Libro A)*. Los Angeles: University of California Press.

Pedretti, 1973: Carlo Pedretti. *Leonardo: A Study in Chronology and Style*. Berkeley: University of California Press.

Pedretti, 1977: Carlo Pedretti. *The Literary Works of Leonardo da Vinci*, 2 vols. London: Phaidon.

Perotti, n.d.: Aurelia Perotti. *I Pittori Campi da Cremona*. Milan: Ulrico Hoepli.

Perrig, 1976: Alexander Perrig. *Michelangelo Studien*, 5 vols. Frankfort am Main: Peter Lang, 1976– .

Peters, 1965: Hans Albert Peters. "Bemerkungen zu Oberitalienischen Zeichnungen des XV and XVI Jahrhunderts," *Wallraf-Richartz Jahrbuch*, XXVII: 149–155.

Pevsner, 1940: Nikolaus Pevsner. *Academies of Art Past and Present*. Cambridge: The University Press.

Pevsner, 1973: Nikolaus Pevsner. *Academies of Art Past and Present*. New York: Da Capo Press.

Philadelphia, 1950: Philadelphia Museum of Art, Masterpieces of Drawing: Diamond Jubilee Exhibition. Cat. foreword by Carl Zigrosser.

Pieyre de Mandiargues, 1978: André Pieyre de Mandiargues. *Arcimboldo the Marvelous*. New York: Abrams.

Pignatti, 1970: Terisio Pignatti. *I disegni dei maestri, la scuola veneta*. Milan.

Pignatti, 1976: Terisio Pignatti. *Veronese*, 2 vols. Venice: Alfieri.

Pillsbury, 1971: see Cleveland, 1971.

Pillsbury, 1976: Edmund P. Pillsbury. "Barocci at Bologna and Florence," *Master Drawings*, XIV (Spring): 56–64.

Pillsbury and Caldwell, 1974: see New Haven, 1974.

Pillsbury and Richards, 1978: see New Haven, 1978.

Pino, 1946: Paolo Pino. *Dialogo di pittura*, ed. Rodolfo and Anna Pallucchini. Venice: Daria Guarnati.

Pochat, 1973: G. Pochat. *Figur und Landschaft*. Berlin and New York: Walter de Gruyter.

Pontormo to Greco, 1954: see Indianapolis, 1954.

Pope-Hennessy, 1948: John Pope-Hennessy. *The Drawings of Domenichino in the Collection of His Majesty The King at Windsor Castle*. London: Phaidon Press.

Pope-Hennessy, 1970: John Pope-Hennessy. *Raphael*. New York: New York University Press.

Popham, 1945: A. E. Popham. *The Drawings of Leonardo da Vinci*. New York: Reynal and Hitchcock.

Popham, 1953: Arthur Ewart Popham. *The Drawings of Parmigianino*. London: Faber and Faber.

Popham, 1957: A. E. Popham, *Correggio's Drawings*. London.

Popham, 1957a: A. E. Popham. "Parmigianino as a Landscape Draughtsman," *Art Quarterly*, XX (Autumn): 275–287.

Popham, 1967: A. E. Popham. *Italian Drawings in the Department of Prints and Drawings in the British Museum*, 4 vols. London.

Popham, 1971: A. E. Popham, *Catalogue of the Drawings of Parmigianino*, 3 vols. New Haven, CT: Yale University Press.

Popham and Di Giampaolo, 1971: Arthur E. Popham and Mario Di Giampaolo. *Disegni di Girolamo Bedoli*. Viadana: Sodalizio Amici dell'arte.

Popham and Fenwick, 1965: Arthur Ewart Popham and Kathleen M. Fenwick. *European Drawings (and Two Asian Drawings) in the Collection of the National Gallery of Canada*. Toronto: University of Toronto Press.

Popham and Wilde, 1949: A. E. Popham and J. Wilde. *The Italian Drawings of the XV and XVI Centuries in The Collection of His Majesty The King at Windsor Castle*. London: Phaidon.

Posner, 1970: Donald Posner. "Antonio Maria Panico and Annibale Carracci," *Art Bulletin*, LII (June): 181–183.

Posner, 1971: Donald Posner. *Annibale Carracci, A Study in the Reform of Painting Around 1590*, 2 vols. London: Phaidon Press.

Poughkeepsie, 1968: Vassar College Art Gallery, New York, The Italian Renaissance.

Pouncy and Gere, 1950-67: Philip Pouncey and John A. Gere. *Italian Drawings in the Department of Prints and Drawings in the British Museum*, 4 vols. London: The British Museum.

Providence, 1961: The Museum of Art, Rhode Island School of Design, Italian Drawings from the Museum's Collection.

Providence, 1967: Museum of Art, Rhode Island School of Design, Seven Centuries of Italian Art.

Providence, 1968: Museum of Art, Rhode Island School of Design, Visions and Revisions. Cat. by Stephen E. Ostrow.

Providence, 1973: Museum of Art, Rhode Island School of Design, Drawings and Prints of the First Maniera 1515–1535. Cat. by Cathy Wilkinson.

Providence, 1978: Bell Gallery, Brown University, The Origins of the Italian Veduta.

Ramsden, 1963: E. H. Ramsden, ed. *The Letters of Michelangelo*, 2 vols. Stanford, CA: Stanford University Press.

J. C. Rearick, 1964a: Janet Cox Rearick. "Some Early Drawings by Bronzino," *Master Drawings*, II: 363–382.

J. C. Rearick, 1964b: Janet Cox Rearick. *The Drawings of Pontormo*, 2 vols. Cambridge, MA: Harvard University Press.

J. C. Rearick, 1970: Janet Cox Rearick. "The Drawings of Pontormo: Addenda," *Master Drawings*, VIII (Fall): 363–378.

W. R. Rearick, 1958-59: W. R. Rearick. "Battista Franco and the Grimani Chapel," *Saggi e memorie di storia dell'arte*, II: 107–139.

Regina, 1970: Norman Mackenzie Art Gallery, University of Regina, Saskatchewan, A Selection of Italian Drawings from North American Collections. Cat. by Walter Vitzthum.

Regoli, 1966: Gigetta Dalli Regoli. *Lorenzo di Credi*. Pisa: Edizioni di Comunità.

Reinach, 1902: Salomon Reinach. *Album de Pierre Jacques, sculpteur de Reims, dessiné à Rome de 1572 à 1577*. Paris: Leroux.

Rhode Island School of Design, 1961: see Providence, 1961.

Richards, 1959: Louise S. Richards. "River Gods by Domenico Beccafumi," CMA *Bulletin*, XLVI (Feb.): 24–29.

Richards, 1961: Louise S. Richards. "Federico Barocci, A Study for Aeneas's Flight from Troy," CMA *Bulletin*, XLVIII (April): 63–65.

Richards, 1962: Louise S. Richards. "Three Early Italian Drawings," CMA *Bulletin*, XLIX (Sept.): 172–173, fig. 5.

Richards, 1964: Louise S. Richards. "Two Early Italian Drawings," CMA *Bulletin*, LI (Oct.): 190–195.

Richards, 1965a: Louise S. Richards. "Drawings by Battista Franco," CMA *Bulletin*, LII (Oct.): 107–112.

Richards, 1965b: Louise S. Richards. "Giovanni Battista Franco's Anatomical Drawings in Cleveland," *Journal of the History of Medicine and Allied Sciences*, XX: 405–409.

Richter, 1970: Jean Paul Richter, ed. *The Notebooks of Leonardo da Vinci*, 2 vols. New York: Dover.

Ridolfi, 1914: Carlo Ridolfi. *Le Maraviglie dell'arte*, ed. Detlev Freiherrn von Hadeln, 2 vols. Berlin: G. Grote'sche Verlagsbuchhandlung, 1914; orig. publ. Venice, 1648.

Riedl, 1976: Peter Anselm Riedl. *Disegni dei barocceschi senesi*. Florence: Leo S. Olschki.

Ripa, 1767: Cesare Ripa. *Iconologia*, 5 vols. Perugia: Piergiovanni Costantini, 1764–1767.

Robert-Dumesnil, 1835-71: A.-P.-F. Robert-Dumesnil. *Le Peintre-Graveur Français*, 40 vols. Paris: Warée.

Robertson, 1967: I. G. Robertson. "Report of The Keeper of The Department of Western Art," pp. 19–42, in *Report of the Visitors, Ashmolean Museum, University of Oxford*. Oxford: The University Press.

Rodinò, 1977: Prosperi Valenti Rodinò. *Disegni fiorentini 1560–1640 dalle collezioni del Gabinetta Nazionale delle Stampe*. Rome: Gabinetto Nazionale delle Stampe.

Rodolfo, 1927: G. Rodolfo. *Disegni di Gaudenzio Ferrari e di Bernardino Lanino*. Carmagnola.

Rome, 1972: Villa Medici, Il paesaggio nel disegno del cinquecento europeo. Cat. by Lidia Bianchi. Rome: De Luca Editore.

Rosand, 1971: David Rosand. "Three Drawings by Paolo Veronese," *Pantheon*, XXIX (May-June): 203–209.

Rosand, 1972: see Birmingham, 1972.

Rosand and Muraro, 1976: see Washington, 1976.

Rosenwald Collection, 1954: The Rosenwald Collection, The Gift of Lessing J. Rosenwald to the Library of Congress. Washington, DC: The National Gallery of Art.

Rosenwald Collection, 1977: The Lessing J. Rosenwald Collection: A Catalogue of the Gifts of Lessing J. Rosenwald to the Library of Congress, 1943–1975. Washington, DC: The National Gallery of Art.

Roskill, 1968: Mark W. Roskill. *Dolce's "Aretino" and Venetian Art Theory of the Cinquecento*. New York: New York University Press.

Rossi, 1975: Paola Rossi. *Jacopo Tintoretto*. Florence: La Nuova Italia.

Ruland, 1876: Carl Ruland. *The Works of Raphael Santi*. London: J. Murray.

Sacramento, 1971: E. B. Crocker Art Gallery, California, Master Drawings from Sacramento. Cat. by J. A. Mahey.

Sacramento, 1975: E. B. Crocker Art Gallery, The Fortuna of Michelangelo, Prints, Drawings, and Small Sculpture from California Collections. Cat. intro. by L. Price Amerson, Jr.

Salerno, 1952: Luigi Salerno. "The Early Work of Giovanni Lanfranco," *Burlington Magazine*, XCIV (July): 188–196.

Sánchez, 1978: A. E. Pérez Sánchez. *I grandi disegni italiani nelle collezioni di Madrid*. Milan: Silvana Editoriale d'Arte.

Sanminiatelli, 1955: Donato Sanminiatelli. "The Sketches of Domenico Beccafumi," *Burlington Magazine*, XCVII (Feb.): 34–41.

Sanminiatelli, 1956: Donato Sanminiatelli. "L'esposizione di chiaroscuri agli Uffizi," *Paragone*, VII: 73, 53–60.

Sanminiatelli, 1957: Donato Sanminiatelli. The Beginnings of Domenico Beccafumi," *Burlington Magazine*, XCIX (Dec.): 401–410.

Sanminiatelli, 1967: Donato Sanminiatelli. *Domenico Beccafumi*. Milan: Bramante Editrice.

San Miniato, 1959: Accademia degli Euteleti Città di San Miniato, Mostra del Cigoli e del suo ambiente. Cat. by Mario Bucci, Anna Forlani, Luciano Berti, and Mina Gregori. San Miniato: Palagini.

Sannazaro, 1888: Jacopo Sannazaro. *Arcadia*. Turin: Ermanno Loescher.

Sarasota, 1970: The John and Mable Ringling Museum of Art, Florida, The Bick Collection of Italian Religious Drawings. Cat. intro. by P. A. Tomory.

Sarasota, 1978: John and Mable Ringling Museum of Art, Masterworks on Paper: Prints and Drawings from the Ringling Museums 1400–1900, A Handbook of the Graphic Arts. Cat. by William H. Wilson.

Saunders and O'Malley, 1950: J. B. de C. M. Saunders and C. D. O'Malley. *The Illustrations from the Works of Andreas Vesalius of Brussels*. Cleveland: World Publishing.

Scholz, 1958: Janos Scholz. "Notes on Drawings: On Brescian Renaissance Drawings," pp. 411–418, in *Essays in Honor of Hans Tietze*. Paris: Gazette des Beaux-Arts.

Scholz, 1967: Janos Scholz. "Italian Drawings in the Art Museum of Princeton University," *Burlington Magazine*, CIX (May): 295.

Scholz, 1976: Janos Scholz. *Italian Master Drawings 1350–1800 from the Janos Scholz Collections*. New York: Dover.

Schön, 1538: Erhard Schön. *Underweisung der Proporzion und Stellung der Possen*. Nuremberg.

Schulz, 1978: Juergen Schulz. "Jacopo de' Barbari's View of Venice: Map Making, City Views, and Moralized Geography Before the Year 1550," *Art Bulletin*, LX (Sept.): 425–474.

Schwarzweller, 1935: Kurt Schwarzweller. *Giovanni Antonio da Pordenone*. Güttingen: privately published.

Seymour, 1972: Charles Seymour, Jr., ed. *Michelangelo: The Sistine Chapel Ceiling*. New York: W. W. Norton.

Shapley, 1973: Fern Rusk Shapley. *Paintings from the Samuel H. Kress Collection*, 3 vols. London: Phaidon, 1966–1973.

Shearman, 1967: John Shearman. *Mannerism*. Baltimore, MD: Penguin.

Shoemaker, 1975: Innis Howe Shoemaker. "Filippino Lippi as a Draughtsman." Ph.D. dissertation, Columbia University, 1975; Ann Arbor, MI: University Microfilms.

Sluys, 1961: Felix Sluys. *Didier Barra et Francois de Noma dits Monsu Desiderio*. Paris: Éditions du Minataure.

Smyth, 1955: C. H. Smyth. "Bronzino Studies." Ph.D. dissertation, Princeton University, 1955; Ann Arbor, MI: University Microfilms, 1973.

Smyth, 1971: C. H. Smyth. *Bronzino as Draughtsman*. Locust Valley, NY: J. J. Augustin.

Sóriga, 1912: see Milan, 1912.

Spear, 1967: R. E. Spear. "Some Domenichino Cartoons," *Master Drawings*, V: 144–158.

Spreti, 1969: Vittorio Spreti. *Enciclopedia storico-nobiliare italiana*, 9 vols. Bologna: Forni editore.

Stampfle, 1974: Felice Stampfle. *Drawings: Major Acquisitions of the Pierpont Morgan Library, 1924–1974*, 4 vols. New York: The Pierpont Morgan Library.

Steinberg, 1971-72: Leo Steinberg. "Salviati's Beheading of St. John the Baptist," *Art News*, LXX (no. 5): 46–47.

Steinberg, 1973: Leo Steinberg. "Leonardo's Last Supper," *Art Quarterly*, XXXVI (Winter): 297–410.

Steinberg, 1975: Leo Steinberg. *Michelangelo's Last Paintings: The Conversion of St. Paul and the Crucifixion of St. Peter in the Cappella Paolina in the Vatican*. New York: Oxford University Press.

Steinitz, 1958: Kate T. Steinitz. *Leonardo da Vinci's Trattato della Pittura*. Copenhagen: Munksgaard.

Steinmann, 1905: Ernst Steinmann. *Die Sistinische Kapell*, 2 vols. Munich: F. Bruckmann, 1901–1905.

Stix and Spitzmüller, 1926–41: Alfred Stix and Anna Spitzmüller. *Beschreibender Katalog der Handzeichnungen in der Graphischen Sammlung Albertina*, 6 vols. Vienna: A. Schroll.

St. Louis, 1972: The St. Louis Art Museum, Missouri, Italian Drawings Selected from Midwestern Collections. Cat. by Nancy Ward Neilson.

Storrs, 1967: The University of Connecticut, The Figure in the Mannerist and Baroque Drawing.

Suida, 1929: Wilhelm Suida. *Leonardo und sein Kreis*. Munich: Bruckmann.

Suida, 1951: W. E. Suida. *Paintings and Sculpture from the Kress Collection*. Washington, DC: National Gallery of Art.

Suida, 1958: See Atlanta, 1958.

C. Swartz, 1973: see Providence, 1973.

Thieme-Becker, 1907–50: Ulrich Thieme and Felix Becker. *Allgemeines Lexikon der Bildenden Künstler von Antike bis zur Gegenwart*, 37 vols. Leipzig: E. A. Seeman.

Thode, 1902: Henry Thode. *Michelangelo: Kritische Untersuchungen über seine Werk*, 3 vols. Berlin: G. Grote, 1908–1913.

Thode, 1912: Henry Thode. *Michelangelo und das Ende der Renaissance*, 3 vols. Berlin: G. Grote, 1901–1912.

Thomas, 1916: T. H. Thomas. "Ottavio Leoni—A Forgotten Portraitist," *Print Collector's Quarterly*, VI: 321–373.

Tietze, 1906–07: Hans Tietze. "Annibale Carraccis Galerie im Palazzo Farnese und seine römische Werkstätte." *Jahrbuch der Kunsthistorischen Sammlungen des allerhöchsten Kaiserhauses*, XXVI: 47–181.

Tietze, 1936: H. Tietze. *Tizian, Leben und Werk*, vol. I. Vienna: Phaidon Verlag.

Tietze, 1947: H. Tietze. *European Master Drawings in the United States*. New York: J. J. Augustin.

Tietze, 1950: H. Tietze. *Titian, the Paintings and Drawings*. London: Phaidon Press.

Tietze-Conrat, 1939: Erica Tietze-Conrat. "A Master Drawing by Antonio Campi," *Art in America*, XXVII (Oct.): 160–163.

Tietze and Tietze-Conrat, 1936: H. Tietze and E. Tietze-Conrat. "Tizian-Studien," *Jahrbuch der Kunsthistorischen Sammlungen in Wien*, n. s., X: 167–191.

Tietze and Tietze-Conrat, 1944: H. Tietze and E. Teitze-Conrat. *Drawings of the Venetian Painters in the Fifteenth and Sixteenth Centuries*. New York: J. J. Augustin.

Tokyo, 1976: The National Museum of Western Art, Masterpieces of World Art from American Museums, from Ancient Egyptian to Contemporary Art. Cat. by Yamade Chisaburo et al.

Toledo, 1940: The Toledo Museum of Art, Ohio, Four Centuries of Venetian Paintings. Cat. intro. by Hans Tietze.

Tolnay, 1943: Charles de Tolnay. *History and Technique of Old Master Drawings, A Handbook*. New York: H. Bittner.

Tolnay, 1943–60: Charles de Tolnay. *Michelangelo*, 5 vols. Princeton, NJ: Princeton University Press.

Tolnay, 1978: Charles de Tolnay. *Corpus dei disegni di Michelangelo*, 4 vols. Novara: Istituto Geografico de Agostini, 1975–1978.

Tomory, 1954: see Leicester, 1954.

Tomory, 1970: see Sarasota, 1970.

Tomory, 1976: Peter Tomory. *Catalogue of the Italian Paintings before 1800, The John and Mable Ringling Museum of Art*. Sarasota, FL: Ringling Museum of Art.

Toronto, 1960: The Art Gallery of Toronto, Titian, Tintoretto, Paolo Veronese with a Group of Sixteenth-Century Venetian Drawings. Cat. ed. by Nancy Robertson, intro. by Martin Baldwin.

Torriti, 1963: Piero Torriti. *Il Palazzo Reale di Genova*. Genoa: Elle Gi, Arti grafiche, 1963.

Toschi, 1900: Giovanni Battista Toschi, "Lelio Orsi da Novellara," *L'Arte*, III: 3–31.

Turner, 1966: Almon Richard Turner. *The Vision of Landscape in Renaissance Italy*. Princeton, NJ: Princeton University Press.

Turnure, 1965: J. M. Turnure. "The Late Style of Ambrogio Figino," *Art Bulletin*, XLVII (March): 35–55.

Van Regteren Altena, 1966: Johan Quirijn van Regteren Altena. *Les Dessins Italiens de la Reine Christine de Suède*. Stockholm: A. B. Egnellska Boktryckeriet.

Vasari-Milanesi, 1878–85: G. Vasari. *Le vite de' più eccellenti pittori, scultori ed architettori con nuove annotazioni e commenti di G. Milanesi*, 9 vols. Florence: G. C. Sansoni.

Vasari, 1927: Giorgio Vasari. *The Lives of the Painters, Sculptors and Architects*, 4 vols., trans. A. B. Hinds. London: J. M. Dent & Sons.

Venice, 1957: Giorgio Cini Foundation, Exhibition of Venetian Drawings from the Collection of Janos Scholz. Cat. by Michelangelo Muraro.

Venice, 1976: Giorgio Cini Foundation, Disegni di Tiziano e della sua cerchia. Cat. by Konard Oberhuber.

Venturi, 1901–40: Adolfo Venturi. *Storia dell'Arte Italiana*, 11 vols. Milan: Ulrico Hoepli.

L. Venturi, 1931: Lionello Venturi. "Eine Historienfolge des Scipio Africanus von Bernardo Parentino," *Pantheon*, VII (May): 204–207.

Vercelli, 1956: Museo Borgogna, Mostra di Gaudenzio Ferrari. Milan: "Silvana."

Vertova, 1960: L. Vertova. "Some Late Works by Veronese," *Burlington Magazine*, CII (Feb.): 68–71.

Vey, 1958a: Horst Vey. *A Catalogue of the Drawings by European Masters in the Worcester Art Museum*. Worcester, MA.

Vey, 1958b: Horst Vey. "Some European Drawings at Worcester." *Worcester Art Museum Annual*, VI: 9–42.

Vida, 1976: Marco Girolamo Vida. *De arte poetica*, ed. R. G. Williams. New York: Columbia University Press.

Virch, 1956: Claus Virch. "A Study by Tintoretto After Michelangelo," *Bulletin of the Metropolitan Museum of Art*, XV (Dec.): 111–116.

Vitruvius, 1960: Vitruvius. *The Ten Books on Architecture*, trans. M. H. Morgan. New York: Dover.

Vitzthum, 1966: Walter Vitzthum. "Drawings from New York Collections," *Burlington Magazine*, CVIII (Feb.): 109–110.

Vitzthum, 1971: W. Vitzthum. *Il barocco a Roma*. Milan: Fratelli Fabbri.

Vogtherr, 1538: Heinrich Vogtherr. *Ein Fremde und Wandbarliches Künstbuchlin*. Strassburg.

Von der Gabelentz, 1922: Hans von der Gabelentz. *Fra Bartolommeo und die Florentiner Renaissance*, 2 vols. Leipzig: Karl W. Hiersemann.

Von Einem, 1973: Herbert von Einem. *Michelangelo*. London: Methuen.

Voragine, 1941: Jacobus de Voragine. *The Golden Legend*, ed. Granger Ryan and Helmut Ripperger. New York: Longmans, Green and Co.

Wackernagel, 1938: Martin Wackernagel. *Der Lebensraum des Künstlers in der florentinischen Renaissance*. Leipzig.

Washington, 1973: National Gallery of Art, Sixteenth-Century Italian Drawings from the Collection of Janos Scholz. Cat. by Konrad Oberhuber and Dean Walker.

Washington, 1974a: National Gallery of Art, Recent Acquisitions and Promised Gifts, Sculpture, Drawings, Prints.

Washington, 1974b: National Gallery of Art, Venetian Drawings from American Collections. Cat. by T. Pignatti.

Washington, 1976: National Gallery of Art. Titian and the Venetian Woodcut. Cat. by David Rosand and Michelangelo Muraro.

Washington, 1978: National Gallery of Art, Master Drawings from the Collection of The National Gallery of Art and Promised Gifts.

Washington, 1979: National Gallery of Art, Prints and Related Drawings by the Carracci Family, A Catalogue Raisonné. Cat. by Diane DeGrazia Bohlin.

Watrous, 1957: James Watrous. *The Craft of Old Master Drawings*. Madison, WI: University of Wisconsin Press.

Wazbinski, 1963: Zygmunt Wazbinski. A Propos de quelques dessins de Parentino pour le Couvent de Santa Giustina," *Arte Veneta*, XVII: 21–26.

Wheelock, 1977: A. K. Wheelock, Jr. "Constantijn Huygens and Early Attitudes towards the Camera Obscura," *History of Photography*, I (April): 93–103.

Wilde, 1953: J. Wilde. *Italian Drawings in the Department of Prints and Drawings in the British Museum: Michelangelo and His Studio*. London: Trustees of the British Museum.

Williamson, 1903: G. C. Williamson, ed. *The Anonimo*. New York: Benjamin Blom.

Wittkower, 1952: R. Wittkower. *The Drawings of the Carracci in the Collection of Her Majesty the Queen at Windsor Castle*. London: Phaidon.

Wittkower, 1969: R. Wittkower. *Art and Architecture in Italy: 1600–1750*. Baltimore, MD: Penguin Books.

R. and M. Wittkower, 1964: R. and M. Wittkower. *The Divine Michelangelo*. London: Phaidon, 1964.

Wittkower, 1965: see Detroit, 1965.

Worcester, 1958: Worcester Art Museum, European Drawings from the Museum Collection.

Zerner, n.d.: Henri Zerner. *The School of Fontainebleau*. New York: Abrams.

Zonta, 1913: Giuseppe Zonta. *Trattati del cinquecento sulla donna*. Bari.

Zuccaro, 1961: see Heikamp, 1961.

Provenance Index

Index

173

Photograph Credits